ALLAN RAMSAY
1713–1784

SPONSORED BY

D1382268

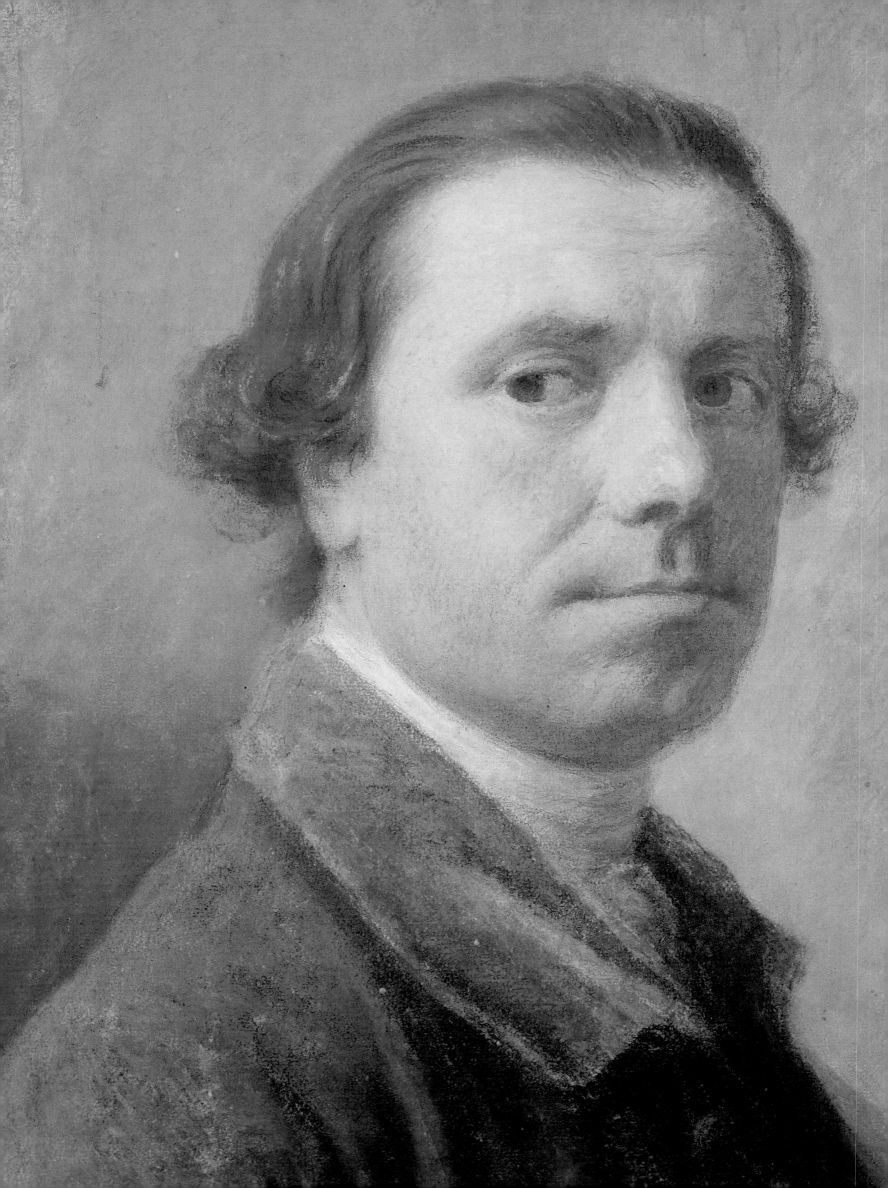

ALASTAIR SMART

ALLAN RAMSAY
1713–1784

SCOTTISH NATIONAL PORTRAIT GALLERY

1992

PUBLISHED 1992 BY
THE TRUSTEES OF THE NATIONAL GALLERIES OF SCOTLAND
FOR THE EXHIBITION HELD AT THE SCOTTISH NATIONAL PORTRAIT GALLERY
EDINBURGH, FROM 1 AUGUST TO 27 SEPTEMBER 1992
AND AT THE NATIONAL PORTRAIT GALLERY, LONDON
FROM 16 OCTOBER 1992 TO
17 JANUARY 1993

EXHIBITION SELECTED AND CATALOGUED BY ALASTAIR SMART
WITH A CONTRIBUTION BY ROSALIND K MARSHALL

EXHIBITION ORGANISED AND CO-ORDINATED BY JAMES HOLLOWAY

CATALOGUE EDITED BY DUNCAN THOMSON

DISTRIBUTED TO THE BOOK TRADE
WORLDWIDE BY NATIONAL PORTRAIT GALLERY PUBLICATIONS
© THE TRUSTEES OF THE NATIONAL GALLERIES OF SCOTLAND
ALL RIGHTS RESERVED
ISBN 0 903598 19 1 (PAPER)
ISBN 0 903598 26 4 (CLOTH)
DESIGNED AND TYPESET IN ADOBE CASLON BY DALRYMPLE
PRINTED BY BURGESS & SON, ABINGDON
BOUND BY HUNTER & FOULIS, EDINBURGH

FRONTISPIECE
SELF-PORTRAIT (NO.52)

FRONT COVER
MARGARET RAMSAY, THE PAINTER'S SECOND WIFE (NO.66)

BACK COVER
SELF-PORTRAIT
(NO.9)

Foreword

Allan Ramsay's reputation is now at least equal to that of the finest British painters of the eighteenth century. This was not always so and that he is now held in such high regard is due primarily to the pioneering work of one man, Alastair Smart, until recently Professor of Fine Art at Nottingham University. His dedication to the cause of Ramsay has become near-legendary, so that it is virtually impossible to mention one name without immediately thinking of the other. We are thus immensely fortunate that Professor Smart has been able to compile the present exhibition on our behalf, covering the whole range of Ramsay's works, and to write this catalogue which is the essential guide. Both exhibition and publication bring the many years of research to a wonderful fruition – although the author remains as eager as ever to glean new knowledge of Ramsay's life and work. It is, in addition, particularly fitting that the exhibition will be seen in both Edinburgh and London for the painter was closely associated with these two cities throughout his life.

Alastair Smart's quest for the real Ramsay first found expression in 1952, with the publication of his *The Life and Art of Allan Ramsay*. Its elegance, wit and precision set a new standard for the many publications on Scottish painting that were to follow in the next few decades. Inevitably, the story it told has changed in the light of subsequent discoveries and a new biography by the author will be published by Yale University Press and the Paul Mellon Centre for Studies in British Art in time to coincide with the exhibition. The present publication does not, therefore, deal with Ramsay's personal life in great detail and concentrates instead on his artistic development and the progress of his career as a painter. In addition to the new biography, the same publishers will bring out next year Professor Smart's *catalogue raisonné* of Ramsay's portraits. As a consequence parts of the usual scholarly apparatus, such as detailed provenances and literary references, have been omitted from the present publication.

An exhibition of this scale and importance can only be mounted with the help of a great many people, of whom only a few can be mentioned here. One who must be is our colleague James Holloway, Assistant Keeper of the Scottish National Portrait Gallery in Edinburgh, who has co-ordinated the whole project and looked after a host of practical details. We are also grateful for the help and encouragement of our colleagues in the National Portrait Gallery in London, particularly the Director, John Hayes, and Jacob Simon. It has been an easy and pleasant co-operation.

Mention must also be made of John Dick, Keeper of Conservation in the National Galleries of Scotland, who has transformed the appearance of a number of major paintings in the exhibition, enabling us to see them as they were originally meant to be seen. In this endeavour he has had sterling help from his colleagues Donald Forbes and Nicola Christie. Additionally, we must thank Estelle Barr for coping with manuscripts of sometimes extraordinary complexity and producing a final typescript of near-perfection.

The author of this publication has, of course, accrued enormous debts throughout his many years of work on Ramsay and Professor Smart has particularly asked us to acknowledge them here – especially the many owners who allowed him access to their collections and scholars who were always generous with their help and encouragement.

Inevitably, our greatest debt is to those owners who have lent works to the exhibition, thereby denuding their own walls of masterpieces over a period of many months. We can only hope to repay their great generosity by means of the pleasure and enlightenment we feel sure the exhibition will give to a wide public in the two capital cities.

Finally, we must thank our sponsors, Mobil North Sea Limited. We regard them as rather special sponsors, having had a very productive and happy relationship with them over a number of years, and we are particularly grateful for the sensitive way that Chris Patey and his colleague Lloyd Slater have dealt with all aspects of the project. We look upon Mobil as indispensable partners in bringing this exhibition into being.

TIMOTHY CLIFFORD *Director, National Galleries of Scotland*

DUNCAN THOMSON *Keeper, Scottish National Portrait Gallery*

Biographical Summary

1713

Allan Ramsay the Younger born 13 October, Old Style
(2 October, New Style), in Edinburgh, the eldest child of the
poet Allan Ramsay (1684-1758) by the latter's wife Christian
Ross.

1726

Enters the Edinburgh High School, where he acquires a
sound knowledge of Latin and French (to which he
subsequently adds Greek, Italian and German).

1729

In October enrols at the newly founded Academy of St.
Luke in Edinburgh.

1732-3

Becomes the pupil in London of the Swedish portrait
painter Hans Hysing.

1732-6

In practice as a portrait painter in Edinburgh. In the winter
of 1733-4 designs for his father's retirement the so-called
'Guse-pye' house, of octagonal construction, on the
Castlehill in Edinburgh, where he sets up his painting-
room, dedicating the house to the 'Sister Arts'. (In 1741 the
title of the property is transferred to him.)

1736-8

First visit to Italy. Travels to Rome, via Paris, in the company
of Dr. Alexander Cunyngham (afterwards Sir Alexander
Dick of Prestonfield). Shipwrecked off Pisa. After a
fortnight in Florence, arrives in Rome on 26 October 1736.
Places himself under the history painter Francesco Imperiali
and also draws at the French Academy. Comes under the
influence of Imperiali's pupil Pompeo Batoni. In the
summer of 1737 enters the studio of the great Neapolitan
master Francesco Solimena, and while in Naples receives
numerous commissions for portrait-drawings of English

residents. Returns to Rome on 1 October 1737. Arrives back
in London in June 1738.

1738

Sets up practice in London (by August), taking apartments
in the Great Piazza, Covent Garden. In December the
antiquary Alexander Gordon reports the general opinion of
the London connoisseurs that, with the exception of 'one
young man, an Italian', evidently Andrea Soldi, Ramsay has
no equal among portrait painters in Britain.

1738-9

Encouraged by Dr. Richard Mead, the physician and
collector, who introduces him into society and to prospective
patrons. In 1739 becomes a member of Mead's exclusive
Dining Club and thereby of a distinguished circle of
scholars, antiquaries and connoisseurs. Joins the group of
artists associated with the St. Martin's Lane Academy
(directed principally by Hogarth). Employs Joseph
Vanhaecken (c.1699-1749) as drapery-painter.

1739

Marries Anne Bayne, the daughter of a law professor at
Edinburgh and a great-granddaughter of the Scottish
architect Sir William Bruce. Full-length of *Lord Hardwicke,*
Lord High Chancellor.

1740

Full-length of *John Campbell, 2nd Duke of Argyll* (begun in
1739). Publishes in the *Philosophical Transactions of the Royal
Society* translations of descriptions sent to him by Camillo
Paderni (his fellow pupil under Imperiali) of the ancient
frescoes lately uncovered at Herculaneum.

1743

Death of Ramsay's first wife Anne Bayne in February.
Elected a Fellow of the Society of Antiquaries.

1744

Commencement of the patronage of Archibald Campbell, 3rd Duke of Argyll.

1745

Visits Edinburgh in the late summer, having offered to paint a full-length of the *2nd Earl of Hopetoun* as a present to the Edinburgh Royal Infirmary, and arrives in time to witness the occupation of the city by Prince Charles Edward Stewart; during the Jacobite occupation the 'Guse-pye' house becomes the scene of a skirmish between the opposing forces.

1747

Presents to the Foundling Hospital in London his full-length of *Dr. Richard Mead*, which is hung up beside Hogarth's *Captain Thomas Coram* of 1740, and which introduces the 'Continental Grand Manner' into British portraiture. Visits Edinburgh between the summer of 1747 and January 1748. About this time completes a full-length of the *MacLeod of MacLeod* and paints a full-length of *John, 4th Earl of Loudoun*. Purchases the estate of Kinkell, in Fife, being known thereafter as 'Allan Ramsay, Esq, of Kinkell'. Pays court to a Miss Mary Scott, but nothing comes of this attachment.

1748

Visits Scotland in August in the suite of the 3rd Duke of Argyll, whose guest he remains for several weeks at Inveraray Castle, Argyllshire.

1749

Full-length of the *3rd Duke of Argyll* for Glasgow Town Council, representing at an early stage a development towards a more informal mode of portraiture. Death of Joseph Vanhaecken in July.

1751

After a visit to his studio in August, the critic George Vertue describes Ramsay's portraits as being 'much superior in merit' to those by his contemporaries, among whom his principal rival is now Thomas Hudson, the teacher of Reynolds.

1752

On 1 March marries in Edinburgh, by elopement, Margaret Lindsay, elder daughter of Sir Alexander and Lady Lindsay of Evelick, who strongly disapprove of the match and break off all relations with their daughter.

1753

Publishes anonymously an essay *On Ridicule*, which reflects the influence of Hume in its excursions into religious questions and also contains a tribute to the work of Hogarth; and a *Letter from a Clergyman* on the notorious Canning case, written in opposition to the conclusions of Henry Fielding and contributing decisively to an elucidation of the affair and to the reversal of the course of justice, Ramsay's arguments being commended by Voltaire. Paints (in London) three-quarter-lengths of *John Sargent the Elder* and *Thomas Lamb of Rye*, reflecting a fundamental change in Ramsay's style under the influence of Hogarth and the French pastellist Maurice Quentin de La Tour, and in rejection of the conventions of Italianate Baroque.

1753–4

From late 1753 to June 1754 works in Edinburgh, painting over forty portraits (mostly on a small scale), including half-lengths of *Lady Helen Wemyss* and *Mrs. Mary Adam*, three-quarter-lengths of *Hew Dalrymple, Lord Drummore* and *James Adam*, and a bust-length portrait of *David Hume*. Develops further his new, 'natural' style, in which powerful characterization is combined with an elegance and delicacy reminiscent of contemporary French painting. Together with his friend Hume and Adam Smith, founds the debating club known as the Select Society.

1754–7

Second visit to Italy, accompanied by his wife and his sister Catherine. Leaves London in July 1754, arriving in Florence in early October, and in Rome in mid-December. Returns to draw at the French Academy in Rome (now under the direction of Charles Natoire). His circle in Rome includes Robert Adam, Clérisseau, Piranesi and the archaeologist and classical scholar Robert Wood. In the spring of 1756 pays a short visit to Naples. In May and early June 1757 spends some time in Florence, before setting out on his journey home via Venice, Düsseldorf and Rotterdam. During his stay in Italy devotes much time to making drawings after the Old Masters, notably Domenichino, but probably paints less than a dozen portraits, which include *Robert Wood, Margaret Ramsay with a Parasol* (both 1755), *James Bateman, John Burgoyne* (both 1756) and an unfinished *Self-portrait* reminiscent of La Tour.

1755

In the spring publishes, anonymously, his *Dialogue on Taste*, in which, besides commending the naturalism of La Tour, Hogarth and the landscape painter George Lambert,

Ramsay argues against Hogarth's theory of the existence in Nature of an objective principle of Beauty (the 'Line of Beauty and Grace'), employing a method of reasoning suggestive of the influence of Hume. By its further insistence on the superiority of the arts of ancient Greece to those of the Romans, the *Dialogue* also takes an early place in the Roman-Greek controversy of the mid-eighteenth century, and by its appreciation of Gothic architecture reflects something of the new taste for the 'Gothick'. Ramsay's vehement strictures upon the medieval Church, even more than his criticisms of the ancient Romans, were to arouse Piranesi to an angry response in his great treatise *Della Magnificenza ed Architettura de' Romani* of 1761.

1757
Returns to London in August. Moves to a new house at 31 Soho Square. In October begins for John Stuart, 3rd Earl of Bute (nephew of the 3rd Duke of Argyll) a full-length portrait of the Prince of Wales, afterwards King George III. Beginning of Lord Bute's patronage of Ramsay. Elected a member of the Society of Arts in December, having been proposed by Lord Stanhope. Subsequently takes a leading part in the Society's Committee for the Polite and Liberal Arts.

1758
Death of his father, the poet, in January. Full-length portrait of the *3rd Earl of Bute*, commissioned by the Prince of Wales. In August Ramsay pays a short visit to Edinburgh. Robert Strange declines to engrave the portrait of the Prince, and subsequently accuses Ramsay of hinting at his disaffection to the Crown.

1759
In February Horace Walpole pays tribute to the 'delicacy' of Ramsay's style, and expresses the opinion that he is superior to Reynolds as a painter of women.

ABOUT 1759–60
Half-length portrait of *Margaret Ramsay with a bowl of roses*.

1760
Visits Edinburgh in September and is much in the company of David Hume. Accession of George III in October.

1761
Full-length State portrait of *King George III in Coronation Robes*; followed (c.1761-2) by a pendant of *Queen Charlotte in Coronation Robes*. In December appointed 'one of His Majesty's Principal Painters in Ordinary', and made responsible for the numerous copies of the coronation portraits now coming into demand. Becomes a favourite at the Court, forming a friendly relationship with the King and pleasing the Queen by his ability to converse with her in her native German. From this time suffers from the anti-Scottish feeling engendered by Bute's patronage of his fellow countrymen, and in particular from the resentment over his Court appointment expressed by the advocates of Reynolds.

1762
Full-lengths of *Lady Mary Coke* and *Richard Grenville, 2nd Earl Temple*; three-quarter-length of *Elizabeth Montagu*; half-length of *Philip, Viscount Mahon* and bust-length portrait of *William Pulteney, 1st Earl of Bath*.

1762–6
Paints a series of family portraits for Holland House, Kensington, commissioned by Caroline, Baroness Holland along with others executed by Reynolds. These include a three-quarter-length of *Emily, Marchioness of Kildare* (1765) and a half-length of *Lady Holland* (completed in 1766). Paints group-portrait of *Queen Charlotte and her two eldest children* (c.1764-5).

1765
Vice-President of the Incorporated Society of Artists. Between September and October, accompanied by his wife and his ten-year-old daughter Amelia (afterwards Lady Campbell), visits Geneva and Paris, staying in Geneva with his friends Lord and Lady Stanhope and calling upon Voltaire at Ferney; in Paris, introduced by the painter Louis-Michel Vanloo to Diderot; meets the Baron d'Holbach; and comforts Horace Walpole, who is suffering from gout. Publishes anonymously *An Essay on the Constitution of England*, in which the liberties enjoyed by the British people 'under the best of Kings' are contrasted with the limited liberties guaranteed by Magna Carta; two years later the essay is published under Ramsay's name in a German edition. Paints a double-portrait of Horace Walpole's nieces Laura Keppel and Charlotte Walpole, Lady Huntingtower.

1767
Death of John Shackleton, Principal Painter in Ordinary to George II and George III, in March. Ramsay succeeds to his office. Takes up residence at 67 Harley Street, having converted an upper storey into a long gallery serving as a

studio for the production by his assistants of copies of the coronation portraits of the King and Queen. Visits Edinburgh in the late summer, and supervises improvements to one of his properties, now occupied by Lady Lindsay.

1767–70

Paints for Princess Augusta, Princess Dowager of Wales, a revised version of the coronation portrait of *Queen Charlotte*, showing the Queen at a maturer age and as conforming to the new French fashion in hair-styles. Commissioned about the same time to paint various royal portraits – a full-length of *Prince William (afterwards William IV)* as a small boy beating a toy drum; a three-quarter-length of the Queen's brother *Prince George Augustus* (1769); a posthumous three-quarter-length portrait of her mother, *Princess Elisabeth Albertina of Mecklenburg-Strelitz* (*c.*1769-70); a masterly three-quarter-length of *Princess Augusta* (1769); and a full-length, sent to Hanover, of *Prince Frederick, Duke of York*, datable in the early 1770s and constituting the last of Ramsay's known royal commissions. Altogether, apart from the numerous replicas in which Ramsay was personally engaged, the number of his commissions for portraits of the Royal family and their German relations amounts to more than a dozen – an employment for which the only true precedent in England is provided by Van Dyck's service to Charles I.

ABOUT 1772

Portrait of *Lady Charlotte Burgoyne*.

1773

At some time before 20 March Ramsay suffers permanent injury to his right arm, in consequence of a fall from a ladder, and is compelled to retire from painting. In the summer visits Edinburgh with his wife and Amelia, evidently in connection with Lady Lindsay's ill health. From October to November, accompanied by his sister Janet, escorts the Hon. Rachel Hamilton to Geneva to see her sister Lady Stanhope, who has been crippled by a fall. Visits Voltaire again at Ferney, taking with him the young 5th Earl of Chesterfield.

1774

Death of Lady Lindsay in February. During the summer complains of 'rheumatic pains', and seeks the benefits of the hot springs of Buxton, Derbyshire.

1775–7

Third visit to Italy, accompanied by his wife and Amelia. Leaves London in August 1775; in Paris is introduced by Horace Walpole to Mme. du Deffand. In Rome, sits to the Irish sculptor Michael Foye for a portrait-bust. Devotes much of his time to the preparation of a treatise on the site of Horace's Sabine villa (never published), engaging the help of Jacob More in the provision of landscape drawings intended for an engraver, and in the summer of 1777 pursuing his researches on the spot as Count Orsini's guest in his palace at Licenza. In July and August 1776 repairs with his family to the island of Ischia, renowned for its curative waters, and there resumes drawing, executing finished studies of his wife and daughter and a self-portrait. Publishes *Letters on the Present Disturbances in Great Britain and her American Provinces* (1777). Returns to London by October 1777.

1778

Publishes a *Plan of Re-Union between Great Britain and her Colonies*, a work of considerable length which advocates the adoption of harsher military measures against the American colonists.

1778–9

Becomes a member of the Johnson-Boswell circle. Urged by Boswell to write a life of his father, the poet, but undertakes only a brief MS. account.

1779–80

On 8 July 1779 Amelia Ramsay marries Lieutenant-Colonel Archibald (afterwards General Sir Archibald) Campbell of Inverneil, with a dowry from the painter of £4,000; in the summer of 1780 Amelia and her younger sister Charlotte join Campbell in Jamaica.

1780

Publishes *A Letter to Edmund Burke, Esq*, arguing against the view that the current system of dispensing salaries and pensions increased the power of the Crown, and defending the democratic system resulting from the powers exercised by Parliament.

1781

In the train of the Gordon Riots, publishes a pamphlet entitled *Observations on the Riot Act*, in which he calls for legislation giving greater protection for life and property against mob violence.

1782

Death of Margaret Ramsay on 4 March.

1782–4

Fourth visit to Italy, in the company of his fourteen-year-old son John (the future General). Leaves London in September 1782, arriving in Rome by December. Continues work on his essay on Horace's villa, commissioning the German artist Philipp Hackert to draw a detailed map of the Licenza region, and in the summer of 1783 revisits Licenza, where he makes a number of shaky landscape sketches in chalks which Jacob More uses as the basis of finished watercolour drawings. His close acquaintances in Rome include such artists as Pompeo Batoni (who gives drawing lessons to his son), John Robert Cozens, Gavin Hamilton, John Brown and the amateur Sir George Beaumont. During a three-month visit to Naples in the spring of 1783 becomes a particular intimate of Sir William Hamilton, the British envoy, and also meets James Barry. Visits Pompeii. Publishes, in Florence, an essay *On the Right of Conquest* (1783). In the summer of 1783 his son sits to him for a portrait (presumably in oils). Visits Florence in October 1783, seeing much of Sir Horace Mann, and contributes to a volume of light verse brought out in 1784 by the minor poet Robert Merry under the title *The Arno Miscellany.* In the summer of 1784 receives word of his daughter's forthcoming return from Jamaica, and decides to hurry home - but the journey is too much for him, and he dies soon after landing at Dover, on 10 August 1784.

ALASTAIR SMART

The Art of Allan Ramsay

ALLAN RAMSAY, after a long period of neglect, is now recognized as one of the supreme portrait painters of the British School. As a Scot who worked chiefly in London, but who also maintained a studio in his native Edinburgh, he belongs to the history of both English and Scottish painting. His career – cut short by a serious accident to his right arm, due to a fall from a ladder – can be divided into two main periods. The earlier of these, the 'first style', covers the period from 1738 to 1752, during which he became the leading portrait painter in London and one of the pioneers in the establishment of a national school. The 'second style' period extends from 1753 to 1773, when he developed an entirely new manner, notable especially for its delicacy of sentiment and exquisiteness of colour.

The portraiture of the 'first style' reflects his training in Italy from 1736 to 1738 and in particular his acquisition of many of the qualities of Late Baroque, which gave his work an air of cultured sophistication such as few of his English rivals could hope to match. This period culminates in 1747 in the famous full-length of *Dr. Richard Mead* (no.28), a work that in effect introduced the 'Grand Manner' into British painting, thereby anticipating the theory and practice of Reynolds by many years. Shortly afterwards, however, Ramsay underwent a remarkable reaction against the Italianate traditions in which he had been trained, in his endeavour to create a 'natural' portraiture free alike from the mannered conventions of Late Baroque and from the artificialities of the post-Kneller tradition. The 'second style', forged principally during a long stay in Edinburgh in 1754 and during a second visit to Italy from that year until 1757, represents, accordingly, an entirely new development in Ramsay's art, and its chief source of inspiration is now the natural idiom of portraiture developed in France by such painters as La Tour, Nattier and Drouais. Horace Walpole described Ramsay in this mature phase of his artistic development as being 'all delicacy' – a quality apparent both in the enhanced elegance of his draughtsmanship and in the ravishing enchantments of his subtle arrangements of colour.

During a period of some three decades, embracing the middle years of the eighteenth century, Ramsay exerted a powerful impact upon the course of portrait painting in England. In turn, Hudson, Gainsborough and Reynolds, among the leading painters of their times, were deeply influenced by him in their diverse ways, while in Scotland he found a conscientious follower in his pupil David Martin, who played some part in the formation of Raeburn – and it was Raeburn who carried forward into the following century, within the terms of his magisterial if less refined manner, the ideal of the 'natural portrait' which Ramsay had done so much to pioneer.

Ramsay's place in the history of British painting is not in doubt. Yet, owing to a combination of circumstances, his importance as an artist had ceased to be appreciated even within his own lifetime. In the first place, his enforced retirement in 1773, leading him to devote himself thereafter to literary and scholarly pursuits, resulted in his being known during the last decade of his life chiefly as an author and as a prominent member of the literary society of his day. Secondly, the close of his career as a painter coincided with the rise of the Royal Academy, with its annual exhibitions, from which he had always remained aloof, and public attention was now focussed upon a new generation of artists whose reputations quickly eclipsed his own. It is only within the last half-century or so that Ramsay's true distinction as an artist has become clear to those with an interest in the classical age of British painting, together with an appreciation of his important role in the development of a native school of portraiture worthy of a place beside the schools of Europe. One of the aims of the present exhibition – besides its attempt to illustrate the main phases of Ramsay's stylistic development, from his youthful beginnings in Edinburgh to the last of the dozen royal commissions which he received as painter to King George III – is to further the process of general reassessment, and to demonstrate the range of qualities that entitle Allan Ramsay to a position of particular eminence among the leading painters of the eighteenth century.

Ramsay stands apart from his contemporaries in his devotion to drawing, and he carefully preserved a great number of

the preparatory studies in chalks which he was accustomed to make for his larger compositions – many of them drawings of his sitters' hands, others being costume-studies and portrait-drawings. Most of these are now in the National Gallery of Scotland in Edinburgh.

His gift for drawing manifested itself in his boyhood, most notably in a portrait-drawing which he made of his father, the poet, in 1729, when he was a mere fifteen years old (no.1). This remarkable performance, as we learn from his father's proud inscription on the back, was Ramsay's first attempt at a portrait from the life: but it already exhibits a power of characterization possible only to a born portrait painter. This youthful work must have made a great impression at the time, for it was soon afterwards engraved and used as the frontispiece to some of the editions of the poet's works and of his celebrated anthology of Scots verse, *The Tea-Table Miscellany*. By this means, as the elder Ramsay must have known, his own readers would have been made familiar with his son's name.

In October 1729, on the foundation in Edinburgh of the short-lived Academy of St. Luke, Ramsay became an artist-member, while his father joined as a lay patron, along with an impressive number of *cognoscenti*. The Academy held its classes – in the evening during the winter months and early in the morning during the summer – in rooms made available by the University (or 'College'). While there was provision for drawing from the living model, the principal training centred on the copying of Old Master drawings, engravings and casts of ancient sculptures. A sketchbook used by Ramsay during his two or three years there has survived (no.2). This includes copies by him from the famous series of engravings after the Antique published by Santi Bartoli and Bellori and also other copies from the equally influential *Figurine* etchings of Salvator Rosa.

Within two or three years of its foundation the Academy of St. Luke had ceased to exist. It was at about this time that Ramsay commenced his career as a portrait painter, presumably setting up his studio in the family home in the Luckenbooths, in Edinburgh's High Street. A head of *Alexander Home of Jardinefield* (no.4) is dated 1732 on the stretcher and a charming bust-length portrait of *Catherine Hope-Vere* (no.5) was probably painted not long afterwards, on the occasion of the sitter's marriage to one of the sons of the Earl of Hopetoun. The commission given to Ramsay for the latter picture is of considerable interest in view of his family's connection with the Hopes – his great-grandfather and grandfather having been, successively, factors on the Hopetoun estates – and it is clear that the Hopes were among his very earliest patrons. A sense of personal indebtedness on Ramsay's part probably lies behind his later gift to the Edinburgh Royal

Infirmary of a full-length portrait of the *2nd Earl of Hopetoun*.

It may have been Ramsay's ambition to become the pupil in London of William Aikman, a close friend of his father in his earlier Edinburgh days (fig.1) and the finest portrait painter that Scotland had yet produced. If that was the case, his wishes were frustrated by Aikman's sudden death in 1731. As it was, Ramsay pursued his studies in London under the Swedish painter Hans Hysing,* a former pupil of Kneller and of his own countryman Michael Dahl. Ramsay remained with him for only about a year – from at least the early summer of 1732 to the spring or summer of the year following – but he was evidently an apt pupil who learnt quickly. Hysing had established a reputation for himself as one of the most accomplished portrait painters in England (fig.2). He had been one of the first artists to be patronised by George II on his accession to the throne, and had been taken up by the Prime Minister, Sir Robert Walpole, who sat to him on several occasions. Ramsay is known to have painted a number of copies of one of Hysing's portraits of Walpole for Scottish clients. How highly Hysing was regarded by the 1730s is indicated by the opinion expressed by the engraver-critic George Vertue that he had eventually proved himself to be the superior of the worthy if somewhat ponderous Dahl. His style possesses the strength of an assured competence, and his special virtues lay in the primary soundness of his technical procedures, in his command of drawing, and in the power of his modelling. The attention that Hysing paid to his sitters' hands may well have been a lesson well learnt by Ramsay, for no painter of the period took more trouble than Ramsay over this essential aspect of portraiture, as the large number of his surviving studies for portraits, very many of them of hands, would alone be sufficient to demonstrate. In a general sense, Ramsay would have been thoroughly groomed in Hysing's studio in the conventions of society portraiture, and during his year or so in London he must have become acquainted at first hand with the current state of painting in England, whether exemplified by the post-Kneller tradition or by the work of such independent masters as Richardson and Highmore.

The portraits painted by Ramsay after his return to Edinburgh in 1733 reflect in varying degrees the lessons he had learnt as Hysing's pupil, but they also demonstrate the distinctiveness of his own genius. The lovely three-quarter-length of *Margaret Calderwood* of 1735 (no.6) possesses close affinities with the work of Hysing, not least in respect of the modelling, with its powerful transitions of tone; but there is much more in the picture than mere conformity to Hysing's exemplary teachings. The engaging intimacy of the girl's portrayal belongs to Ramsay alone; and his evident interest in her is

* Pronounced *Hissing*

answered by her own undisguised response. In terms of the development in the eighteenth century of a 'natural' portraiture free from the artificialities of the Knelleresque tradition, the portrait of *Margaret Calderwood* is extremely advanced for its time, whether it is seen in relation to English or to Scottish painting. Certainly there cannot be the least doubt that by the mid-1730s, when he was still in his early twenties, Ramsay found himself without an equal among portrait painters working in Scotland. It is possible that his thoughts were now directed anew towards the sympathetic art of William Aikman, examples of which he could have seen, for instance, in the houses of his father's friends, such as Mavisbank (outside Edinburgh) and Newhall (near Carlops, to the south), the homes respectively of Sir John Clerk of Penicuik and Sir David Forbes. In his ability to express a sitter's individuality Ramsay may certainly be regarded as Aikman's artistic heir. But Ramsay surpasses Aikman both in the vitality of his portraiture and in its conviction of truth. In the charming bust-length portrait of *Katherine Hall of Dunglass* (no.7), painted on the eve of his visit to Italy in 1736, we already find presentiments of the qualities typical of the female portraits which he was to paint on his return from his Italian studies two years later, combining, as it does, intimate characterization and decorative appeal. Indeed, when Ramsay set out for Rome in the summer of 1736 to place himself under the fashionable Francesco Imperiali, and to draw at the French Academy, it was not by any means as a callow student but as a painter well established in his native country who had been in successful practice for several years.

Although by the year 1736 Ramsay had already formed a personal style of his own, distinct in essence from that of any of his English or Scottish contemporaries, his period of study in Italy added to his artistic vocabulary the sophisticated language of Continental Baroque – or, more precisely, those elements of it that he chose to assimilate. In Imperiali, moreover, he had a master who combined a tasteful manner moulded by his own training under Carlo Maratta and refined by the infusion of the graceful classicism of Raphael (fig.3). From Imperiali Ramsay would have learned, besides, to value the virtues of a highly polished technique productive of a uniform smoothness of surface. A similar method characterizes the work of Imperiali's former pupil Pompeo Batoni. Ramsay was to come to know Batoni in Rome, enjoying what was evidently a close acquaintanceship with him – renewed on subsequent visits to Italy. Ramsay supplemented his training under Imperiali by attendance at the French Academy, where he drew regularly from the life. The few surviving drawings that he made there – all of the male model – are on the whole undistinguished, but his appreciation of what has traditionally

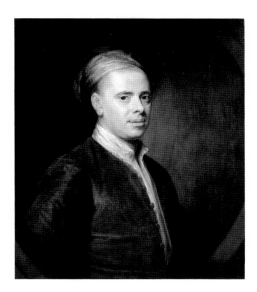

fig.1
William Aikman
Allan Ramsay the Elder
Scottish National Portrait Gallery

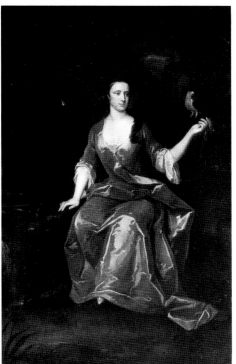

fig.2
Hans Hysing
Lady with a parrot
Location unknown

fig.3
Francesco Imperiali
St. Cecilia
Sir John Clerk of Pencuik, Bt.

been recognized as the best of all methods by which to train the hand to obey the eye is witnessed to in his persistence with life-drawing from this moment onwards, whether on his return to Italy in 1754 or in London at the St. Martin's Lane Academy. In his later years he produced quite lovely drawings of this kind, especially studies of the female nude, in which his natural response to feminine grace and delicacy was engaged (no.56).

In the summer of 1737 Ramsay went to Naples to enter the studio of the aged Francesco Solimena, who was now enjoying a European fame as the supreme religious painter of the period. Solimena's numerous works in the churches of Naples and its environs entitle him to be called the most eminent exponent in Italy of the late Baroque style, which he infused with a personal feeling for the graceful, while exploiting to the full its preoccupation with dramatic movement and bold contrasts of lighting. There has survived from Ramsay's stay in Naples a drawing by him of the figure of the Virgin in a painting by Solimena of *The Visitation* (no.13). This is inscribed on the back, in Ramsay's hand: *From a picture of Solimena in his own house 1737*. Ramsay's choice of this particular figure to copy suggests that he was especially drawn to the graceful component of his master's style. But it is clear that during his few months in Naples he also acquired from Solimena a new understanding of the role of light in pictorial composition; and the influence of Solimena's predilection for powerful effects of *chiaroscuro* is detectable in several of Ramsay's portraits of the late 1730s and early 1740s, such as the finely composed double-portrait of *The Honourable Rachel Hamilton and her brother Charles* (fig.4). Much later, in the *Dr. Mead* of 1747 (no.28), Ramsay was to apply such effects to a magisterial exercise in the Grand Manner. Even over a decade later, long after he had totally rejected the Baroque idiom in favour of a style attuned to French rococo taste, he paid final tribute to his Neapolitan master by adopting the design of Solimena's self-portrait in the Uffizi to a three-quarter-length of the *3rd Duke of Argyll* (fig.5).

It is possible that Ramsay's own youthful self-portrait (no.9) was painted in Naples during these summer months of 1737, or soon after his return to Rome in the same year. Certainly no other portrait by Ramsay comes quite so close to Solimena's manner, and while there can be no certainty about its date, it is just the sort of work that might be expected of an aspiring young painter proud of the privilege of enjoying an Italian training under the most prestigious masters. Whether it was painted in Italy or shortly after his return to London in the following year, it is a masterly performance in its own right, and it would be difficult to point to anything in the work of his English contemporaries – Richardson, perhaps, alone

excepted – to compare in power of statement with Ramsay's intense scrutiny of his own features. The assurance of the execution may be said to match the impression given of ambitious self-confidence.

The only painting by Ramsay that we definitely know to have been painted during the period of his Italian studies is the half-length of his friend Samuel Torriano (no.10), who sat to him in Rome early in 1738. Here the luminous colouring and the smooth polish of the execution, besides reflecting the teachings of Imperiali, suggest that by this date Ramsay had come under the strong influence of Batoni (who, however, had yet to turn his attention very much to portraiture). Ramsay's admiration for Batoni at this time is witnessed to by the fact that he acquired from him a number of his meticulously executed drawings; and that he had access to Batoni's studio in Rome is suggested further by the existence of a copy by him of one of the Italian painter's characteristic studies of hands (no.12). Indeed, Ramsay's own chalk study for Torriano's pointing right hand (no.11) is entirely in Batoni's own manner. In a more general sense the portrait exemplifies Ramsay's assimilation of the Late Baroque style, as is most strikingly shown by Torriano's grandiose gesture, by the imposing sweep of his voluminous crimson gown and by the effect of *contrapposto* in the figure as a whole. Commanding gestures of this kind possessed the capacity to impart a sense of importance, and Ramsay was to employ much the same language of gesture on other occasions – for example, among works represented in the present exhibition, in the *Dr. Mead* (no.28) and the *MacLeod of MacLeod* (fig.6: see no.33). In the case of the *Torriano*, the sitter wears a scholar's cap and points to a shelf-ful of books, so that the precise meaning of his gesture is very clear: Torriano was evidently desirous of possessing a likeness of himself that drew attention to his scholarly studies in Rome.

It is only a short step from this portrait to the enchanting picture of *Agnes Murray-Kynynmond Dalrymple* (no.14) painted in the following year (1739). Besides being one of the most delightful of eighteenth-century representations of children, this studied composition compares closely with the *Torriano* in its brilliance of colour and in its adherence to the conventions of Italianate Baroque, among which the freezing of the movement, allowing the little girl's lively attitude to be held up for contemplation, has innumerable parallels in Augustan poetry. Here, as also in such later works by Ramsay as the double-portraits of *The Honourable Rachel Hamilton and her brother Charles* (fig.4) and *The Hope Children* (no.25), the increasingly sympathetic understanding of childhood that is observable in the eighteenth century finds sensitive expression. Instead of being regarded as immature adults, children

are now treated much more on their own terms and with a new awareness of their special needs and their vulnerability. Captain Thomas Coram's foundation in London of the Foundling Hospital for Children was itself a reflection of this change of attitude. Ramsay's portrayals of children, of which the present exhibition contains other fine examples, from the *Mansel Family* of 1742 (no.22) to the *Lord Mahon* of 1749 (no.30) and the *Prince William* of the late 1760s (no.95), are remarkable for their sensitivity and total avoidance of sentimentality.

In the *Agnes Murray-Kynynmond Dalrymple* (no.14), the *Honourable Rachel Hamilton and her brother Charles* (fig.4), the double-portrait of *Sir Edward and Lady Turner* (no.20) and the *Mansel Family* (no.22) – all belonging to the first few years of his practice in London – Ramsay was clearly intent upon demonstrating his powers of design. Such early works are, besides, intense exercises in realism, and they are notable for variety of attitude and gesture – as, for instance, in the treatment of a sitter's hands, always carefully studied from life. It is not impossible that Ramsay saw the *Mansel Family* as a response to Hogarth's famous *Graham Children* (National Gallery, London), which was under way at the same time. On his arrival in London from Italy in 1738 Ramsay had joined Hogarth's academy in St. Martin's Lane, and there are works by him in this period that suggest that he was receptive to Hogarth's uncompromising realism. An example is the bust-length portrait of *Patrick Lindsay* (no.16), painted in 1739.

In these early years Ramsay's principal rivals, apart from such English painters of an older generation as Highmore and Knapton, were the foreigners Andrea Soldi, Jean-Baptiste Vanloo and Francesco Carlo Rusca. But within two years of his setting up his practice he was able to boast to a friend that he had put them all 'to flight' and was now 'playing the first fiddle' himself. The claim can now be seen to have been fully justified. There can be no doubt that by his later twenties he had proved himself to be the most distinguished of all the professional portrait painters working in London. He was fortunate in enjoying the interest of great Scottish families (whose presence in the capital had been increased by the Union of 1707). The most important to his career were the powerful Argylls – the eminent soldier and statesman John Campbell, 2nd Duke of Argyll and, after his death in 1743, his brother Archibald, the 3rd Duke (no.29), who controlled Scottish affairs, earning the sobriquet of 'the King of Scotland'. But Ramsay also attracted many notable English patrons, among them Lord Hardwicke, the Lord Chancellor, who sat to him for a full-length in 1739, and Dr. Richard Mead (no.28), the eminent physician and connoisseur, who formed a lasting attachment to him, introducing him into society and generally promoting his career. (Much fascinating information is now

fig.4
Allan Ramsay
The Hon. Rachel Hamilton and her brother Charles
The Rt. Hon. The Earl of Haddington

fig.5
Allan Ramsay
Archibald, 3rd Duke of Argyll
His Grace The Duke of Northumberland

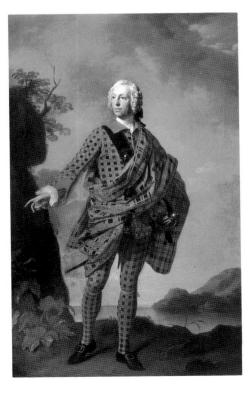

fig.6
Allan Ramsay
The MacLeod of MacLeod
The MacLeod of MacLeod

available about Mead's close connection with Ramsay, whom he invited to join his exclusive dining club, in consequence of which the painter was able to consort with many of the leading literary figures, antiquaries and scientists of the period.)

It is clear that Ramsay won his early reputation largely by major works on the scale of the full-length, of which his portraits of the *2nd Duke of Argyll* (Inveraray Castle: fig.7), *Lord Hardwicke* (Private Collection) and *The Duke of Buccleuch* (no.18) are among the most important. In the first two Ramsay displayed to full effect the sophistication of manner which he had acquired in Italy, and which perhaps only Knapton among his English competitors was capable of approaching. The full-length of *The Duke of Buccleuch* of 1739 (no.18) possesses less swagger, and impresses less by its cosmopolitan air than by its combination of unaffected characterization and richness of colour. These triumphs on a grand scale should not, however, be allowed to obscure Ramsay's early achievements on the more intimate scale of the bust-length and half-length portrait. Such portraits as the *Honourable James Keith* (no.19), the *Lavinia Fenton* (no.17), the *Anne Bayne* (no.15) and the *Lady Banff* (no.23) have in common a vitality of treatment that transcends the basic requirements of portraiture. The sitters are presented to us as living personalities with whom we feel we might converse. Particularly in female portraiture in the 'feigned oval' format, the intensity of the expression of the sitter's individuality is accompanied by the sort of decorative charm that the taste of the time encouraged and to which Ramsay gave a distinctive flavour.

Moreover, Ramsay was a superb technician, and his craftsmanship is of a quality unsurpassed in the period. He insisted always on a smooth surface, making extensive use of transparent glazes and generally avoiding the heavy impasto beloved of Reynolds. At the first sitting he drew and modelled the head entirely in a vermilion underpainting, upon which the final colours were laid. He acquired this technique during his early studies in Italy, and it is only from the year 1766 that we find portraits in which no trace of a red underpainting is visible. It is a method that contributes significantly to the exceptional freshness of his flesh-tints, especially as the vermilion foundation serves, in the shadowed areas, to prevent any tendency to leadenness of tone. It is very apparent that the vivacity of Ramsay's portraits owes much to his refined technical procedures.

As we trace Ramsay's development through the 1740s we discern in due course presentiments of those masterpieces of 'delicacy' from his final period which prompted Horace Walpole, in contrasting his style with that of Reynolds, to declare: 'Mr Reynolds seldom succeeds in women; Mr Ramsay is formed to paint them.' The lovely bust-length portraits, for

example, of *Lady Inglis* (no.27) and *Rosamund Sargent* (no.35) could be hung beside the *Lady Mary Coke* of 1758 (no.64) or the *Anna Bruce of Arnot* of the late 1760s (no.94) without any sense of disharmony. Indeed, by the later 1740s Ramsay was already evincing dissatisfaction with the conventions of Late Baroque and with the largely Italianate foundations of his earlier style, and, after the year 1747, when he clothed his magisterial full-length of *Dr. Mead* (no.28) in imposing trappings of the 'Grand Manner', he turned gradually towards a quite different source of inspiration – the less formal, more 'natural' ideal of portraiture exemplified by such leading French painters as La Tour, Nattier and Perronneau. This change of direction can be seen to have been the product of a fundamental rethinking of the nature of portraiture and it will be considered more fully in due course.

By the mid-1740s Ramsay was making regular visits in the autumn months to Scotland. On the return to London of Jeremiah Davison – apart from Ramsay the most gifted of all Scottish portrait painters of the time – there remained no competition in Edinburgh to speak of. On such visits Ramsay was to preserve his unique standing in Scotland until the close of his working life and his frequent presence in Edinburgh had entirely beneficial consequences for Scottish painting in general. He was there in the fateful year of the 1745 Rising, and arrived in time to witness Prince Charles Edward's occupation of the city. It may have been then that he painted, among other works, the sensitive picture of *Anne Dalrymple, afterwards Countess of Balcarres* (no.24). But on that occasion he would have had little time for the undertaking of portrait commissions, for by October he had returned to London. In any case his house on the Castlehill (popularly known as the 'Guse-pye' house) was no place for an artist's studio, having become the site of a skirmish between the Hanoverian and Jacobite forces.

As has already been hinted, the year 1747 marks a watershed in Ramsay's artistic development. It was in that year that he completed and presented to the Foundling Hospital his grand full-length of *Dr. Richard Mead* (no.28), a Governor of the Charity and its medical adviser. The *Dr. Mead* belongs to the series of pictures which fifteen of the leading British painters, inspired by Hogarth's example in presenting to the Foundling his 'mighty' portrait, as he called it, of its founder, Thomas Coram, had promised in 1746 to give to the Hospital. In the same year Thomas Hudson (a painter senior to Ramsay by some twelve years and by now – after slow beginnings – his principal rival for the most prestigious patronage) had contributed to what was to become a unique public gallery of modern British painting his full-lengths of Theodore Jacobsen (fig.8) (the architect of the Charity's new premises in

Lamb's Conduit Fields) and Justice John Milner (a Vice-President of the Hospital). Ramsay's *Dr. Mead*, completed by the summer of 1747, was to follow, and to be hung alongside Hogarth's *Coram*. In the *Theodore Jacobsen* in particular, Hudson seems to have made a conscious effort to emulate the elegant sophistication of Ramsay's style – introducing, for example, the fashionable cross-legged pose, of antique origin, which Ramsay had employed in his full-length of the *2nd Duke of Argyll* (fig.7); and, as though in compensation for his not having visited Italy and explored the antiquities of Rome, he gave prominence in his composition to a relief *all' antica* and some fragments of a fallen Corinthian column. In the *Dr. Mead*, by contrast, Ramsay set out, as the late Sir Ellis Waterhouse observed, to paint a picture in the European grand style. In the fullness of its Continental sophistication this was something entirely new to British painting, and the *Dr. Mead* is far removed in intention and execution from the somewhat staid Englishness of Hudson's two portraits. The closest affinities are rather with the *grandezza* of such earlier masters as Solimena, LeBrun and Maratta. George Vertue, to whose extensive jottings on the art of his times we owe much of our knowledge of the progress of the arts in eighteenth-century England, noted that the portrait of Mead in particular was drawing the admiration of visitors to the Foundling Hospital.

Yet, no sooner had Ramsay demonstrated in this masterly performance his aspiration to the Grand Manner, than he abandoned it altogether. Within another two years, with the completion of his last major work of the late 1740s, the seated full-length of the *3rd Duke of Argyll* (no.29), painted in 1749 for the Town Council of Glasgow, the process of renunciation had become virtually complete.

The nature of this decisive development can best be assessed by a comparison between the *Argyll* and the *Dr. Mead* of two years earlier, both of them public portraits. Although Argyll is portrayed in the splendid crimson and ermine robes of a Lord Justice-General, their display as attributes of his authority is muted, and indeed the viewer becomes more aware of their function as forms of distinct texture affected by the fall of light; while the sitter's natural attitude, as he turns the pages of a large volume at his side, offers the strongest contrast to Mead's almost imperious posture and grandiloquent gesture. Both pictures, within the context of their styles, are exercises in realism: in the *Mead* Ramsay avails himself of all the resources of Italianate Late Baroque, but the *Argyll* is a *tour de force* of realism of a different order. A dominant role is played by the strong lighting from above, chiselling the sitter's features in sharp relief, and suggesting the possibility that one clue to Ramsay's abrupt change of style at this time may lie in a new interest on his part in the portraiture of Rembrandt,

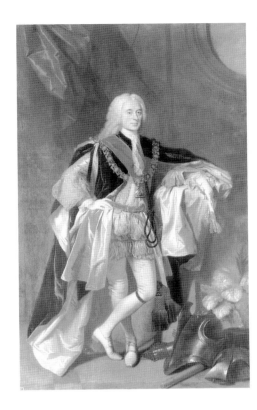

fig.7
Allan Ramsay
John, 2nd Duke of Argyll
His Grace The Duke of Argyll

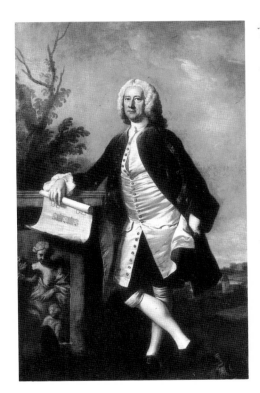

fig.8
Thomas Hudson
Theodore Jacobsen
The Thomas Coram Foundation for Children

whose art was coming to be increasingly appreciated by several of his contemporaries (such as Hudson and Frye).

There follows a quality of relaxation in Ramsay's method. He no longer strives for the striking effect, and least of all does he countenance anything in the nature of 'importance' in a sitter's attitude or gesture. His child-portrait of *Philip, Viscount Mahon* (no.30), commissioned in the same year as the *Argyll*, no longer reflects the ideal of beauty that inspired the picture of Agnes Murray-Kynynmond Dalrymple (no.14), painted a decade earlier; and, similarly, much of the charm of the tender half-length of the Jacobite heroine Flora Macdonald (no.36), painted in the same year (1749), resides in its reticence of statement. A considerable step has been taken towards the creation of the 'natural portrait' – whose perfection, however, was to await the assimilation of the lessons proffered by contemporary painting in France. In the *Flora Macdonald* the very limpness of the sitter's visible hand, in its attitude of repose, serves the same purpose of 'naturalness', and it is interesting to note how frequently in much later portraits Ramsay adheres to this unpretentious mode of representation – the most famous instance being the great portrait of his friend David Hume (no.93). Further, we observe from this time an increasing tendency to discard the marked depth of chiaroscuro typical of the *3rd Duke of Argyll* and the *Flora Macdonald* in preference for lighter and more fluid tonalities: this change can be seen at an early stage in the bust-length portrait of *John Sargent the Younger* (no.34), also painted in 1749. It is evident that Ramsay was already taking notice of the work of his French contemporaries, among whom Maurice Quentin de La Tour and Jean-Marc Nattier were to exert the strongest influence upon his style. A new interest on the part of several artists within Ramsay's circle in developments on the Continent is implicit in the visit made to Paris and the Low Countries in 1748 by Thomas Hudson, Joseph and Alexander Vanhaecken and the sculptor Henry Cheere. William Hogarth and Francis Hayman had originally been members of the party, only to be arrested at Calais for somewhat imprudently sketching the coastal fortifications; but the others had continued their journey safely to Paris, afterwards going on to Flanders and Holland. George Vertue records that they visited the studios of all the famous artists in all the cities on their itinerary, so that Hudson and the Vanhaeckens in particular could have brought back fresh reports of the state of portraiture in France, and not least their impressions of the eminent crayon-painters La Tour and Perronneau. It is also of considerable interest that the Scottish portrait painter Catherine Read, whose delicate style possesses certain affinities with Ramsay's own, became La Tour's pupil in Paris at about this time.

The clearest indications of Ramsay's interest in La Tour

and Nattier appear from 1753 onwards; but when some three years earlier he depicted the Duchess of Somerset (no.37) with a muff concealing her hands, he was introducing a motif that is particularly common in eighteenth-century French portraiture, and one that he was later to employ in some of the most French-inspired of his portraits of women – such as the pair of half-lengths of the Earl of Wemyss's daughters (nos. 42 and 43) and the *Countess of Elgin* (no.78). Apart from this consideration, the *Duchess of Somerset* (no.37) exemplifies the profundity of characterization which Ramsay was able to attain in these years, especially when working on an intimate scale.

It seems probable that it was Hogarth who first drew La Tour's merits to Ramsay's attention. From the time of his setting up practice in London Ramsay had been a prominent member of Hogarth's academy in St. Martin's Lane, but the relationship of the two painters appears not to have been a close one: indeed, one would hardly expect it to be otherwise in the case of such contrasting personalities as the blunt, down-to-earth Englishman and the refined, elegantly mannered Scot. Furthermore, Hogarth would have had every cause to envy Ramsay's easy success in a branch of painting in which he himself achieved greatness without attracting a fashionable clientele. But by the early 1750s, when Hogarth was engaged in the writing of his *Analysis of Beauty* (published towards the end of 1753), he and Ramsay had evidently come closer together on a personal level, and it may be that discussions between them concerning the contents of Hogarth's treatise brought them into a more intimate association. The treatise certainly inspired Ramsay to subject Hogarth's theory of the 'Line of Beauty' to trenchant criticism in his own *Dialogue on Taste* – almost certainly written in Edinburgh during his long visit to his native city in the first half of 1754, and published in the following year. While opposing Hogarth's aesthetic theories he praises him warmly as an artist. Afterwards Hogarth, on his part, genially admitted that Ramsay – whom he acknowledged as a friend – was the person best qualified to expose the 'nonsense' contained in the *Analysis*. La Tour himself is accorded similar praise in Ramsay's *Dialogue*, along with the landscape painter George Lambert, for his truth to Nature. In his essay *On Ridicule*, published in 1753 as the first of his literary works, Ramsay had already criticized Addison for 'not establishing a constant attachment to Truth as the leading and inseparable principle' in all works of art. In one of his *Spectator* pieces on the 'Pleasures of the Imagination', Addison had remarked that 'we love to see a picture where the resemblance is just, or the posture and air graceful', and had implied that a likeness in a painting ought to be either 'very exact' or 'very agreeable'. Ramsay argues that this is a false alternative. 'The agreeable,' he affirms, 'cannot be separated

from the exact; and a posture, in painting, must be a just resemblance of what is graceful in nature, before it can hope to be esteemed graceful.' It is clear that this conviction lies at the heart of the aesthetic principles which guided the development of Ramsay's 'second style'; and his new approach to the art of portraiture from the 1750s onwards may be defined as the quest of 'the graceful in Nature'.

Two portraits painted in London in 1753, shortly before his protracted visit to Edinburgh later in the same year, exemplify the radical change of direction now apparent in his style. The frank realism of the seated three-quarter-length of *John Sargent the Elder* (no.40) is hard to account for except on the supposition of Hogarth's direct influence. On the other hand, the elegant *Thomas Lamb of Rye* (no.47), also at three-quarter-length, is already redolent of the unmistakable flavour of contemporary French painting. The informality of design which Ramsay had been developing during the previous few years has now been assimilated to the requirements of French rococo taste – reflected alike in the rhythmic gracefulness of the pose, in the pastel-like shades of powder-blue and light gold, in the high-pitched tonal key throughout and in the avoidance of all suggestion of strong contrast in preference for a harmonious limpidity.

This fundamental change in Ramsay's style would undoubtedly have been encouraged by the growing popularity, both in England and Scotland, of French fashions in dress – to which indeed his second wife, Margaret Lindsay, was herself attached. Ramsay must have welcomed the pictorial advantages afforded by the new taste, and his sensitive response to it is a feature of many of the portraits – over forty in number – which he painted in Edinburgh in the first half of 1754, prior to his second visit to Italy. Among society ladies who sat to him in that year few can have matched the two daughters of the 5th Earl of Wemyss as leaders of the latest fashion. Both sisters (nos. 42 and 43) posed for their likenesses in dresses exquisitely embroidered with colourful floral motifs, their powdered hair trimmed in the French mode and their hands concealed in muffs in the manner frequently adopted by the ladies painted by Nattier, La Tour, Drouais and other French artists. Furthermore, the slight inclination of Lady Walpole Wemyss's head, while not unprecedented in Ramsay's work, conforms to a device commonly used by French painters of the period for the purpose of avoiding stiffness and formality of pose. While the *Lady Walpole Wemyss* (no.43) exhibits decorative qualities that recall the exquisite art of Nattier, the portrait of her younger sister, Lady Helen (no.42), has closer affinities with La Tour, and the broad, sweeping brushwork and generally crisp handling may be said to adapt to the requirements of oil-painting the bold crayon technique of the French master – a feature of Ramsay's style at this stage that is no less marked in the expressive bust-length portrait of *Sir John St. Clair* (no.48). Likewise, Lady Helen's open, smiling mien reminds us of La Tour's propensity to enliven a sitter's countenance with a hint, or more than a hint, of a smile; and it was evidently in allusion to her vivacious appearance that Ramsay once remarked of her, appropriately enough in French, 'Les joues de My Lady Nelly Wemyss parlent François'. In portraying her he may be said to have offered the same observation in the language of painting. The two half-lengths of the Wemyss sisters demonstrate the important part played by the example of contemporary French painting in liberating Ramsay's already refined sense of colour. Only a painter deeply concerned with colouristic values could have made such brilliant use of the contrasting blue of Lady Helen's dress and the bright red of her muff. It would be difficult to find elsewhere in British painting anything quite comparable with this inventiveness. In his work of the late 1750s and 1760s – that is to say, in the period following his second visit to Italy – Ramsay was to demonstrate the full range of his feeling for colour, and no doubt there will be many visitors to the present exhibition who will give their assent to David Irwin's claim that Ramsay was superior as a colourist to all his English contemporaries, including Hogarth, Reynolds and Gainsborough. It should be emphasized further that, however deeply Ramsay was influenced by the French rococo style, he was far from being a mere imitator, and although his work has sometimes been confused with that of one or other of his French contemporaries – as in the case of a version of a half-length of Lady Hervey, which was at one time thought to be by Drouais – he thoroughly assimilated the qualities of French portraiture to his own distinctive taste. There is always present in his finest works a quality of reticent meditativeness, a sense of classical order (as we may term it) and a primary emphasis upon his sitter's individuality, which can be said to have belonged to his conception of portraiture from the very beginning.

During his long stay in Edinburgh in 1754 Ramsay developed with apparently increasing confidence the 'natural' style of portraiture which he had been pursuing, with varying results, for the past five or six years. His presence in the Scottish capital encouraged many of the leading lights of Edinburgh society to sit for their portraits. They included, among members of the legal profession, the great judges Alexander Boswell, Lord Auchinleck (the father of James Boswell) and Hew Dalrymple, Lord Drummore (no.44), and, among literary figures, the philosopher and future historian David Hume, with whom Ramsay had formed a warm friendship. The young James Adam and his mother – the widow of the eminent Scottish architect William Adam – sat for two of the

finest of the more ambitious compositions from this extensive Edinburgh series. The half-length of *Mary Adam* (no.41) is particularly remarkable for its assurance and clarity of statement, besides being a supremely accomplished realization of the sheer presence of an individual human being. One will search in vain for the likes of it in eighteenth-century English painting. The nearest parallel is to be found, perhaps, in the work of Subleyras in France; but Ramsay entirely lacks Subleyras's mannerisms of style, and what we are made aware of here are rather the simplicity and purity of the natural eye, supported by draughtsmanship of rare subtlety. Yet the Mary Adam would not be the masterpiece that it is if its representational elements were not so finely controlled and ordered within the picture's simple but measured design.

Similar qualities inform the famous three-quarter-length of *Lord Drummore* (no.44). Both pictures exhibit an extreme restraint in the range of colour employed, being largely composed of blacks and greys enhanced by the merest touch of muted red. The reaction against the more violent contrasts of the Baroque style is now complete. In a more general sense the *Lord Drummore* demonstrates the distance that Ramsay has now travelled from his early manner, with its profound debt to his Italian training; and if we did not know it, modern art-historical method would have difficulty in demonstrating that the *Dr. Mead* of 1747 and the *Lord Drummore* of seven years later were by the same hand. The importance that Ramsay attached to Lord Drummore's commission is shown by the thorough preparatory studies in chalks which he made both of the pose and the hands (nos. 45 and 46). The informality of the conception is incorporated in a design of hitherto unattained refinement which holds the simple elements of the composition in perfect equipoise. Here intimations of that later manifestation of eighteenth-century sensibility to which we give the name Neo-classicism are to be discerned in the rational order imposed upon the whole. In such a detail as the introduction of a pilaster to one side of the sitter, adding an element of stasis to the composition, we perceive something of the intellectual – and essentially 'classical' – character of Ramsay's approach to design; and similar motifs, with a similar function, are to found in numerous works of later date, from the fluted pilasters in the *Robert Wood* of 1755 (no.49) and the *3rd Duke of Argyll* of 1758 (fig.5) to the window-shutters against which Margaret Ramsay is posed in the famous picture at Edinburgh (no.66). The contrast with the full-length of *Dr. Mead* (no.28) is absolute: whereas Mead is placed on a curtained dais, and addresses us loftily with a grandiloquent sweep of his hand, Lord Drummore is seated in his own parlour, and what air of 'importance' is accorded him is imparted by natural, although still eloquent, gesture, such as might accompany any everyday conversation. On a more purely aesthetic level, the completeness of Ramsay's distancing of himself from the Baroque manner is no less conspicuous in the diffused lighting, which helps to give the composition its harmonious unity.

Ramsay's radical rethinking of the nature of portraiture must have been assisted by his disengagement from his London practice. Nevertheless, he was still kept extremely busy with commissions (notably for portraits on a small scale), and he also found time to write the most important of his literary works, the *Dialogue on Taste* (published early in 1755), as well as to found, with the help of Hume and Adam Smith, the celebrated debating club known as the Select Society – one of the early manifestations of the Scottish Enlightenment. It is appropriate that what was to prove to be the most important development in his artistic career took place largely in his native Edinburgh, for he was returning to his Scottish roots and in a sense resuming the mantle of Aikman. That he felt the need to explore at leisure the implications of his new aesthetic seems clear from his decision to return in the summer of 1754 to Rome and the French Academy. In the event, he was to remain in Italy for three years.

When he came back to London in August 1757 it was as the exponent of a 'natural' style of portraiture which combined French elegance and delicacy with an essentially Italianate gracefulness derived not now from Late Baroque but from the study of such masters as Raphael and Domenichino and owing much to his renewed contacts with Batoni. It has been suggested by Sir Ellis Waterhouse that Ramsay's development of what may be called his 'second style' is to be explained by a realization on his part of the desirability of countering the 'grand manner' of Reynolds (fig.9), who had returned to London in 1753 after his studies in Italy. It can, however, be objected to this interpretation that the development in question had begun long before Reynolds's arrival; nor does it seem probable that, if Ramsay feared competition from his young English rival, he would have chosen to absent himself from London for several years, leaving Reynolds to dominate the field. Moreover, it would surely have been out of character for a painter of Ramsay's seriousness of mind and aesthetic conviction to decide to change his whole approach to his art simply in order to be seen to be doing something different. On the contrary, the development of Ramsay's style from the late 1740s to the late 1750s shows a consistency compatible solely with profound personal reassessments, and clearly sprang from inner reflection stimulated, where external influence was concerned, by the revelatory example of La Tour and his contemporaries in France.

Ramsay made his second visit to Italy in the company of his

wife and his sister Catherine. They arrived in Florence in Oct-
ober 1754, and decided to remain there for two months before
proceeding on the final stage of their journey to Rome. In
Florence Ramsay spent much of his time making chalk stud-
ies in the Pitti Palace after Raphael (no.59), Fra Bartolommeo
and Andrea del Sarto – all of whom, in their various ways, had
created an art combining truth to Nature and an ideal of per-
fected grace. But the most interesting of all his studies after
the Italian masters are a series of six extremely detailed copies
in chalks, executed in Rome in the following year, of Domeni-
chino's frescoes of *The Life of St. Cecilia* in San Luigi dei
Francesi (no.58) – 'models of gracefulness', as Waterhouse
aptly described them. The beauty of Ramsay's mature drawing
style, as it is seen in the preliminary studies that have survived
for many of the portraits of the late 1750s and 1760s (nos. 63
and 70), must owe much to the discipline he set himself in
Rome, when he put himself to school again with the great
Italian masters and especially with the elegant, tasteful
Domenichino (who had come to be regarded in the eight-
eenth century as virtually the equal of Raphael himself). Ram-
say's drawings in this period take on, besides, a lightness of
touch akin to the delicacy of such French draughtsmen as
Fragonard and Greuze, who were both members of the
French Academy during Ramsay's stay in Rome, although it is
probable that he owed a more direct debt to Charles Natoire,
at that time the Director of the Academy. Ramsay also came
to know the young German painter Anton Raphael Mengs,
and renewed at this time what must have been an old
acquaintanceship with his fellow Scot Gavin Hamilton. In
Mengs and Hamilton we have, of course, the two principal
creators of the Neo-classical style, and there can already be
discerned in the half-length of *Robert Wood* (no.49), one of
some half-dozen portraits painted by Ramsay during this visit
to Italy, a discreet flavour of Neo-classicism in the design.
This is particularly evident in the presence as a stabilizing fac-
tor of a fluted pilaster such as the Neo-classical painters fre-
quently introduced into their compositions. It is relevant in
this context to take note of Ramsay's early intervention, in his
Dialogue on Taste, in the Roman-Greek controversy which
had sprung up in the middle years of the century between the
'Romanists' – the advocates of the merits of the art and archi-
tecture of the ancient Romans – and the 'Hellenists', among
them Ramsay, who upheld the superiority of the Greeks.
Ramsay's appreciation of the refined taste of the ancient
Greeks seems now to be matched by a quality in his own art
which, however difficult to define, adds a distinctively 'classi-
cal' flavour to several portraits painted from this time onwards.
Among such works the full-length of *Lady Louisa Conolly*
(no.65) is notable, both for the almost frieze-like effect pro-

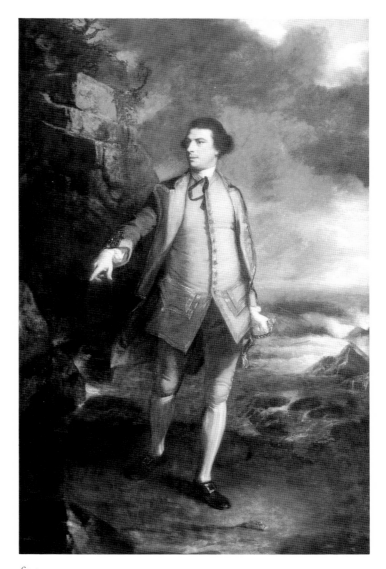

fig.9
Sir Joshua Reynolds
Commodore Augustus Keppel
The National Maritime Museum, Greenwich

duced by the treatment of the draperies and for a subtlety in the ordering of its design which reflects a taste attuned to the Greek ideal.

Paradoxically, the general admiration expressed in the *Dialogue on Taste* for the cultural attainments of the Greeks is accompanied by some extraordinarily heterodox criticisms of one aspect of Greek sculpture. Ramsay argues that the generalized physiognomic ideal created by the sculptors of antiquity in their statues of Venus and other divinities, or mortals who were deemed to be beautiful, represented 'a medium in all its features and proportions' which preserved the same 'mediocrity' in all the proportions of the face. 'Here, then, in the antique,' he writes, 'we find a sort of common measure, but which falls mightily in its value when we consider that it is only of a negative kind, from which no excellence, no striking grace can be expected.' This unprecedented view of the 'negative' value of the classical ideal of human beauty goes entirely against the accepted canons of eighteenth-century taste. At the very time that Ramsay penned these words, the studious Reynolds was giving practical expression in his art to the lofty ideas he had imbibed in Italy, accepting as models of perfection the ideal generalizations of the ancients. As he afterwards declared in his Fourth Discourse to the students of the Royal Academy, 'If a portrait-painter is desirous to raise and improve his subject, he has no other means than by approaching it to a general idea.' Ramsay's observations in the *Dialogue on Taste* represent an exactly opposite viewpoint, which corresponds precisely to the new direction of his art. Especially from the year 1754 onwards, the beauty of Ramsay's portraits is the beauty of the particular. Moreover, there is something foreign to the spirit and tradition of Scottish portraiture as a whole in the assumption that the good people who came to an artist for likenesses of themselves required 'improvement' on canvas. At the beginning of the following century William Blake, in one of his scathing annotations to his copy of Reynolds's *Discourses*, expressed in his idiosyncratic manner a view very similar to Ramsay's own: 'To Generalize is to be an Idiot. To Particularize is the Alone Distinction of Merit'. Ramsay's position on this question is entirely in accord with his admiration for La Tour and with his larger receptivity to the terms of contemporary French portraiture in general, with its vital evocation of the individual personality, nowhere more profound in its implications than in its studied portrayals of the great *philosophes* of the Enlightenment – paralleled in Ramsay's portraits of Rousseau and Hume (nos. 92 and 93).

Ramsay never came closer to La Tour than when he painted his *Self-portrait at the Easel* (no.50), which was probably begun in Rome towards the end of 1755 and left unfinished in the following year. The design echoes that of La Tour's well-known portrait of himself at Amiens (fig.10), the influence of La Tour's pastel being apparent in the turn of the slightly tilted head over one shoulder, in the elegant and pronounced curve of the back and not least in the studied intensity of the painter's self-scrutiny. Where, on the other hand, La Tour presents himself as an extrovert of almost excessively lively demeanour, Ramsay shows a characteristic reserve, and his portrayal of himself is at once more solemn and more meditative. So expressive is the rich handling of the pigment that one may wonder whether the fact that the painting was never quite completed is to be explained by some measure of apprehension on Ramsay's part that he might spoil it in the finishing process.

In addition to several chalk studies that seem to be directly related to this *Self-portrait*, Ramsay executed about the same time a head-and-shoulders portrait of himself which is largely in crayons, suggesting conscious emulation of La Tour, although touches of watercolour are introduced (no.52). He had, in fact, lately taken up watercolour drawing under the influence of the young Robert Adam and his friend Charles-Louis Clérisseau, who had joined Ramsay's circle in Rome; and evidently he accompanied the two architects on sketching expeditions to some of the sites of ancient monuments. The surviving watercolour drawings by Ramsay consist chiefly of a series of views of the Colosseum which are close in style to the numerous watercolours made by Robert Adam on like occasions. One such drawing by Ramsay, showing the interior of the amphitheatre (no.55), came to serve as a study for the background in a half-length portrait, painted in Rome in 1756, of *John Burgoyne* (no.54), the future general, politician and dramatist, who was travelling in France and Italy with his newly wedded wife. The portrait of John Burgoyne provides the clearest possible evidence of Ramsay's renewed contacts with Batoni – two of whose compositions he copied at this time (no.57). Batoni had lately begun to introduce representations of the Colosseum into portraits of *inglesi* making their Grand Tour (fig.11) – and indeed there could be no more readable symbol or token of a patron's proud distinction in having travelled to Italy to drink at the fount of ancient culture and learning. However, in none of the known examples of such portraits by Batoni that can be dated to 1756 or earlier does the Colosseum form more than a relatively insignificant detail confined to a small area of the composition. In Ramsay's portrait, on the other hand, Burgoyne is portrayed as standing inside the amphitheatre, which, besides being necessarily brought close to him, is made to fill the entire background and to relate to him in a satisfying manner. With this work and a three-quarter-length (in a private collection) of a sitter named James Bateman, painted in the same year, Ramsay created a

type of male portrait, combining 'naturalness' and elegance in equal measure, which he was to develop on his return to England in August 1757.

Although he had been absent for almost four years, first in Scotland, then in Italy, Ramsay seems to have found no difficulty in resuming his place among the leading portrait painters of the day, and for about a decade his only major rival was to be Joshua Reynolds, a man ten years his junior. In fact, within a few months of his return to London, he was elevated to a uniquely privileged position by the patronage of John Stuart, 3rd Earl of Bute, the Prince of Wales's tutor, mentor and 'dearest friend' (and afterwards, following the Prince's accession to the throne in October 1760, his Chief Minister). So also, Bute's uncle, the Duke of Argyll, renewed his patronage, sitting for a three-quarter-length portrait (fig.5) to which reference has already been made. As in the days of Ramsay's first setting-out in London almost twenty years earlier, he was enjoying the advantage of the Scottish interest.

Bute's first commission was for a full-length portrait of the Prince of Wales, and the sittings for a preliminary drawing of the pose took place at Kew Palace on 12 October 1757. This elegant composition (fig.12), completed almost ten months later, reflects to the full the union in Ramsay's 'second style' between French rococo taste and Italianate grace which he had forged during his years in Rome. Ryland's engraving of the picture (no.62) soon made it the best known likeness of the Prince of Wales for almost a decade. It remained so until 1767, when, seven years after the Prince's accession as George III, Ryland published his mezzotint of Ramsay's coronation portrait of the King. Bute's commission of 1757 inspired Ramsay to create one of his supreme masterpieces – a composition of appropriate dignity but without any apparent striving after effect. It is remarkably intimate for a royal portrait, and in this respect entirely in tune with the affection in which the personable young heir to the throne was held by the nation. This brilliant performance must have played a major part in ensuring the Prince's choice of Ramsay rather than Reynolds as his official painter on his accession to the throne – a preference already intimated by the commission which Ramsay received from the Prince in 1758 for a full-length of Lord Bute (no.60).

The *3rd Earl of Bute* (no.60) is no less distinguished a work than its predecessor, and Ramsay's elegance of style was the perfect match for Bute's elegant presence. Ramsay indeed would have been well aware of the pride that this worthy but vain nobleman took in his famously shapely legs, possessed as he was, in the words of one contemporary tribute, of 'the finest leg in Europe', an advantage which he is said to have contemplated with admiration on solitary walks by the Thames. As though to pay proper respect to that attribute, Ramsay

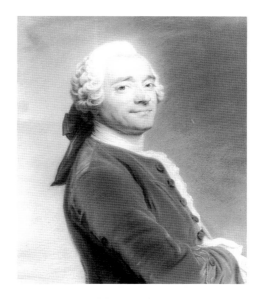

fig.10
Maurice-Quentin de La Tour
Self-portrait at the easel
Musée de Picardie, Amiens

fig.11
Pompeo Batoni
James, 1st Earl of Charlemont
Yale Center for British Art,
New Haven

fig.12
Allan Ramsay
George III as Prince of Wales
Private Collection

asked him to adopt the fashionable cross-legged pose with which, long since, he had graced the 2nd Duke of Argyll, and he was amused to observe (as he recounted afterwards) that during the first sittings his Lordship took care to hold his robes well above one knee so that his leg would be seen. Something of the impression made at the time by this splendid picture is reflected in Reynolds's witty remark concerning a picture he was painting of comparable design: 'I wish to show a leg with Ramsay's Lord Bute.'

Reynolds indeed was taking careful note of the new manner which Ramsay had brought back from his three years in Italy; and it would seem that with his customary perceptiveness he appreciated immediately the distinctive charms of Ramsay's portrayals of women, for there is a whole series of female portraits by Reynolds of the late 1750s and early 1760s that are painted very much in Ramsay's manner (fig.13). What may have been a general opinion concerning Ramsay's special gift for feminine portraiture was given expression by Horace Walpole in a now well-known letter written in February 1759 to Sir David Dalrymple (Lord Hailes), one of the early members of Ramsay's Select Society in Edinburgh. Walpole there referred to Ramsay and Reynolds as 'our favourite painters' and 'two of the very best we have ever had', and went on to remark that Ramsay was 'all delicacy' and superior to Reynolds as a painter of women, being 'formed to paint them'. He would have had in mind, no doubt, the portrait he had himself commissioned from Ramsay of his favourite niece, Maria Walpole, on the occasion of her marriage to Lord Waldegrave, or, for example, the lovely half-length of *Lady Mary Coke* of 1758 (no.64). It is also possible that he knew, on visits to Ramsay's house in Soho Square, the artist's most famous picture, the half-length of Margaret Lindsay, the painter's second wife (no.66), which is datable about 1758-9, or shortly afterwards. Certainly, this masterpiece of sensibility may be held up as a perfect *exemplum* of the qualities of 'delicacy' that captivated Walpole's sensitive eye. It was in a happy moment that Ramsay captured, as the motif for a supreme expression of the 'graceful in Nature', his interruption, by his entry into the room, of his wife's everyday task of arranging flowers in a vase. It is to her husband that Margaret Lindsay turns her lovely face, demurely presenting, without affectation (which was foreign to her), her calm, classical features. It is the exquisite colour scheme of the picture that makes the most immediate impact on the receptive viewer. Margaret Ramsay's rich plum gown, her blue pompon, the paler blue decoration on the vase and the pink, white and yellow flowers combine in a unique melody, set off by the muted ochre reserved for the background passages but also serving as the underpainting for the figure and its draperies and so assisting in the general unity of the whole design.

However profoundly Ramsay was indebted to his contemporaries in France, this work of his final maturity as a painter would alone be sufficient to remind us of the profoundly personal character of his 'second style'. There is nothing here, for instance, of the 'flutter' typical of so much eighteenth-century French portraiture, with its tendency to modish display, and the sentiment evoked is all the more telling for being contained within the rational order of a structured design and held, as it were, in a stasis amenable to contemplation. Ultimately, the *Margaret Ramsay* speaks to us less of the influences that helped to mould its painter's manner than of the distinctiveness and originality of his own art.

Much the same considerations apply to other portraits of this period that reflect Ramsay's indebtedness to his French contemporaries but which he alone could have painted. In turn we are reminded of La Tour, Nattier, Aved, Drouais and Chardin, or, in the case of the unusual profile portrait, at three-quarter-length, of *Anne Chambers, Countess Temple* (no.68), of the designs of such lesser artists as Jules Chevillet and Louis de Carmontelle. It would have been with the example of French portraiture in mind that Ramsay represented Lady Temple as being seated in her own drawing-room and occupied with spool and thread on a piece of embroidery. The brilliant colour scheme, dominated by the sitter's vivid blue dress, witnesses to Ramsay's response to the often strong effects of colour, rather than to the quieter harmonies, of the rococo style. Yet once again, even where, as here, he seems to be most inspired by the values of contemporary French painting, he invariably preserves a certain distance: its measure lies in an essentially classical restraint.

On George III's accession in October 1760 Ramsay was commissioned to paint a full-length of the new king, to be sent to Hanover. After the coronation ceremony in the following September he was commanded to revise the picture in order to show the King in his coronation robes, and to paint a similar coronation portrait, together with a pendant of the Queen, for St. James's Palace. The latter pair of portraits then provided the basis for the endless copies which were produced in Ramsay's studio in response to applications to the Lord Chamberlain's department, and to which ambassadors and governors of British provinces abroad were entitled as gifts from the King. As the artist entrusted with the task of painting what were to remain for a quarter of a century the official State portraits of their Majesties, Ramsay understood, correctly, that it was the King's wish to appoint him as his Principal Painter in Ordinary. He therefore thought it unnecessary to make a formal application for the post, as was customary at the beginning of a new reign. Owing to this omission, a regrettable mistake was made: the Lord Chamberlain, having received no application,

and himself neglecting to consult the wishes of the King, took the step of swearing in the previous holder of the office of Principal Painter, the worthy but unremarkable John Shackleton. The consequences were naturally embarrassing, for whereas Ramsay was undertaking all the functions of Principal Painter, including the provision of replicas of the coronation portraits, Shackleton enjoyed the title while performing none of the duties attached to it. Ramsay accordingly brought the situation to the notice of Lord Bute and the difficulty was resolved, at least as satisfactorily as the circumstances allowed, by Ramsay's appointment in December 1761 as 'one of His Majesty's Principal Painters in Ordinary'. At the same time he was given to understand that it was the King's desire that he continue to produce all the replicas of the State portraits ordered through the Lord Chamberlain's department. The Principal Painter's salary, on the other hand, had necessarily to be reserved for Shackleton. In effect, Ramsay had attained to the most prestigious position open to a British painter prior to the foundation of the Royal Academy in December 1768, although he did not succeed to the full title until Shackleton's death in March 1767. It was an office that had been held not only by Sir Godfrey Kneller (whose reputation had long survived his death) but by Van Dyck himself; and it is understandable that, in the consciousness of having fallen heir to Van Dyck's position as Court painter, he should have sought renewed inspiration in the art of that matchless exemplar.

The commission for the portrait of *George III in Coronation Robes* (see under no.74) demanded the full exercise of Ramsay's powers in grand-scale portraiture, and the result should have been sufficient to convince those who were complaining that the office of Principal Painter should have gone to Reynolds, and who were ascribing Ramsay's elevation to Bute's propensity for promoting the interests of fellow Scots, that the King's preference for Ramsay was entirely just. Indeed the coronation full-length is now recognized as the finest State portrait to have been painted in England since the time of Van Dyck. Appropriately, Ramsay's engagingly intimate portrayal of the King when Prince of Wales is now replaced by a more imposing emblem of majesty. Yet there is neither bombast nor overstatement in the presentation, such as we find, for instance, in the State portraiture of Rigaud and the Vanloos in France, but rather a dignified naturalness which does not seem out of keeping with the grand, rhythmical design. Nor is the delicate rococo harmony of light gold and powder-blue any less distinctive, and this is a feature of the composition that must have contributed to the picture's vast popularity.

The numerous replicas of the portrait and of the pendant of *Queen Charlotte* (no.75), executed mostly by Ramsay's assist-

fig.13
Sir Joshua Reynolds
Anne, Countess of Albemarle
The National Gallery, London

ants, were initially produced in his house at 31 Soho Square, but eventually the enormous demand for such copies prompted him to build a large studio in a new house at 67 Harley Street. Here, from 1767 until his death seventeen years later, their production continued, many of them being shipped abroad to grace the official residences of ambassadors and governors of overseas territories, keeping pace, it may be said, with the ineluctable expansion of the British Empire. At first their execution was entrusted largely to Ramsay's chief assistant David Martin; but for some years Ramsay insisted on painting the head himself and in many cases the final touches in general were from his own hand, so that a considerable number of the earlier copies cannot be regarded as merely studio products. The example of the King's portrait shown in the present exhibition (no.74) belongs to this category. From the late 1760s, on his leaving Ramsay's studio to set up practice on his own, David Martin was succeeded as principal assistant by Philip Reinagle, the son of a Hungarian musician who had settled in Scotland. From this time the replicas tend towards a certain heaviness of execution which does scant justice to the quality of the originals. Nevertheless, like Martin, Reinagle was an accomplished artist in his own right, and after his long years of drudgery in the Harley Street studio – during which time he is said to have been responsible for ninety pairs of the coronation portraits – he rose to become one of the finest animal painters of his day. This was a fitting choice of specialization, since his labours for Ramsay had left him, as he said, incapable of contemplating portraiture 'without a sort of horror'.

At this point a caveat is desirable against a serious misapprehension to which the replication of the coronation portraits has given rise in modern times. Again and again one reads in accounts of Ramsay's career that after he became painter to the King he painted little or nothing except these copies of his original State portraits. In fact many of his finest achievements as a painter belong to the decade following his Court appointment. What has not been appreciated in the first place is that it has normally been the duty of every Court painter to be responsible for replicas of official portraits of a reigning monarch, as well as for other work of a like nature. If Ramsay was in any way exceptional in fulfilling this duty, it was only in the sense of an extreme conscientiousness, such as prompted him for many years to put the finishing touches to the royal copies himself. As to the wider misconception concerning this phase in Ramsay's career – the final phase as it proved to be – it should be pointed out that after the execution of the coronation portraits he continued to enjoy regular patronage by the royal family, amounting altogether to nine entirely new commissions. Six of the pictures in question are included in the present exhibition – *Queen Charlotte with a fan* (no.81), the group-portrait of *Queen Charlotte and her children* (no.86), the full-length of *Prince William, Duke of Clarence* (no.95), the *Princess Augusta* of 1769 (no.97), the posthumous portrait of the Queen's mother (no.99) and, not least, the full-length of another royal prince, *Frederick, Duke of York* (no.100). All the indications are that Ramsay's career as a portrait painter, together with his employment at Court, came to an end solely as a result of the accident which he suffered to his right arm early in 1773.

As has been suggested, Ramsay must have taken especial pride in his having succeeded to the office that had been held by Van Dyck. In the coronation portrait of *Queen Charlotte* (no.75) he seems to have been content to base his design, although at full-length, on Van Dyck's three-quarter-length of *Queen Henrietta Maria* (Her Majesty The Queen), in which Charles I's consort stands beside a table bearing her crown, with one arm outstretched towards it. Once again Ramsay avoids the grandiloquent gesture, expressing the pomp of majesty largely by the attention he has lavished on the Queen's magnificently jewelled dress, as well as by the imposing setting, and, in the process, adding a touching note to her contrasting simplicity of demeanour. The picture exhibited is not the version of the coronation portrait in the Royal Collection, which has hitherto been assumed to be the original of 1761–2, but which, in fact, is in Ramsay's much later style and seems to have been commissioned by Princess Augusta for the purpose of obtaining a likeness of the Queen in maturer years. In its design, especially in respect of the architectural setting, the latter picture shows differences from the replicas of the coronation portrait produced in Ramsay's studio, which could not have been derived from it. The exhibited picture, from Kassel, has claims to being the prime original of the coronation portrait, whose qualities have escaped recognition owing to its identification with the painting in the Royal Collection. Unfortunately, the canvas has been reduced in size by reframing; but the loss hardly affects the composition as a whole. The painting is entirely in Ramsay's style of the early 1760s, and in its delicacy of treatment it may be compared, for example, with the well-known *Lady Susan Fox-Strangways* of 1761 (no.71), which Horace Walpole, on a visit to Melbury House, noted as being 'very good'.

One of Ramsay's duties as painter to the Court was to paint a profile portrait of the King for the coinage, for which a pendant of the Queen was also commissioned (no.81). Here too, in his profile portraits of Queen Henrietta Maria, Van Dyck had set the standard for this type of picture, not least by combining intimacy of sentiment and evident truthfulness. To Van Dyck's simple conception Ramsay added the charming

idea of representing Queen Charlotte with a closed fan in her hand – a motif providing a secondary point of interest and complementing in its beauty the delineation of her notoriously plain but sympathetically rendered features. For this motif Ramsay made four separate chalk studies (nos. 82 and 83), which testify to his concern to attain to a perfect realization of natural grace; and it was in great measure on that account that the picture drew the praises of Reynolds's pupil James Northcote. 'In the mental part,' he told William Hazlitt, 'I have never seen any thing of Vandyke's equal to it,' even adding that he would find it difficult 'to produce anything of Sir Joshua's that conveys an idea of more grace and delicacy.' Besides such reflections, Northcote's phrase 'the mental part' is of particular interest, not only because it draws attention to an essential component of Ramsay's approach to portraiture but also because Northcote's conversation with Hazlitt took place at a time when the values of Ramsay's unassertive art had been all but forgotten in the wake of Reynolds's ascendancy and the exaltation of an intellectuality tied to the concept of the 'Grand Style' – a style that, paradoxically, Ramsay had introduced into British portraiture in his full-lengths of *Dr. Mead* (no.28) and *The MacLeod of MacLeod* (fig.6), but which he had long since come to regard as alien to his aesthetic principles.

Notwithstanding the heavy demands made upon his time and energies by his first royal commissions, it was during this immensely busy period that Ramsay produced many of his finest portraits of other sitters. Among those represented in the present exhibition, special mention may be made of the unusual profile portrait of the *Countess Temple*, painted in 1760 (no.68), the half-length of *Lady Susan Fox-Strangways* (no.71), and the three-quarter-length of *Mary Martin* (no.69), both of 1761, and, from the year 1762, the grand full-length of *Richard Grenville, 2nd Earl Temple* (no.77) and the informal seated portrait of *Philip, Viscount Mahon* (no.79). With the exception perhaps of the *Earl Temple*, these works all reflect, if anything, an intensification of French influence, but also the translation of the rococo style into Ramsay's more restrained pictorial language. The question remains as to how he gained so apparently wide an acquaintance with what his contemporaries in France were doing – especially as visits to France would have been out of the question prior to the ending of the Seven Years' War with the signing of the Peace of Paris in 1763. There are, for instance, precedents in French portraiture for the way Ramsay has represented Lady Temple (no.68) in profile in her own drawing-room, and the inclusion of a mantelpiece with china ornaments is the sort of detail one finds in the work of such French painters as Aved and Nattier. But the *Countess Temple* could never be mistaken for a painting of the French School, perhaps the most obvious difference lying in

Ramsay's imposition upon his subject of a rigidly structured design which tends to freeze all suggestion of movement. So too the tender intimacy of the *Lady Susan Fox-Strangways* is expressed within the framework of a composition that is as deceptively simple as it is carefully pondered.

By the time that he painted the portrait of *Mary Martin* (no.69) Ramsay had begun to develop a new interest in spatial composition. The sitter's head now lies back from the picture-plane, and the illusion is created of intervening space and air between her and ourselves. This effect is produced largely by the use of subtle tonal transitions, and increasingly from this time greyish notes are swept into the modelling of a sitter's head and into the background areas – which are usually treated broadly without much detail. The latter characteristic has close parallels in the work of Chardin, in which Ramsay seems clearly to have been taking an interest at this time. He could have seen paintings by Chardin in the house of his friend William Hunter, and although the dates of their acquisition are far from certain it may have been Ramsay who brought Chardin's art to Hunter's attention. Fauquier's collection in London also included works by Chardin, and Fauquier was known to Ramsay's old friend Dr. Birch, a member, like Ramsay, of Mead's circle. In composition, the work by Ramsay that brings Chardin most to mind is the half-length portrait of the young Philip, Viscount Mahon (no.79), shown seated at a table with a *porte-crayon* and a sheet of paper in his hands. This picture surely reflects an acquaintance on Ramsay's part with Chardin's *Jeune Dessinateur taillant son crayon*, which had been engraved by Faber, and perhaps with his variations on the theme of the 'Card Castle'. Ramsay would have responded appreciatively to the unaffected naturalism and the studied meditativeness of Chardin's art.

In the dashing *Earl Temple* of 1762 (no.77) Ramsay seems to be matching himself once more against Van Dyck. Lord Temple's Garter robes gave him the opportunity of producing one of his most brilliant exercises in colour. The contrasting dark of the sky may offer us a rare instance of Ramsay's interest in the work of Reynolds, in which warring skies are so frequently the vehicle for an added note of drama. Interestingly enough, Reynolds himself evidently adapted the commanding design of the *Earl Temple* to his full-length of the *Marquess of Cholmondeley* (fig.14), painted some eighteen years later, and about seven years after Ramsay's enforced retirement from practice. That Reynolds apparently felt at this late stage in his life that he could still learn something from Ramsay is in itself striking; but a comparison between the two pictures only throws into relief the differences between the two painters. Where Reynolds emphasizes mass and weight in the rendering of form, with the example of Michelangelo and Tintoretto

not far from his thoughts, Ramsay by contrast achieves his effects largely by means of graceful drawing and subtle transitions of tone. In one respect the *Earl Temple* is unusual for Ramsay in this period, in that it contains an emphatic expression of movement – contrasting in that respect, for example, with another great full-length painted in the same year, the famous portrait of *Lady Mary Coke*.

After the birth of the Queen's second son, Prince Frederick, Ramsay was commissioned to paint a group-portrait of her with the two princes. In its subject-matter this noble composition (no.86) has obvious affinities with Van Dyck's group of *Charles I and Queen Henrietta Maria with their two eldest children* (Her Majesty The Queen) – the 'greate peece' of 1632 – and there is some evidence that Ramsay made a particular study of Van Dyck's composition. As on other occasions, he would undoubtedly have responded to the unpretentious naturalness of Van Dyck's conception, which is all the more striking in the context of a royal commission of this nature; and in its informality and intimacy his own composition has much in common with it. The actual style, on the other hand, belongs essentially to the same modern idiom of French rococo that distinguishes Ramsay's female portraits of this period, and which is especially in evidence in the familiar enchantments of delicate pastel-tints, quietly ranging from the dominant pink of Queen Charlotte's flounced dress to the notes of light green in the embroidered 'coats' worn by the Prince of Wales. The domestic character of the ensemble is emphasized by the inclusion of a harpsichord, on which there lies a workbasket and a copy of Locke's treatise *Some Thoughts concerning Education*. The representation of the Prince of Wales with bow and arrows in his hands and with a toy drum behind him, recalls the pleasure taken by George III and his Queen in having their children playing around them in the palace drawing-rooms. Nevertheless, an appropriate sense of regal dignity is conveyed by the pyramidal grouping of the three figures and, more particularly, by the majestic interior in the forefront of which they are posed. The palatial setting brings to mind the State portraits of the Vanloos in France – and in fact one feature of it, the massive plinth supporting a pair of draped columns, repeats almost exactly, down to its perspectival treatment, a detail to be seen in the grandiose background introduced by Louis-Michel Vanloo into his full-length of *Louis XV* at Versailles, painted in 1761. It is of more than passing interest that in the autumn of 1764, the year in which Ramsay's group-portrait was probably begun, Louis-Michel accompanied his even more eminent uncle Carle Vanloo, *peintre du roi*, on a visit to London, when the latter, on being received by Ramsay (the holder of a similar office), presented him, as a mark of his esteem, with a drawing by himself, a *tête*

d'expression in the manner of Charles LeBrun.

It is possible that for some years this distinguished family of artists constituted an important source of information for Ramsay concerning the state of painting in France. In certain instances, however, we may plausibly infer Ramsay's acquaintance with portraits by French painters in British collections. A case in point is a portrait by Drouais, painted in 1763, of the celebrated beauty Elizabeth Gunning (fig.15), whose second husband, the 5th Duke of Argyll, was the second cousin of Ramsay's great patron the 3rd Duke (no.29). Ramsay's lovely half-length of the *Countess of Elgin* (no.78) corresponds so closely in its design to Drouais's picture that it is hard to resist the conclusion that there is a connection between them. But if that is so, the *Countess of Elgin* differs in sentiment from the work of any French painter of the period. Characteristically, the mood is tenderly meditative; and there can also be discerned in the tonal treatment an early reflection of an increasing concern on Ramsay's part with the role of light in pictorial composition – leading eventually to the lyricism of such later portraits as the *Anna Bruce of Arnot* of about 1767 (no.94) and the *Princess Augusta* of 1769 (no.97). So too, for example, in respect of male portraiture, it is the brilliant handling of light in the three-quarter-length of *William Guise* (no.73) that first captivates the eye.

In the early and middle 1760s Ramsay and Reynolds came into direct rivalry on being commissioned by Lady Caroline Lennox, Baroness Holland to execute a series of family portraits for her new gallery at Holland House in Kensington. The full-length of Lady Holland's sister Lady Louisa Conolly (no.65) was painted before the gallery came into existence, but it is virtually certain that it later formed the companion-piece in Holland House to Reynolds's well-known group-portrait of *Charles James Fox, Lady Sarah Bunbury and Lady Susan Fox-Strangways*. Besides Lady Louisa, two of Lady Holland's three other sisters – Emily, Marchioness of Kildare and Lady Cecilia Lennox – sat to Ramsay for the Holland House gallery, and a portrait by him of the remaining sister, Lady Sarah Bunbury, although of uncertain provenance, has recently been identified. Lady Holland herself sat to both Reynolds and Ramsay, and it is of some interest that in his portrait of her Reynolds produced one of the finest of the several intimate portrayals of women from his hand that seem to reflect his conscious emulation of Ramsay's 'delicacy'. Ramsay's own portrait of *Lady Holland* (no.90) is unquestionably one of his most original achievements – the most powerful perhaps of all his realizations of 'natural' portraiture, and one that is all the more notable on account of its unaffected devotion to a standard of visual truthfulness that allows the characterization of the sitter a dominance over all other considerations. Like

Ramsay's well-known portrait of *Elizabeth Montagu* (fig.16), the *Lady Holland* pays tribute to a woman who combined erudition and elegance in equal degrees. In the latter respect, the rhythmic representation of her hands, both in his preliminary chalk drawing (no.91) and in the painting itself, may be said to encapsulate the essentially rococo flavour of the composition as a whole. Further, the richness of the scheme of colour, with its surprising contrast between pinkish-red and light green (in Lady Holland's gown and in the chairback), while possibly evincing a particular debt on Ramsay's part to Drouais, draws attention to his range and variety as a colourist.

With the completion of the portrait of *Lady Holland* in 1766 Ramsay's work for the Holland House gallery was concluded. It was the same year that brought to his studio the most widely admired but also the most notorious of the *philosophes* of the French Enlightenment. Jean-Jacques Rousseau had accompanied Hume to England on the expiry of the Scottish philosopher's term as secretary to Lord Hertford, the British ambassador to the French Court. Rousseau by this time was showing increasing signs of paranoia, and he saw England as a place of refuge from his persecutors in France and Switzerland, both real and imaginary, and it was thus that Hume became his protector, seeing to all his domestic needs and seeking a pension for him from the King. The story of how Rousseau repaid these kindnesses has often been told, and does not require retelling here. His violent quarrel with the good Hume has, nevertheless, a particular interest in that it involved the portrait which Ramsay painted of Rousseau early in 1766 (no.92), and of which he made Hume a present. At first Rousseau was delighted with the portrait, but, after gaining the impression that Hume had commissioned it, he came to see it as an example of his friend's affectation and vanity, since Hume was not known to possess a collection of fine pictures. Still later, he was to accuse Hume of having the portrait painted in order to convince all Europe that he – the handsome Rousseau – was ugly. But to the student of eighteenth-century portraiture the most interesting part of Rousseau's various complaints against Hume consists of his statement that during his sittings to Ramsay he was posed, uncomfortably, 'in a dark spot'. It is, in fact, the Rembrandtesque system of lighting, whereby Rousseau's features are brightly illuminated while his upper frame and visible hand are thrown into shade, that is one of the most noteworthy aspects of the picture. A similar device of lighting is to be seen in the small head-and-shoulders portrait of the French ambassador, the cultured Duc de Nivernais (no.84), and it reappears in the half-length of Hume (no.93) which Ramsay painted later in 1766 as a companion-piece to the *Rousseau*. Comparable effects of Rembrandtesque lighting are found elsewhere in

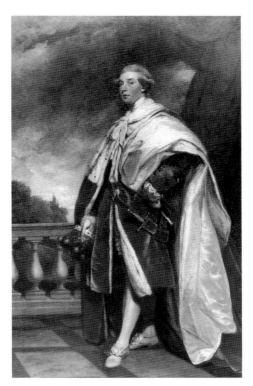

fig.14
Sir Joshua Reynolds
The Marquess of Cholmondeley
The Most Hon. The Marquess of Cholmondeley

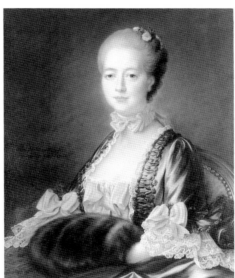

fig.15
François-Hubert Drouais
Elizabeth, Duchess of Argyll
His Grace The Duke of Argyll

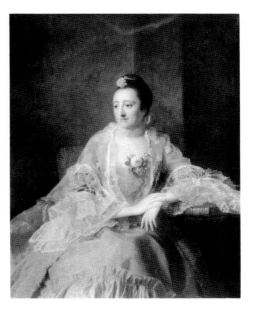

fig.16
Allan Ramsay
Elizabeth Montagu
Private Collection

British portraiture of the period, most notably in the work of Reynolds and Frye; but, unlike Reynolds, Ramsay makes no attempt to imitate Rembrandt's technique, with its complexity of brushwork and solid passages of impasto. He preserves throughout the lightness of touch and smoothness of surface which had always remained inseparable from his practice. In the *Rousseau* Ramsay did, however, depart in one important respect from his customary method, for we now find no trace of the vermilion underpainting which he had invariably employed since the time of his early studies in Italy. Rousseau's features are modelled throughout in browns and greys, and it is understandable that this change in technique should have occurred in the context of a work inspired to a great extent by Rembrandt's example. From this time Ramsay often prefers not to employ a red underpainting. Furthermore, the light grey typical of the backgrounds in the portraits of the earlier 1760s has been replaced in the *Hume* (no.93) by a dark tone tending to brown.

The *Rousseau* (no.92) has justly become one of the most famous of all eighteenth-century portraits. Ramsay seized upon the pictorial possibilities offered by Rousseau's exotic Armenian costume – consisting of a purple robe, lined with brown fur, and a black fur cap – to create an image that is perhaps the most immediately striking in his whole *oeuvre*. Ramsay, however, fixed still greater attention upon his strange sitter's finely chiselled features, and Rousseau's dark, arresting eyes gleam from the canvas with a smouldering glow. It is a memorable image, more powerful indeed than the genial crayon-portrait for which Rousseau had sat to La Tour, and one that we might expect at first sight to be the product of a considerably later period in the history of European painting; so much so that when the picture was shown in 1959 at the great exhibition at the Tate Gallery devoted to the Romantic Movement, it did not seem at all out of place. When Hume finally, and thankfully, left London for Edinburgh his portrait by Ramsay (no.93) was hung together with the *Rousseau* in the parlour of his house in the New Town; and the two pictures should, ideally, always hang together as they did then. Not only were they painted as companion-pieces, as gifts from the artist to his old friend, but the scarlet 'uniform' in which Hume is dressed, and which he had originally adopted when he had been attached to the British military mission at Vienna, was surely intended as a match for Rousseau's purple garment.

The design of the portrait of Hume, on the other hand, presents a contrast. The sitter is given an assertively frontal pose, eloquent in its monumental simplicity. He stolidly meets our eye, seated square-on without forced expression or distracting gesture, as though all but interior thought were excluded. His left arm rests limply on two leather-bound books,

in presumable allusion to his dual eminence as philosopher and historian. The contemplative mood of the picture owes much to the enveloping, Rembrandtesque shadows playing, as in the *Rousseau*, across the canvas, and throwing the lower part of Hume's ample frame into shade by contrast with the spotlighting of his face and visible hand. As an image reflective, in a deep sense, of the eighteenth-century Enlightenment, the portrait is scarcely less powerful than its companion. Nor in any other portrait did Ramsay approach more closely to the profound meditativeness of Rembrandt himself. It is not without significance, in relation to our earlier consideration of scale (in connection principally with the Edinburgh portraits of 1754), that the profundity attained by Ramsay in the portraits of Hume and Rousseau was contained within the amenable restrictions of the half-length. Much the same reflection is prompted by other masterpieces of characterization from the 1760s, such as the *William Hunter* (no.85) – a work that may also be described, in respect of its perfectly balanced design, as the counterpart in Ramsay's male portraiture of the famous portrait of his second wife (no.66).

The notion that Ramsay's employment at Court fell to the level of mere commissions for copies of his own works has distorted the entire picture of his standing as painter to the King, especially from the time of his second Court appointment in March 1767, when he succeeded to the full title of Principal Painter in Ordinary to their Majesties. In actual fact, between that date and his enforced retirement from practice in 1773, Ramsay received as many as six new commissions from the royal family. He now had two rivals for the royal favour in the persons of Cotes and Zoffany, but there is no question but that his patronage at Court continued until the end. Four of these portraits are included in the present exhibition – the full-lengths of *Prince William, Duke of Clarence* (the future King William IV) (no.95) and *Prince Frederick, Duke of York* (no.100) and the three-quarter-lengths of *Princess Augusta* (no.97) and the Queen's mother *Princess Elisabeth Albertina of Mecklenburg-Strelitz* (no.99). All of them are of very high quality, and neither in these works nor in portraits of other sitters painted during the same period do we find the least sign of any falling-off in Ramsay's powers.

Nor does this final phase of Ramsay's career show any lessening of the inspiration he had long found in contemporary painting in France, but he was never more original in adapting the rococo style to his own vision. Such a detail, for example, as the tea-service laid out on a table in the portrait of *Prince William* (no.95), and comprising a gilt vase, a cream-jug and two teacups, recalls the kind of domestic 'property' that is found in portraits by Nattier, Aved and other French painters. Similarly, in the *Princess Elisabeth Albertina* (no.99) the closed

fan held in the princess's hands revives a motif particularly popular in France and one that Ramsay had already used in the *Mary Martin* (no.69). Princess Elisabeth Albertina had died in 1761, and Ramsay's picture belongs to a small class of posthumous portraits from his hand in which the likeness was derived from a portrait by another painter but in which the composition itself was his own invention. In this case Ramsay based the likeness upon a portrait by the German artist Daniel Woge (Her Majesty The Queen) and modelled the composition upon the same three-quarter-length of *Mary Martin*. This offered a precedent for the motif of the closed fan, and he evidently consulted his preparatory chalk drawing (no.70) of the pose for the latter picture, in which, by contrast with the actual painting, where one of the sitter's hands is concealed in a muff, both hands are represented. As the *Mary Martin* was painted in 1761, Ramsay was consequently able to ensure that Princess Elisabeth Albertina was dressed according to the fashion still prevailing in her lifetime. Probably because the head was not painted from life, the portrait is slightly lacking in vitality; but the ravishing harmony of blue, crimson and green constitutes one of Ramsay's most inventive arrangements of colour, and reflects his frequent preference, in his final period, for the more resonant chords typified at an earlier stage by the *Lady Holland* of 1766 (no.90).

The lyricism of mood that distinguishes most of Ramsay's last works, and which has long been associated in particular with the lovely bust-length portrait of *Anna Bruce of Arnot* (no.94), painted probably about 1767 or 1768, attains its fullest and most consummate realization in the three-quarter-length of *Princess Augusta* (no.97) completed by May 1769 for the Brunswick Court – where the garden setting provides the context for a wonderful evocation of the magic of light. This poetry, known to many critics solely by its presence in the *Anna Bruce*, which is the only very late portrait by Ramsay to be seen in a public gallery, has on occasion prompted comparisons with Gainsborough; and it is quite possible that Gainsborough renewed at this time the interest he had manifestly taken in Ramsay's approach to portraiture in the 1750s. One piece of supportive evidence is the apparent echo in Gainsborough's full-length of Queen Charlotte (Her Majesty The Queen) of Ramsay's profile portrait of her (no.81), in which the graceful representation of the Queen's gesture in lightly holding a closed fan may well have been noted appreciatively no less by Gainsborough than by Northcote. But it is hardly appropriate to go much further in speculations of such a kind. Ultimately, Ramsay keeps his distance as much from Gainsborough, the painter of instinctive genius and natural gifts, as from Reynolds, the studious exponent of aesthetic idea and principle. Ramsay's portraiture has nothing in it

either of the ideal generalizations of Reynolds or of the glancing brilliancies of Gainsborough. At its heart there lies a distinctive regard for the truth of appearances matching a no less profound concern to evoke a sitter's personality and character, so far as that endeavour can be said to be possible to a portrait painter.

The qualities that most distinguish Ramsay's last works, outwith his royal commissions, are to be seen in such portraits as the poetic *Anne Howard* (no.89) and *The Honourable Anne Gray* (no.96), both of them enhanced by the discreet introduction of landscape features. These portraits can be reasonably assigned to the period 1766-70; but the question of a still later dating arises with regard to other works to which due attention has only lately been given. Among these, the lively three-quarter-length of *Lady Charlotte Burgoyne* (no.104) suggests, even by the sitter's hairstyle, a dating in the early 1770s, and there are grounds for postulating, at least provisionally, a date in or about the year 1772. Here we see continued that delight in brilliancy of colour which is increasingly reflected in Ramsay's portraiture from the mid-1760s. The affinities with French portraiture are as marked as ever, and the picture could readily hang next to a Perronneau without the least sense of disharmony, although such a pairing would no less assuredly bring out the distinctive qualities in Ramsay's style, not least its delicate reserve and lightness of touch. There are other portraits, not represented in this exhibition, that would appear to belong to Ramsay's very last years in practice and to require a dating shortly before the accident to his arm in 1773 which resulted in his retirement from painting. In that context the enchantingly lovely half-length of an unidentified young lady lent to the exhibition from the Yale Center for British Art at New Haven (no.106) comes into the reckoning if the present writer's hypothesis that the girlish sitter is none other than the painter's daughter Amelia is correct. On grounds of style alone, the portrait could be easily dated closer to the year 1760, except for one particular: the dark brown background would be quite unusual in any work of the 1760s prior to the *David Hume* (no.93) of 1766. But the question of dating can be best left, for the present, unresolved. It is a problem which should not intrude upon the response of viewers to one of Ramsay's most exquisite realizations of his particular gift for female portraiture, and one that, even by virtue of its not having been brought to completion, enables us to see in the unfinished lower area the sheer beauty of Ramsay's draughtsmanship, the foundation of his excellence as a painter.

As, after all, Ramsay occupied for almost a quarter of a century the prestigious office of painter to the King, it is appropriate to conclude this survey of his career with a word about his last certainly known royal commission. The full-length of

Prince Frederick, Duke of York (no.100) must have been painted not very long before the accident which Ramsay suffered to his right arm in March 1773 and which forced his retirement. The picture was destined for Hanover, and there have come down to us a pair of oil-sketches on paper (nos. 102 and 103), quite exceptional in Ramsay's *oeuvre*, which show two alternative designs for the portrait, and which were presumably submitted as trial-pieces before work was begun on the approved composition. The design finally decided upon showed the Prince standing in the fashionable cross-legged attitude (no.102), in which he then posed for a study in chalks (no.101).

Ramsay had used this attitude in several earlier works (such as no.60 in the present exhibition), but in this case there are affinities with Van Dyck's portrayal of the Prince of Wales in the second of his two groups of *The Three Eldest Children of Charles I* (fig.17), both in respect of the pose and of the directness of the portraiture, offering a further intimation of the inspiration that Ramsay drew from his great predecessor as Court painter. Indeed, the relationship between Ramsay's art and that of Van Dyck carries with it much deeper implications, for not only did Ramsay share to a large extent Van Dyck's graceful ideal of portraiture but he can be truly said to have revived it in his own times.

Although Ramsay gave up painting in 1773 – in his sixtieth year – a few portrait-drawings of later date are known. Most of these were made during his third visit to Italy from 1775 to 1777 – a visit undertaken with the object of seeking some alleviation of his physical infirmities – and they include a fine self-portrait (no.108), a charming study of his wife, caught in the momentary action of looking downwards with lowered head (no.107), and another of his daughter Amelia (no.105). It would seem that the accident of 1773 had caused damage chiefly to his upper arm and shoulder and that by leaning his elbow on a desk or table he was still able to draw with some freedom. Other drawings, however, and especially the landscape sketches he made in the region of Licenza during this visit and his final Italian visit of 1782-4 for the purpose of illustrating his treatise (never to be published) on Horace's villa (*An Enquiry into the Situation and Circumstances of Horace's Sabine Villa*), show an increasing shakiness, suggestive of a marked tremor of the hand. During the eleven years that were left to him after his accident he concentrated his energies upon the literary and scholarly pursuits which had for long occupied his leisure hours, and it was as a man of letters and erudite conversationalist, rather than as a painter, that he became chiefly known in the literary world of London – most notably the Johnson circle – and on his death in August 1784 it was principally to these secondary accomplishments that his obituarists paid tribute. The public in general were unaware that the country had lost one of her finest artists.

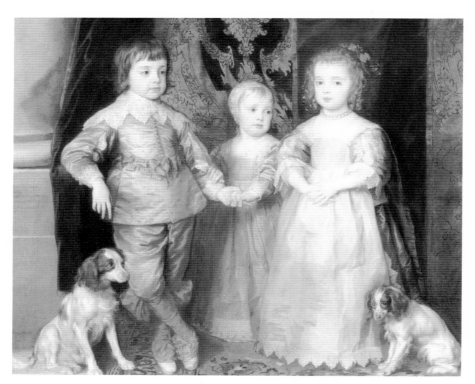

fig.17
Sir Anthony van Dyck
The Three Eldest Children of Charles I
Reproduced by gracious permission of
Her Majesty The Queen

Allan Ramsay and Fashion in Art

Costume is an important element in the portraits of Allan Ramsay, where gleaming satins, crisp flowers and frothy lace enhance the form and features of the sitters and seduce the eye of the beholder. Ramsay employed drapery painters, it is true, but he concerned himself always with the entire composition, and the differing textures of silk and velvet, ribbon and net, clearly fascinated him. One has only to look at the rustling draperies of John, 3rd Earl of Bute (no.60) or the delicate detail of Margaret Lindsay (no.66) to sense his feeling for costume as an expression of personality.

In his earliest pictures, clothing is plain, almost severe. Margaret Calderwood's golden gown for example is completely unadorned (no.6), while Alexander Home of Jardinefield (no.4) wears generalized draperies and Marshal Keith (no.19) is encased in drearily conventional armour. Gazing at the later, London portraits with their elaborate, almost fanciful accessories, the viewer might be tempted to assume that the difference is geographical: that Scots in Scotland favoured a sober and restrained garb, while wealthy Englishmen and their wives eagerly imitated every vagary of French taste.

This is not so. Court and parliament were in London, and every year the Scottish aristocracy and many others travelled south for the winter season and enthusiastically shipped home the latest furniture, dishes, coaches and clothing. The difference between the early and the later portraits is not one of place but of time. It so happened that in the opening years of Ramsay's career, when he was working in Edinburgh, the wealthy strove for elegant simplicity in dress. By the time he was settled in London, the new desire for ostentation was reaching its apogee, and his skills allowed him to exploit every frill and frippery of fashionable attire.

Sack-back dresses for instance, make frequent appearances in his portraits. The sack had been introduced from France in the 1720s, a voluminous, rather shapeless garment falling from shoulders to hem in tent-like folds. Before long, the bodice became more fitting, but with single, double or treble box pleats concealing the back, as can be seen in the portraits of

Lady Walpole Wemyss (no.43), Anna Bruce of Arnot (no.94) and The Honourable Anne Gray (no.96).

Skirts had changed too. For most of the seventeenth century layers of petticoats had given the required fullness, but now an old device was revived. The hoop came back into style. In the sixteenth century hoops were used to distend skirts to exaggerated proportions. They consisted of a series of circles of whalebone, cane or wire, taped together and increasing in circumference from waist to hem. The Spanish farthingale gave a natural enough line, but the popular French farthingale, seen in, for example, portraits of Anne of Denmark, had made the wearer look as though she were carrying a broad, flat shelf round her waist.

Cumbersome to wear, the farthingale had been discarded by 1630, but now hoops were back, still made of the same materials, sometimes incorporated in the petticoat rather than being a separate structure, but designed to emphasize rather than to distort the shape of the wearer. The delightful portrait of Agnes Murray-Kynynmond Dalrymple (no.14) provides a good example of a dome-style hoop. Gradually, however, the desire for novelty resulted in exaggeration once more, and from the 1740s onwards the oblong hoop was in favour, with its extraordinary width at either side. It was no easier to wear than the farthingale had been: indeed, some oblong hoops had to be hinged so that the lady could fold up the side-pieces when confronted with a narrow doorway. Sitting down in a hoop was not always comfortable, either, and Anne, Countess of Balcarres (no.38) perches somewhat gingerly in hers.

Another sixteenth-century revival frequently seen in Ramsay's portraits is the stomacher front to a dress. Shaped like a long, inverted triangle, the stomacher was a piece of cloth inserted in the open front of the sack bodice. Stiffened with pasteboard or canvas and with whalebone stays, in its original form it was heavily embroidered and often sewn with jewels. Queen Charlotte in her coronation robes (no.75) has a gemencrusted stomacher, but that was unusual in the eighteenth century, part of archaic costume for a very special occasion. Other stomachers of the 1750s and 60s had either light

embroidery or were trimmed with a vertical row of ribbon bows diminishing in size from neck to waist. The bows were called breast knots; the row of bows was an échelle, from the French word for ladder. Lady Louisa Conolly's stomacher has ruched ribbon (no.65), while Mrs Martin's is sewn with fancy braid (no.69). Eventually, the stomacher became quite different in form, fastening down the front with buttons as Lady Elgin's does (no.78). This was known as a compère stomacher bodice.

The ruff also made a reappearance at this period, but it was very different from the stiffly starched, wheel-like collar of the previous century. Now it consisted of a delicious little wisp of lawn or lace, worn high on the neck, quite separate from the dress. Lady Helen Wemyss (no.42) and Ann Howard (no.89) are two among many of Ramsay's sitters whose long necks are enhanced by this style. His own second wife, Margaret Lindsay (no.66), and no less a personage than Princess Augusta (no.97) are portrayed with a ruched ribbon instead, while in the portrait of *A Young Lady in a Pink Dress* (no.106) the sitter wears both ribbon and ruff. Even when pearl necklaces were worn, the big satin bows fastening them were almost more noticeable than the pearls themselves (see nos. 81 and 96).

Strings of pearls in the hair, round the neck or looped up on the bodice do appear in Ramsay's paintings, particularly the earlier ones, but gems were no longer fashionable in portraits. As a result, ribbons and lace often replaced necklaces, and posies of artificial flowers were used instead of brooches and clips. Flowers are a particular feature of the portrait of Flora Macdonald (no.36), partly as a play on her name, perhaps, partly to symbolise the Jacobite cause with its white rose. The flowers worn by other ladies had no such political connotations, however. Anna Bruce of Arnot (no.94) and the Honourable Anne Gray (no.96) tucked small bunches of roses into their bodices, Lady Walpole Wemyss (no.43) is portrayed in the height of French fashion with a dainty pompon of pink flowers on top of her head and the Countess of Elgin (no.78) has posies pinned to both hair and bodice.

Accessories such as these enhanced the allure of a society beauty, but Ramsay also used costume to emphasize the dignity of an elderly sitter such as Charlotte, Duchess of Somerset (no.37). She and Lady Inglis (no.27) are both lent solidity and presence by being muffled up in all-enveloping kerchiefs and hoods, while the somewhat dominating features of Ramsay's first wife, Anne Bayne (no.15), are softened by the frilly edges of her cap.

Women in the eighteenth century usually wore their own hair. Most men, however, sported wigs. Introduced from France by Charles II at the time of the Restoration, the first early wigs were long, with masses of ringlets hanging down over the shoulders. By Ramsay's day, it was increasingly popular to wear a shorter, bob wig (see nos. 18 and 40) or a neat tye-wig with, as the name suggests, the hair tied back in a long tail which was sometimes placed in a silk bag (see no.84).

The best quality wigs were made from human hair, with horsehair as a cheaper alternative. In the mid-eighteenth century many of these wigs were powdered either white or grey. Special hair powder containing starch was sold by peruke-makers and was applied by the gentleman's valet or barber to the wig, which had been previously treated with pomatum to make the powder adhere. Because of the popularity of wigs, hats were largely superfluous, and are rarely worn in portraits of the period. The three-cornered hat was far more often tucked under the sitter's arm, as in the *Sir John St. Clair* (no.48), or held in the hand, which is what John Burgoyne does (no.54).

The principal item of masculine attire remained the three-piece suit, consisting of coat, waistcoat and breeches. The portrait of *Francis, 2nd Duke of Buccleuch* (no.18) provides an excellent example of the type of outfit worn in aristocratic circles. The Duke's dark coat is collarless and long, the sleeves slit at the cuff to show the frilled shirt beneath. He wears it open, to reveal the splendour of his scarlet waistcoat, which matches so dramatically the lining of his coat. The front edges of the coat curve back slightly, and the stiff fall of the skirt suggests that it has an interlining of buckram.

As time passed, coats became rather shorter and their front edges curved back even more, for the waistcoat had become the focal point of the entire outfit. Sometimes it was plain, relying for effect on a colour contrast with the coat, but more often it was trimmed with fancy braid or metal lace, down the edges and across low, horizontal pockets. Both devices are used in the *Thomas Lamb of Rye* (no.47), where the pale yellow waistcoat sets off the powder-blue coat, and each is sewn with an abundance of silver lace. David Hume the philosopher (no.93) prefers the sumptuous effect of matching scarlet coat and waistcoat, both edged with gold, while Dr. William Hunter (no.85) relies upon ornamental buttonholes to give his garments a dashing air. Breeches remained plain and unobtrusive, usually made of the same material as the coat, and with small buckles at the knees. They were worn without a belt, relying on their cut and on the tightening of the waistband at the back to keep them in position. The outfit was completed by silk hose and buckled shoes.

Not all Ramsay's masculine sitters are shown in the three-piece suit, for public men often preferred to be portrayed in clothing symbolic of their office or status.

John, 3rd Earl of Bute (no.60) cuts a fine figure in his coronation robe and surcoat, the long, cloak-like mantle with

its cape of white fur indicating his precise rank by means of the three rows of black ermine tails. Likewise, Lord Temple in the portrait painted in 1762 (no.77) appears in the full splendour of his robes as a Knight of the Thistle. His silk-lined mantle and embroidered surcoat are worn over paned trunk hose of the style of the 1620s, another example of a fashionable garment being preserved in ceremonial costume long after it has passed from normal use.

Portraits such as these obviously allowed Ramsay to give free rein to his love of rustling silks and contrasting textures. In other instances, however, he used the very plainness of middle-class professional costume to give authority to some of the eminent men who sat to him. John Sargent the Elder (no.40) has a perfectly plain coat, his frilled shirt cuffs forming the only decorative feature of his subdued outfit, and the same is true of the soberly clad judge, Lord Drummore (no.44). By way of contrast, Ramsay's Italian friend Samuel Torriano (no.10) relaxes in a flamboyant nightcap and nightgown, the vivid colours expressive, surely, of the sitter's personality.

Striking as his portraits are in their psychological penetration, Allan Ramsay did not concentrate on his sitters' features to the exclusion of all else. Their garments and their accessories are recorded with verve and appreciation, be they the delicate, flowered silks of the Wemyss sisters' sack-back dresses (nos. 42 and 43) or the sombre fur of Jean-Jacques Rousseau's cap (no.92). Not only do the black lace tippets, the feather fans and the lace-trimmed waistcoats allow us to glimpse the fashionable world of the eighteenth century: they also mysteriously enhance our understanding of the personalities Ramsay has caught for us on canvas.

Index of Lenders

H. M. The Queen 86, 95, 99

His Grace The Duke of Atholl 16

Bath, Holburne Museum and Crafts Study Centre 34, 35, 40

Birmingham Museums and Art Gallery 69

His Grace The Duke of Buccleuch and Queensberry K.T. 18

The Trustees of the Chevening Estate 30, 68, 79, 80

Mrs A. Dundas-Bekker 6

Edinburgh, National Gallery of Scotland 2, 3, 11, 12, 13, 26, 27, 32, 33, 39, 45, 46, 47, 51, 53, 55, 56, 57, 58, 59, 61, 63, 66, 67, 70, 72, 76, 82, 83, 87, 88, 91, 92, 94, 98, 101, 102, 103, 105, 107

Edinburgh, National Trust for Scotland 60

Edinburgh, Scottish National Portrait Gallery 1, 15, 44, 52, 74, 93, 109

The Rt. Hon. The Earl of Elgin and Kincardine K.T. 78

The Finch Family 37

Glasgow Art Gallery and Museum 29

Glasgow, Hunterian Art Gallery 85

Sir John Guise and the Trustees of the Elmore Court Estate 73

The Rt. Hon. The Earl of Haddington 10

Ian Henderson, Esq. 5

The Rt. Hon. Lord Home of The Hirsel K.T. 64

Ickworth, The National Trust 84

The Leger Galleries 48

London, The Thomas Coram Foundation for Children 28

London, National Portrait Gallery 9, 49, 62, 108

London, Tate Gallery 22

The Hon. Rosamund Monckton 8

Oxford, Ashmolean Museum 36

F. A. W. Page-Turner Trust 20

The Paxton Trust 4

The Rt. Hon. The Earl of Wemyss and March K.T. 42, 43

OVERSEAS

Berlin, Staatliche Schlösser und Gärten 19

S. K. H. der Prinz von Hannover 97, 100

Kassel, Schloss Wilhelmshöhe 75

Melbourne, The National Gallery of Victoria 77

New Haven, Yale Center for British Art 41, 106

AND MANY OWNERS WHO PREFER TO REMAIN ANONYMOUS

Index of Sitters

ALLAN RAMSAY 1713–1784

Colour Plates

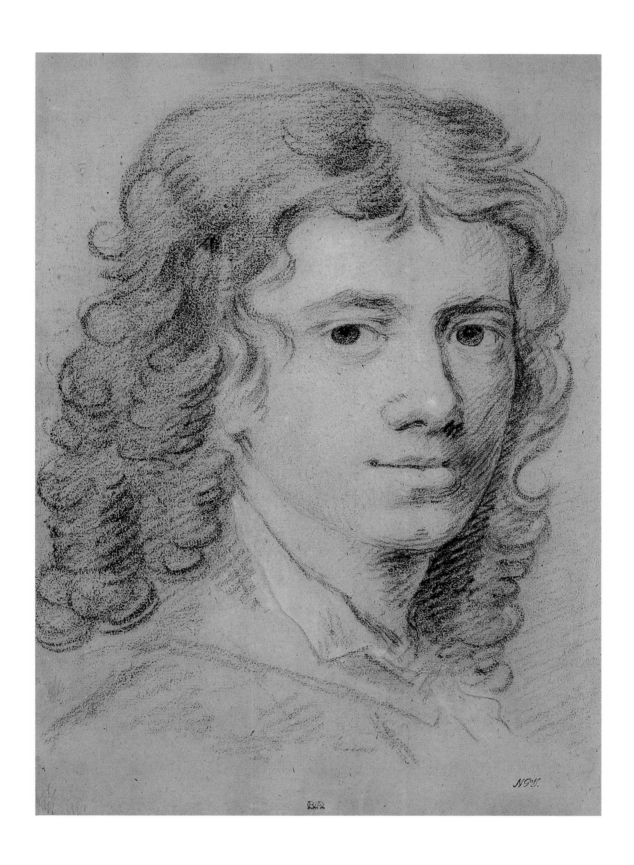

PLATE I

SELF-PORTRAIT AS A YOUTH

NO.3

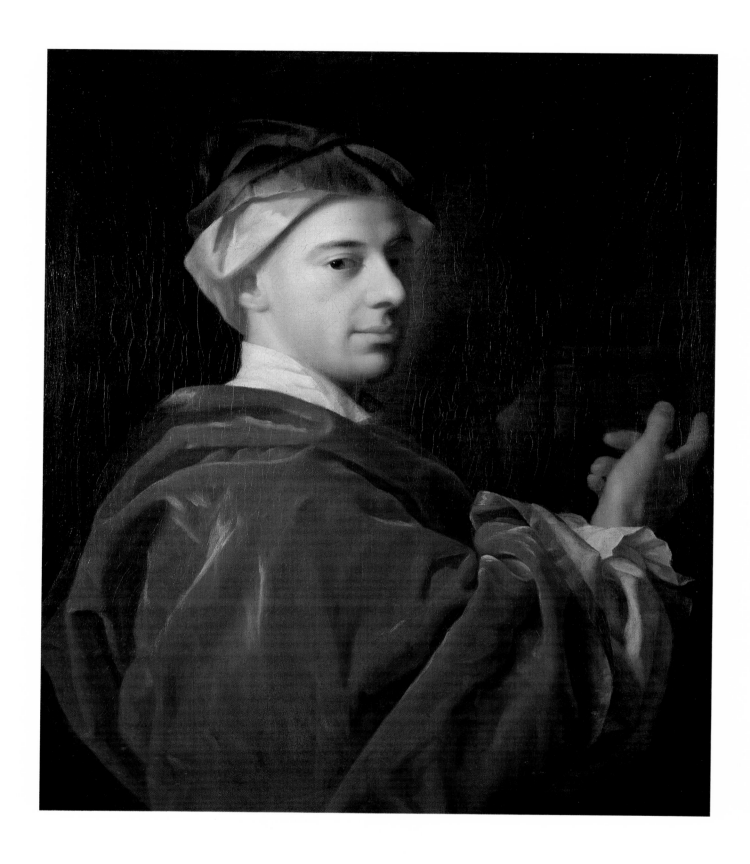

PLATE 2

SAMUEL TORRIANO

NO. 10

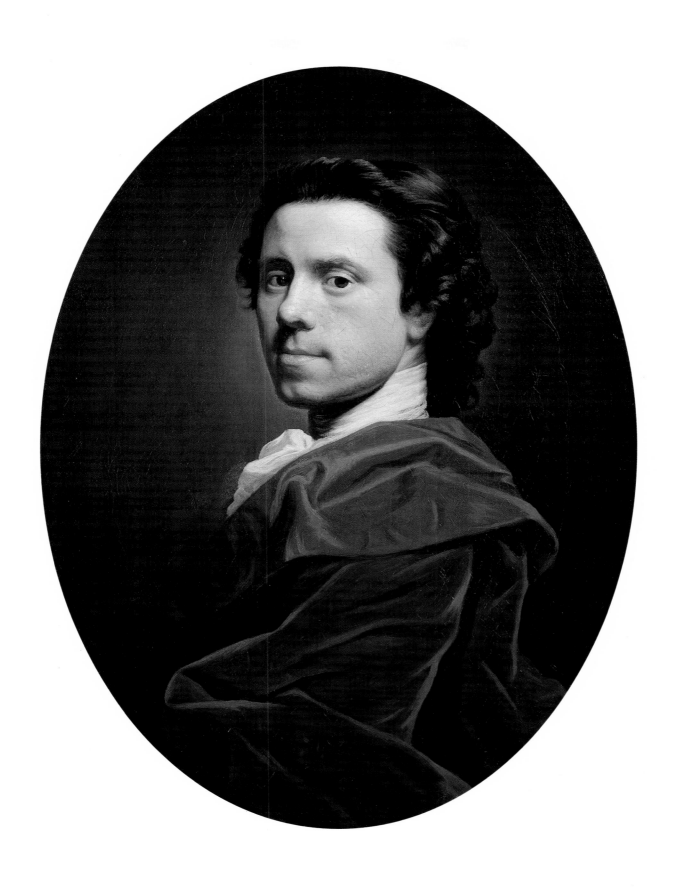

PLATE 3
SELF-PORTRAIT
NO. 9

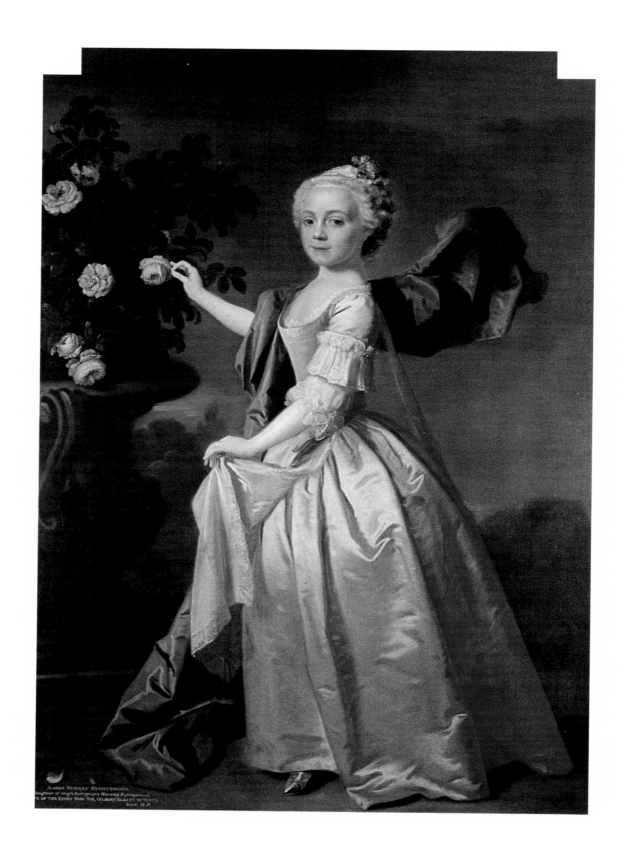

PLATE 4
AGNES MURRAY-KYNYNMOND DALRYMPLE
NO.14

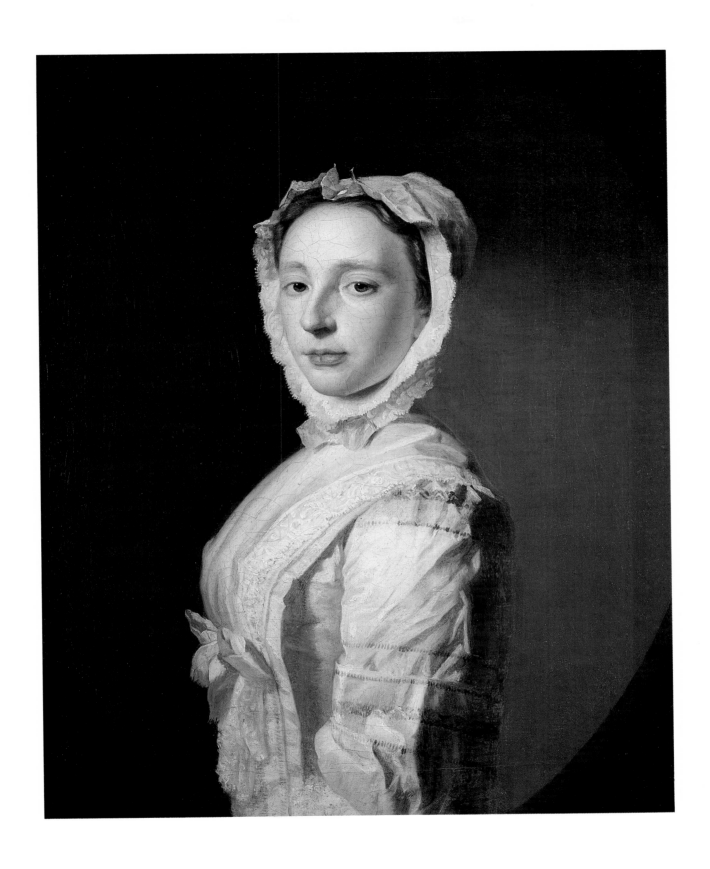

PLATE 5

ANNE RAMSAY, THE PAINTER'S FIRST WIFE

NO.15

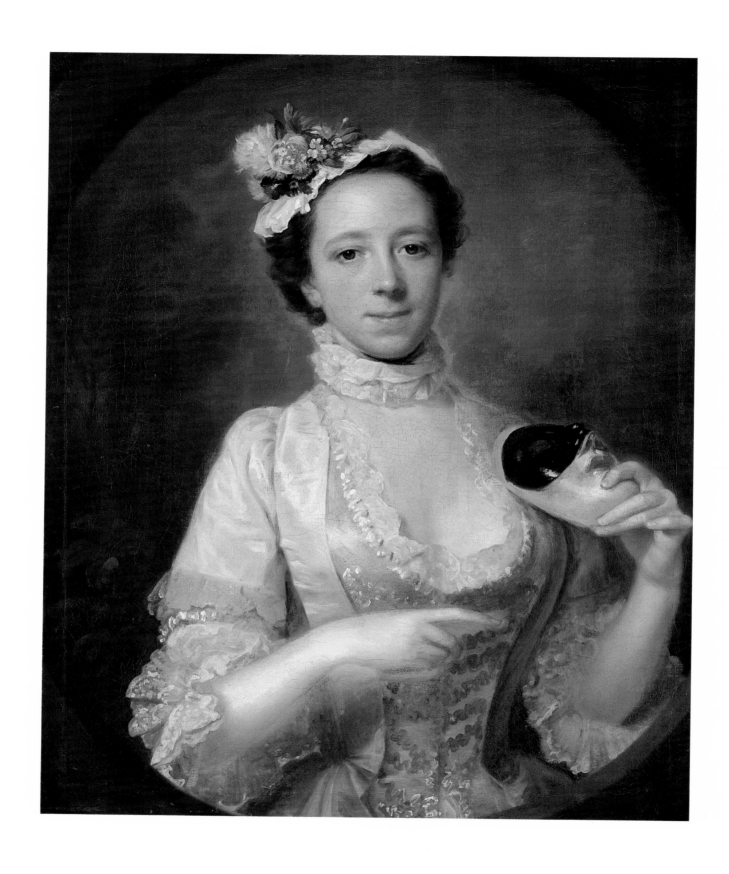

PLATE 6
LAVINIA FENTON, AFTERWARDS DUCHESS OF BOLTON
NO.17

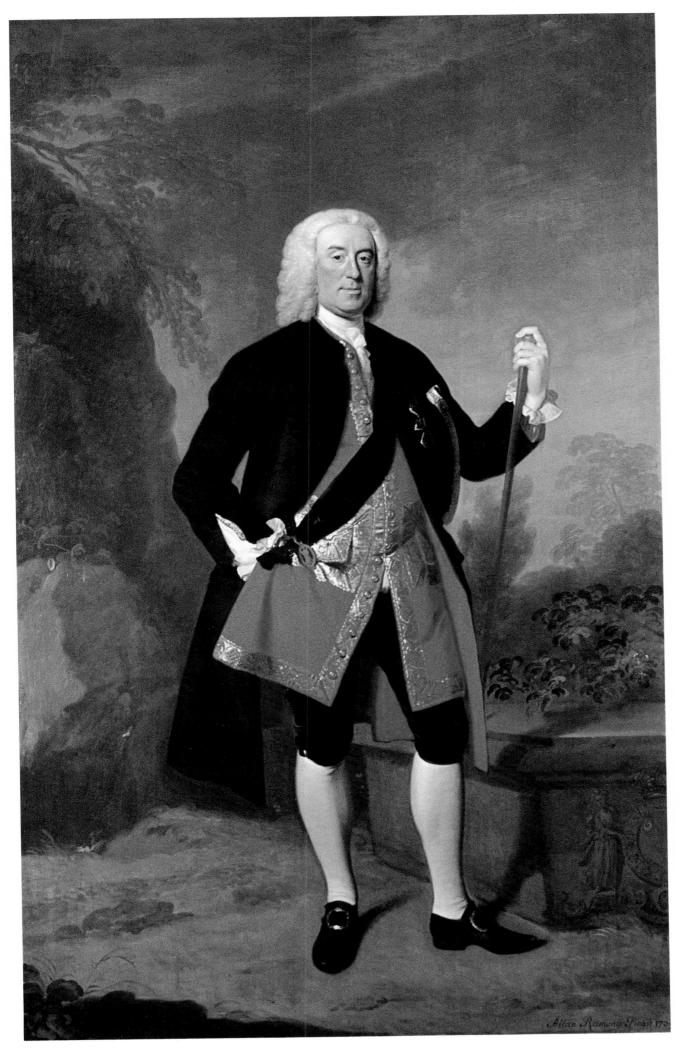

PLATE 7
FRANCIS SCOTT,
2ND DUKE OF
BUCCLEUCH
NO.18

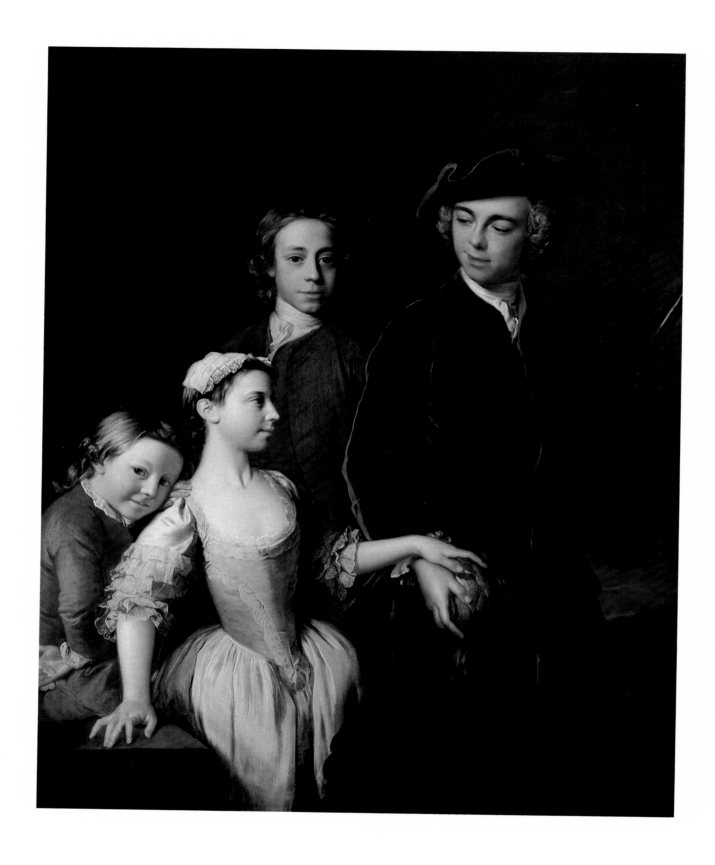

PLATE 8
THE MANSEL FAMILY
NO. 22

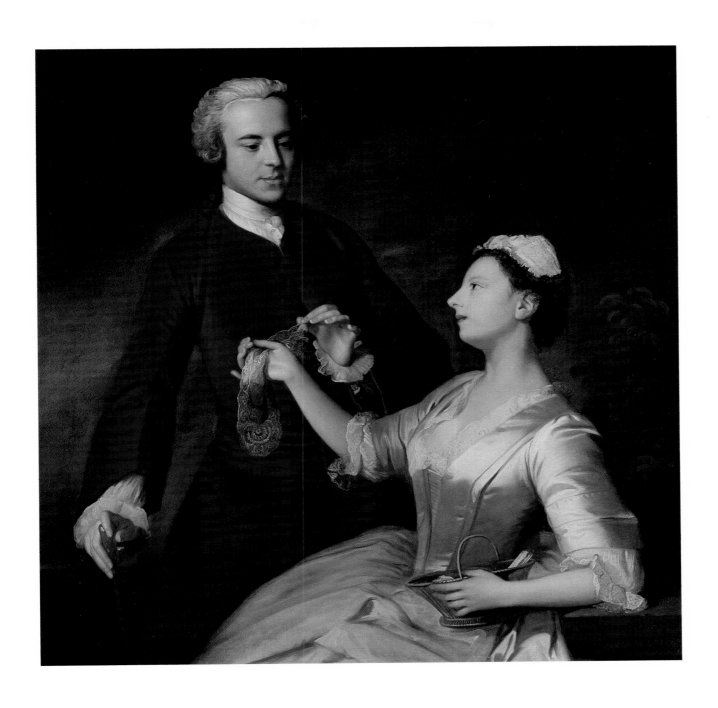

PLATE 9
SIR EDWARD AND LADY TURNER
NO.20

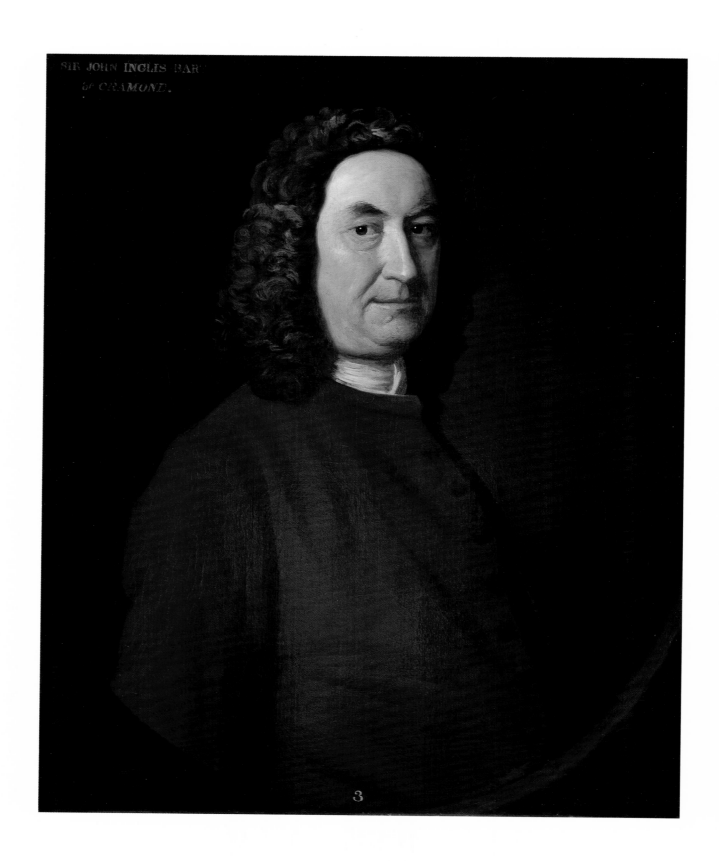

PLATE 10
SIR JOHN INGLIS OF CRAMOND
NO. 26

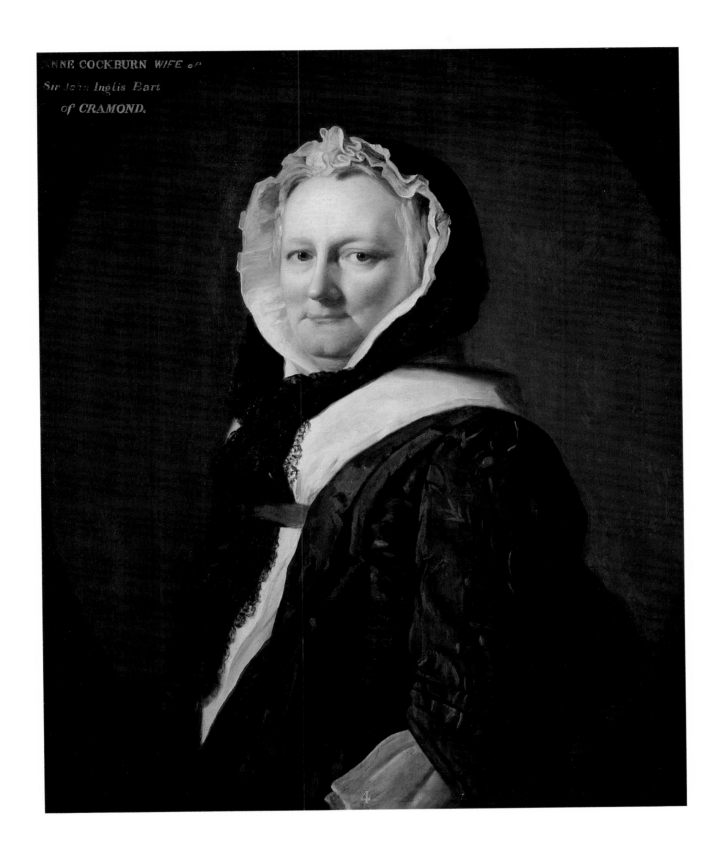

PLATE II

ANNE COCKBURN, LADY INGLIS

NO.27

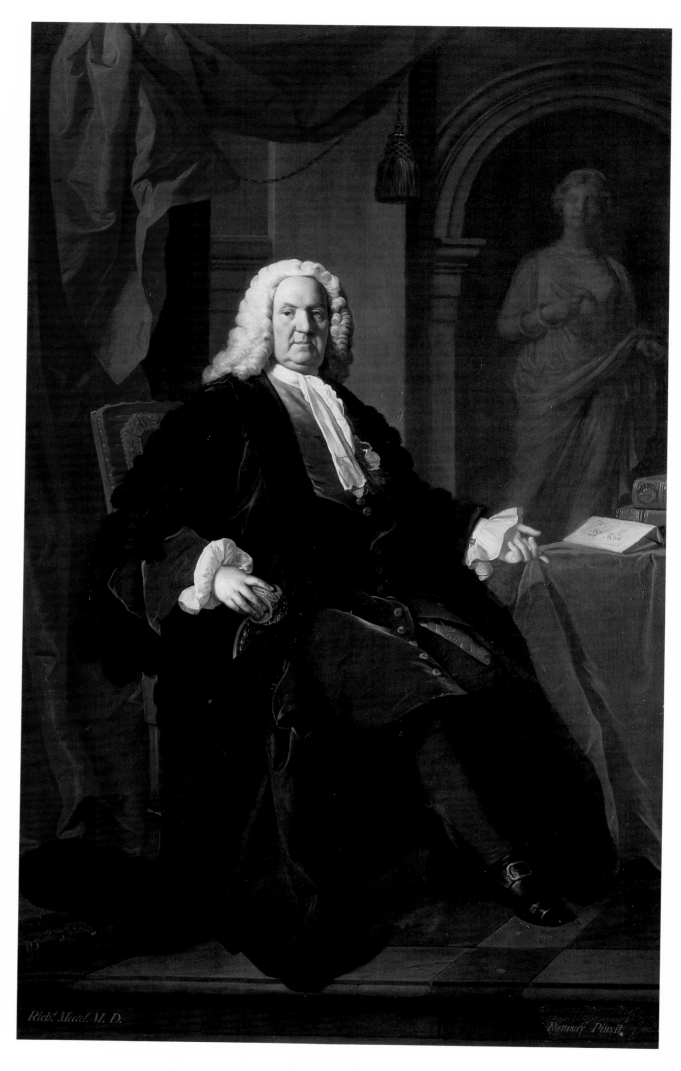

Rich.ᵈ Mead. M. D.

Ramsay Pinxit

PLATE 12
DR. RICHARD
MEAD
NO. 28

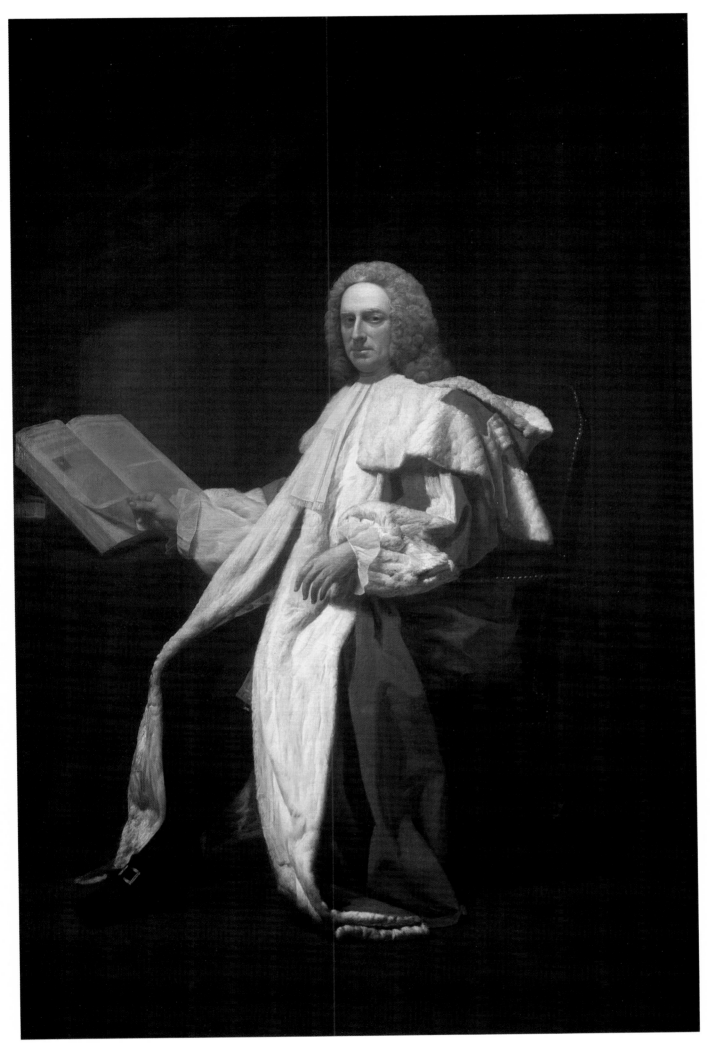

PLATE 13
ARCHIBALD,
3RD DUKE OF
ARGYLL

NO.29

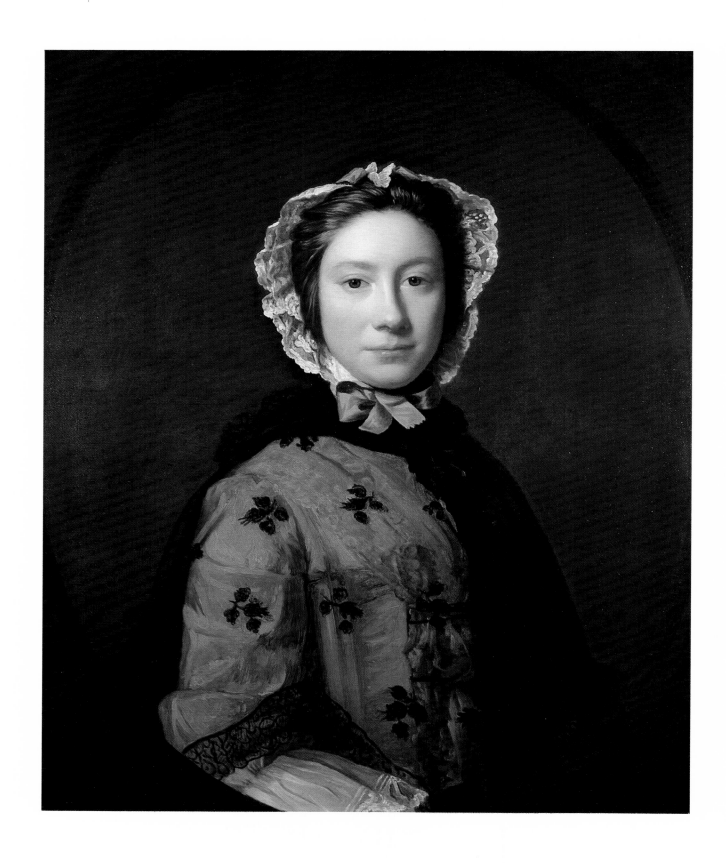

PLATE 14

ROSAMUND SARGENT

NO. 35

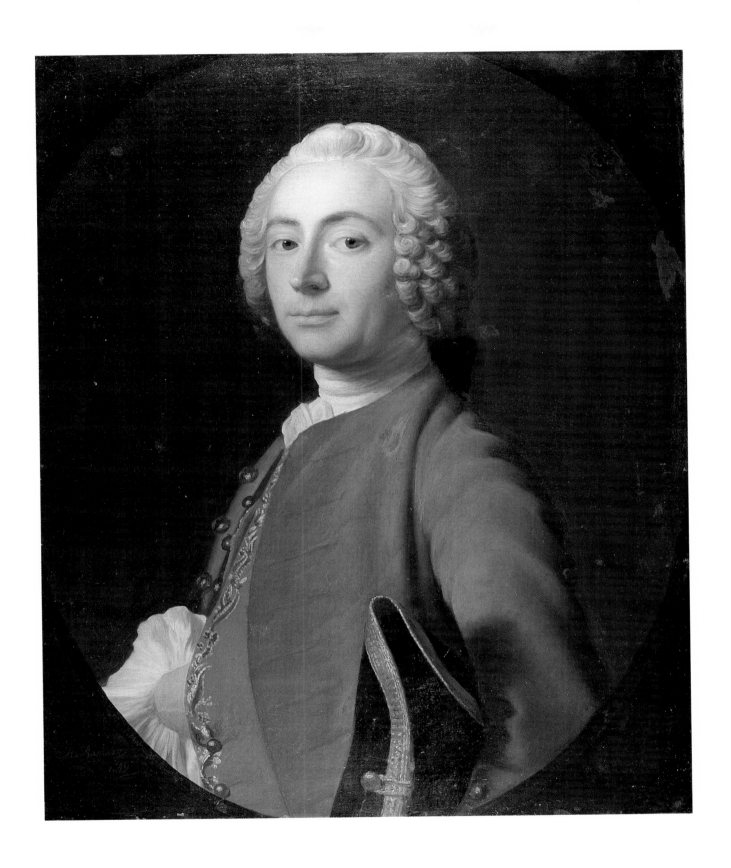

PLATE 15
JOHN SARGENT THE YOUNGER
NO. 34

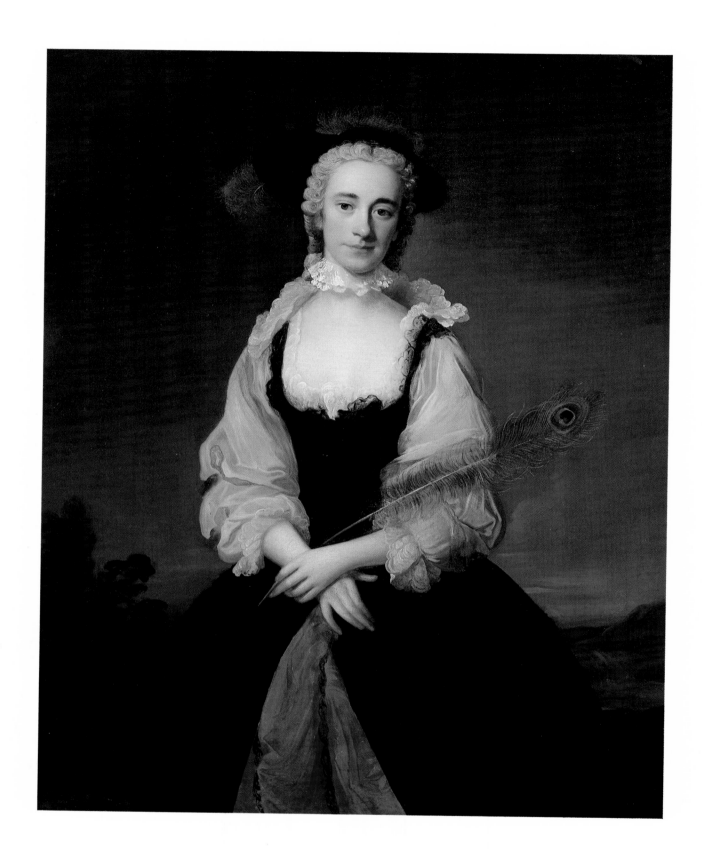

PLATE 16

A LADY IN 'VAN DYCK' DRESS

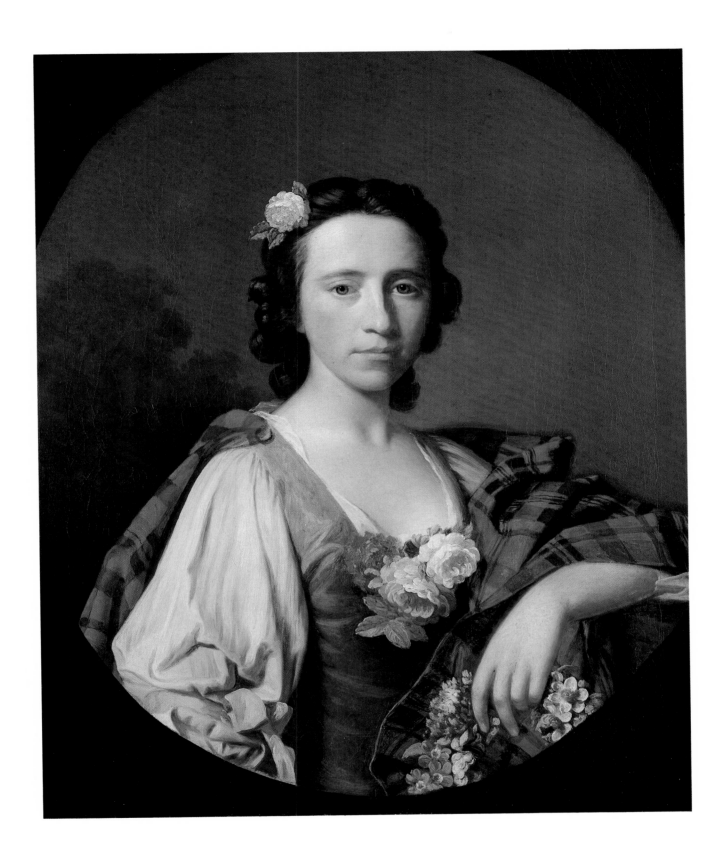

PLATE 17
FLORA MACDONALD
NO. 36

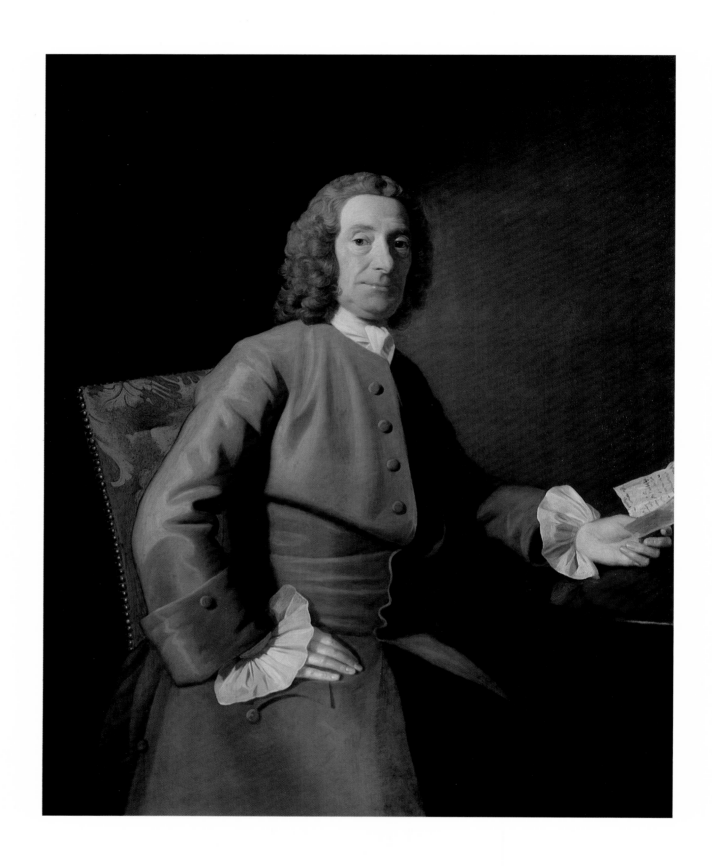

PLATE 18

JOHN SARGENT THE ELDER

NO.40

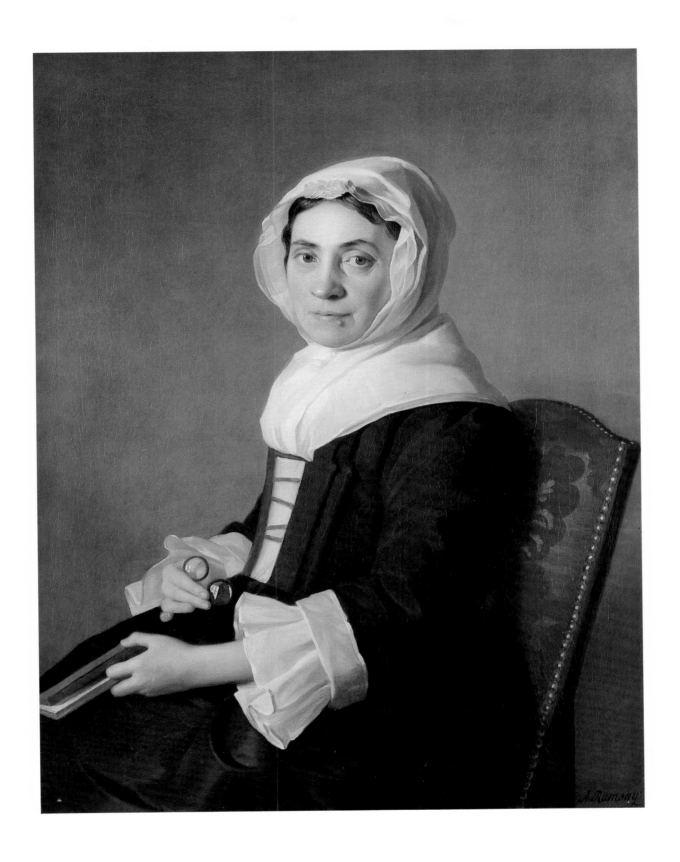

PLATE 19

MARY ADAM

NO.41

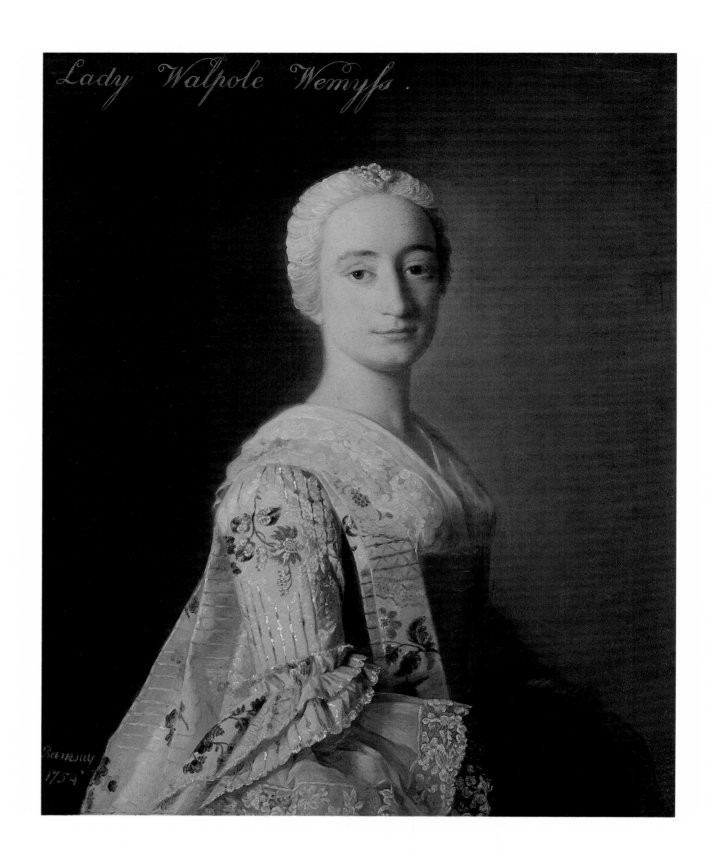

PLATE 20
LADY WALPOLE WEMYSS
NO.43

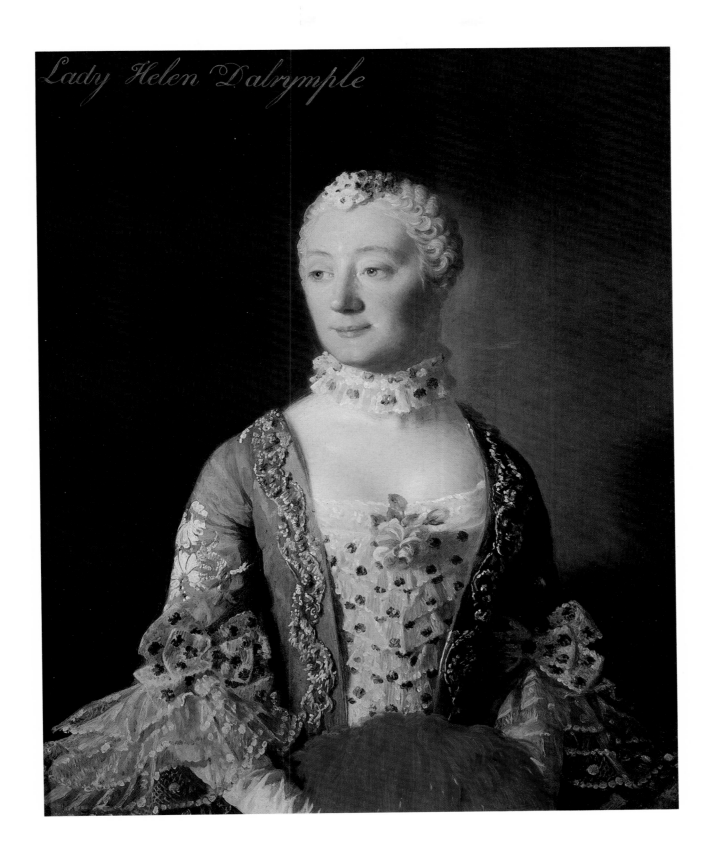

Lady Helen Dalrymple

PLATE 21
LADY HELEN WEMYSS
NO. 42

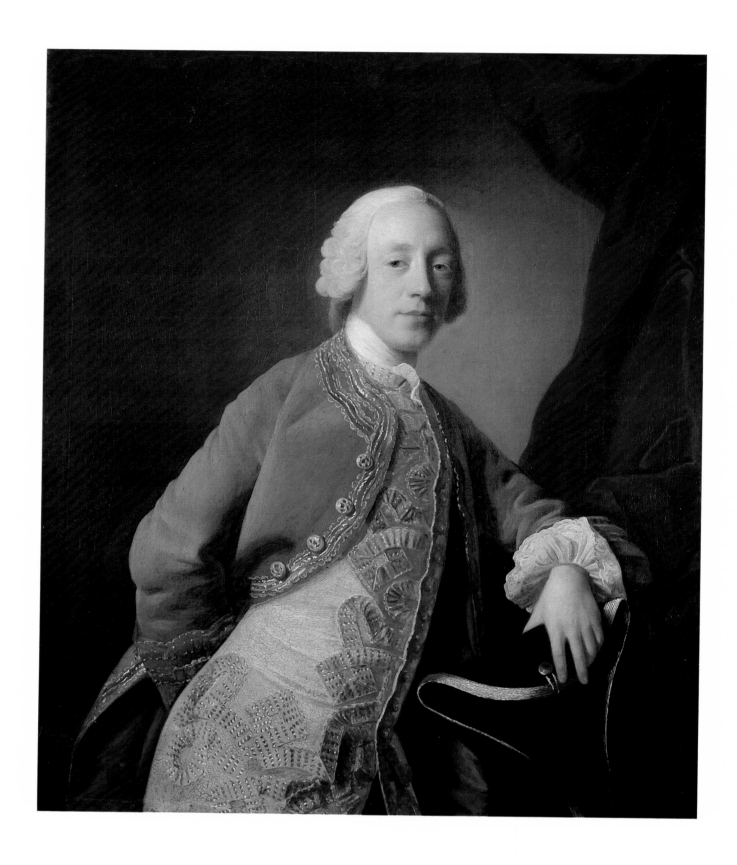

PLATE 22

THOMAS LAMB OF RYE

NO.47

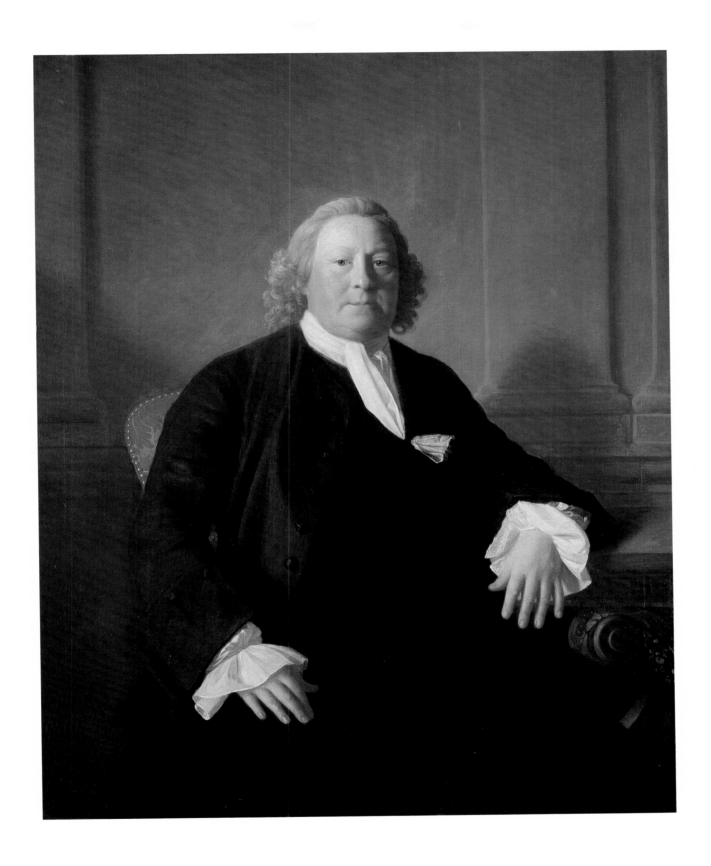

PLATE 23

HEW DALRYMPLE, LORD DRUMMORE

NO. 44

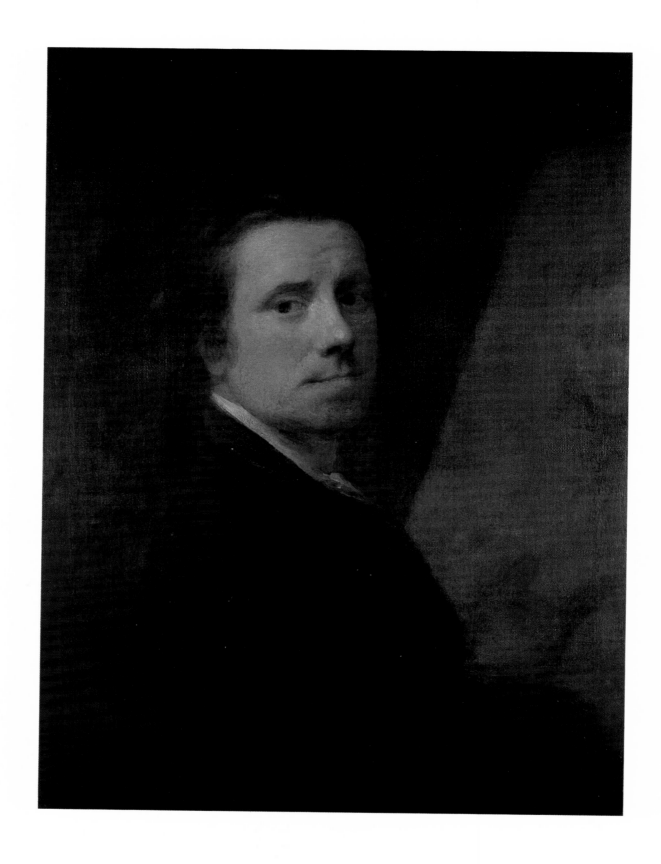

PLATE 24

SELF-PORTRAIT AT THE EASEL

NO.50

PLATE 25
SIR JOHN SINCLAIR
NO.48

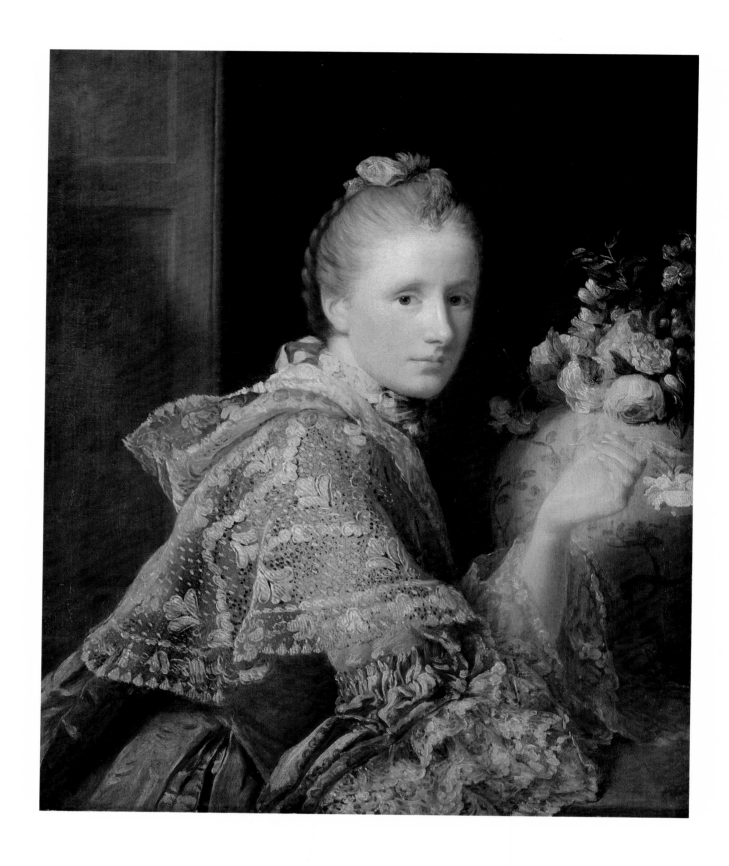

PLATE 26

MARGARET RAMSAY, THE PAINTER'S SECOND WIFE

NO.66

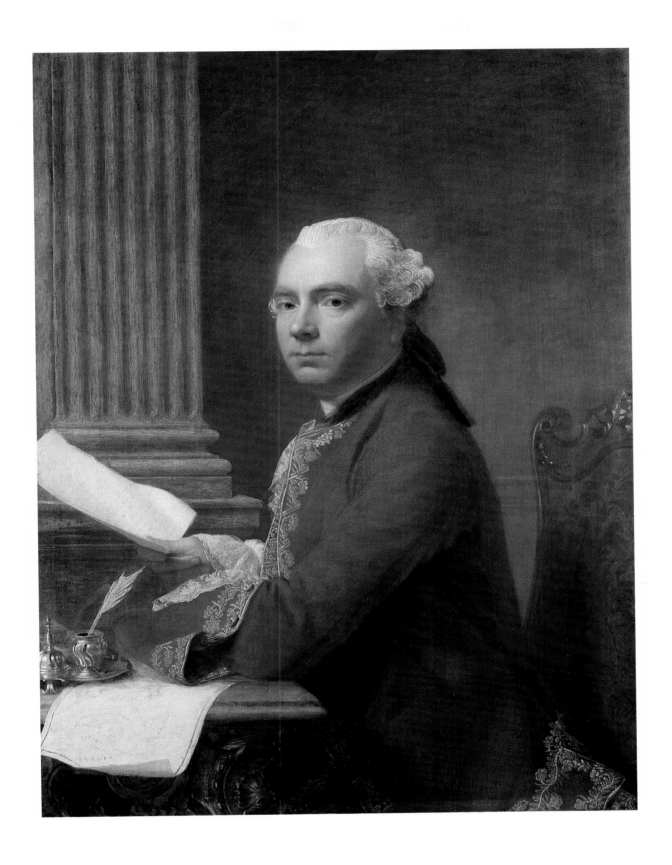

PLATE 27
ROBERT WOOD
NO.49

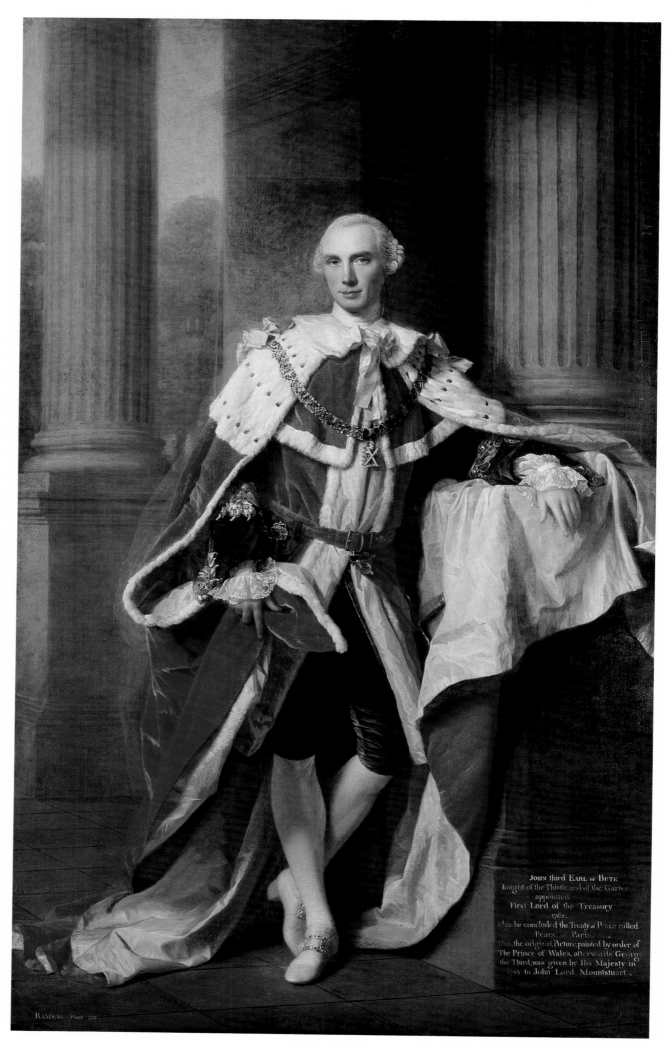

PLATE 28
JOHN STUART,
3RD EARL OF
BUTE

NO.60

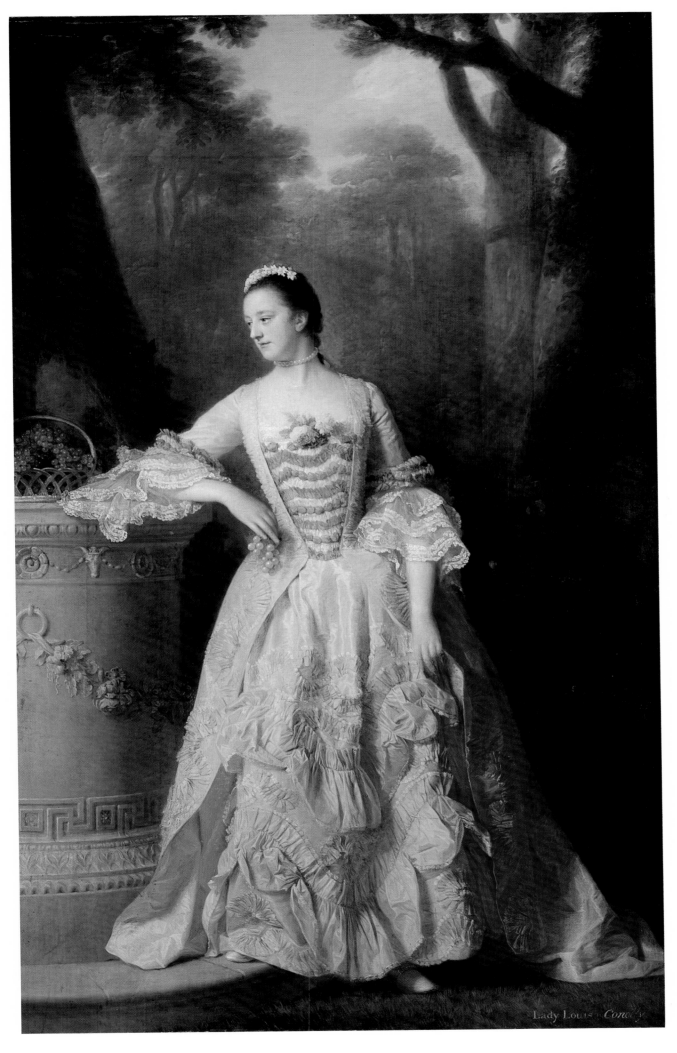

Lady Louisa Conolly

PLATE 29
LADY LOUISA
CONOLLY
NO.65

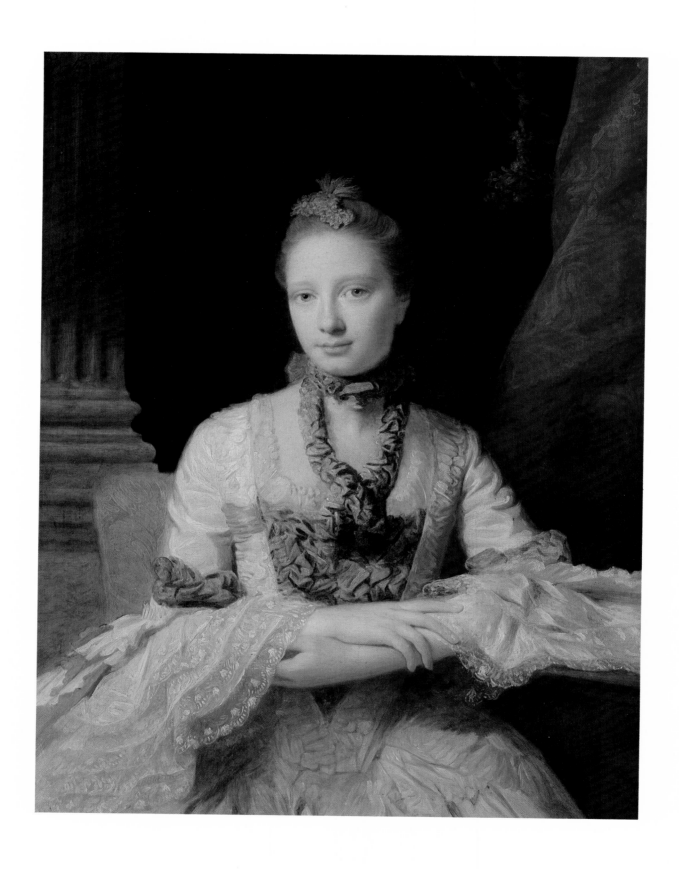

PLATE 30
LADY SUSAN FOX-STRANGWAYS
NO.71

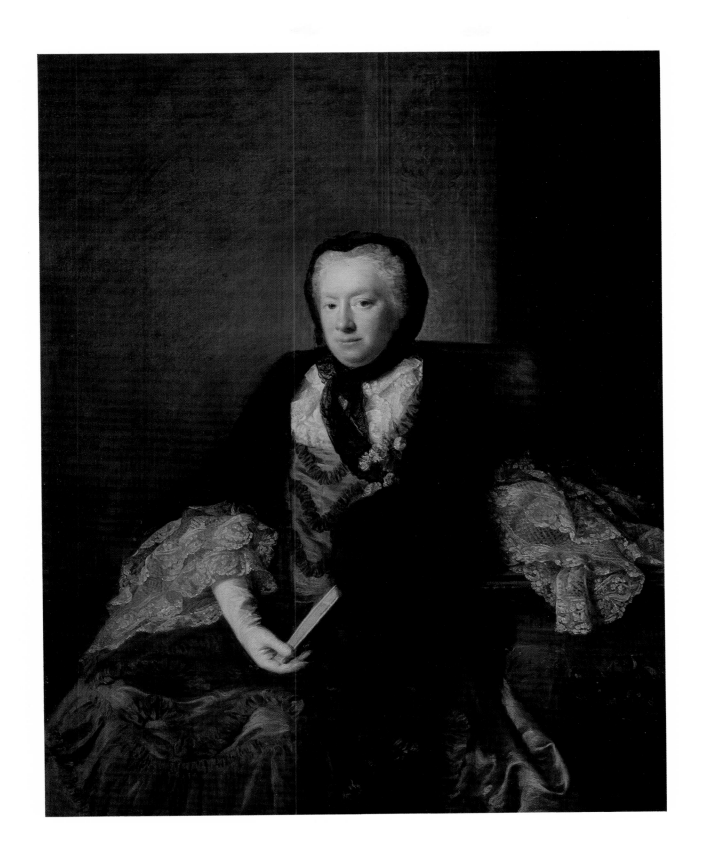

PLATE 31
MARY MARTIN
NO.69

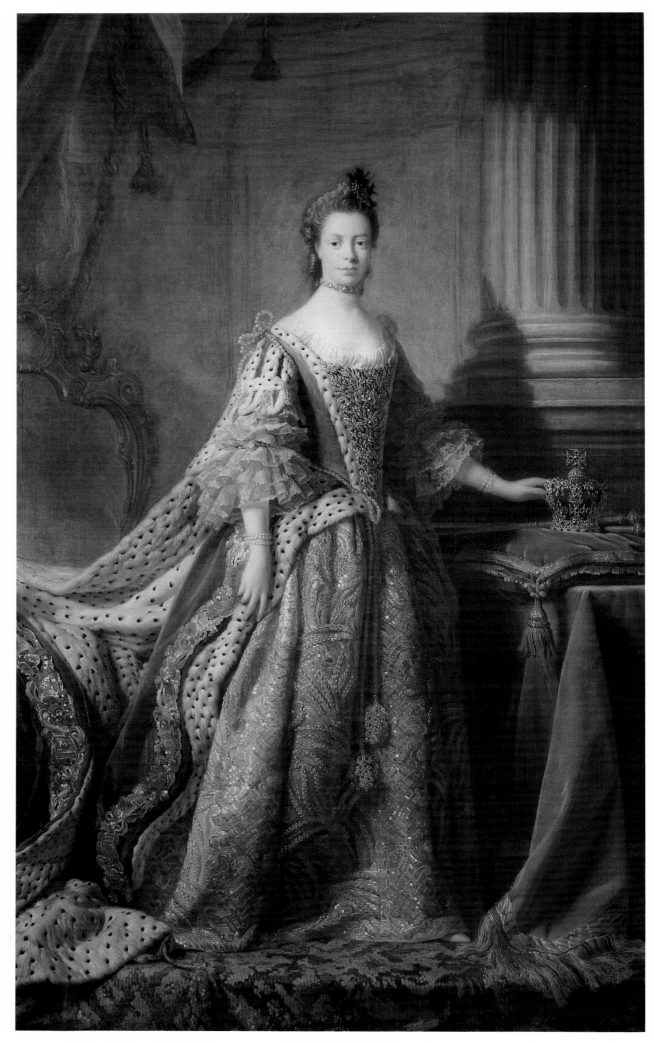

PLATE 32
QUEEN
CHARLOTTE
IN CORONATION
ROBES
NO.75

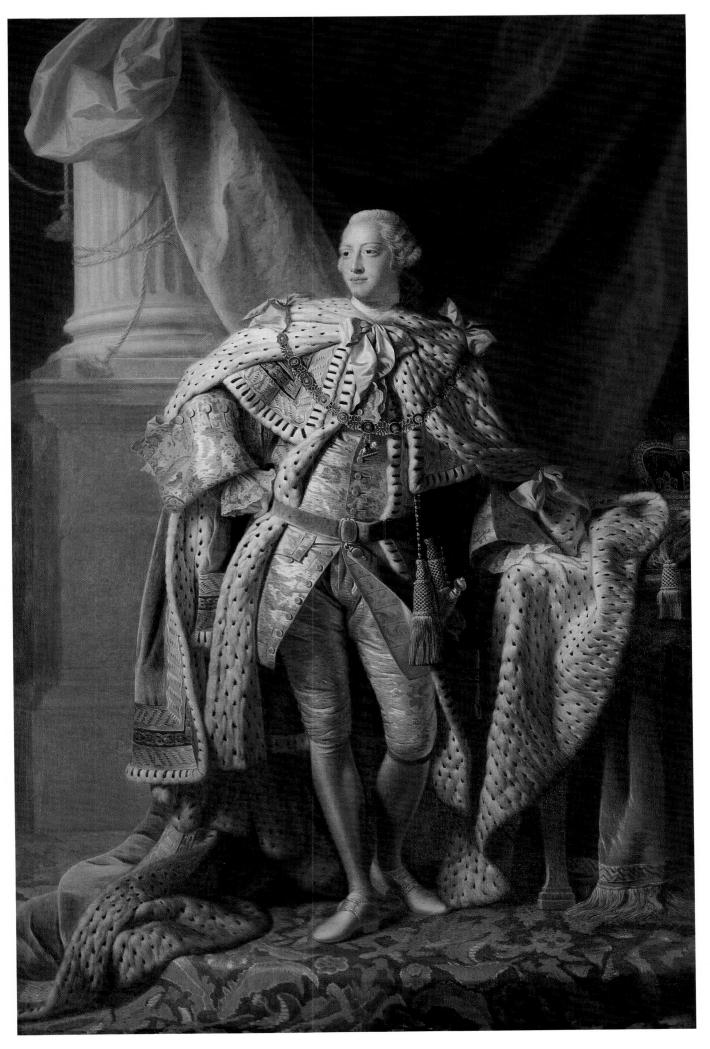

PLATE 33
KING
GEORGE III
IN CORONATION
ROBES
NO.74

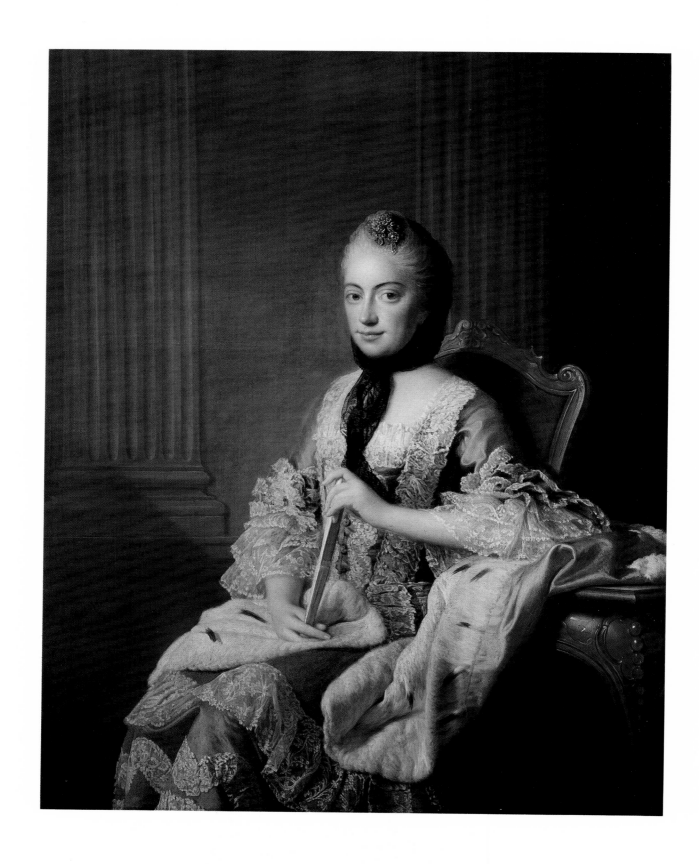

PLATE 34
PRINCESS ELISABETH ALBERTINA
NO. 99

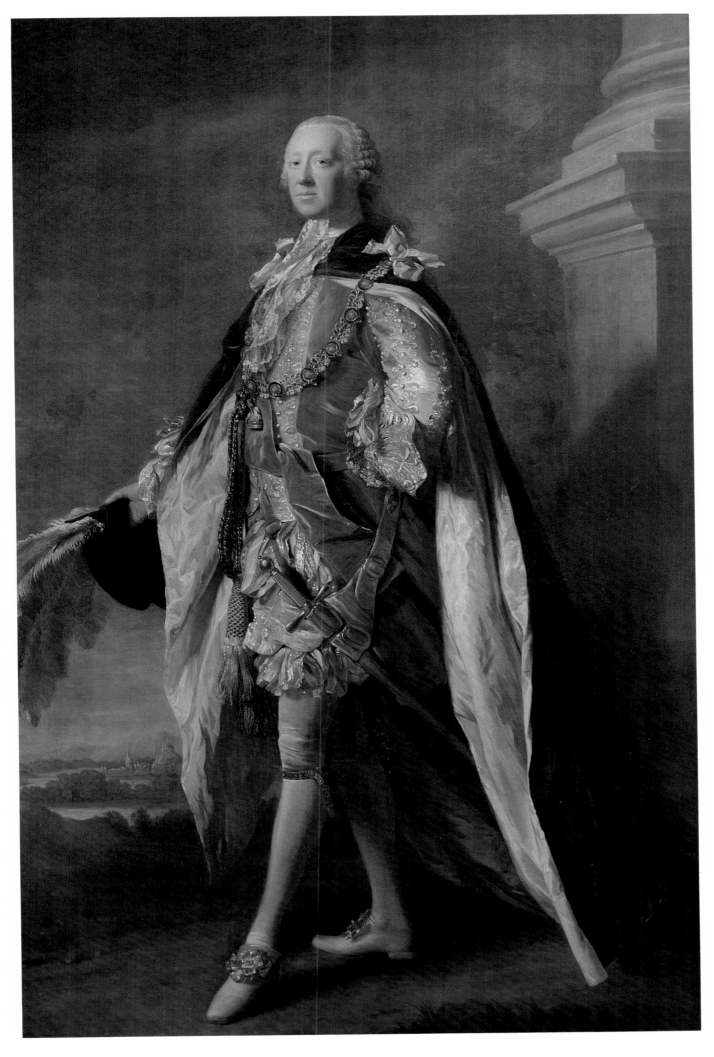

PLATE 35
RICHARD
GRENVILLE,
2ND EARL
TEMPLE

NO.77

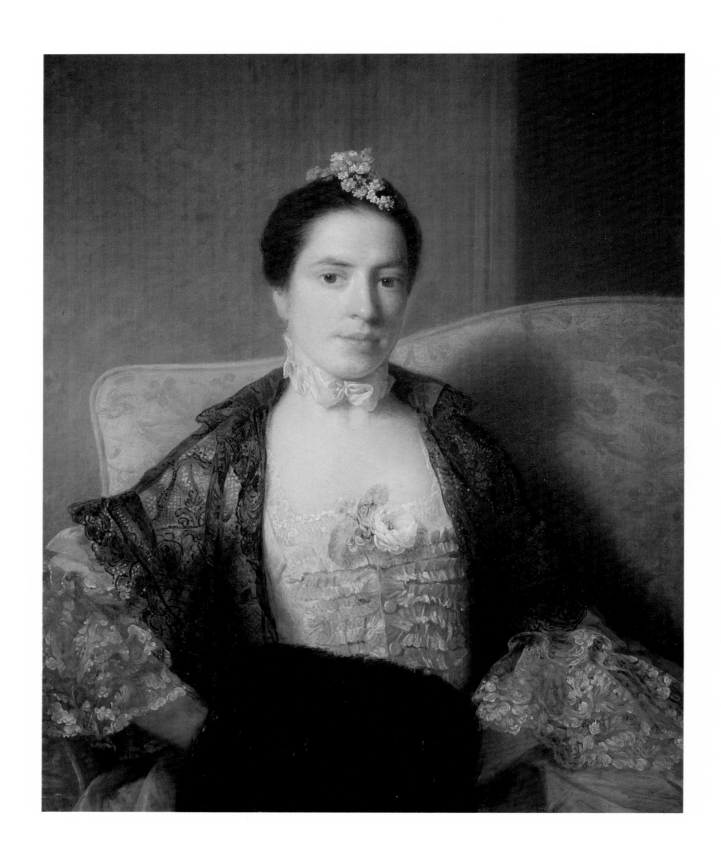

PLATE 36
MARTHA, COUNTESS OF ELGIN
NO. 78

PLATE 37

A YOUNG LADY IN A PINK DRESS

NO.106

PLATE 38
QUEEN CHARLOTTE WITH A FAN
NO. 81

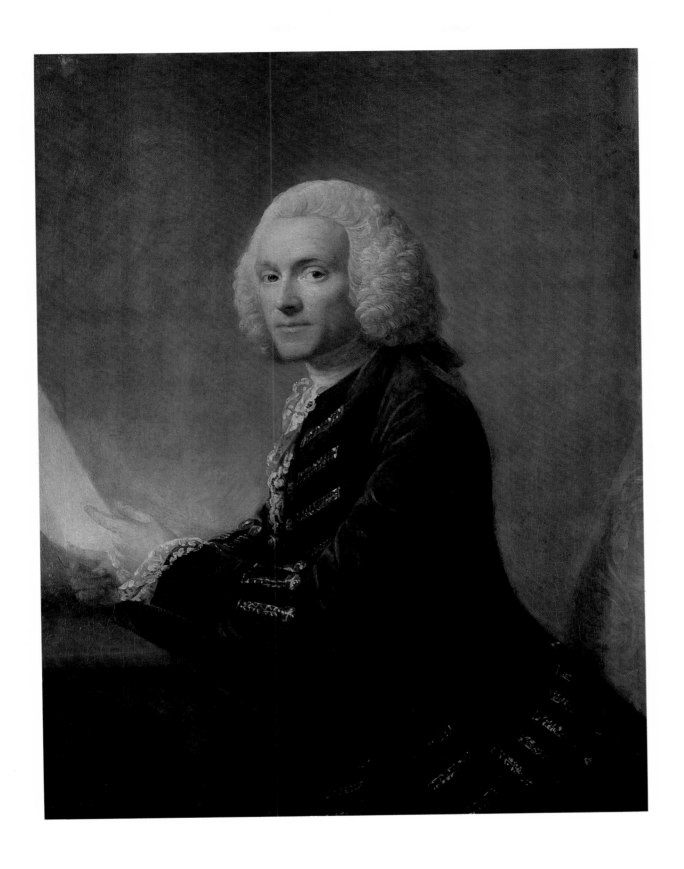

PLATE 39
WILLIAM HUNTER
NO. 85

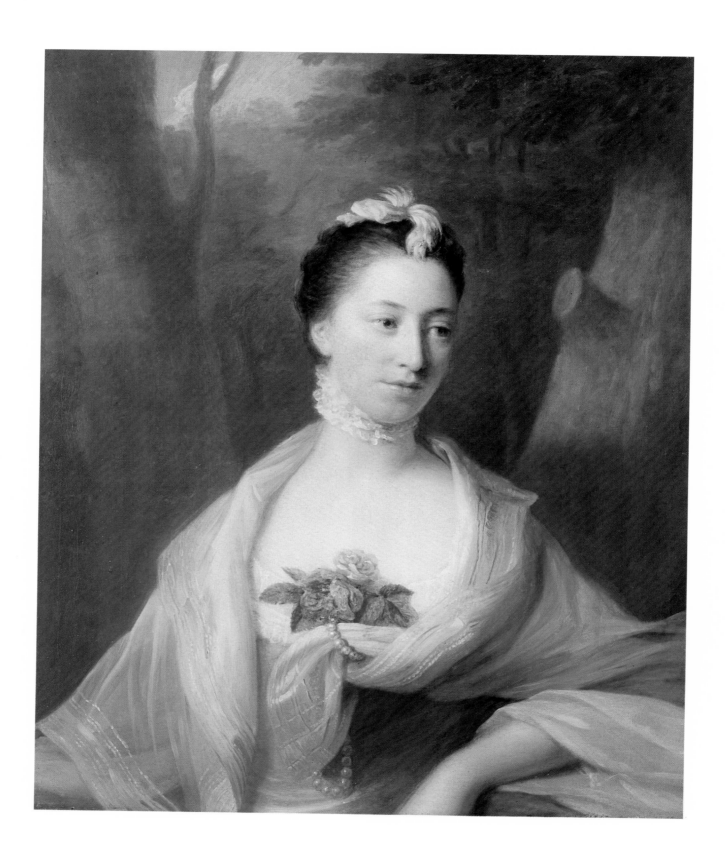

PLATE 40
ANN HOWARD
NO. 89

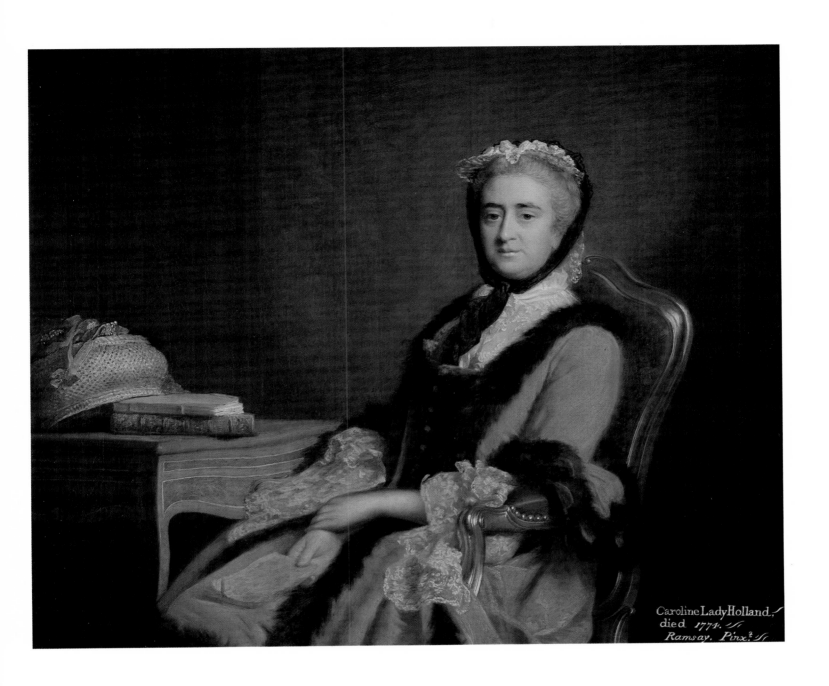

Caroline Lady Holland,
died 1774.
Ramsay. Pinxt.

PLATE 41
LADY CAROLINE FOX, BARONESS HOLLAND
NO. 90

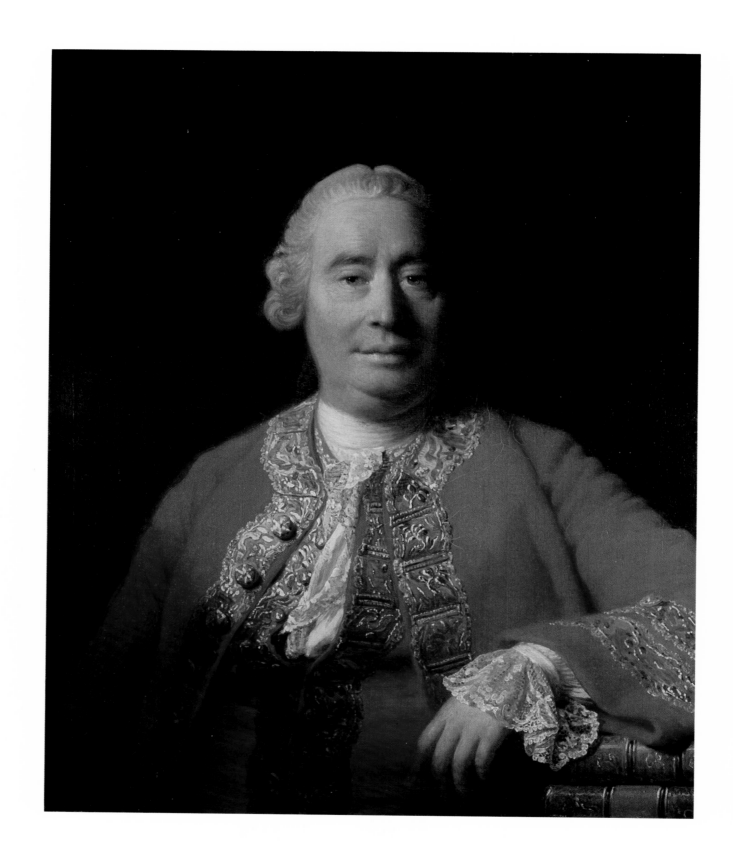

PLATE 42
DAVID HUME
NO.93

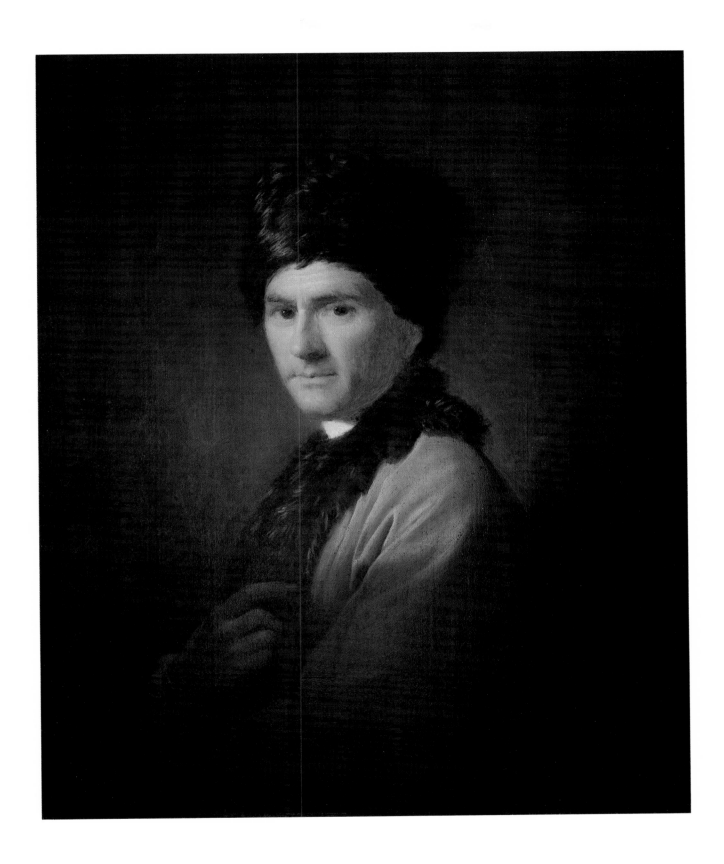

PLATE 43
JEAN-JACQUES ROUSSEAU
NO.92

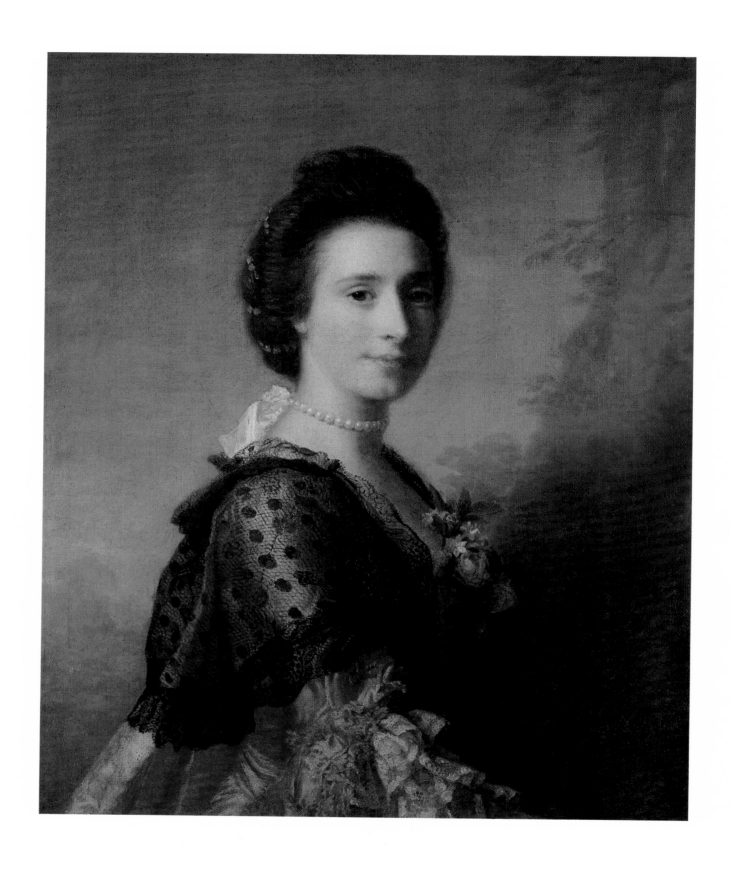

PLATE 44
THE HONOURABLE ANNE GRAY
NO. 96

PLATE 45

ANNA BRUCE OF ARNOT

NO.94

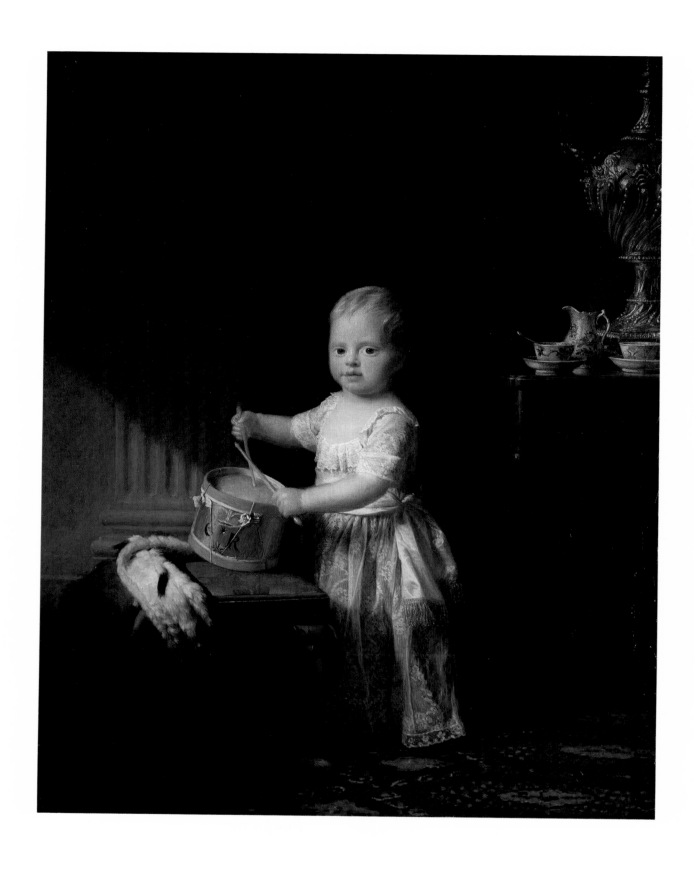

PLATE 46
PRINCE WILLIAM
NO. 95

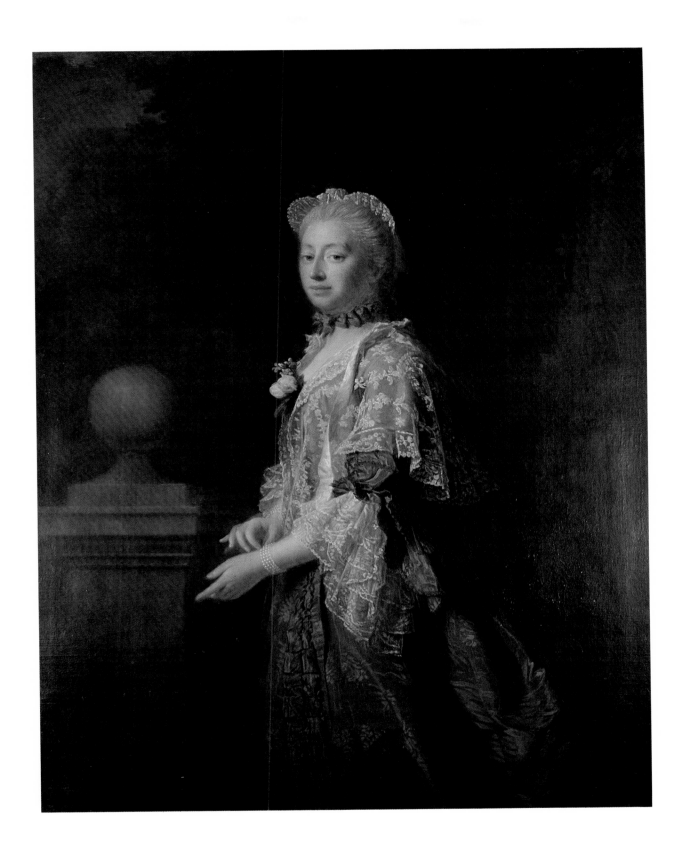

PLATE 47

AUGUSTA OF SAXE-GOTHA, PRINCESS DOWAGER OF WALES

NO.97

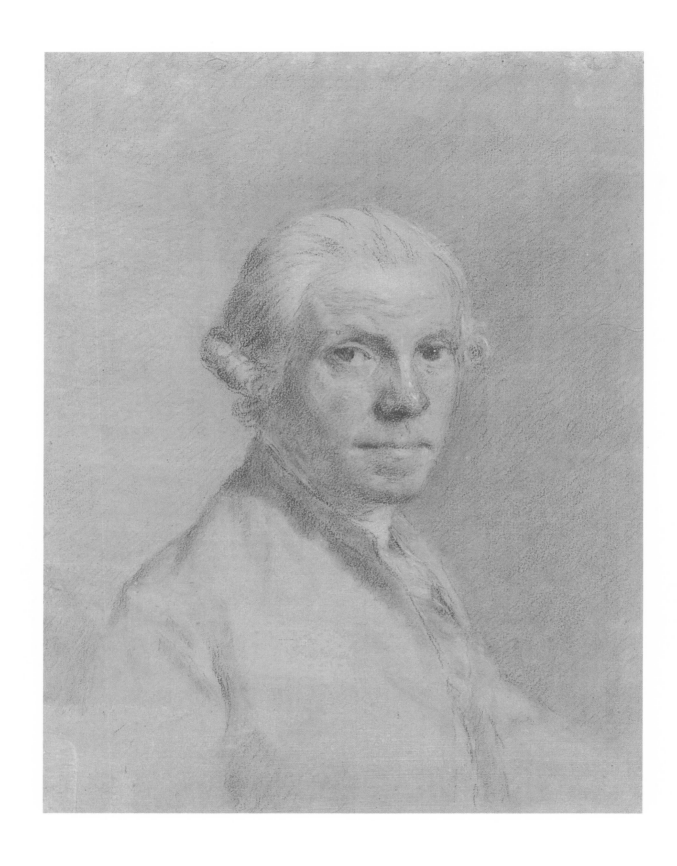

PLATE 48

SELF-PORTRAIT AT THE AGE OF SIXTY-TWO

ALLAN RAMSAY 1713–1784

Catalogue

Black chalk, heightened with white, on light blue paper, 15¼ × 11¼in (40 × 28.6cm). Head only, in profile. Inscribed on the verso, at the bottom: Allan Ramsay's Head done by his son Allan 1729. *Also on the verso, a lightly sketched drawing of a male nude at full length, seated with his right foot raised. Inscribed on the original backing to the drawing, in the sitter's hand:* To the Honourable Sʳ Gilbert Eliot of Minto one of the Senators of the Colege [*sic*] of Justice. This drawing, by Allan Ramsay Junior, of his Fathers Head is humbly Presented. Being his first atempt [*sic*] of that kind from the life, and perform'd before he was sixteen years of age. A.D. 1729.

Scottish National Portrait Gallery, Edinburgh

Shortly after its execution this remarkable drawing was engraved (in reverse) by Richard Cooper, who had been made treasurer of the Academy of St. Luke in Edinburgh (founded in October 1729). Cooper's engraving formed the frontispiece to the fourth edition of Ramsay's *Poems*. Engravings by other hands followed throughout the century, forming frontispieces to further editions of Ramsay's poems, to *The Gentle Shepherd* and to the *Tea-Table Miscellany*. By this means the painter's name would have become familiar from an early date to a large number of his father's readers, whether in Scotland or in England.

Allan Ramsay (1684–1758), poet, editor and bookseller, and father of the painter; son of John Ramsay, factor on the Hopetoun estates, by his wife Alice Bower, daughter of Allan Bower, a mining engineer from Derbyshire; born at Leadhills; married, in 1712, Christian Ross, daughter of Robert Ross, of Edinburgh; began as a wigmaker in Edinburgh, but turned to bookselling after the publication in 1721 of an octavo edition of his collected poems, which established his fame; opened a playhouse in Edinburgh, which was nefariously suppressed by the Scottish Kirk; in 1724 published *The Evergreen: being ane Collection of Scots Poems, wrote by the Ingenious before 1600*, which drew attention to such major Scottish poets as Robert Henryson, William Dunbar and Gavin Douglas; became the leading figure in the revival of Scottish poetry by his *Tea-Table Miscellany* (3 vols., 1724–7), to which Lady Grizel Baillie and William Hamilton of Bangour (see under no.7) were among the contributors; best known for his satires in imitation of Horace, and his pastoral poem *The Gentle Shepherd*, with its charming lyrics, which he unwisely remodelled as a dramatic comedy (although with vast success) in emulation of Gay's *Beggar's Opera*; retired in 1734 to the octagonal house on the

NOS. 13, 24, 38, 58, 59 AND 74 ARE EXHIBITED IN EDINBURGH ONLY.

Castlehill in Edinburgh, known as the 'Guse-pye', which his son had built with the assistance of Sir John Clerk of Penicuik during the winter of 1733–4 and had dedicated to the Sister Arts. It was there that the painter had his Edinburgh studio. The poet was held in great esteem by his Scottish contemporaries and by such fellow poets in England as Alexander Pope and John Gay; he was particularly proud of Hogarth's dedication to him of his *Hudibras* engravings. His open character, geniality and good humour endeared him to his many friends, and he was on particularly intimate terms with Sir John Clerk of Penicuik and Sir Alexander Dick of Preston-field, at whose country residences he was a frequent guest, often for long periods. He presents a contrast to his son by his deficient education, general lack of sophistication and sometimes coarse wit, and not least by his poetic genius; but father and son shared a reputation for sociability and conversational amenity. The poet, the father of numerous offspring, delight-ed in entertaining his friends' children, and in 1825 (when she was nearing her hundredth year) Mrs Murray of Henderland told Dr. Robert Chambers about 'the charming manner with which he entered into their amusements and gained their hearts', speaking of him as 'the most amiable man she had ever known'.

In his youth the elder Ramsay had considered becoming a painter – an aspiration relevant to his enthusiastic encouragement of his son. Some of the manuscripts of his poems are decorated in the margin with *caricatura* heads. One of the poet's diversions in later life consisted in the moulding of casts after ancient gems and cameos, some of which were lent to him by Lord Ilay, afterwards 3rd Duke of Argyll (no.29), an occasional visitor to his house. He also manufac-tured children's dolls, and a doll represented in a portrait by William Millar at Prestonfield House of Janet Dick (daughter of Sir Alexander Dick) is traditionally believed to have been his handiwork. His interest in painting is reflected in his close friendships with such Edinburgh artists as the landscape painter James Norie and the portrait painters William Aikman and John Smibert, as also by his having become a founding member of the Academy of St. Luke on its establishment in 1729, shortly after he had sat for this drawing.

According to the dedicatory inscription on the contemporary backing of no.1, the drawing was executed before the younger Ramsay's sixteenth birthday, which fell on 2 October 1729, Old Style (13 October, N.S.): it therefore slightly predates the founding of the Academy of St. Luke on 28 October (O.S.) of that year. It seems very possible, therefore, that, because the dedicatee, Sir Gilbert Elliot of Minto (Lord Minto), was one of the leading promoters of the Academy, the poet's presentation to him of the drawing of himself was designed to draw attention to his son's worthiness to be admitted to the new institution as an artist member.

Sir Gilbert Elliot, 2nd Bt., of Minto (1693–1766), a personal friend of the elder Ramsay, was appointed a Lord of Session, as Lord Minto, in 1726; in 1763 he became Lord Justice Clerk. He was a man of wide culture and an accomplished musician, and possessed an extensive knowledge of Italian literature. He was the father of the politician and philosopher of the same name, and of the poetess Jean Elliot, author of 'The Flowers of the Forest'.

The drawing reveals exceptional precocity, especially as Ramsay can have had little or no systematic training prior to its execution. The qualities of draughtsmanship shown in it would be remarkable in any boy of fifteen, demonstrat-ing as it does an exceptionally sure eye and a natural gift for portraiture. The clear-cut definition of the planes of the head suggests that Ramsay had already had some experience of working from antique casts – as also may be suggested by his father's statement to the effect that this was his first attempt at the drawing of a head *from the life*. Ramsay was to be devoted to drawing throughout his working life (and beyond it), and many of his preparatory chalk studies for portraits have survived, the majority being in the National Gallery of Scotland.

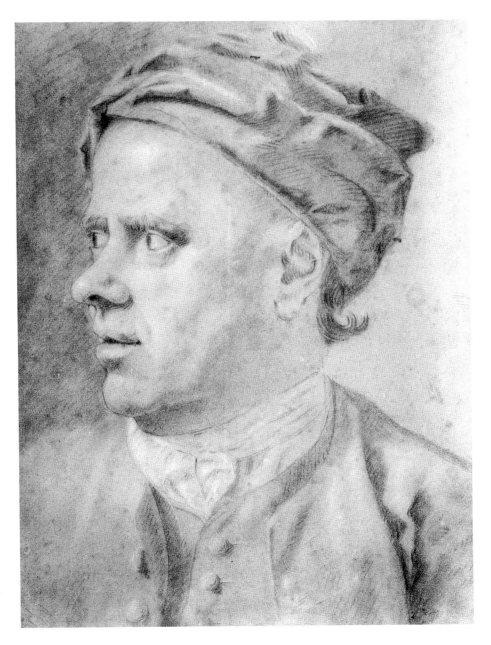

2

COPY OF A ROMAN STATUE OF
THE EMPEROR TRAJAN, FROM
THE EDINBURGH SKETCHBOOK

NGS, D. 5109. *Pen over chalk, 9½ × 6½in
(24 × 16.5cm).*

National Gallery of Scotland, Edinburgh

This sketchbook, which only recently came to
light, contains drawings made by Ramsay during
his early studies at the Academy of St. Luke,
which he entered at the age of sixteen on its
foundation in October 1729. It is opened here to
show a drawing by him of the statue of the
Emperor Trajan, which Ramsay copied from
the celebrated anthology of plates contained in
the *Admiranda Romanorum Antiquitatum ac
veteris sculpturae vestigia* of Pietro Santi Bartoli
(*c.*1635–1700) and Giovanni Pietro Bellori (1615–
1696). Ramsay also made copies from the same
source of the Dionysiac frieze on the Borghese
Vase. Among the more interesting of the other
drawings in the sketchbook are a pair of studies
after the *Figurine* etchings of Salvator Rosa.

A comprehensive account of the sketchbook
is to be found in Iain Gordon Brown, 'Young
Allan Ramsay in Edinburgh', *Burlington
Magazine*, CXXVI, December 1984, pp.778 ff.,
figs.51–4.

3 *plate 1*

SELF-PORTRAIT
AS A YOUTH

NGS, D.223. *Black chalk, heightened with white, on
buff paper, 14¼ × 10in (36.2 × 25.4cm). Head and
shoulders. c.1730–33(?).*

National Gallery of Scotland, Edinburgh

This self-portrait drawing seems more advanced
in style than the study of the artist's father of
1729 (no.1), and its greater sophistication would
appear to reflect Ramsay's training in London
under Hans Hysing from 1732 to 1733.

The artist's dark locks flow to the shoulders.
In later life Ramsay seems to have preferred to
wear his hair without the fashionable wig. In his
youth he was evidently proud of his appearance
and his attractiveness to the opposite sex – at
least to judge from a long poem by him describ-
ing an outing on the ornamental canal at
Redbraes (outside Edinburgh) on 12 October
1734, when he had fallen into the water, to the
amusement of a mixed party. In these rather
unpolished verses Ramsay refers to himself as
'Bold Allan …, all dressed in frock of Blew and
wastcoat of the Linning Green,' and records his
desire that afternoon 'to take & bear away' the
hearts of the girls in the party, 'who eer they
were' (National Library of Scotland, MS. 1036:
'The sailing at the Red-Braes on Oct^r 12^th 1734, a
new Ballad' [by Allan Ramsay the Younger;
transcribed in the hand of Allan Ramsay the
Elder]).

4

ALEXANDER HOME
OF JARDINEFIELD

*Paper laid on canvas, 17½ × 12⅛in (44.2 ×
30.8cm). Head and shoulders. A typewritten label
on the stretcher reads:* married Isobel, second
daughter of Sir George Home of Wedderburn
(died 1720), who was out in the 1715 rebellion.
This picture was painted in 1732 by Allan
Ramsay.

**Paxton Trust, Paxton House,
Berwick upon Tweed**

Alexander Home of Jardinefield (or Jardinfield);
married Isabella Home, second daughter of
George Home of Wedderburn (died 1720) by his
wife Margaret Home (eldest daughter of Sir
Patrick Home, Bt., of Lumsdean). Their eldest
son, Ninian Home of Paxton, became Governor
of Grenada, where he was murdered; their
younger son, George Home of Wedderburn and
Paxton, became Principal Clerk of Session in
Edinburgh.

2

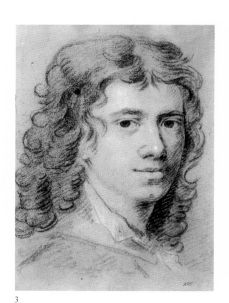

3

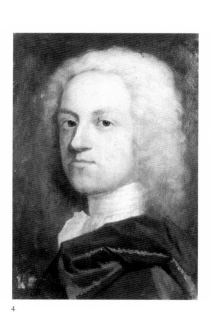

4

5

CATHERINE HOPE-VERE

Canvas, feigned oval, 30 × 25in (76.2 × 63.5cm).
Bust length: in a mid-yellow dress with a pink bow
at her breast, and a pink wrap; wearing a pink cap
with a white fringe. Inscribed, bottom left:
Katherine / only child of Sir William Vere /
married Hon^ble. Charles Hope of Craigiehall /
2^nd. son of Charles 2^nd. Earl of Hopetoun. *There*
are traces of a tear in the canvas to the right. c. 1733.
Probably a marriage portrait.

Ian Henderson, Esq.

This is one of three portraits of the sitter
recorded by Sir William Musgrave in 1796 as
hanging at Craigiehall and at Blackwood. It was
probably painted on the occasion of the sitter's
marriage in 1733 to the Hon. Charles Hope
(1710–1791), second son of Charles, 1st Earl of
Hopetoun by his wife Henrietta Johnstone
(1682–1750), daughter of William, 1st Marquess
of Annandale.

The recent identification of this picture and
other portraits as very early works by Ramsay
makes it clear that the Hopes of Hopetoun were
among Ramsay's first patrons – a fact of
considerable interest in that his great-grand-
father and grandfather served successively as
factors on the Hopetoun estates.

6

MARGARET STEUART, AFTERWARDS MRS CALDERWOOD OF POLTON

Canvas, 50 × 40in (127 × 111.6cm). Three-quarter-
length: in a dress of tawny colouring and a blue
wrap, seated in a landscape, with a dog looking up
at her to the right: to the left, trees and a sunset sky;
to the right, a rocky bield. Inscribed, bottom left:
Marg^t Stewart of Coltness / M Tho^s
Calderwood of Polton/1735.

The National Trust for Scotland,
The Georgian House, Edinburgh
(on loan from Mrs A. Dundas-Bekker)

Margaret Steuart (died 1774), daughter of Sir
James Steuart, Bt., of Goodtrees, Solicitor-
General for Scotland and Member of
Parliament for Edinburgh, by his wife Anne
Dalrymple, daughter of Sir Hew Dalrymple,
Lord President of the Court of Session; married,
in March 1735, Thomas Calderwood of Polton.
The sitter is celebrated as the author of journals
of her travels in later life: *Letters and Journals of*
Mrs Calderwood of Polton … (ed. Alexander
Fergusson), Edinburgh, 1884.

Margaret Steuart sat to Ramsay shortly
before her marriage in March 1735, as is known
from a letter written by the painter's father, the
poet, to the Lord Provost of Edinburgh, Patrick
Lindsay (no.16), on 5 April of that year, in which
he says:

> Miss Peggy Stuart Sir James's Sister was
> married the other day to Mr Calderwood of
> Polton, my son had made ane excelent [*sic*]
> half length picture of Her, & I begin to think
> it not a bad politick for young Beautys to be
> seen and known in my Son's painting Room
> where so many of the Beau-Monde so
> frequently resort.
> (National Library of Scotland, Eaglescairnie
> MS. 23.3.26, fos. 19–20v.)

The sittings would have taken place in the new
house, of octagonal design – known affection-
ately as the 'Guse-pye' – which in the previous
year the painter had built for his father on the
Castlehill in Edinburgh with the assistance of
Sir John Clerk of Penicuik, and which, although
now much altered, forms part of the present
Ramsay Garden.

This lovely picture, painted in the artist's
twenty-second year, can be regarded as the most
important of the known portraits by Ramsay
from the period of his early practice in Edin-
burgh, prior to his studies in Italy and subse-
quent decision to base himself principally in
London. In general, its style reflects his training
in London under the Swedish portraitist Hans

Hysing; but the intimacy of the treatment and
the sensitivity that is shown to the sitter's
personality come closer to the Scottish tradition
exemplified most notably by John Smibert and
especially William Aikman, both of them close
friends of the poet Ramsay. Indeed, one of the
most charming features of the picture lies in its
intimation of Margaret Steuart's active
response, as though, so far from regarding the
sittings as a tedious duty (as many did), she was
fascinated by the conversation of her refined and
erudite young painter. Already in this early work
Ramsay can be seen as a pioneer of the 'natural'
style which was to transform the art of portrait-
ure in England, and of which, along with
Hogarth and Highmore, he became one of the
leading exponents. It is also clear from the
Margaret Calderwood that by the middle 1730s
Ramsay found himself without a peer among
portrait painters working in Scotland.

The recent identification of this picture with
the portrait of Margaret Steuart mentioned in
the poet Ramsay's letter to Patrick Lindsay has
not only given for the first time a clear idea of
the painter's style in his early 'Edinburgh'
period, but has opened the door to other
attributions to Ramsay within the period 1731–6.

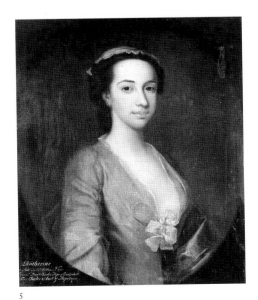

5

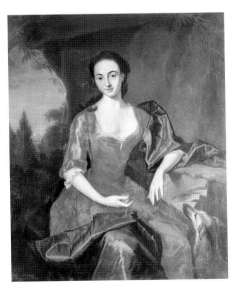

6

7

KATHERINE HALL OF DUNGLASS

Canvas, feigned oval, 30 × 25in (76.2 × 63.5cm). Bust-length: in a blue dress adorned with pearls at the breast, wearing a light pink drape over her right shoulder; her hair worn loose. Painted in Edinburgh in 1736.

Private Collection

Katherine Hall, younger daughter of Sir James Hall, 2nd Bt., of Dunglass (died 1742), by his second wife Margaret Pringle; married in 1743, as his first wife, the poet William Hamilton of Bangour. Hamilton was one of the contributors to the poet Ramsay's *Tea-Table Miscellany*, and was the first to translate Homer into English blank verse. He is probably best known as the author of 'The Braes of Yarrow'. During the 1745 Jacobite Rising he joined the forces of Prince Charles Edward, after the Battle of Culloden escaping to France, where he was to die.

A receipt for payment which has come down in the Hall of Dunglass family bears the signature of the artist's father and the date 31 May 1736:

Edr May 31 1736
Recieved [*sic*] from Ja: Lesley in name of Mr James / Home Writer to Signt three Guineas for Miss Katy / Halls picture by my son Allan Ramsay.

This charming picture was painted in Edinburgh shortly before Ramsay's departure for London, on the first leg of his journey to Rome in the summer of 1736 to study under Francesco Imperiali and to attend the French Academy. The sittings would have taken place in the house on the Castlehill, known as the 'Guse-pye', which some two years earlier Ramsay had built for his father, with the assistance of Sir John Clerk of Penicuik.

8

JEAN RAMSAY, AFTERWARDS MRS CHARLES HAMILTON OF SPITALHAUGH

Canvas, feigned oval, 30⅜ × 25½in (77.1 × 64.1cm). Bust-length: in a yellow dress with a blue stole. Inscribed on the stretcher, in ink: Mrs Hamilton (Jean Ramsay) wife of Charles Hamilton Esq of Spitalhaugh (1738) / painted by Allan Ramsay. *An old label on the stretcher reads:* Painted by / Allan Ramsay / 1713–1784 / Mrs Hamilton was granddaughter of / Sir William Fergusson. *Probably painted c.1734–6.*

The Hon. Rosamund Monckton

Jean Ramsay (baptized 28 February 1714), daughter of Andrew Ramsay of Abbotshall; married on 15 August 1738, in Edinburgh, Charles Hamilton of Isle of Nevis and Spitalhaugh of the family of Hamilton, earls of Arran. Her husband practised as a doctor.

This sympathetic portrait, which is remarkable alike for the vivacity of the characterization and for the freshness of its colour, must be assigned to the period between Ramsay's studies in London under Hysing in 1732–3 and his first visit to Italy in 1736, and would presumably have been painted in Edinburgh. Previously unrecorded in the literature, it adds considerably to our knowledge of Ramsay's style during his very early years in Edinburgh, when, as his father put it, he had been painting 'like a Raphael', and when 'young beauties' were prominent among his sitters.

9 *plate 3*

ALLAN RAMSAY THE YOUNGER: SELF-PORTRAIT

Canvas, oval, 24 × 18¼in (61 × 46.4cm). Bust-length: in a brown cloak with gold turnover. Perhaps painted in Italy in 1737. Recent X-ray photography has disclosed traces of a man's head (inverted), evidently part of an abandoned half-length, the canvas being subsequently reduced in size.

National Portrait Gallery, London

In respect of the Baroque sweep of the draperies, this early self-portrait, showing the artist in his middle twenties, resembles the half-length of *Samuel Torriano* (no.10), painted in Rome in 1738, but differs from it in technique and in its depth of chiaroscuro. This is suggestive of the influence of Francesco Solimena, Ramsay's teacher in Naples in the summer of 1737, whereas the *Torriano* has more in common with the work of Pompeo Batoni, whose drawings Ramsay copied in Rome (see no.12). The self-portrait has usually been assigned to the period immediately following Ramsay's return from Italy in 1738, and a case can certainly be made for a dating around 1739 or 1740. On the other hand the picture is just the sort of work that might be expected from his early studies in Rome and Naples – a confident, even assertive, self-portrait of an aspiring young artist, conceived conscientiously in terms of the Late Baroque manner of which Solimena was the supreme exponent, and

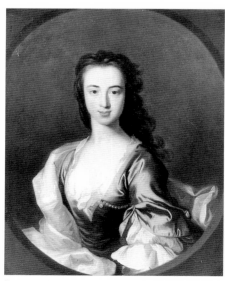

7

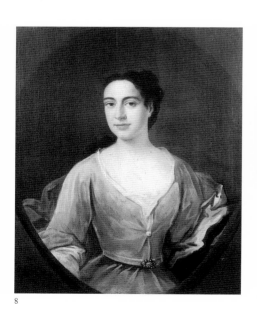

8

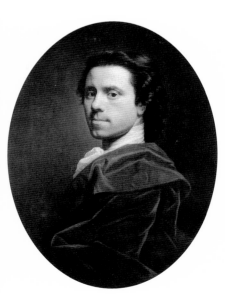

9

expressive, no doubt, of his pride in his Italian training.

A small copy (canvas, 15 × 12½in (38.1 × 31.8cm)) was painted by Ramsay's pupil Alexander Nasmyth (Scottish National Portrait Gallery, Edinburgh (PG189)). This was acquired, apparently in 1781, by the 11th Earl of Buchan for his eccentric 'Caledonian Temple of Fame' at his seat of Dryburgh Abbey – a gallery of portraits of eminent Scotsmen (on which see Iain Gordon Brown, '"The Resemblance of a Great Genius": Commemorative Portraits of Robert Adam', *Burlington Magazine*, CXX, July 1978, pp.444 ff.). The portraits were intended by Buchan to honour 'the men who have done most credit to Scotland by their reputation'. He expressed his patriotic hope regarding the inspiration to others that his gallery of portraits would offer in the following terms: 'May my countrymen strive to enter in at the strait gate of this venerable apartment. Marcus Aurelius and Seneca [evidently represented by busts or statues] are on the outside of this building. None can enter that are not truly Scots' ('An Account of Dryburgh Abbey: a letter from Albanicus [Lord Buchan] to his friend Hortus [Lord Gardenstone]', *The Bee, or Literary Weekly Intelligencer*, IV, 1791, pp.164 f.).

Canvas, 30 × 25in (76.2 × 63.5cm). Half-length: in a crimson gown and a flamboyant cap, pointing to a shelf of books with his right hand. Signed and dated, bottom right: A. Ramsay / Romae 1738. *The back of the relining canvas bears the transcribed inscription:* Sam. Torrianum, Romae Pinxit A. Ramsay / Amicus Amicum / Hic cum amicis poni optavit /1738.

The Earl of Haddington

Dr. Samuel Torriano (died 1785), a member of a distinguished Anglo-Italian family, which, according to John Ward (*The Lives of the Professors of Gresham College*, London, 1740, p.117), 'is said to have come from Flanders, but by tradition to have sprung originally from the royal blood of France'; became a friend of Ramsay in Rome and Naples during the painter's early studies in Italy (1736–8); accompanied Ramsay as far as Lyons on the latter's return journey from Italy in the spring and early summer of 1738. In 1760 he was appointed secretary to the Archbishop of York.

This is the only portrait definitely known to have been painted by Ramsay during his first visit to Italy. It demonstrates Ramsay's thorough assimilation, under the tutelage of Francesco Imperiali, his master in Rome, of the polished language of Late Baroque; and we can discern a similar debt, especially in relation to the luminous colouring, to Imperiali's former pupil Pompeo Batoni, with whom Ramsay established a lasting friendship in Rome, and whose drawings he copied (see no.57) and collected. Indeed, his own study of Torriano's pointing right hand (no.11) is executed entirely in Batoni's meticulous manner.

Although on his return to London Ramsay adopted a more 'English' manner, he remained

profoundly indebted to his Italian training, which gave his portraiture an elegance and an air of sophistication which few of his English rivals could match.

II

STUDY FOR THE PORTRAIT OF SAMUEL TORRIANO

NGS, D.2143. *Red chalk, heightened with white, on yellow paper, 4 × 5½in (10.2 × 14cm). Study of the hand for no.10 (painted in Rome in 1738).*

National Gallery of Scotland, Edinburgh

The style closely imitates the meticulous manner of the Lucchese painter Pompeo Batoni, who, like Ramsay, was a pupil in Rome of Francesco Imperiali. During the period of his early studies in Italy Ramsay seems to have had the entry to Batoni's studio in Rome, and there can certainly be no doubt about Batoni's influence upon his style at this stage in his artistic development. See also no.12 (a copy by Ramsay of one of Batoni's drawings).

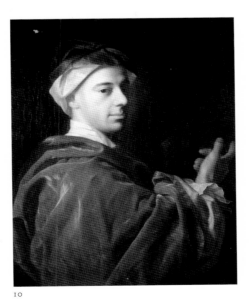

10

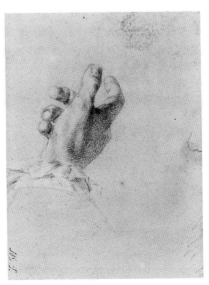

11

COPY OF TWO STUDIES BY BATONI OF A MAN'S HANDS

NGS, D.2144. *Red chalk, heightened with white, on yellow paper, 8½ × 6in (21.6 × 15.2cm). Inscribed on the verso, in Ramsay's hand:* After a drawing by Pompeio Batoni.

National Gallery of Scotland, Edinburgh

Ramsay's admiration of the art of Pompeo Batoni, whom he came to know during his first visit to Italy (1736–8), and whose acquaintance he renewed on his second visit of 1754–7, is reflected not only in this finely executed copy but also in Ramsay's thoroughgoing adoption of Batoni's drawing-style in the study (no.11) he made for the portrait of *Samuel Torriano* (no.10). It is also noteworthy that Ramsay almost certainly owned several of the drawings by Batoni now in the National Gallery of Scotland (NGS, D. 1940, D. 2145, D. 2146 and D. 2148: see Keith Andrews, *National Gallery of Scotland: Catalogue of Italian Drawings*, Cambridge, 1968, vol. I, pp. 14f.; vol. II, figs.125–8).

STUDY AFTER A PAINTING OF 'THE VISITATION' BY SOLIMENA

NGS, D.2014. *Black chalk, heightened with white, on green-tinted paper, 16½ × 10⅜in (41.9 × 27cm). Inscribed on the verso, in Ramsay's hand:* From a Picture of Solimena in his own house 1737. *Copy of the figure of the Virgin Mary in a painting by the Neapolitan master Francesco Solimena, under whom Ramsay studied in Naples in the summer of 1737. (On the verso, faint sketches of heads of* putti, *a full-length figure and other studies.)*

National Gallery of Scotland, Edinburgh

Solimena's *Visitation* was engraved by P.A. Kilian for *Picturae Chalcographicae Historiarum Veteris Testamenti* (1758), and also by Walker for Southwell's *Family Bible*. The identification of Ramsay's drawing as a study after this picture was made by Sir Michael Levey in his review of Ferdinando Bologna's *Francesco Solimena* (1958) in the *Gazette des Beaux-Arts*, V, Supplement, April 1959, p.53.

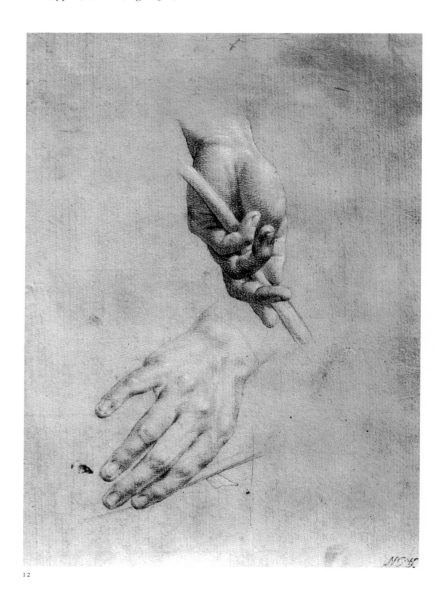

12

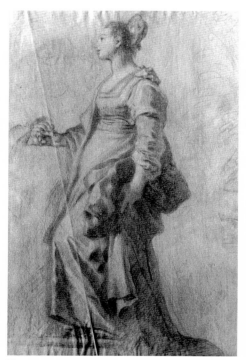

13

AGNES MURRAY-KYNYNMOND DALRYMPLE AS A CHILD

Canvas, 56 × 40in (142.2 × 101.6cm). Full-length: in a pink satin dress and a blue cloak which flutters behind her; standing in a country park and gathering roses into her apron from a rose-bush growing in a large garden urn. Signed and dated, lower left: A. Ramsay pinxit/1739. Inscribed, bottom left: AGNES MURRAY KYNNYNMOND. Daughter of Hugh Dalrymple Murray Kynynmond, / WIFE OF THE RIGHT HON. SIR GILBERT ELIOT OF MINTO / BT., M.P.

Private Collection

Agnes Murray-Kynynmond Dalrymple (1731–1778), daughter of Hew Dalrymple-Murray-Kynynmond of Melgund (second son of the Hon. Sir David Dalrymple, 1st Bt., of Hailes) by his wife Isabella Somerville (daughter of Hugh Somerville of Inverteil, w.s.); married, in 1746, Gilbert Elliot, afterwards the Rt. Hon. Sir Gilbert Elliot of Minto, 3rd Bt. (died 1777), Privy Councillor and Treasurer of the Navy from 1771.

This enchanting picture was commissioned by the young sitter's father, who was born Hew Dalrymple but took the name Murray-Kynynmond on inheriting property in Forfar and in Fife from a half-brother, Sir Alexander Murray. He practised as an advocate in Edinburgh, being known as 'Mr Murray'. His final payment for the picture and for a bust-length portrait of himself is recorded in a receipt signed by Ramsay on 1 October 1739:

> received from Hugh Murray, Twenty pounds Nine shillings being in full the Second pay[t]. for two pictures and frames. rec[d]. the above sum by the hands of James Baird, 1 Octo[r].
> 1739
> Allan Ramsay
> £20:9:6

Mr Murrays Picture	£ 4: 4
Miss Murrays Picture	£ 9: 9
Mr Murrays frame	£ 2: 2
Miss Murrays frame	£ 4: 14: 6
	£20: 9: 6

(National Library of Scotland, Minto Charters, Bundle 145.)

As was the frequent custom, the payments (excluding the charge for the frame) were made in each case in two equal amounts, the first when the picture was begun, and the second on its completion. Thus Ramsay's charge for the portrait of 'Mr Murray' was £8 8s (excluding the cost of the frame), which agrees with the poet Ramsay's statement in August 1738, in a letter to a friend, that his son was receiving '8 Guineas a head'. Likewise, Ramsay's charge for the portrait of Agnes Murray-Kynynmond Dalrymple was

18 guineas, plus £4 14s 6d for the richly carved frame. Over the years Ramsay gradually increased his prices. Complete information is lacking, but by 1748 he was charging 10 guineas for a bust-length portrait, by 1751 12 guineas, by 1759 15 guineas, and by 1760 20 guineas. For a full-length portrait his price was 40 guineas by 1747 and 80 guineas by 1769.

The idea of portraying very young girls in the act of gathering flowers into their aprons was popular in the eighteenth century; but Ramsay's adaptation of it is quite distinctive, and the picture displays to the full the sophisticated manner which he had developed in Italy. Stylistically it belongs essentially to the tradition of Late Baroque, in the phase which saw a reaction against the vehement gesturings and powerful effects of pictorial movement typical of High Baroque painting. The action represented is suspended, as if frozen in a moment of time and held up for contemplation – a convention that finds comparable expression in many of the descriptive passages in Augustan poetry. The brilliant colouring, while clearly reflecting the influence of his master in Rome, Francesco Imperiali, and of Imperiali's former pupil Pompeo Batoni, is highly personal and inventive, and has no parallel in contemporary painting in England.

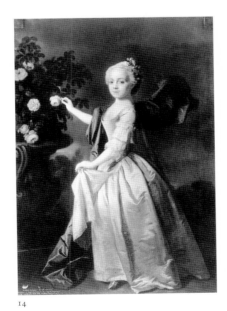
14

ANNE RAMSAY, THE PAINTER'S FIRST WIFE

Canvas, feigned oval, 27 × 21in (68.6 × 53.3cm). Bust-length. Probably painted c.1739, the year of the sitter's marriage to Ramsay.

Scottish National Portrait Gallery, Edinburgh

Anne Bayne, daughter of Alexander Bayne of Logie (1685–1737), Professor of Municipal Law at the University of Edinburgh, by his wife Mary Carstairs, a granddaughter of the architect Sir William Bruce of Kinross (c.1630–1710). Ramsay had come to an understanding with her in Edinburgh before his first visit to Italy in 1736–8, when in letters to his friend Dr. Alexander Cunyngham (afterwards Sir Alexander Dick of Presontonfield), he was already referring to her as his 'Rib' and his 'Spouse'. The Bayne family papers record a marriage contract of 1739. Anne Ramsay died in February 1743 in giving birth to a daughter, Anne, whom Ramsay later referred to as his 'much accomplished child'. Altogether she bore the painter three children, all of whom died in infancy or childhood: Allan (1740–1); Bayne (1741–8); and Anne (1743–53). The sitter's brother William Bayne, a captain in the Navy under Rodney, died from wounds received in action in 1782, and is one of three naval officers commemorated in the monument by Nollekens in Westminster Abbey. Anne Bayne was a half-cousin of Anna Bruce of Arnot (no.94).

In addition to its effectively direct characterization, without affectation (or, it would seem, flattery), this early portrait of Ramsay's first wife already announces the artist's distinction as a colourist, unsurpassed by any of his English rivals.

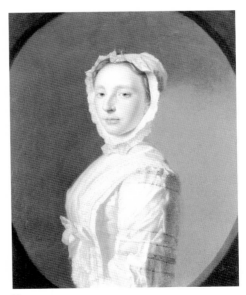
15

16

PATRICK LINDSAY

Canvas, feigned oval, 30 × 25in (76.2 × 63.5cm).
Bust-length: in a red coat. Signed and dated,
bottom right: A. Ramsay Pinx./1739.

The Duke of Atholl

Patrick Lindsay (died 1753), Lord Provost of
Edinburgh and Governor of the Isle of Man;
son of Patrick Lindsay (1652–c.1722), Rector of
the Grammar School at St Andrews, by his first
wife Janet Lindsay, daughter of John Lindsay of
Newton of Nydie; married (1) Margaret
Monteir, daughter of David Monteir, an
Edinburgh merchant, (2) Janet Murray (died
1739), daughter of James Murray of Polton, and
(3), in 1741, Lady Catherine Lindsay (died 1769),
daughter of William, 18th Earl of Crawford and
2nd Earl of Lindsay by his second wife
Henrietta, widow of the 5th Earl of Wigton and
daughter of the 2nd Earl of Dunfermline; Lord
Provost of Edinburgh from 1729 to 1731 and from
1733 to 1735; Member of Parliament for the City
of Edinburgh from 1734 to 1741; Governor of the
Isle of Man from 1744 to 1751; author of *The
Interest of Scotland Considered* (1733).

On 5 April 1735 Allan Ramsay the Elder wrote
a long letter to Patrick Lindsay with the object
of enlisting his assistance in obtaining from
King George II a grant of money to enable his
son to pursue his studies in Italy (National
Library of Scotland, Eaglescairnie MS. 23.3.26,
fos. 19–20v.). The poet particularly had in mind
Lindsay's contacts in London as Member of
Parliament for Edinburgh, not least with the
influential Earl of Ilay, afterwards 3rd Duke of
Argyll (no.29), who had himself befriended the
elder Ramsay. Nothing is known of the response
to this appeal.

As has been pointed out by Robin Hutchison
and Colin Thompson (*Allan Ramsay (1713–1784)
his masters and rivals*, exhibition catalogue,
National Galleries of Scotland, Edinburgh,
1963, p.19, no.46), the manner in which Patrick
Lindsay is portrayed, together with 'the square
modelling of his features', suggests comparisons
with such portraits by Hogarth as the *Martin
Folkes* of *c.* 1741 (Royal Society, London). The
frank realism of the portraiture also invites
comparison with Hogarth's full-length of
Thomas Coram of 1740 (Thomas Coram
Foundation for Children, London), which was
presumably under way in 1739.

17 *plate 6*

LAVINIA FENTON, AFTERWARDS DUCHESS OF BOLTON

Canvas, feigned oval, 29½ × 24½in (74.9 × 62.2cm).
Half-length: holding a mask in her left hand, and
pointing to it with her right. c.*1739.*

Private Collection

Lavinia Fenton (1708–1760), celebrated English
actress; daughter of a Lieut. Beswick, R.N., but
on her mother's marriage to a Mr Fenton she
was given her step-father's name; achieved great
fame in 1728 as the original Polly Peachum in the
production at Lincoln's Inn Fields of Gay's
Beggar's Opera; eloped in the same year with
Charles Paulet, 3rd Duke of Bolton (1685–1754),
whose mistress she remained for twenty-three
years, and who consented to marry her in 1751 on
the death of his estranged wife Lady Anne
Vaughan. Joseph Warton wrote of her: 'She was
very accomplished; was a most agreeable
companion; had much wit, and strong sense,
and a just taste in polite literature.'

The picture has been ascribed in the past both
to William Hogarth and to George Knapton.
The attribution to Hogarth was presumably
inspired by the sitter's association with his series
of *Beggar's Opera* paintings in which she is
portrayed. The attribution to Knapton may have
been suggested in part by the sitter's gesture,
which has affinities with Knapton's deployment
of hands in some of his portraits of the
'Dilettanti', and which may indeed reflect
Knapton's influence. The tradition that the
sitter in the portrait is Lavinia Fenton is of
unknown antiquity, but there is no particular
reason to question it.

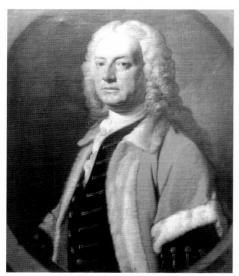

16

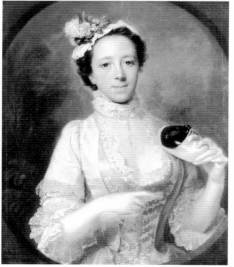

17

FRANCIS SCOTT, 2ND DUKE OF BUCCLEUCH

THE HONOURABLE JAMES KEITH (KNOWN AS MARSHAL KEITH)

Canvas, 95 × 58in (241.3 × 147.3cm). Full-length. Inscribed, bottom right: Allan Ramsay Pinxit 1739.

The Duke of Buccleuch and Queensberry, K.T.

Francis Scott, 2nd Duke of Buccleuch (1694–1751), grandson of the Duke of Monmouth (1649–1685), the illegitimate son of Charles II and pretender to the throne; a Representative Peer for Scotland from 1734 to 1741; married (1) Lady Jane Douglas and (2), in 1744, Alice Powell (died 1765).

This powerfully characterized portrait was commissioned within about a twelvemonth of Ramsay's return in 1738 from his studies in Italy, and is probably the first of a series of major full-lengths executed during his earliest years in London, among the others being portraits of the 1st Earl of Hardwicke, the Lord Chancellor (Private Collection) and the 2nd Duke of Argyll (Inveraray Castle: fig.7). The portrait of the Duke of Buccleuch differs from these in its relative informality, and while the Duke conforms to correct eighteenth-century etiquette by standing with his feet at right-angles to each other, he is far from being concerned with elegance of pose. His relaxed and unselfconscious attitude contributes to the conviction of the portraiture and, not least, to the realism of the presentation. The picture is notable, in addition, for its rich orchestration of luminous colour, reflecting Ramsay's training in Rome under Francesco Imperiali.

Canvas, 30 × 25in (76.2 × 63.5cm). Half-length: in armour and fur-lined cloak. Inscribed, top left: Marshal Keith. Painted in 1740, during the sitter's visit to London from February to May of that year.

Staatliche Schlösser und Gärten, Berlin

The Hon. James Francis Edward Keith (1696–1758), soldier and Jacobite; second son of William Keith, 9th Earl Marischal (died 1712), by his wife Lady Maria Drummond, eldest daughter of James, 4th Earl of Perth; after studying at Marischal College, Aberdeen, and at Edinburgh, joined his elder brother George (10th Earl Marischal) in the Jacobite Rising of 1715 and fought at Sheriffmuir; on the collapse of the Jacobite cause, escaped to France, continuing his studies and becoming a member of the Académie des Sciences; served in the Spanish army, before entering the Russian service in 1728; fought in the war between Russia and Turkey, with the rank of major-general; after treatment for wounds in Paris, visited London in 1740 and was granted an audience by George II; subsequently appointed Governor of the Ukraine; took part in the war against Sweden of 1741–3, when Eva Merthens, an orphan who was found among the Swedish prisoners, became his mistress (and by whom he had several children); in 1747 left Russia; entered the service of Frederick the Great, who created him a Field-Marshal of Prussia; made Governor of Berlin in 1749; played a leading part in the

Seven Years' War; mortally wounded at the battle of Hochkirchen on 14 October 1758; died unmarried; buried, by command of Frederick the Great, in the Garrison Church in Berlin.

In his *Life of Frederick the Great* Thomas Carlyle describes Keith as 'a man of Scotch type – the broad accent, with its sagacities, veracities – with its steadfastly fixed moderation and its sly twinkles of defensive humour. Not given to talk, unless there is something to be said, but well capable of it then.'

It was in 1740, the year in which this portrait was painted, that Ramsay boasted in a letter to a friend that he had now 'put to flight' his rivals Andrea Soldi, Jean-Baptiste Vanloo and Carlo Rusca, and that he now 'played the first fiddle' himself (Scottish Record Office, GD 331/5/20: Allan Ramsay to Dr. Alexander Cunyngham, 10 March 1740). It is noteworthy, as Waterhouse observes, that Ramsay mentioned only the names of three fashionable foreigners, who were now leading the field in London. Within less than two years of his setting out in London in the highly competitive profession of portrait painting, Ramsay was already confident that he had no serious rivals among his English competitors. The portrait of Keith is representative of his best work on a modest scale at this time, and demonstrates his worthiness to be considered, even by his middle twenties, as a painter of European stature.

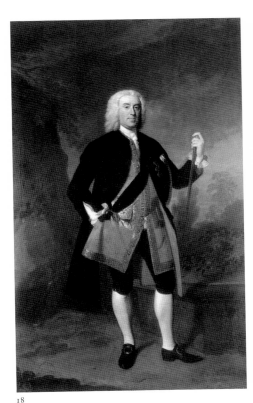

18

19

SIR EDWARD AND LADY TURNER

WILLS, VISCOUNT HILLSBOROUGH
AFTERWARDS 1ST MARQUESS OF
DOWNSHIRE

Canvas, 42½ × 42½in (108 × 108cm). Double-portrait at half length: in a landscape, Sir Edward in a brown coat, standing with his right hand on the gold knob of a cane, and fingering with his left hand a piece of lacework which his wife, seated to the right in profile, and wearing a white satin dress and white and pink bonnet, holds in her extended right hand, while resting her left arm on a stone ledge and holding a basket in her left hand; the sky crimson towards the horizon. Signed and dated, bottom right (on the side of the stone ledge): A. Ramsay 1740.

F.A.W. Page-Turner Trust in conjunction with the National Trust (Canons Ashby)

Sir Edward Turner, 2nd Bt., of Ambrosden (1719–1766); educated at Balliol College, Oxford; admitted to Lincoln's Inn in 1745; Member of Parliament for Bedwyn from 1741 to 1747, for Oxfordshire from 1754 to 1761, and for Penrhyn from 1761 to 1766; married, in September 1739, Cassandra Leigh (1723–1770), daughter of William Leigh of Adlesthrop.

It would be difficult to point to a more sensitive expression of conjugal affection in British portraiture of the eighteenth century.

This type of design, in which a standing and a seated figure, the latter in profile, are placed in conversational relationship, was taken up again by Ramsay twenty-five years later in a double-portrait of Horace Walpole's nieces (Private Collection, U.S.A.).

Canvas, feigned oval, 30 × 25 (76.2 × 63.5cm). Bust-length. Inscribed, upper left: Wills Hill. Earl / of Hillsborough. *Probably painted in 1742 (see below).*

Private Collection

Wills Hill, Viscount (and subsequently Earl of) Hillsborough, afterwards 1st Marquess of Downshire (1718–1793), politician and statesman; Member of Parliament for Warwick from 1741 to 1772; succeeded his father in May 1742 as 2nd Viscount Hillsborough in the peerage of Ireland; advanced to the British peerage in 1772 as Viscount Fairford and Earl of Hillsborough; created Marquess of Downshire in 1789; married (1), in March 1747, Margaretta Fitzgerald (died 1766), daughter of the Earl of Kildare, and (2) Mary, Baroness Stawell. A Privy Councillor, the sitter held various government offices, including that of Secretary of State for the Colonies.

A version in the collection of the Marquess of Downshire, but with the sitter differently attired, is inscribed: *Lord Hillsborough AEt. 24.* The sitter reached his twenty-fourth year on 30 May 1742, and it was in the same month that he succeeded to the viscountcy. It may reasonably be assumed that both versions of the portrait were painted in that year.

20

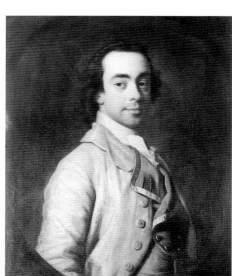

21

THE MANSEL FAMILY: THOMAS, LORD MANSEL OF MARGAM AND HIS HALF-BROTHERS AND HALF-SISTER

JEAN NISBET, AFTERWARDS LADY BANFF

Canvas, 49½ × 39½in (125.7 × 100.3cm). Group-portrait at three-quarter length: in a landscape; Lord Mansel standing, to the right, in a long velvet coat of dark blue and a black tricorne hat bordered in gold, with a sporting gun under his left arm and a dead partridge in his right hand, and looking down at his half-sister; the latter, in a white dress and pink cap, looking up at him while resting her left hand on the dead bird and her right hand on a stone table; the older boy, in light grey, standing behind her, towards the centre; the younger boy, in a yellow suit, seated sideways on the table, to the left, and looking out at the spectator with his right hand on his hip and his left hand on his sister's right shoulder; trees behind, to the left; to the right a deep blue sky with a red sunset. Signed, bottom left (on the side of the table): A. Ramsay / 1742.

The Trustees of the Tate Gallery, London

Thomas Mansel (1719–1744), son of the Hon. Robert Mansel by his wife Anne Shovel, daughter of Admiral Sir Clowdisley Shovel; in 1723 succeeded his grandfather, Thomas, 1st Baron Mansel (1668–1723) as 2nd Baron Mansel of Margam (his father having already died). His mother married, secondly, John Blackwood, whose children by her are portrayed in the picture with Lord Mansel.

Group-portraits are rare in Ramsay's *oeuvre*: indeed the only other one that is known is the full-length group of *Queen Charlotte and her two eldest children* (no.86), painted more than twenty years later. The *Mansel Family* is particularly unusual in being conceived as a conversation-piece, as well as being related, as Elizabeth Einberg has noted, to the tradition of English sporting paintings (Elizabeth Einberg, *Manners & Morals: Hogarth and British Painting 1700–1760*, exhibition catalogue, Tate Gallery, London, 1987, p.155, no.117). The picture was painted in the same year as Hogarth's *Graham Children* (National Gallery, London), and it is possible that Ramsay was consciously setting out to rival Hogarth's powers of design. There is, besides, something particularly Hogarthian in the gentle torsion of the girl's figure. A notable feature of Ramsay's composition is the attention paid to the sitters' four visible hands, which combine variety of attitude with a studied naturalism. The polished sophistication of the style reflects to the full Ramsay's training in Italy. Lord Mansel's half-smile (matched by that of the small Blackwood boy, who seems to be fascinated by the painter's operations) suggests French influence: it is a convention often found in the work of Philip Mercier, who had been Ramsay's neighbour briefly in lodgings in the Great Piazza of Covent Garden, and from whom Ramsay may have first learned the value of this means of enlivening a sitter's features. In other respects, however, Mercier's relatively insubstantial poeticizing has little in common with Ramsay's commanding prose, with its emphasis upon structure and searching definition.

Canvas, feigned oval, 29 × 24½in (73.7 × 62.2cm). Bust-length. Signed and dated, bottom right: A. Ramsay – 1743.

Private Collection

Jean Nisbet (died 1790), daughter of William Nisbet of Dirleton by his second wife Jean Bennet; married, in 1749, Alexander Ogilvy, 7th Lord Banff (died 1771), son of Alexander Ogilvy of Forglen by his wife Jean French.

The portrait of Jean Nisbet is representative of the vitality and charm of Ramsay's bust-length portraiture during his first few years in London. The rich handling has points of similarity to Hogarth's technique in the same period, but its greater refinement produces an effect of polished smoothness, such as prompted the engraver-critic George Vertue to remark of Ramsay's pictures that they were 'rather lick't than pencilled' (i.e. painted smoothly rather than with expressive handling).

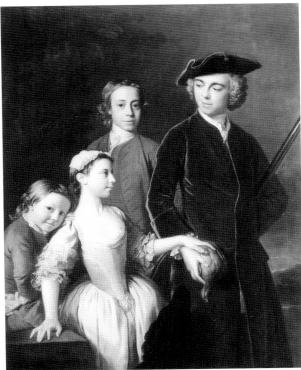

22

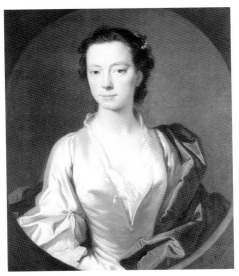

23

24

ANNE DALRYMPLE,
AFTERWARDS COUNTESS OF
BALCARRES

Canvas, feigned oval, 30 × 25in (76.2 × 63.5cm).
Bust-length. Signed and dated, bottom right:
A. Ramsay / 1745.

Private Collection

Anne Dalrymple (1727–1820), daughter of Sir
Robert Dalrymple, Kt., of Castleton, by his wife
Anne Cunningham, daughter of Sir William
Cunningham, or Cunyngham, Bt., of
Caprington; married, on 24 October 1749, James
Lindsay, 5th Earl of Balcarres (1691–1768), who
was then in his fifty-eighth year, and to whom
she brought eleven children, one of them being
Lady Anne Lindsay (afterwards Barnard), the
authoress of the song 'Auld Robin Gray'.

The sitter was the niece of Ramsay's friend
and travelling-companion Sir Alexander Dick of
Prestonfield, while her husband was related to
Sir Alexander Lindsay of Evelick, the father of
the painter's second wife Margaret Lindsay
(no. 66). When, in March 1752, Ramsay eloped
with Margaret Lindsay, her parents broke off all
relations with her, and Lord Balcarres's attempt
to intercede with Sir Alexander on Ramsay's
behalf proved unavailing. Later, the Countess of
Balcarres made a similarly unsuccessful
approach to Lady Lindsay.

This portrait of Anne Dalrymple, showing
her at about the age of eighteen, may have been
painted in Edinburgh during a short visit to
Scotland which Ramsay made in the late
summer of 1745 – in time, indeed, to witness
Prince Charles Edward Stewart's occupation of
the city. Anne Dalrymple sat again to Ramsay
shortly after her marriage (see no.38).

25

THE HOPE CHILDREN
(LADY ELIZABETH HOPE AND HER
BROTHER CHARLES, LORD HOPE)

Canvas, 49 × 39in (124.5 × 99.1cm). Double-
portrait at three-quarter length: in a landscape,
Lady Elizabeth Hope holding a wreath of bay
leaves above the head of her brother, who has a bow
in his right hand and an arrow in his left. c.1746–7.

Private Collection

Lady Elizabeth Hope (1736–1756) and Charles,
Lord Hope (1740–1766), children of John, 2nd
Earl of Hopetoun by his first wife Anne (died
1759), daughter of James, 5th Earl of Findlater
and 2nd Earl of Seafield. Lady Elizabeth
married, in July 1754, Henry, Earl of Drumlanrig
(1722–1754), elder son of the 3rd Duke of
Queensberry, who was accidentally killed in
October of the same year.

Double-portraits by Ramsay are rare, and this
picture has unusual features; but there is no
cause to question the attribution, although the
participation of the drapery painter Joseph
Vanhaecken can be presumed: his skill in the
rendering of silks and satins, which earned him
the sobriquet of 'the tailor', seems to be espec-
ially in evidence in the treatment of Lady
Elizabeth's costume.

26 *plate 10*

SIR JOHN INGLIS OF CRAMOND

Canvas, feigned oval, 30 × 25in (76.2 × 63.5cm).
Bust-length: in a light grey coat and long wig, a
tricorne hat under his left arm. Inscribed, top left:
SIR JOHN INGLIS BARᵗ OF CRAMOND.
Companion to no.27. Probably painted in
Edinburgh in 1747.

National Gallery of Scotland, Edinburgh

Sir John Inglis, 2nd Bt., of Cramond (1683–1771);
son of Sir James Inglis (died 1688), who had been
created a baronet of Nova Scotia in 1687;
Postmaster-General for Scotland from 1717 to
1725 and from 1742; Chancellor of the Jury at the
trial of Captain John Porteous in 1736, presided
over by Lord Milton as judge; married Anne
Cockburn (no.27); died at the age of 88, 'without
suffering as much as one day's confinement by
sickness'.

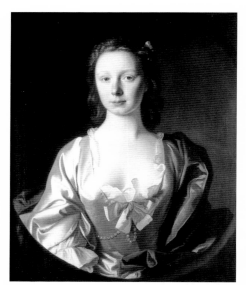

24

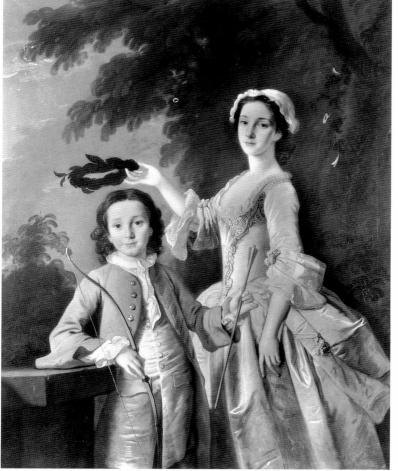

25

*Canvas, feigned oval, 30⅛ × 24⅜in (76.5 × 61.9cm).
Bust-length: in a rich blue and white dress, wearing
a white cap covered by a black shawl. Inscribed, top
left:* ANNE COCKBURN WIFE OF / Sir John
Inglis Bart / OF CRAMOND. *Companion to no.26.
Probably painted in Edinburgh in 1747.*

National Gallery of Scotland, Edinburgh

Anne Cockburn (died 1772), daughter of Adam
Cockburn of Ormiston, Lord Justice-Clerk, by
his first wife Lady Susan Hamilton, daughter of
John, 4th Earl of Haddington; married Sir John
Inglis, 2nd Bt., of Cramond (1683–1771). The
sitter's daughter Janet married, as his second
wife, Sir John Clerk of Penicuik. Another
daughter, Margaret Erskine, sat to Ramsay in
1747, presumably during a visit made by the
painter to Edinburgh in that year; and Lady
Inglis and her husband probably sat to him at
about the same time.

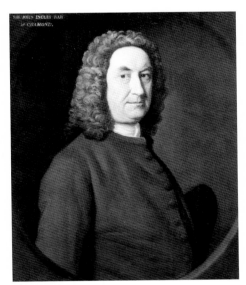

26

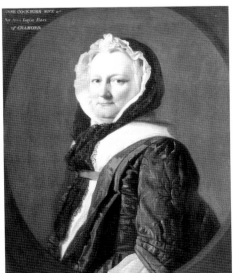

27

*Canvas, 93 × 57in (236.2 × 144.8cm). Full-length:
in a brown coat, black academic gown and long
white wig, seated on a red-backed chair placed on a
dais, his left hand extended towards a table covered
with a red tablecloth, on which there are two
leather-bound volumes and a letter addressed* To
Dʳ Mead; *behind, to the left, a heavy scarlet curtain
with a tassel, and to the right a statue of Hygeia in a
niche; in the foreground, on the dais, two further
books. Inscribed, bottom left:* Richᵈ. Mead. M.D.;
and, bottom right: Ramsay Pinxit. *The latter
inscription covers an earlier one, which reads:*
Painted and given by Ramsay 1747. *Painted for
the Foundling Hospital in 1747, when presented by
the artist (at some time between 1 April and the late
summer of that year).*

The Thomas Coram Foundation for Children

Richard Mead, M.D. (1673–1754), eminent
physician, classical scholar and collector; son of
the Revd. Matthew Mead; studied the Classics
at Utrecht and medicine at Leiden, before
travelling to Italy, where in 1695 he obtained the
degree of M.D. at the University of Padua;
published a paper on poisons in 1702; elected a
Fellow of the Royal Society in 1703 and a Fellow
of the College of Physicians in 1716; appointed
physician to George II in 1727; became
consultant doctor to the Foundling Hospital, of
which he was a Governor; married (1) Ruth
Marsh, and (2) Anne Alston, daughter of Sir
Roland Alston, of Odell in Bedfordshire. A man
of great wealth, Dr. Mead built up a private
library of some 10,000 volumes and extended his
fine residence in Great Ormond Street in order
to create a museum adequate to house his
magnificent collection of paintings, sculptures,
manuscripts, coins and gems, which he made
available to scholars, scientists and artists. The
collection included portraits by Rubens,
Rembrandt, Hals, Holbein, Kneller, Richardson
and Ramsay, landscapes by Claude, Gaspar
Dughet, Bruegel and Salvator Rosa,
architectural subjects by Canaletto and Panini,
and numerous historical and religious pictures
by Veronese, Poussin, Annibale Carracci,
Maratta, Rembrandt, Rubens, Van Dyck,
Teniers, Solimena, Watteau and others (see
Bernard Denvir, *The Eighteenth Century: Art,
design and society 1689–1789*, London and New
York, 1983, p. 7).

Ramsay was one of several artists whom
Mead encouraged, and to whom he gave access
to his collections. In 1736, on the eve of his
departure for his studies in Italy, Ramsay was
supplied by Dr. Mead with letters of intro-
duction. At the same time Mead commissioned
him to purchase on his behalf, in Italy, a

celebrated volume of coloured drawings by
Pietro Santi Bartoli (c.1635–1700), the antiquar-
ian and engraver, after ancient paintings and
mosaics: these drawings, whose sale to Dr.
Mead Ramsay successfully negotiated, are now
in Glasgow University Library (see especially
Claire Pace, 'Pietro Santi Bartoli: drawings in
Glasgow University Library after Roman
paintings and mosaics', *Papers of the British
School at Rome*, XLVII, 1979, pp.175 ff., and Iain
Gordon Brown, 'Allan Ramsay's rise and
reputation', *Walpole Society*, L(1984), pp.209 ff.,
and p.246, n.101).

On Ramsay's arrival in London from Italy in
the summer of 1738, Mead was zealous in
promoting his career, introducing him to
prospective patrons as well as sitting to him for a
half-length portrait, as George Vertue noted in
the autumn of 1739 (*Walpole Society*, XXII (1933–
4), *Vertue III*, 1934, p.96). In the same year Dr.
Mead founded an exclusive dining-club, whose
membership consisted largely of classical
scholars and antiquaries, and invited Ramsay to
join it. (Much new information about these and
other connections between Ramsay and Mead is
contained in the writer's new biography of
Ramsay (Yale University Press and The Paul
Mellon Centre for Studies in British Art, New
Haven and London, 1992).)

Ramsay's full-length of Dr. Mead has a
particular importance in the history of the arts in
Great Britain, both on account of its place in the
series of pictures painted for the Foundling
Hospital by the leading artists of the period and
because of its significance as a hitherto unprece-
dented exercise in the Grand Manner.

In 1740 Hogarth had presented to the
Foundling Hospital his great full-length of the
founder of the Charity, Captain Thomas
Coram. His example was to inspire many of the
most eminent painters of the time to offer works
of their own. The consequences for British art
cannot be overestimated. The growing collec-
tion of pictures – including portraits, religious
paintings, landscapes and marine subjects – soon
attracted the attention of a public as yet
unaccustomed to exhibitions but now invited to
consider the hitherto obscured (and often
decried) merits of the native school, and it
became fashionable to visit the Foundling
Hospital and to study the works of art on
display. Further, at the meetings held at the
Foundling Hospital by the contributing artists,
who were all elected Governors on their pledge
to present a work to the Charity, one of the ideas
that were most discussed was the possibility of
instituting annual exhibitions of the work of
British artists under the aegis of a national

academy. The views aired at the meetings of the artist-governors, and, from 1754, at the newly founded Society of Arts, were to see fruition in the establishment in 1760 of the Society of Artists and ultimately of the Royal Academy of Arts in 1768. (For fuller accounts, see especially R. H. Nichols and F. A. Wray, *The History of the Foundling Hospital*, London, 1935, and Benedict Nicolson, *The Treasures of the Foundling Hospital*, London, 1972.)

Ramsay's name appears in the Court Minutes of the Foundling Hospital for 31 December 1746, which lists the names of fifteen artists who by then had promised, following Hogarth's example, to present further works of their own, and who were thereupon elected Governors. Referring to a public dinner given at the Foundling Hospital on 1 April 1747, when the guests had the opportunity of admiring, in addition to the *Coram*, the four history-pictures painted for the Court Room by Hogarth, Hayman, Highmore and Wills, George Vertue noted: 'some other portraits are done & doing by Ramsay Hudson ...' (*Walpole Society*, XXII (1933–4), *Vertue III*, 1934, p.135). Hudson had promised two portraits – the full-lengths of Theodore Jacobsen (the architect of the new premises of the Charity: fig.8) and Justice John Milner (its vice-president and one of the original Governors). Both were painted and presented in 1746; and by December of that year Ramsay had promised what was to be the full-length of Dr. Mead. As Hudson's portraits had already been completed long before April 1747, it must have

been Ramsay's *Mead* that was still 'doing'. The portrait was evidently finished several months before the next record of it, on 16 December 1747, when, together with Hogarth's *Coram*, it was transferred from the Committee Room to the Secretary's office, for, by the late summer or early autumn of that year, Ramsay had left London for Edinburgh on a visit that detained him until the following January.

In 1751 Vertue returned to the subject of the pictures at the Foundling Hospital. After referring to the four histories and Andrea Casali's altarpiece for the chapel, he briefly mentioned the four portraits by Hogarth, Hudson and Ramsay:

> The portraits at [full] length given their by Mr Hudson, of Justice Milner Mr Jacobson the builder of the Hospital – and that of Dr Meade which has the admiration of most people is by Mr Ramsay and that of Capt Coram is by Hogarth –
> (*Walpole Society*, XXII (1933–4), *Vertue III*, 1934, p.157).

The implication is that it was the portrait of Dr. Mead that was attracting the most attention. By the time of Vertue's comment it would have been familiar to many people from Baron's very accurate engraving of 1749; but it must also have been seen in the original by thousands of visitors to the Foundling Hospital, who were not by any means confined to those representatives of high society who went there because it had become the fashion to display benevolent concern for the abandoned children whom the hospital, if not always with the happiest results, took into its care. The reactions of two such visitors, not long after the picture had been hung up in the hospital, have come down to us in a curious work, published anonymously in two volumes in 1839, which contains recollections of celebrated medical men of former times, including Dr. Mead. One of these visitors was Aaron Hill, the poet and dramatist; the other was a young, unidentified friend who apparently also became a friend of Ramsay and knew Mead. The visit must have taken place in the period 1747–9, since Hill died in January 1750. As they stood in front of Ramsay's portrait Aaron Hill offered the opinion that it was not like, and that in any case no one could paint nowadays, 'except Mr Reynolds' – and even he was 'not fit to hold a candle to Vandyke'. It is an interesting judgment if accurately reported, as Reynolds at this time had still to establish his reputation in London. Hill's young friend, on the other hand, was not in agreement and concluded that the poet was 'ignorant' about such matters. Recollecting the

portrait afterwards, he observed: 'I thought it so strong a resemblance, that I fancied it was alive, and wondered how such work could be done.' (*Physic and Physicians: A Medical Sketch Book, exhibiting the Public and Private Life of the Most Celebrated Medical Men, of Former Days; with Memoirs of Eminent London Physicians and Surgeons*, London, 1839, vol. II, p.22.)

Even apart from the sheer power of the characterization and the impressive authority of the presentation, there was novelty in the *grandezza* of Ramsay's conception. Waterhouse has observed that the European 'Grand Style', which was to be Reynolds's ideal, had been foreshadowed in Ramsay's work by a number of years: 'It is impossible', he remarks, 'to escape the conclusion that the marriage of the Italian grand style to British portraiture was primarily the achievement of Ramsay' (Ellis Waterhouse, *Painting in Britain 1530 to 1790*, London, 1953, pp.152–3).

29 *plate 13*

ARCHIBALD, 3RD DUKE OF ARGYLL

Canvas, 94 × 61½in (238.8 × 156.2cm). Full-length: in the robes of a Lord Justice-General of Scotland, seated in a chair and turning the pages of a large volume. Signed and dated, bottom right:
A. Ramsay 1749.

Glasgow Art Gallery and Museum

Archibald Campbell (1682–1761), Earl of Ilay and 3rd Duke of Argyll, eminent Scottish statesman; second son of Archibald Campbell, 1st Duke of Argyll by his wife Elizabeth Tollemache; succeeded his elder brother John, 2nd Duke of Argyll as 3rd Duke in 1743; educated at the universities of Glasgow and Utrecht before serving in the Army under Marlborough; after abandoning his army service for a political career, appointed in 1705 Lord High Treasurer of Scotland, and nominated one of the commissioners for the Treaty of Union; elected a Representative Peer for Scotland in 1707. A strong supporter of Walpole and the Whig party, Argyll virtually directed Scottish affairs for the Westminster Government, becoming known as 'the King of Scotland'. He filled the offices of Lord Justice-General of Scotland (from 1710) and Keeper of the Great Seal (from 1733). He married, in January 1712/13, Anne Whitfield (died 1723), daughter of Major

28

Walter Whitfield, Member of Parliament for Romney.

When Lord Ilay, the sitter befriended the poet Ramsay, whose hobby of making casts of ancient gems and cameos he encouraged by lending him examples from his own collection. The poet himself expressed in a letter of April 1735 to the Lord Provost of Edinburgh, Patrick Lindsay (no.16), the hope that Ilay's good offices might be enlisted in order to secure a grant from the King to enable his son to pursue his study of painting in Italy. On succeeding to the dukedom Lord Ilay continued the patronage which had been extended to Ramsay by his brother the 2nd Duke, sitting to him first in 1744 and again in 1748 – the portrait of 1748 (at bust length) becoming the basis for the Glasgow full-length. Altogether, Ramsay's patronage by the Argylls embraced a period of almost two decades, from 1739 – when the 2nd Duke sat for a major full-length (Inveraray Castle: fig.7) – until 1758, the date of a further portrait of the 3rd Duke (fig.5). The importance in Ramsay's career of the Argylls' interest cannot be emphasized too strongly, and it can be seen to be all the more significant in that their nephew, John Stuart, 3rd Earl of Bute (no.60), became his greatest and most influential patron, being instrumental in bringing him to the notice of the future King George III and in helping to secure his appointment as painter to the King in the new reign. Ramsay came to be on friendly terms with the 3rd Duke, enjoying his hospitality both in his

London residence and at his ancestral home of Inveraray.

The full-length of 1749 was commissioned by the City Council of Glasgow, and a payment to Ramsay of £42 is recorded in the Town Council minutes under 1 May 1750, by which date the picture had been hung in the Council Hall.

This work occupies an important place in Ramsay's artistic development. Only two years earlier, in the full-length of *Dr. Richard Mead* (no.28), Ramsay had displayed to the full his mastery of the Baroque style which he had absorbed in Italy, and (as was pointed out by the late Sir Ellis Waterhouse) had in effect introduced the Continental Grand Manner into British painting. Similar qualities inform the dramatically conceived full-length of *Norman, 22nd Chief of MacLeod* at Dunvegan Castle (fig. 6: see also no.33), painted about the same time. In these grandiose compositions the Glasgow *Duke of Argyll* presents an almost absolute contrast, marking as it does a significant stage in Ramsay's reaction by the late 1740s both against the conventions of European Baroque and against the artificialities of the Knelleresque tradition in English portraiture. The *Argyll* moves, indeed, a step nearer the quiet informality and reticence of such portraits of the early 1750s as the *John Sargent the Elder* of 1753 (no.40) and the *Lord Drummore* (no.44) of the following year. Grandiloquent gesture, such as gave expressive power to the *Dr. Mead* (no.28), is now avoided as Ramsay adapts an unaffected naturalness of manner to the requirements of public portraiture. The Duke of Argyll is represented in the robes of a Lord Justice-General, but this attire, while lending an appropriate dignity to the whole, is less note-worthy as a symbol of status or authority than for the beauty of its painterly handling as its folds catch the fall of the strong lighting from above – an element in the style of the picture that suggests Ramsay's study of Rembrandt.

Canvas, 44 × 38in (111.8 × 96.5cm). Full-length: in 'coats', seated on the ground in a landscape, with his left arm resting on a toy drum, edged at the rim in red, and holding a red drumstick in each hand; a feathered hat on the ground in front of him; red roses to the left; trees in the background. Signed and dated, lower right: A. Ramsay 1749.

The Trustees of the Chevening Estate

Philip, Viscount Mahon (1746–1763), elder son of Philip, 2nd Earl Stanhope by his wife the Hon. Grisel Hamilton; died on 6 July 1763, at the age of seventeen, being succeeded in the title by his brother Charles (no.80), the future scientist and statesman. Ramsay painted a second portrait of him in 1762 (no.79). (The name Mahon was pronounced 'Mahoon' with the stress on the second syllable.)

The year 1749 marks the commencement of Ramsay's patronage by the 2nd Earl Stanhope. Lady Stanhope was a sister of his old patron the 7th Earl of Haddington and would probably have been instrumental in bringing Ramsay to her husband's notice.

Besides being one of Ramsay's finest portraits of young children, the picture is notable for its sensitively balanced design and for the effective manner in which the figure is related to the landscape setting. A comparison with the *Agnes Murray-Kynynmond Dalrymple* (no.14) of a decade earlier brings out the extent to which Ramsay had moved away by 1749 from the spirit of Late Baroque.

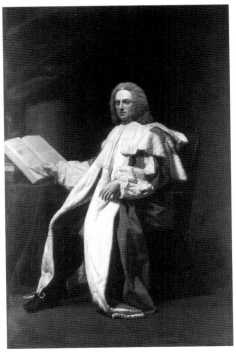

29

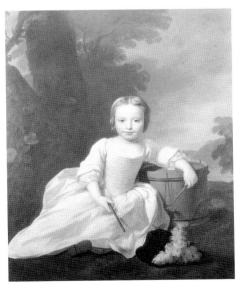

30

A LADY IN 'VAN DYCK' DRESS

Canvas, 50 × 40in (127 × 101.6cm). Three-quarter-length: in 'Van Dyck' costume, standing in a landscape and holding a peacock feather in her hand. Signed and dated: A. Ramsay 1749.

Private Collection

The popularity in the 1730s and 1740s of portraits in which the sitters are shown in costumes reminiscent of those in works by seventeenth-century painters, most notably Van Dyck and Rubens, is discussed under no.32. This convention cannot be regarded merely as exemplifying a sentimental historicism, since such costumes were frequently worn in the eighteenth century at the fashionable masquerades (e.g. at Ranelagh), and furthermore were often modified to conform more to contemporary fashions in dress. In portraits of ladies, the most popular model was Rubens's full-length of his sister-in-law Susanna Fourment (Gulbenkian Foundation, Lisbon), which had been acquired by the Prime Minister, Sir Robert Walpole, and which had come to be believed to be a portrait by Van Dyck of Rubens's second wife Helena Fourment; and this is the source of the exhibited drawing by Joseph Vanhaecken of a lady so attired (no.32). In this period a large number of 'Van Dyck' costume portraits can be associated with Vanhaecken, who seems to have specialized in the genre, working as a drapery-painter for many eighteenth-century portraitists and especially for Hudson and Ramsay. The design of no.32 lies behind this portrait and a similar portrait by Ramsay of *Mary Mackenzie, Lady Fortrose* (Private Collection), also painted in 1749. Vanhaecken collaborated on the execution of both pictures, which must be among the last for which Ramsay engaged his services, since he died in July of the same year.

It was at this time that Ramsay was beginning his quest of a new, 'natural' mode of portraiture, which can already be seen in an early stage in the full-length of the *3rd Duke of Argyll* (no.29), also painted in 1749. This development in his conception of portraiture required the discarding of all pictorial conventions that were not attuned to contemporary sensibility, and these included many of the features of the Baroque style in which Ramsay had been trained in Italy. It was clearly for this reason that he felt it necessary to revise, in the present picture, Rubens's treatment of Susanna Fourment's hands, and to make for the purpose a fresh drawing from life (no.39). The picture lends a new vitality to the tradition of the 'Van Dyck' costume portrait, and, with the *Lady Fortrose*, it is one of the most beautiful of all the products of

Ramsay's collaboration with Vanhaecken.

The portrait was for a long time ascribed to Hudson, the signature being hidden by grime, and the qualitative differences between Hudson and Ramsay being then not fully appreciated. In May 1969 the compiler of the present catalogue reattributed it to Ramsay; when the picture was cleaned in 1978 Ramsay's signature came to light, but only after the portrait was exhibited in Edinburgh (Scottish National Portrait Gallery, exhibition catalogue, *Van Dyck in Check Trousers*, 1978, no.22) with the cautious ascription, 'attributed to Allan Ramsay'.

It can be seen from this picture how signally Ramsay had foreshadowed his style of the later 1740s in his youthful masterpiece, *Margaret Calderwood of Polton* (no.6).

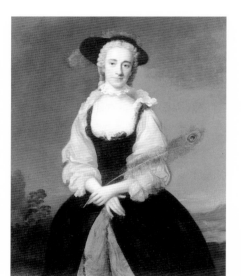

31

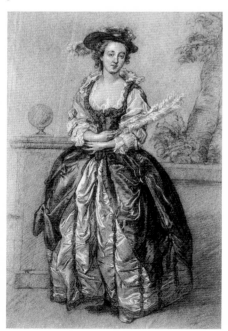

32

A LADY IN 'VAN DYCK' COSTUME, BY JOSEPH VANHAECKEN

NGS, D.2153. Black chalk, heightened with white, on light blue paper, 18¼ × 11⅞in (46.4 × 30.2cm). Full-length study of a lady in 'Van Dyck' costume; the pose as in Rubens's full-length of his sister-in-law Susanna Fourment (Gulbenkian Foundation, Lisbon), which had been acquired by the statesman and Prime Minister Sir Robert Walpole, and which was commonly supposed in the eighteenth century to be a portrait by Van Dyck of Rubens's wife Helena Fourment.

National Gallery of Scotland, Edinburgh

Rubens's picture became the model for a vast number of eighteenth-century English portraits of high-born ladies, such as might be displayed without dishonour among the portraits of their seventeenth-century ancestors. These portraits also possessed a particular reference to the contemporary fashion for dressing up in period costume – frequently borrowed from the works of such painters as Holbein, Van Dyck and Rubens – when in attendance at the popular masquerades. Especially in the first half of the eighteenth century, it was very much *à la mode* for both ladies and gentlemen sitting for their portraits to be represented in costumes reminiscent especially of portraits by Rubens or Van Dyck. The provision of such pictures was aided by the services of the talented drapery-painter Joseph Vanhaecken (died 1749), who assisted Ramsay, Hudson and a number of other portraitists of the period, and who may be said to have had a sort of corner in the production of 'Van Dyck' costume portraits. In the 1740s Ramsay himself employed Vanhaecken extensively as his drapery-assistant, and on occasion he adhered to the 'Van Dyck' convention, e.g., in no.31 and in his well-known three-quarter-length of *Jane Hale, afterwards, Mrs Martin Madan* (Lady Lever Art Gallery, Port Sunlight), painted in 1745.

33

COPY BY JOSEPH VANHAECKEN OF RAMSAY'S PORTRAIT OF THE MACLEOD OF MACLEOD

NGS, D.2163. *Black and red chalk, heightened with white, on light blue paper, 20½ × 12⅝in. (52.1 × 32.1cm). The red chalk confined to the flesh areas (i.e. the head and the visible hand). Stamped:* VH. *Copy of Ramsay's full-length of* The MacLeod *at Dunvegan Castle, Isle of Skye. Probably c.1747–8.*

National Gallery of Scotland, Edinburgh

This is one of several large copies made by Joseph Vanhaecken (*c.*1699–1749) of portraits by Ramsay, Hudson and other painters who employed him as their drapery-assistant. Such drawings have sometimes been thought to be preparatory studies by Vanhaecken for portraits in whose execution he assisted. It has also been suggested that Vanhaecken employed black chalk on those areas of the composition for which he would be responsible, and red chalk for the passages executed by the master employing his services – a hypothesis, however, that cannot be reconciled with the fact that in his copies after portraits by earlier painters (such as Lely and Maratta) Vanhaecken used precisely the same procedure, drawing the flesh areas in red and the rest in black. This method was clearly calculated to lend a pictorial quality to such copies, which may said to have been enhanced by their large size.

The drawing is of special interest for two reasons: first, it confirms Vanhaecken's partici-pation in the execution of Ramsay's portrait; and secondly, as is argued below, it provides a plausible link between the latter picture and Reynolds's full-length of *Commodore Augustus Keppel* of *c.*1753 at Greenwich (fig.9), which contains similarities in design.

Norman MacLeod, 22nd Chief of MacLeod (1706–1772), known in the family as 'the Red Man', an agname derived from Ramsay's portrait, in which he is represented in red and black diced trews and plaid; Member of Parliament for Inverness-shire from 1739 to 1754; known to his contemporaries as an agricultural reformer, and not least for his charity to the widows and crippled folk of the clan; married, first, Janet MacDonald (died 1741), daughter of Sir Donald MacDonald of Sleat (died 1718), she being said to have been 'a greedy, peevish woman'; and, secondly (and more happily), Ann Martin, daughter of William Martin, Tacksman of Brea. Although a Jacobite in his sympathies and by family tradition, MacLeod declined to bring out his clansmen in 1745 in support of the Young Pretender, apparently on the grounds that there were no reasonable prospects of success, raising instead a troop of 1,450 men for the Government and so incurring accusations of disloyalty. He voted against the Disarming Bill

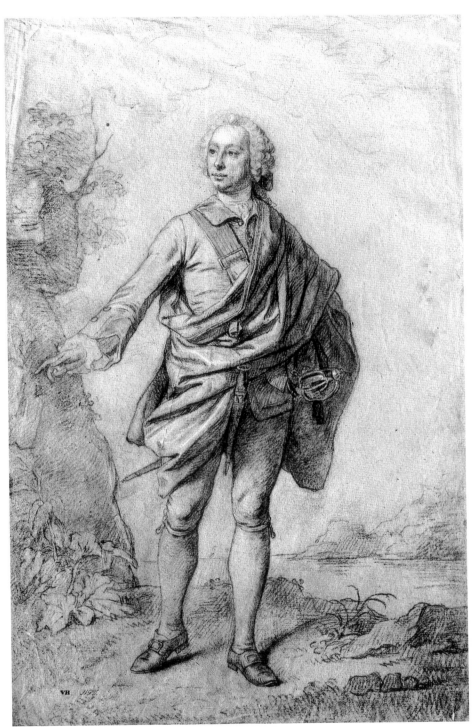

33

of 1746 which proscribed Highland dress except for Highland regiments serving in the British Army. After years of pleading, he obtained in 1748 repayment from the Government of the outlay of £2,500 which represented the cost of his military assistance during the Forty-five Rising; retired from Parliament in 1754. MacLeod had a son, John, by his first wife, together with two daughters, and three daughters by his second wife; he also had two illegitimate sons. He was notorious for his extravagance, in which his second wife encouraged him, and he incurred large debts which compelled him in 1769 to force up his rents. His purchase of Whitehouse, near Edinburgh, in 1756, was typical of this profligacy, as it necessitated his borrowing £3,000 to pay for it. It was in the same manner that he conducted his life in London, where his presence was required during sessions of Parliament. He was a close friend of Lord President Forbes. His grandson, the 23rd Chief (also Norman MacLeod and known as 'the General'), entertained Johnson and Boswell at Dunvegan during their tour of Scotland in 1773.

A receipt at Dunvegan Castle for the portrait of MacLeod, for a pendant of his second wife, and for a further portrait of a Miss Young (untraced) bears the signature of Laurence Craigie, Writer to the Signet in Edinburgh, and is dated 8 June 1748:

> Accompt Normand McLeod [sic] of that Ilk to Allan Ramsay painter in London.
> To the second payt. of Miss Young's
> picture sent home £ 5 5 0
> To the second payt. of McLeod's own
> picture still at Mr. Ramsay's house £ 21
> To the first payt. of Lady McLeod's £ 21
> To the second payt. of ditto £ 21
> £68 5 0
>
> Edin 8 June 1748 Received …
> [indecipherable] Lau Craigie.
> (The abbreviation *Lau*, for *Laurence*, in Craigie's signature has been misread as *Ian*.)

In the light of MacLeod's propensity to run up large debts, and of the fact that it was only in the same year that he managed to recoup from the Government the high costs of his military support during the Forty-five, it is possible that his payment for the three pictures referred to in the above bill had been for some time overdue; in which case Ramsay's portrait of him would have been painted well before 1748, perhaps about the same time as the *Dr. Mead* (no.28) of 1747, which compares closely with it in its air of the 'grand manner'.

There has been considerable speculation about the Highland costume in which the MacLeod is attired, and it has been suggested on the one hand that he designed it himself and on the other hand that it constituted the traditional dress of a MacLeod of MacLeod. However, the Hon. Francis Charteris is portrayed in similar mock-tartan trews and plaid in a double-portrait of comparable date (Private Collection). What is clear is that the 22nd Chief was so enamoured of the costume that, notwithstanding the 1746 Disarming Bill – proscribing from 1 August 1747 all forms of Highland dress, including the kilt, plaid and trews – he flaunted it in London and even at Westminster. In 1746, writing from London, he requested his half-sister to send on to him his tartan plaid, and two years later he paid a bill for eleven yards of superfine worsted tartan. It is conceivable that both these circumstances have a connection with his sittings to Ramsay. (The word 'tartan' does not, traditionally, signify of necessity an actual clan tartan, being also used to designate any checked woollen cloth.) He is represented in the picture as walking beside the coast of the mainland, with the Isle of Skye in the distance.

The now generally accepted view that in designing the picture Ramsay borrowed the pose from the *Apollo Belvedere* (Vatican, Rome) was first expressed by the late Sir Ellis Waterhouse in a broadcast on British portraiture, published in *The Listener* of 22 May 1950. As the *Apollo* was celebrated in the eighteenth century as the supreme representation in ancient art of perfect male beauty, such a borrowing might well have been deemed appropriate to the portrayal of a man of strikingly handsome figure whom his grandson described as having 'a body singularly well made and active', especially when his unusual mode of dress revealed his shapeliness of limb to the full. Recently, however, questions have been raised about the correctness of Waterhouse's identification of the *Apollo* as Ramsay's source, and in particular David Solkin (*The Oxford Art Journal*, IX, 2, 1986, pp.42 ff.) has suggested that Ramsay based the MacLeod's attitude on that common to Roman togate statues of public figures, such as the statue of Tiberius in the Louvre, in which 'the extended right hand operated as a rhetorical instrument to be read by spectators familiar with the conventions of public speaking' – this gesture, known as the *adlocutio*, signifying 'either greeting or clemency or both'. In respect of Ramsay's *MacLeod*, the same writer goes on to observe: 'Surely both artist and patron would have appreciated the way in which the flowing lines of MacLeod's plaid costume echoed the shape of an antique toga.' The similarities are striking,

not least with regard to the toga-like sweep of the MacLeod's plaid, while Solkin's argument illuminates convincingly the meaning of the sitter's gesture, which would certainly have befitted a clan chieftain notable for his humanity who was also, as a long-serving Member of Parliament, something of a public figure. Nevertheless, the *Apollo Belvedere* still has persuasive claims of its own (highlighted, one might say, not by the plaid but by the trews), and it may be suggested that Ramsay combined both antique sources. Ramsay had made a drawing of the *Apollo Belvedere* shortly after his arrival in Rome in 1736, and several years earlier, during his boyhood studies at the Academy of St. Luke in Edinburgh, he had made a copy of the figure of *An Archer* from the *Figurine* series of etchings by Salvator Rosa (NGS, D.5109: Edinburgh Sketchbook), which shows a similar pose and which Salvator himself presumably based on the *Apollo*. Although Ramsay is usually given credit for being the first to introduce into British portraiture the presumed 'quotation' from the *Apollo Belvedere*, almost exactly a century earlier Lely had evidently adapted the pose of the *Apollo* to his full-length of *Henry Sidney, afterwards Earl of Romney* (c.1649) at Penshurst Place. However, Lely's picture is hardly an exercise in the 'grand manner' in the sense of Ramsay's *MacLeod*. In the latter respect the *MacLeod*, like the full-length *Mead* (no.28), foreshadows the practice and theory of Reynolds, and with these two works the Grand Style, as Waterhouse observed, has been introduced into British painting. Almost immediately thereafter, however, as is demonstrated particularly clearly by the *3rd Duke of Argyll* of 1749 (no.29), Ramsay's style can be seen to be moving in an entirely different direction, as he abandons the Italianate, late Baroque conventions in which he was trained and gradually develops a new, informal manner in his quest of the 'natural', ultimately seeking inspiration in the work of his French contemporaries.

It was originally Waterhouse's opinion that Reynolds's presumed adaptation of the *Apollo Belvedere* to the design of his full-length of *Commodore Augustus Keppel* of c.1753 (fig.9) was inspired by Ramsay's *MacLeod*. Eventually, however, Waterhouse came to the conclusion that the *Keppel* could not have been dependent in any way upon the *MacLeod*, since Ramsay's picture (never engraved) would not have been known to Reynolds in 1748, when he was absent from London, where the picture was still to be seen in Ramsay's studio. In addition, it was probably inaccessible by 1753 (and long before)

on the Isle of Skye (although this is merely a plausible assumption). Nevertheless, the resemblances between the two compositions seem too remarkable to be coincidental: both figures are represented as striding forward on the seashore, towards the spectator, in virtually identical attitudes, with a stretch of sea behind them and a cliff rising up on the left, and both pictures have been associated with the same antique source. A plausible solution to the problem brings into consideration Joseph Vanhaecken's connection with the *MacLeod*, in respect both of his assistance in the execution of the picture and of this large copy of it in chalks. Reynolds, who had been well acquainted with Vanhaecken when he was Hudson's pupil (and had sometimes been given the humble task of carrying unfinished canvases by his master to Vanhaecken's painting-room), could easily have seen the drawing in 1753, whether it was still in the possession of Vanhaecken's widow or had been acquired by then by Ramsay (the drapery-painter's executor) along with the other drawings by Vanhaecken which he came to own. Further evidence that has hitherto escaped attention strongly supports this solution of the problem. About 1754–5 or earlier, Hudson, who like Ramsay had employed Vanhaecken extensively as his drapery-painter, copied the pose of the *MacLeod* in a full-length portrait, said to be of *Charles Douglass* (Christie's, 21 November 1975, lot 88: reproduced in R. Simon, *The Portrait in Britain and America*, Oxford, 1987, pl. 56), and even transferred to his own picture the antique urn represented in the pendant of *Lady MacLeod*. Such adaptations could have been made only from Vanhaecken's drawings; and it would therefore appear that Hudson here followed the same procedure as Reynolds, his former pupil. It may be added that Hudson's *Marlborough Family Group* at Blenheim Palace (*c*.1753) shows the clear influence of Reynolds's *Keppel*, not least in the lighting, and one of the sitters again suggests by his pose a reminiscence of the *Apollo Belvedere*. Indeed both these works by Hudson, taken in conjunction with the *Keppel* and with the *MacLeod* and its pendant, seem to give back echoes of the kind of discussions that would have taken place in the artists' studios.

Canvas, feigned oval, 30⅛ × 24¾in (76.5 × 62.9cm). Bust-length: his right hand tucked inside his waistcoat, a tricorne hat under his left arm. Signed and dated, bottom left: A. Ramsay 1749. *Companion to no.35.*

The Holburne Museum and Crafts Study Centre, Bath

John Sargent of Halstead Place in Kent (1715–1791), son of John Sargent (no.40) by his wife Mary; became Storekeeper of the King's Yard at Deptford in 1746, and a Director of the Bank of England in 1757; Member of Parliament for Midhurst from 1754 to 1761, and for West Looe from 1765 to 1768; married Rosamund Chambers (no.35). He was an intimate of the American statesman Benjamin Franklin.

John Sargent was also a personal friend of Ramsay, who once remarked in a letter to David Hume on Sargent's domestic happiness. His house, Halstead Place, was not far from Chevening, the residence of the Stanhopes, for whom Ramsay was executing important commissions in 1749, the year in which the portraits of Sargent and his wife were painted.

Canvas, feigned oval, 30 × 25in (76.2 × 63.5cm). Bust-length: in a pink dress, covered by a black lace shawl, and a white lace cap trimmed under the chin with a blue silk bow. Signed and dated, bottom right: A. Ramsay/1749. *Companion to no.34.*

The Holburne Museum and Crafts Study Centre, Bath

Rosamund (or Rosomund) Chambers (1722–1792), wife of John Sargent the Younger (no.34).

Painted at the time that Ramsay was moving away from the Late Baroque, Italianate conventions in which he had been trained, and beginning his search for a more 'natural' style, the portrait of Rosamund Sargent foreshadows the delicate manner which he developed, under the particular influence of French portraiture, in the mid-1750s and thereafter.

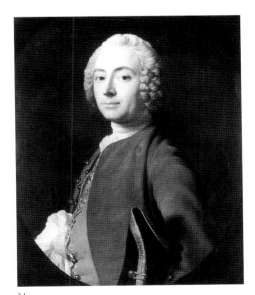

34

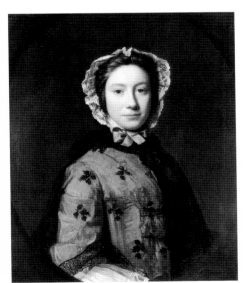

35

FLORA MACDONALD

CHARLOTTE FINCH,
DUCHESS OF SOMERSET

ANNE DALRYMPLE,
COUNTESS OF BALCARRES

*Canvas, feigned oval, 29 × 24in (73.7 × 61cm).
Half-length: seated with a wreath of flowers in her
left hand; wearing a tartan plaid; a white rose in
her hair (see below). Inscribed on the back of the
canvas (now covered):* RAMSAY PINXIT ANNO
1749. *Painted in London in 1749.*

*Canvas, 30 × 25in (76.2 × 63.5cm). Half-length: in
widow's cap, her hands in a muff. Signed and dated,
lower right: A. Ramsay / 1750. Inscribed, bottom
left:* Char^tte 2^nd wife of Cha^s 6^th D. of Somerset /
mother of the 3^d Countess of Aylesford.

*Canvas, 50 × 40in (127 × 101.6cm). Three-quarter-
length: in a blue dress and white cap adorned with
red flowers, a black ribbon worn around her neck,
seated in a landscape, her right hand resting on a
book, her left hand on her lap; sunset streaks in the
sky. Signed and dated, bottom right: A. Ramsay/
1750. A marriage-portrait, forming the pendant to a
three-quarter-length of the sitter's husband James,
5th Earl of Balcarres.*

The Visitors of The Ashmolean Museum, Oxford

The Finch Family

Private Collection

Flora Macdonald (1722–1790), celebrated for her
romantic association with Prince Charles
Edward Stewart; daughter of Ranald
Macdonald, a farmer of South Uist; in 1746
assisted the Prince in escaping to Skye after his
defeat at Culloden; imprisoned in the Tower of
London for her Jacobite sympathies, but soon
pardoned, being released in 1747, when she
enjoyed in London a wide fame as a romantic
heroine; married in 1750, on her return to
Scotland, Allan Macdonald, a local farmer who
emigrated with her to North Carolina and,
having entered the Army, rose to the rank of
Brigadier-General; died at Kingsburgh.

 The white rose in the sitter's hair is the *Alba
Maxima*, a rose of great antiquity which became
a Jacobite emblem. (Ramsay accepted
commissions from his patrons irrespectively of
their political allegiance.) Ramsay made a
preliminary study of the sitter's left hand and
forearm, with a slight indication of the wreath of
flowers: NGS, R.S.A. 617. Red chalk, with touches
of black, on yellow paper, 7¼ × 7⅓in (18.4 ×
18.6cm). The painting would have become
widely known through a mezzotint by James
McArdell. An eighteenth-century copy is in the
Scottish National Portrait Gallery, Edinburgh
(PG947).

Lady Charlotte Finch (died 1773), daughter of
Daniel Finch, 7th Earl of Winchelsea and 2nd
Earl of Nottingham by his second wife Anne,
only daughter of Christopher, Viscount Hatton;
married, in 1725, as his second wife, Charles
Seymour, 6th Duke of Somerset (1662–1748), the
politician (known as 'the proud Duke'); famous
as Mistress of the Robes to Queen Anne. In 1750
(when no.37 was painted) both the sitter's
daughters married: her elder daughter Frances
married (on 3 September) John, Marquis of
Granby; and the younger daughter Charlotte
married (on 6 October) Heneage, 3rd Earl of
Aylesford.

 This tender interpretation of widowhood,
one of the finest of all the portraits on an
intimate scale painted by Ramsay prior to his
second visit to Italy in 1754, is notable for its
sensitive rendering of the sitter's sad, reflective
expression. The Duchess of Somerset had been
widowed two years earlier and was now losing
her two daughters by marriage.

 The motif of the muff concealing the hands is
found in many French portraits of the period.
The simple directness of the portraiture is an
early indication of the change in Ramsay's style
in the 1750s which was to culminate in the
masterly series of portraits painted in Edinburgh
in 1754. This change followed directly upon
Vanhaecken's death in 1749.

Three studies by Ramsay for this portrait are
known: (i) Same collection. Black chalk,
heightened with white, on blue paper, 16 × 12½in
(40.6 × 31.8cm). Study of the head, very
complete. (ii) NGS, D.2057. Black chalk,
heightened with white, on blue paper, 7¼ × 8¼in
(18.4 × 21cm). Study of the right hand and book.
(iii) NGS, D.2062. Black chalk, heightened with
white, on blue paper, 13⅜ × 9⅝in (34 × 24.5cm).
Study of the left hand.

 For the sitter see under no.24.

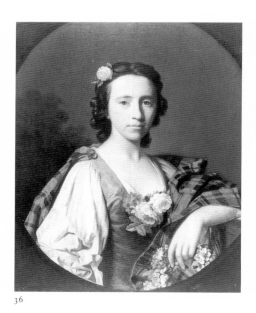

36

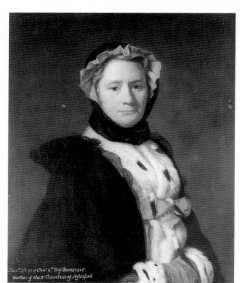

37

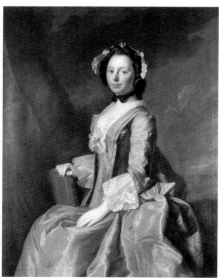

38

39

STUDY OF HANDS FOR A PORTRAIT OF A LADY

NGS, D.2130. *Red chalk, heightened with white, on yellow-tinted paper, 5 × 8⅜in (12.7 × 21.9cm). Study for no.31.*

National Gallery of Scotland, Edinburgh

For comments see no.31.

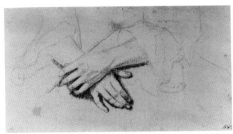

39

40 *plate 18*

JOHN SARGENT THE ELDER

Canvas, 49 × 39in (124 × 99.1cm). Three-quarter-length: in a light grey coat, seated to the right by a circular table, on which he rests his left arm (reflected in the table-top), with his right hand on his thigh, and holding a letter in his left hand. Signed and dated, lower right: A. Ramsay 1753.

The Holburne Museum and Crafts Study Centre, Bath

John Sargent (c.1690–1760), father of John Sargent of Halstead Place (no.34) by his wife Mary. (Statements about the sitter are not always reliable, since he is often confused with his son: see *The Genealogist*, XXXIII, January 1917, pp.189 ff.)

Two preliminary drawings for the portrait are known: (i) NGS, D.246: study of the pose. Black chalk, heightened with white, on grey paper, 17⅛ × 11¼in (43.5 × 28.6cm). (ii) NGS, D.1064: studies of the hands, together with studies for other portraits. Black chalk, heightened with white, on grey paper, 11⅜ × 9in (28.9 × 22.9cm).

This unusual portrait may be said to mark the beginning of the decisive change in Ramsay's style in 1753 which led to his development of an entirely new manner under the influence of Maurice Quentin de La Tour – a development probably connected with his close association at this time with William Hogarth, something of whose down-to-earth realism of manner seems to be reflected in Ramsay's frank portrayal of his sitter. The portrait represents an important stage in Ramsay's creation of a 'natural' idiom of portraiture, freed from the artifices of Italianate Baroque and the English Knelleresque tradition alike.

As Hayes has pointed out, there are similarities in conception and design between the *John Sargent the Elder* and Gainsborough's three-quarter-length of *John Sparrowe* at Auckland, which shows much the same kind of relaxed informality. Similar resemblances of style occur in other works by the two painters in the 1750s, and Hayes infers Ramsay's strong influence upon Gainsborough in this period (see John Hayes, 'Some Unknown Early Gainsborough Portraits', *Burlington Magazine*, CVII, February 1965, pp.62 ff.).

About the same time Reynolds was also developing a comparable type of intimate and informal portrait, e.g., in the *Samuel Johnson* of 1756 in the National Portrait Gallery, London.

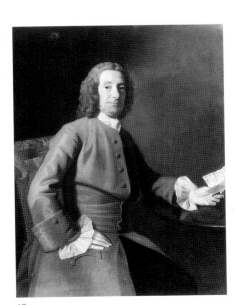

40

41 *plate 19*

MARY ADAM

Canvas, 37 × 28in (94 × 71.1cm). Half-length: as a widow, in a black dress and white cap, seated in a chair with a book and a pair of spectacles in her hands. Signed and dated, bottom right: A. Ramsay / 1754.

Yale Center for British Art, Paul Mellon Collection

Mary Robertson (1699–1761), widow of the Scottish architect William Adam (1689–1748), whom she married in 1716; daughter of William Robertson of Gladney by his wife Margaret Mitchell; mother of the architects John, Robert and James Adam; sister of the Revd. William Robertson of Gladney, minister of Old Greyfriars Church, Edinburgh, and aunt of the celebrated Revd. William Robertson (1721–1793), author of *The History of Scotland* and Principal of Edinburgh University.

A sheet of chalk drawings by Ramsay (NGS, D.2127) includes studies for the hands in the portrait and for the spectacles and book which the sitter holds at her lap. Mrs Adam is represented in a black dress and white cap, such as were customarily worn by widows in this period.

The treatment is strikingly informal, and it would be difficult to find parallels elsewhere in British portraiture of the eighteenth century for the intense realism of the presentation. For anything quite comparable one has to look rather to contemporary painting in France, and there are particular affinities with the three-quarter-length by Pierre Subleyras of *Princess Eleanora Chigi*, painted about 1744 (formerly in the collection of the Marchesa Eleanora Incisa della Rochetta, Rome: reproduced – not in reference to Ramsay's portrait – in Anthony M. Clark, 'Neo-Classicism and the Roman Eighteenth-Century Portrait', *Apollo*, LXXVIII, November 1963, pp.352 ff., fig.3).

41

Canvas, 29 × 24½in (73.7 × 62.2cm). Half-length: in a blue and silver embroidered dress, her hands concealed in a scarlet muff. Signed and dated, lower right: A. Ramsay/1754. Inscribed, top left: Lady Helen Dalrymple. Companion to no.43.

The Earl of Wemyss and March, K.T.

Lady Helen Wemyss (1729–1812), fourth and youngest daughter of James, 5th Earl of Wemyss (1699–1756) by his wife Janet Charteris (daughter of Colonel Francis Charteris); married on 25 April 1754, at Bargany, Captain Hugh Dalrymple of Fordel, R.N. (died 1784), third son of Sir James Dalrymple, 3rd Bt., of Hailes, by his wife Lady Christian Hamilton (the aunt of the Hon. Charles and the Hon. Rachel Hamilton: fig.4); sister of Lady Walpole Wemyss (no.43).

This unusual picture has a strikingly French air, and shows particular affinities with the work of the French pastellist Maurice Quentin de La Tour, which Ramsay praised for its naturalness in his *Dialogue on Taste*, published in 1755 and presumably written in Edinburgh in 1754, the year in which Lady Helen sat to him. The sitter's features are modelled in broad, divided brushstrokes suggestive of the technique of crayon-painting as practised especially by La Tour, as are other aspects of the handling. The rich colouring indicates the same source of inspiration in contemporary French painting, but in no slavish sense, being at once inventive and distinctively personal: the contrast between the intense blue of the sitter's gown and the scarlet of her muff is startling in its boldness, and Ramsay was to explore similar effects in much later portraits, such as the *Lady Temple* (no.68) and the *Lady Charlotte Burgoyne* (no.104).

Lady Helen posed for Ramsay in a dress eloquent of the latest French fashions, and with her hair, likewise, trimmed and powdered in the new French mode. Her smiling expression, enhancing the vitality of her portrayal, again recalls La Tour, who frequently enlivened his sitter's features in a similar manner. Ramsay indeed seems to have been struck by Lady Helen's vivacious appearance, for her brother-in-law Sir David Dalrymple (Lord Hailes) recorded among a number of witticisms ascribed to Ramsay the remark: 'Les joues de My Lady Nelly Wemyss parlent François' (National Library of Scotland, MS. Acc.7228/117, fo. 2: Sir David Dalrymple (Lord Hailes), *Collection of Witticisms &c*). Ramsay's portrait could be taken as an illustration of this observation, and certainly, if any of his works may be said to 'speak French', it is this.

Canvas, 29½ × 24½in (74.9 × 62.2cm). Half-length: in a dress delicately embroidered with a floral motif, and with her hands concealed in a muff. Signed and dated, bottom left: A. Ramsay/1754. Inscribed, top left: Lady Walpole Wemyss. Companion to no.42.

The Earl of Wemyss and March, K.T.

Lady Walpole Wemyss (1724–1755), second daughter of James, 5th Earl of Wemyss (1699–1756) by his wife Janet Charteris (died 1778), daughter of Colonel Francis Charteris; married, in Edinburgh, on 17 January 1754, Louis de Chastel, Sieur de la Barthe, a French captain of cavalry; died without issue at Toulouse; sister of Lady Helen Wemyss (no.42).

This sensitive and unpretentious half-length reflects at an early stage Ramsay's appreciation of contemporary French portraiture and especially the work of Jean-Marc Nattier, which it rivals in its combination of intimacy of characterization and decorative charm. A new refinement in Ramsay's technical procedures, also indebted to the French rococo style, is to be seen in the tonal treatment: the strong contrasts of the 1740s have given way to subtle modulations within a tonal scale of higher pitch, and delicate greys, added in light glazes to the flesh tints, assist in the harmonious blending of the tones.

42

43

HEW DALRYMPLE, LORD DRUMMORE

TWO STUDIES FOR THE PORTRAIT OF LORD DRUMMORE

Canvas, 50 × 39½in (127 × 100.3cm). Three-quarter-length: in a light grey coat; seated on a red-backed chair by a table. Signed and dated, bottom left: A. Ramsay/1754. Painted in Edinburgh.

Scottish National Portrait Gallery, Edinburgh

Hew Dalrymple of Drummore (1690–1755), eminent Scottish judge; second son of Sir Hew Dalrymple, 1st Bt., of North Berwick (third son of James, 1st Viscount Stair) by his first wife Marion Hamilton, daughter and heiress of John Horn, of Horn and Westhall; distinguished himself as an advocate, being appointed a Lord of Session in 1726, with the title of Lord Drummore, and becoming a Lord of Justiciary in 1745. A lover of music, he was a Governor of the Edinburgh Musical Society, of which Ramsay was also a supporter, and which commissioned a copy of this portrait for St. Cecilia's Hall. On his death he was paid the tribute of a funeral concert in St. Mary's Chapel, Edinburgh, which included a performance of the Dead March from Handel's *Saul*. The Battle of Prestonpans (1745), resulting in a victory for the Jacobite forces led by Prince Charles Edward Stewart, was fought on Drummore's estate. Drummore was known for his wit and, in the words of Lord Woodhouselee, for the 'great urbanity of his manners' and his 'keen relish of social enjoyments'.

There are two known studies by Ramsay for the picture – one for the pose (no.45) and one for the hands (no.46).

This famous work probably represents Ramsay's greatest achievement prior to his second visit to Italy of 1754–7, marking as it does an important stage in his development of the 'natural' portrait following his abandonment of the Baroque idiom in which he had been trained. This, however, is not merely an exercise in naturalism, for of all Ramsay's works the portrait of Lord Drummore is one of the most perfectly composed, and it is clear that in the process of creating a new, natural mode of portraiture Ramsay was concerned to impose upon it a rational order of design which was no longer dependent upon either the artifices of the Baroque style or the more parochial conventions of the Knelleresque tradition. A clue to his thinking may be seen in the reticence with which a solitary note of red (in the chair-back) is introduced into a colour-scheme dominated by greys and ochres. The contrast with the dramatic oppositions in the *Mead* of blacks and strong reds is striking; and instead of the powerful effect of chiaroscuro in the portrayal of Dr. Mead we find a blending of related tones by means of the subtlest transitions.

For further comments see pp.23-4

NGS, D.2024. Study of the pose. Black and red chalk, heightened with white, on grey paper, 16⅛ × 11⅜in (40.9 × 28.9cm). Drawn in Edinburgh in 1754.

NGS, D.2069 verso. Studies of the hands. Red chalk, heightened with white, on buff paper, 13½ × 9⅝in (34.3 × 24.5cm). Drawn in Edinburgh in 1754. On the recto, study of the hands for a portrait of James Adam *(Laing Art Gallery, Newcastle upon Tyne).*

National Gallery of Scotland, Edinburgh

These studies mark a development in Ramsay's drawing-style matching that seen in the mid-1750s in his manner as a painter, and are notable alike for their assurance and for their simple concern with the truth of appearances. In the study of the pose the restrained note of red chalk in the chairback already suggests one feature of the picture's muted scheme of colour.

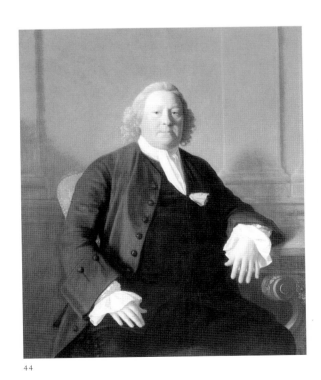

44

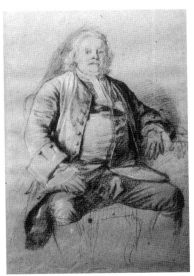

45

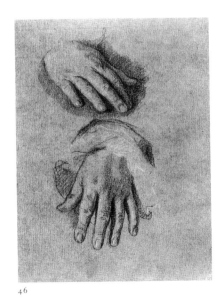

46

Canvas, 41 × 31in (104.1 × 78.7cm). Three-quarter-length: in a blue coat and gold-embroidered waistcoat, standing with a tricorne hat in his left hand and with his right hand behind his back; a light red curtain behind, to the right. Signed and dated, lower left: A. Ramsay/1753.

National Gallery of Scotland, Edinburgh

Thomas Lamb (1719–1804), eldest son of James Lamb (1693–1756), Mayor of Rye and borough manager for the statesman Thomas Pelham-Holles, Duke of Newcastle (1693–1768), by his wife Martha Grebell; in both of which capacities he succeeded his father (even being elected Mayor twenty times); inherited Lamb House at Rye (now a National Trust property), an elegant brick-fronted building dating in its final form from the early eighteenth century. A memorial erected in the Augustan Church at Rye by his son Thomas Phillips Lamb describes him as being 'benevolent and humane, in his manners cheerful and social, in the discharge of every duty faithful, and in his religious tenets firmly attached to the Established Church'. His wife, Dorothy Eyles (1717–1756), daughter of the Revd. Charles Eyles, vicar of Turk Dean, Gloucestershire, whom he survived by almost half a century, is eulogized on the same memorial as one who 'filled with equal lustre her station in life,' and, more obscurely, as 'having heightened every amiable quality of her sex with a manly sense and elegance of taste.'

The portrait of Thomas Lamb has an important place in Ramsay's artistic development, being the first known work to exhibit in any full sense his assimilation of the qualities of contemporary portraiture in France. This is to be seen especially in the graceful figure-style, in the high-pitched tonalities and in the subtle colour-scheme, with its harmonies of powder-blue and light gold. Altogether the style suggests that the portrait postdates the *John Sargent the Elder* (no.40), painted in the same year, in which the influence of French painting is much less in evidence. Further, the *Thomas Lamb* marks a significant stage in Ramsay's development of a type of three-quarter-length male portrait in which the sitter is represented in an attitude expressive at once of elegance and of a sort of nonchalant ease. A later example included in the present exhibition is the portrait of *John Burgoyne* of 1756 (no.54).

Canvas, feigned oval, 30 × 25in (76.2 × 63.5cm). Bust-length: in a blue military coat, with gold facings, and scarlet, gold-embroidered waistcoat. Signed and dated, bottom right: A. Ramsay/1754. Painted in Edinburgh.

The Leger Galleries, London

Sir John St. Clair (died 1767), soldier; son of Sir George St. Clair, Bt., of Kinnaird; entered the Army and served on the Continent, becoming a Major in the 22nd Foot in 1754, and subsequently Quarter-Master-General to the British Forces in America.

The sweeping, confident brushstrokes and the suggestion of mobility in the sitter's features can be related directly to Ramsay's admiration of the crayon-portraits of Maurice Quentin de La Tour, which he expressed in his *Dialogue on Taste*, published in 1755 and almost certainly written in Edinburgh in the previous year, when this portrait was painted.

47

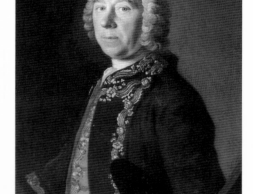

48

*Canvas, 38¾ × 29¼in (98.4 × 74.3cm). Half-length:
in a brown coat embroidered with gold, seated at a
table and holding in his right hand a sheet of paper
closely written; on the table an inkstand with a quill
pen, sealing-wax and a map of Greece inscribed
 ELLESPONT and EUROPA; a fluted pilaster to the
left. Signed and dated, lower left (along the edge of the
table):* A. Ramsay. 1755. *Painted in Rome, before
August 1755.*

National Portrait Gallery, London

Robert Wood (1716–1771), classical scholar,
archaeologist and politician; educated at the
University of Glasgow; after early travels in
France, Italy and the Middle East, joined John
Bouverie (who died during the journey) and
James Dawkins on their expedition to Asia Minor
and Greece, setting out from Naples in the spring
of 1750 and arriving at Athens in the early summer
of 1751, having visited Egypt, Palestine, Syria, and
a great part of the European and Asiatic coasts of
the Hellespont and Bosphorus, together with
most of the Greek islands; published in 1753 his
Ruins of Palmyra and in 1757 the *Ruins of Balbec*,
works praised by Horace Walpole (no.63) as
'standards of writing'; about 1753 accompanied the
young Francis Egerton, 3rd Duke of Bridgewater
as his tutor on the Grand Tour, becoming a
member of the circle of Allan Ramsay and Robert
Adam in Rome, and sitting for his portrait to
Mengs as well as to Ramsay; returned to England
in August 1755, and entered upon a political career,
becoming Under-Secretary of State in 1756 and
serving as Member of Parliament for Brackley;
elected a member of the Society of Dilettanti in
1763; published in 1769 his influential *Essay on the
Original Genius of Homer*; married Anne Skottowe
(or Skettowe).

This is one of the portraits painted by Ramsay
in Italy which Robert Adam listed in a letter of 2
January 1756 to his sister Elizabeth (see John
Fleming, 'Allan Ramsay and Robert Adam in
Italy', *Connoisseur*, CXXXVII, January 1956, pp.78
ff.; and idem, 'Two Rediscovered Portraits by
Allan Ramsay', *Connoisseur*, CXXXIX, March 1957,
p.76, fig.1). Robert Adam described Wood and
Ramsay as being 'intimate': the two men would
have found that they had much in common, not
least because Ramsay was himself a very compet-
ent classical scholar whose archaeological interests
were increasingly to preoccupy him and eventually
to inspire his unpublished *Enquiry into the
Situation and Circumstances of Horace's Sabine
Villa*. For comments on this important portrait
see p.25.

Some *pentimenti* in the area of the quill pen
and inkstand show that these details were origin-
ally placed a little higher up and more to the left.

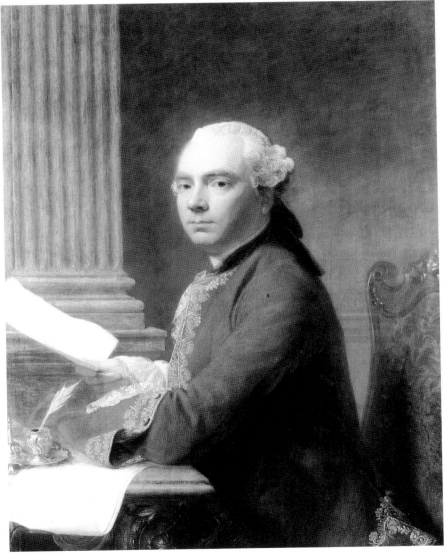

49

50 *plate 24*

ALLAN RAMSAY THE YOUNGER:
SELF-PORTRAIT AT THE EASEL

Canvas, 24¾ × 18¾in (62.9 × 47.6cm). Half-length: in a blue coat, with his hair tied at the back, pointing with his right hand to a canvas on an easel on which is represented a woman's head; his figure in profile to the right, his head turned over his right shoulder to face the spectator. Unfinished. Evidently painted in Rome in 1756.

Private Collection

An approximate date for the picture is indicated by a drawing dated *Nov.ʳ 1755* (no.51) representing the artist as seated in a chair with palette and brushes in his left hand and pointing with his right. The drawing presumably constitutes an early idea for the *Self-portrait*, for which it can be regarded as a reliable *terminus post quem*. As the picture is not mentioned in the list of portraits begun or finished by Ramsay since his arrival in Italy in 1754 which Robert Adam communicated in a letter to his sister Elizabeth on 2 January 1756, it was probably not begun until after that date. The woman represented on the canvas to which the artist is pointing is presumably Margaret Ramsay, and conceivably Ramsay's intention was to show himself in the act of painting the portrait of her which he is known to have executed in 1755. Other drawings may also be connected with the *Self-portrait*, including an unusual study of himself in pastel and watercolour (no.52).

The design of the painting suggests the direct influence of the similarly composed self-portrait, in the Musée de Picardie, Amiens, by the French crayon painter Maurice Quentin de La Tour (fig.10). Ramsay's treatment is remarkable for its rich handling of pigment and for the vivacity of the brushwork. Long after the painter's death the picture was engraved in mezzotint by Abraham Wivell (1786–1849) as the only engraved likeness of Ramsay.

51

SELF-PORTRAIT
WITH PALETTE AND BRUSHES

NGS, D.2020. Black chalk, heightened with white, on white paper washed with grey, 11⅛ × 10in (28.3 × 25.4cm). Three-quarter-length study of the artist seated in a chair with palette and brushes in his left hand and pointing with his right. Inscribed on the verso, in Ramsay's hand: Nov.ʳ 1755.

National Gallery of Scotland, Edinburgh

The design has close affinities with that of the *Self-portrait at the Easel* (no.50), for which it presumably constitutes an early idea, and which on that account it helps to date within the period of Ramsay's second visit to Italy of 1754–7.

52 *frontispiece*

SELF-PORTRAIT

Pastel and watercolour, 16 × 11⅛in (40.6 × 28.2cm). Head and shoulders. Probably executed in Rome c.1755–6.

Scottish National Portrait Gallery, Edinburgh

This unusual study is closely related to the artist's *Self-portrait at the Easel* of *c*.1756 (no.50), and almost certainly dates from Ramsay's second visit to Italy (1754–7). The influence of the French crayon-painter Maurice Quentin de La Tour is apparent both in the choice of pastel as the primary medium and in the vigorous handling. In 1755 Ramsay made a number of watercolour drawings of Roman ruins, notably the Colosseum (no.55), evidently on sketching expeditions with Robert Adam and his friend Clérisseau. It is likely that Clérisseau was Ramsay's mentor in the techniques of watercolour.

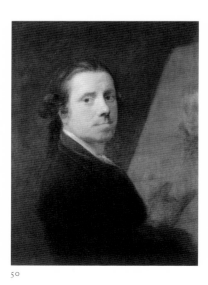

50

51

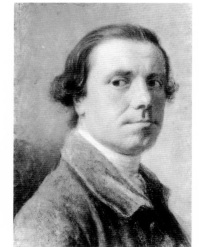

52

53

SKETCH OF THE BOBOLI GARDENS IN FLORENCE, AND A STUDY OF A SEATED WOMAN, FROM THE ITALIAN SKETCHBOOK

(a) NGS, D.4878. *Left-hand page. Red chalk, 8 × 5½in (20.3 × 14cm). Sketch of trees in the Boboli Gardens. Inscribed, bottom left, in Ramsay's hand:* Boboli.

(b) NGS, D.4878. *Right-hand page. Slight sketch of a seated woman, perhaps the artist's wife.*

National Gallery of Scotland, Edinburgh

In May 1757, towards the end of his second visit to Italy, Ramsay left Rome for Florence, on the first stage of his journey home that summer. His principal task in Florence was to paint a picture of Galileo commissioned by the Master of Trinity College, Cambridge. Ramsay based the likeness for the portrait on a painting by Justus Suttermans in the Uffizi, but in all other respects creating a design of his own. A similar procedure was used in the posthumous portrait of *Princess Elisabeth Albertina* (no.99), where the likeness was based on a painting by Daniel Woge.

The *Italian Sketchbook* contains many other landscape drawings, together with studies of Roman antiquities and sculpture, copies of pictures seen on the painter's return journey through Germany, and numerous notes of various kinds, varying from comments on the scenery of the Tivoli region to observations on pigments obtainable in Italy and *memoranda* concerning people with whom he became acquainted in his travels, such as the eminent Italian author and connoisseur Count Algarotti and Lady Mary Wortley-Montagu, the mother-in-law of Ramsay's future patron the 3rd Earl of Bute (no.60).

53

Canvas, 39 × 28½in (99.1 × 72.4cm). Half-length:
in a red military coat, standing inside the
Colosseum. Signed and dated, bottom right:
A. Ramsay 1756. Begun in Rome in 1755.

Private Collection

John Burgoyne (1722/3–1792), soldier, dramatist
and politician; known to his troops as
'Gentleman Johnny'; son of Captain John
Burgoyne and grandson of Sir John Burgoyne,
3rd Bt., of Sutton Park, Bedfordshire; educated
at Westminster School, where he formed a
lasting friendship with Lord Strange, the eldest
son of the Earl of Derby and the brother of
Burgoyne's future wife Lady Charlotte Stanley
(no.104), with whom he was to elope (probably
in 1751 or 1752); travelled with her in France and
Italy, joining the Ramsay and Adam circle in
Rome in 1755; in his later life distinguished
himself as a soldier, being elevated to the rank of
Brigadier-General in 1762; elected in the same
year Member of Parliament for Midhurst, and
in 1768 for Preston; sent to America to reinforce
Gage, and in 1776 appointed second-in-
command in Canada to Sir Guy Carleton. His
plan for an offensive from Canada against the
American colonists having been thwarted by the
failure of the British Government to provide the
number of troops that he had specified as being
necessary, he eventually surrendered to Gates at
Saratoga in October 1777, having recently been
promoted Lieutenant-General. On his return to
England, he joined the Opposition, befriending
Charles James Fox and enjoying the support of
Sheridan; turned increasingly to the writing of
plays and the librettos of operas, achieving
particular success with *The Heiress*, the best
known of his dramatic works. Burgoyne had the
reputation of being something of a libertine and
a reckless gambler, and in his sixties he fathered
four illegitimate children (one of whom, Sir
John Fox Burgoyne (1782–1871), went on to a
distinguished military career). Burgoyne died on
4 August 1792, and was buried in Westminster
Abbey. His engaging personality made him a
popular figure. His large circle of friends
included Reynolds and Garrick.

Ramsay represented Burgoyne as standing
inside the Colosseum in Rome. A watercolour
of the interior of the Colosseum which Ramsay
had made in the summer of 1755 (no.55),
probably in the company of Robert Adam and
Clérisseau, served as a study for the background
of the picture. There could be no clearer
evidence of the influence of Pompeo Batoni,
who had recently begun to specialize in 'Grand
Tour portraits', wherein a visitor to Italy was
shown standing in front of some celebrated

monument of antiquity – frequently the
Colosseum – in recognition of the cultured
tastes which had drawn him to drink at the very
fount of the liberal arts. Batoni had already
painted a portrait of Lord Charlemont with the
Colosseum glimpsed in the distance through a
window (fig.11: see Anthony M. Clark, *Pompeo*
Batoni: A Complete Catalogue of his Works …,
Oxford, 1985, cat. no.219, pl. 205). Not, however,
until 1762, in a portrait of the *Marquess of*
Tavistock (ibid., cat. no.249, pl. 230), did Batoni
take the step of integrating the Colosseum
satisfactorily with the design as a whole, as
Ramsay had done in the *John Burgoyne*, and even
so, he still consigned it to the far distance. In
Ramsay's portrait, on the other hand, it is
carefully harmonised with the figure of the
sitter, who, in any case, stands inside the
amphitheatre and is thus more closely related to
it. Precedents for portraits of this type prior to
the eighteenth century include Domenico
Caprioli's *Lelio Torelli* of 1528 (Bowes Museum,
Barnard Castle) and Maerten van Heemskerck's
Self-portrait of 1553 (Fitzwilliam Museum,
Cambridge). An isolated early eighteenth-

century example is the half-length at Badminton
of *Henry, 3rd Duke of Beaufort*, datable in the
1740s and tentatively ascribed to Francesco
Trevisani and John Wootton.

Ramsay's portrait of Burgoyne is document-
ed, when still unfinished, in Robert Adam's
letter of 2 January 1756 to his sister Elizabeth –
for which see no.49.

Two small copies in oil are known:
(i) National Portrait Gallery, London, no.4158.
Canvas, 20 × 14in (50.8 × 35.6cm); (ii) New York
Historical Society, New York City. Canvas, 20 ×
14in (50.8 × 35.6cm). The latter was engraved for
Edward Barrington De Fonblanque's *Political*
and Military Episodes in the Latter Half of the
Eighteenth Century, Derived from the Life and
Correspondence of the Right Hon. John Burgoyne,
General, Statesman, Dramatist, London, 1876.
The New York picture was published as the
original portrait in John Fleming, 'Two
Rediscovered Portraits by Allan Ramsay,'
Connoisseur, CXXXIX, March 1957, p.76, fig 2.
See also Alastair Smart, 'The Genuine Portrait
of General Burgoyne by Allan Ramsay', *Apollo*,
XCIV, September 1971, pp.198 ff., fig.1.

54

55

THE INTERIOR OF THE COLOSSEUM

NGS, D.3775. *Watercolour, 14⅝ × 10¼in (37.2 × 27.3cm). Inscribed on the verso, in Ramsay's hand: Drawn in the Colisseum by A. R. Summer 1755. One of a number of watercolours, principally of the Colosseum, made by Ramsay in the summer months of 1755, almost certainly during sketching expeditions with the architects Robert Adam and Charles-Louis Clérisseau, who had in that year joined the painter's circle in Rome. It is probable that Ramsay was advised on the techniques of watercolour by Clérisseau, a practised exponent of the medium who was already well known as a vedutista.*

National Gallery of Scotland, Edinburgh

This watercolour drawing has a particular importance in that it came to serve as a study for the background in one of the finest portraits painted by Ramsay during his second visit to Italy, the half-length of *John Burgoyne* of 1756 (no.54).

56

ACADEMY STUDY OF A FEMALE NUDE

NGS, D.2209. *Black and white chalk on grey paper, 15⅝ × 20⅜in (39.8 × 51.8cm). Study of a nude woman, reclining. Inscribed on the verso, in Ramsay's hand: St Martin's Lane Nov* 1758. *Drawn at the St. Martin's Lane Academy.*

National Gallery of Scotland, Edinburgh

Ramsay had become a member of Hogarth's academy in St Martin's Lane on his return in 1738 from his early studies in Italy. It is a striking fact that not only did he draw regularly from the life during his first and second visits to Italy (1736–8 and 1754–7), but he continued to engage in this exacting discipline in his later years, when he was at the height of his success and reputation. The life-drawings that he made at the French Academy in Rome during his second Italian visit were severely criticized by Robert Adam: few of the surviving drawings from these years in Rome are particularly distinguished, and Ramsay was rarely at his best when drawing from the male figure, but, just as he excelled in the portraiture of women, so too the many known studies by him of the female nude, without exception, stand apart by their gracefulness and sensitivity.

57

STUDY AFTER BATONI

NGS, D.1946. *Black chalk, heightened with white, on grey paper, 16¼ × 10⅞in (41.3 × 27.6cm). Study of the figure of Christ in Glory in the altarpiece by Pompeo Batoni in the Church of Santi Celso e Giuliano, Rome. Drawn during Ramsay's second visit to Italy from 1754 to 1757, when he renewed his acquaintanceship with Batoni, whom he had come to know at the time of his early studies in Rome in 1736–8. This is one of a number of studies after Batoni executed by Ramsay on both these visits to Italy. See also no.12. For Batoni's influence on Ramsay see pp.17–18 and 26.*

National Gallery of Scotland, Edinburgh

57

55

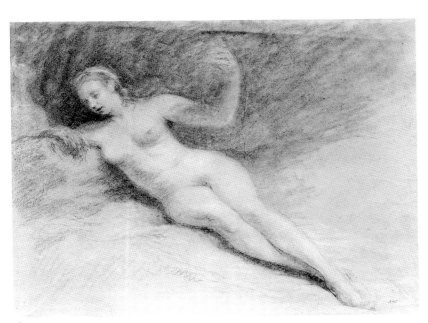

56

NGS, D.1949. *Red chalk, heightened with white, on grey paper, 10½ × 7½in (26.7 × 19cm). Inscribed on the verso, in Ramsay's hand:* Domenichino Chiesa S Luigi Oct[r]. 16. *One of a series of six detailed chalk studies made by Ramsay in September and October 1755 after the fresco-cycle of* The Life of St. Cecilia *painted in 1615–17 by the Bolognese master Domenichino (Domenico Zampieri) in S. Luigi dei Francesi, the church of the French community in Rome.*

National Gallery of Scotland, Edinburgh

Waterhouse has aptly described Domenichino's frescoes at S. Luigi dei Francesi as 'models of gracefulness', and there can be no doubt that it was as such that they attracted Ramsay's prolonged attention. His copies of them are the most detailed and completely realized of all his known studies after the great Italian masters, and in undertaking the task, which occupied several weeks of the year 1755, Ramsay was clearly responding especially to Domenichino's purity of draughtsmanship and controlled reticence of feeling.

NGS, D.3791. *Red chalk, heightened with white, on grey paper, 10¼ × 15⅝in (26 × 39.7cm). Inscribed on the verso, in Ramsay's hand:* Rafael in the French Accadamy August 26th 1755. *Study after the figure of 'Moderation' in Raphael's fresco of* The Cardinal Virtues *in the Stanza della Segnatura in the Vatican Palace; evidently made not from the original fresco but from a copy of it housed in the French Academy in Rome.*

National Gallery of Scotland, Edinburgh

Like most of the other studies after the Italian masters executed by Ramsay during his second visit to Italy (1754–7), the drawing is chiefly expressive of grace of line. It was at this time that Ramsay was developing the elegant drawing-style that characterizes his preparatory chalk studies after his return to London in 1757.

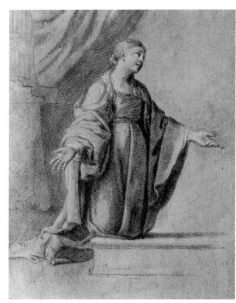

58

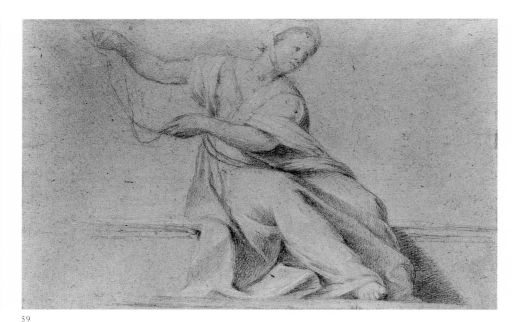

59

JOHN STUART, 3RD EARL OF BUTE

Canvas, 93 × 58in (236.2 × 147.3cm). The head and the upper part of the body painted on a separate rectangular piece of canvas sewn into the main support. Full-length: in Court dress, wearing the collar and jewel of the Thistle. Inscribed, bottom left: RAMSAY Pinxit 1758. *Inscribed, lower right:* JOHN third EARL OF BUTE / Knight of the Thistle and of the Garter / appointed / First Lord of the Treasury/1762, / when he concluded the Treaty of Paris called / Peace of Paris. This, the original Picture, painted by order of / The Prince of Wales, afterwards George / the Third, was given by His Majesty in/1783 to John, Lord Mountstuart. *Painted in 1758.*

The National Trust for Scotland, Bute House, Edinburgh

John Stuart, 3rd Earl of Bute (1713–1792), statesman and Prime Minister; elder son of James, 2nd Earl (died 1723) by his wife Lady Anne Campbell, daughter of Archibald, 1st Duke of Argyll and sister of John, 2nd Duke and Archibald, 3rd Duke (no.29); married, in 1736, Mary Wortley-Montagu, Baroness Mount Stuart of Wortley (daughter of Lady Mary Wortley-Montagu); a representative peer for Scotland from 1737, although at first preferring botanical and agricultural pursuits to politics; became tutor to the Prince of Wales, after whose accession to the throne in 1760 as King George III he was appointed a Privy Councillor; succeeded Newcastle as First Lord of the Treasury, and Prime Minister, in May 1762; resigned his office in April 1763, in the train of mounting unpopularity, and soon retired from politics.

Bute was a man of high principle and of considerable ability; but his lofty demeanour, his influence with the King and his alleged bias in promoting fellow Scots to prominent positions, together with scurrilous accusations of an improper relationship with the King's mother, the Princess Dowager of Wales (no.97), all contributed to a general feeling against him among Englishmen in particular. From this Ramsay himself suffered in a considerable degree, not least on account of insinuations that his elevation to the office of painter to the King, over the head of Reynolds, was to be explained by his Scottish birth.

Nevertheless, great importance attaches to the benefits enjoyed by Ramsay from Bute's patronage, and Bute's influence can be seen behind his first appointment, in 1761, as 'one of his Majesty's Principal Painters in Ordinary' – in effect the King's principal painter – and his second appointment, in 1767, to the full title of Principal Painter in Ordinary. On his return in 1757 from his second visit to Italy, Ramsay had been commissioned by Lord Bute to paint a full-length of the Prince of Wales (the future George III: see no.62); and the portrait of Bute was commissioned by the Prince in the following year. Like the portrait of the Prince, it was well received, and Ramsay's subsequent choice as painter to the King can be directly attributed to the recognition he had won by these two major works.

Ramsay made a preparatory study in black chalk of the pose, incorporating the coat and sash, but not the ermined robes seen in the painting (no.61). A drawing, also in black chalk, of the ancient statue of the *Satyr* on the Capitol in Rome, which is contained in a sketchbook used by Ramsay during his visit to Italy in 1754–7 (NGS, D.4878, fo.18), may be of some relevance, since the cross-legged pose of the ancient figure, which was much admired in the eighteenth century for its nonchalant elegance, may well have suggested to Ramsay the idea of adapting it to the portrait of the elegant Bute.

The portrait was popularized by two engravings by W.W. Ryland, in the second of which, executed in 1763, Ryland added a representation of the Garter, which had only recently been bestowed upon Lord Bute and which accordingly does not feature in the painting.

STUDY OF THE POSE FOR THE PORTRAIT OF THE 3RD EARL OF BUTE

NGS, D.233. Black chalk, heightened with white, on light blue paper, 19 × 11¼in (45.3 × 28.6cm). Full-length study of the pose for no.60, in coat and sash, without the ermined robes seen in the painting.

National Gallery of Scotland, Edinburgh

Ramsay has 'corrected' the drawing by adding some diagrammatic lines and scribbled directions: the three vertical lines marked *a* appear to indicate features that were to be vertically aligned, e.g., the right eye and right instep; the horizontal line marked *b* indicates the need to raise the lower right point of the sleeve to the level of the lower edge of the belt (as is suggested by the note to the left: *b / point sleeve*); the third button of the jacket is likewise, by way of correction, marked *4th*. The principal effect of these revisions, as is apparent from the finished painting, was to increase the graceful swing of the pose by bringing the head and torso further to the right.

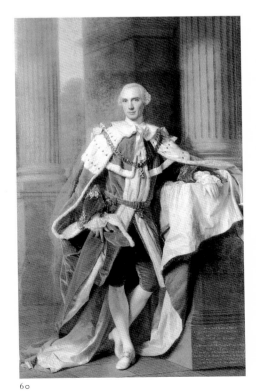

60

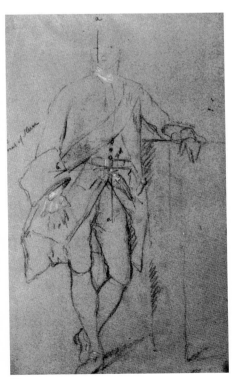

61

62

ENGRAVING BY W. W. RYLAND OF RAMSAY'S PORTRAIT OF GEORGE III WHEN PRINCE OF WALES

Line engraving, 23½ × 15¼in (59.7 × 38.7cm). Lettered, below the title: Engrav'd from an Original Picture painted by Mʳ. A. Ramsay in yᵉ Possession of the Earl of Bute. Pubᵈ. According to the Act of Parliamᵗ. March 20ᵗʰ. 1761, by W. Ryland in Litchfield Street, S. Ann, Soho.

National Portrait Gallery, London

William Wynne Ryland (1732–1783), who was trained in Paris, studying drawing under François Boucher and engraving under Jacques Philippe Le Bas, became official engraver to George III. His engraving of Ramsay's portrait of the King when Prince of Wales (Private Collection) was undertaken after Robert Strange had refused the commission. In 1767 Ryland engraved Ramsay's full-length of *George III in Coronation Robes* (see nos. 74 and 75), exhibiting the engraving at the Society of Artists in the same year.

Ramsay's portrait was commissioned by John Stuart, 3rd Earl of Bute (no.60), the Prince's tutor and, after his accession as George III, his chief minister. Ramsay received the commission shortly after his return from his second visit to Italy, and the Prince gave his first sitting – for a drawing of the pose – at Kew Palace on 12 October 1757. The painting was completed in August 1758, as Ramsay reported to Lord Bute on the 12th of that month, writing from his house at 31 Soho Square:

> The Prince of Wales's picture is dry enough to be transported if necessary; but I must beg leave to represent to your Lordship that, till it is put into its frame and hung upon a hook, it is no where safe but in my house, where my Student and the rest of my family are well instructed not to suffer any body to approach it without proper caution, and to guard it from copiers and print makers. I have seen too many fatal accidents befall loose picture[s] in unskillfull hands, not to be anxious about one that procured me so much notice.
> (Bute MSS., Mount Stuart.)

(The 'Student' referred to in the letter was presumably David Martin, who had become Ramsay's pupil about seven years earlier.)

The success of this splendid portrait, which for many years after the accession remained the most familiar likeness of the personable young monarch, must have played a decisive part in ensuring that Ramsay, rather than Reynolds, was appointed painter to the King. The picture is discussed on p.27.

63

COSTUME STUDY FOR A PORTRAIT OF HORACE WALPOLE

NGS, D.240. *Black chalk, heightened with white, on blue paper, 16⅝ × 11½in (42.2 × 29.2cm). Half-length study for the portrait in The Lewis Walpole Library, Yale University, Farmington, Connecticut, which was originally at half length but which has been reduced to a scale slightly under half length. The drawing shows the complete composition, including details now missing from the painting – e.g., the sitter's right hand, the whole of the quill pen and the table. (The drawing has been wrongly described as a study for a three-quarter-length.) The painting is reproduced in Wilmarsh S. Lewis,* Horace Walpole *(The A. W. Mellon Lectures in the Fine Arts), London, 1961, pl. 14, and in* The Yale Edition of Horace Walpole's Correspondence *(ed. W. S. Lewis), vol. VIII:* Horace Walpole's Correspondence with Hannah More, Lady Browne, Lady George Lennox, Lady Mary Coke, Anne Pitt, Lady Hervey, Lady Suffolk, Mary Hamilton (Mrs. John Dickenson) *(ed. W. S. Lewis, Robert A. Smith and Charles H. Bennett), London and New Haven, 1961, pl. opp.p. 9. A tablet on the frame of the picture gives the date of the painting as 1759, which may, however, have been suggested by the fact that it was in that year that Walpole made his famous comparison between Ramsay and Reynolds. Nevertheless a dating in 1758 or 1759 seems entirely acceptable.*

National Gallery of Scotland, Edinburgh

Horace (or Horatio) Walpole, afterwards 4th Earl of Orford (1717–1797), author, letter-writer and connoisseur; fourth and youngest son of Sir Robert Walpole, 1st Earl of Orford (Prime Minister in the reigns of George I and George II) by his first wife Catherine Shofer; educated at Eton and at King's College, Cambridge; travelled in France and Italy in 1739–41 with the poet Thomas Gray (a close friend); lived from 1747 in his 'Gothick Castle' at Strawberry Hill, Twickenham, where he built up a fine library and art collection and established a printing-press (Gray's *Odes* being among the works printed there); engaged in a vast, gossipy and illuminating correspondence with a host of people in various walks of life; published in 1764 his 'Gothic' novel *The Castle of Otranto*, and from 1762 to 1771 the four volumes of his *Anecdotes of Painting in England*, the first attempt at a comprehensive history of the arts in England, based partly on the *Notebooks* of George Vertue (which he had acquired); his *Memoirs* contain much information about political events of the day.

Walpole much admired Ramsay as a painter, coupling his name with that of Reynolds in an encomium in the Preface to the *Anecdotes*, in which he observed:

> Painting has been circumscribed within as selfish bounds as statuary; historic composi-

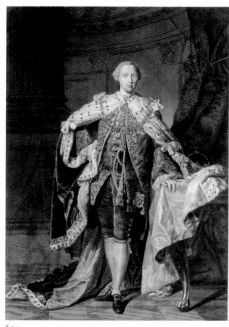

62

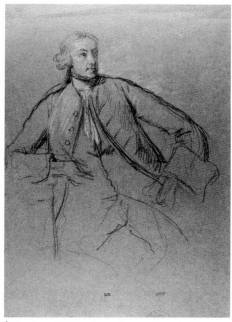

63

He had already compared the two artists in a now famous letter of 25 February 1759 addressed to Sir David Dalrymple of Hailes, afterwards Lord Hailes (1726–1792), the Edinburgh lawyer and scholar, in which, having expressed his admiration of William Robertson's *History of Scotland*, he found himself dwelling first on Ramsay's merits as a writer:

> I have discovered another very agreeable writer among your countrymen, and in a profession where I did not look for an author: it is Mr Ramsay the painter, whose pieces being anonymous, have been overlooked. He has a great deal of genuine wit and a very just manner of reasoning. In his own walk, he has great merit. He and Mr Reynolds are our favourite painters, and two of the very best we ever had – Indeed, the number of good has been very small, considering the numbers there are – A very few years ago, there were computed *two thousand* portrait painters in London; I don't exaggerate the computation but diminish it, though I think it must have been exaggerated. Mr Reynolds and Mr Ramsay can scarce be rivals, their manners are so different. The former is bold, and has a kind of tempestuous colouring; yet with dignity and grace; the latter is all delicacy. Mr Reynolds seldom succeeds in women; Mr Ramsay is formed to paint them.
> (*Horace Walpole's Correspondence with Sir David Dalrymple* (ed. W.S. Lewis and Andrew G. Hoover), London, Oxford University Press, and New Haven, Yale University Press, 1952: vol. XV of *The Yale Edition of Horace Walpole's Correspondence* (ed. W.S. Lewis), p.47.

The early provenance of Ramsay's portrait of Walpole is unknown, but it seems to have been painted at the suggestion of Lady Hervey, who may not, however, have commissioned it, since if she had done so we should expect it to have hung at Ickworth. The connection with Lady Hervey, a personal friend of Walpole's, is provided by a letter which he wrote to her on 17 October 1758, and in which he says:

> Your Ladyship, I hope, will not think that such a strange thing as my own picture seems of consequence enough to me to write a letter about it: but obeying your commands does seem so; and lest you should return and think I had neglected it, I must say that I have come to town three several times on purpose, but Mr. Ramsay (I will forgive him) has been constantly out of town – so much for that.
> (ibid., pp.9 ff.)

Canvas, 30 × 25in (76.2 × 63.5cm). Half-length: in a white satin dress in mock seventeenth-century style, with a pearl necklace. Signed and dated, bottom left: A. Ramsay/1758.

The Rt. Hon. Lord Home of The Hirsel, K.T.

Mary Campbell (1726–1811), fourth and youngest daughter of John, 2nd Duke of Argyll by his second wife Jane Warburton; married, in 1747, the profligate Edward, Viscount Coke (died 1753), only son of Sir Thomas Coke, Earl of Leicester; but, as he treated her with complete indifference, even abandoning her at the church after the marriage service, she remained his wife only in name. Lady Mary spent much of her time at Court, forming a friendship with Princess Amelia (the daughter of George II). She travelled widely on the Continent, becoming a particular favourite of Court circles in Vienna. She was celebrated for her handsome presence, for her wit and for her wilfulness and independence of character. Horace Walpole dedicated to her the second edition of *The Castle of Otranto*.

Lady Temple (no.68) penned the following verses upon her:

> She sometimes laughs, but never loud;
> She's handsome too, but somewhat proud.
> At court she bears away the bell;
> She dresses fine, and figures well;
> With decency she's gay and airy;
> Who can this be but Lady Mary?

This may be one of the pictures that Horace Walpole had in mind when in January 1759 he remarked in a letter to Sir David Dalrymple (Lord Hailes) that Ramsay was 'formed' to paint women (see no.63). Lady Mary sat to Ramsay again in 1762 for the well-known full-length (Private Collection).

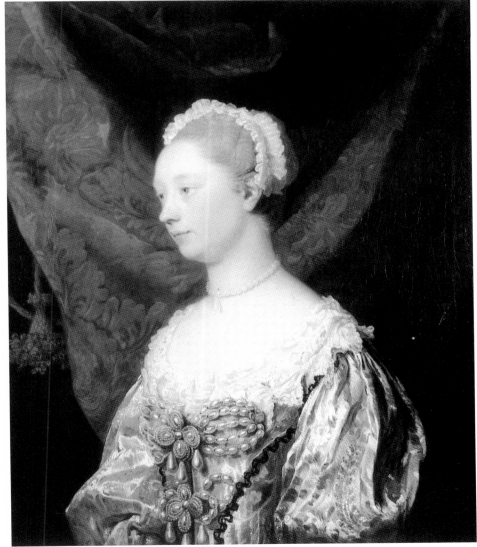

64

LADY LOUISA CONOLLY

Canvas, 92 × 56in (233.7 × 142.2cm); painted on five pieces of canvas sewn together. Full-length: in a pink flounced dress and bodice with blue bands, with pink flowers in her hair, standing in a garden with a bunch of grapes in her right hand, and resting her right arm on a finely carved pedestal à la Grecque, *on which there stands a basket of grapes. Signed and dated, bottom left:* A. Ramsay 1759. *Inscribed, bottom right:* Lady Louisa Conolly.

Private Collection

Lady Louisa Lennox (1743–1821), daughter of Charles, 2nd Duke of Richmond and Lennox; married, in 1758, the Rt. Hon. Thomas Conolly of Castletown; sister of Caroline, Baroness Holland (no.90).

Ramsay made a preliminary chalk drawing of the pose and two studies of the sitter's right hand and the bunch of grapes (NGS, D.2092 and D.2093).

In the early and middle 1760s Caroline, Baroness Holland commissioned from Ramsay and Reynolds a series of portraits of members of the Fox and Lennox families, to hang in her new gallery at Holland House in Kensington. A full-length of Lady Louisa Conolly was among these, and was intended to form the companion piece ('over against the chimney') to Reynolds's group-portrait of *Charles James Fox, Lady Sarah Bunbury and Lady Susan Fox-Strangways* (painted in 1762). The painting in question is mentioned in Lady Holland's correspondence in the years 1762 and 1763, but initially in the context of her wish to have 'a copy' of a portrait of Lady Louisa by Ramsay, as we learn from a letter which she wrote to her sister on 14 June 1762: 'I will beg to have a copy of your picture done by Ramsay when I have settled what size it should be' (*Correspondence of Emily, Duchess of Leinster* (ed. Brian FitzGerald), Dublin, 1949, vol.I, p.330). In a further letter, addressed to her sister Emily on 11 September 1763, in which she explained that she had marked the places in the gallery where the various pictures would be hung, she stated: 'The two full-lengths over against the chimney are for Louisa, and the picture of Sal, Lady Sue and Charles, done by Reynolds [i.e. Reynolds's group-portrait].' As Ramsay's full-length of Lady Louisa, painted in 1759, was already in existence prior to the creation of the gallery at Holland House, it may be presumed that this was the picture of which Lady Holland desired a copy. Either the original portrait or a version of it is known to have once hung at Holland House, being recorded there in 1874 (Princess Marie Liechtenstein, *Holland House*, London, 1874, vol.II, pp. 77f.), and in 1904 the Earl of Ilchester gave a full description

of the composition and noted that the picture hung at that time in Addison's Room at Holland House (Henry Edward Fox Strang-ways, Earl of Ilchester, *Catalogue of Pictures belonging to the Earl of Ilchester at Holland House*, privately printed, 1904, p.117, no.151). Two solutions to this problem suggest themselves: either that the idea of having a copy of the original full-length of 1759 was abandoned for some reason, and that the original portrait was sent to Holland House; or that the copy was made, but was retained by the Conollys, the original being sent to Holland House. The picture has descended through the Ilchester family, and must of course be Ramsay's original.

This portrait foreshadows the tender poetry of his manner in the late 1760s, as exemplified most notably by the *Princess Augusta* of 1769 (no.97). While the delicacy of treatment recalls the flavour of contemporary French portraiture, the frieze-like effect of the draperies, matching the relief on the garden ornament against which the sitter is posed, may be said to reflect a sensibility attuned to the decorative refinement of antique relief-sculpture; qualities brought out, for instance, in a pair of drawings by Ramsay of an antique urn at Windsor (introduced into a portrait of *Princess Augusta* of c.1764): see no.98.

There are two remarkable passages of observation in the picture: the lower two grapes in the sitter's hand reflect the pink of her dress, and the underside of her chin picks up the silvery tone of her pearl necklace.

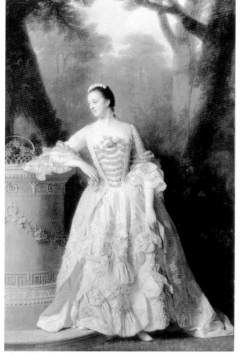

65

MARGARET RAMSAY, THE PAINTER'S SECOND WIFE

Canvas, 29¼ × 24⅜in (74.3 × 61.9cm). Half-length: in a plum-coloured dress covered by a fichu (or 'handkerchief') of blonde lace, with blue silk necklace and blue pompon, seated to the right, with her elbows resting on a table and with her head turned over her right shoulder to face the spectator, and holding in her raised left hand a white rose in front of a bowl of roses and other flowers, which she is in the act of arranging; window shuttering in the background, to the left. Probably painted c.1758–60 (see below).

National Gallery of Scotland, Edinburgh

Margaret Ramsay (died 1782), elder daughter of Sir Alexander Lindsay, Bt., of Evelick (died 1762), by his wife Amelia Murray (died 1774), daughter of David Murray, 5th Viscount Stormont and sister of William Murray, 1st Earl of Mansfield (the great Lord Chief Justice); eloped with Allan Ramsay in Edinburgh on 1 March 1752, the marriage taking place on the same day in the Canongate Church, without the consent of her parents, who immediately broke off all relations with her, although after Sir Alexander's death a reconciliation was achieved with Lady Lindsay, who was now looked after by her elder daughter and son-in-law.

Robert Adam, who came to know Margaret Ramsay very well in Rome a few years after her marriage, described her as 'a sweet, agreeable, chatty body'. Hester Thrale said of her that she 'did love, honour and obey' her husband 'as never sovereign prince was loved, honoured and obeyed'. Margaret Ramsay bore the painter three children who survived childhood: Amelia (Lady Campbell), Charlotte (Mrs Henry Malcolm) and John, who made his career in the Army, rising to the rank of Major-General, and died unmarried.

There is a drawing by Ramsay of the left hand and rose (no.67). Its feathery lightness and almost fragile delicacy, very much in the French rococo taste, are typical of the drawing style which he had developed during his second visit to Italy (1754–7), when he had returned to draw from the life at the French Academy.

This is by far the most famous of all Ramsay's portraits and one that epitomizes the exquisite qualities of his female portraiture in the period immediately following his return from Italy in the summer of 1757. It hung originally in Ramsay's house in Soho Square and may have been one of the portraits of women that drew Horace Walpole's praises in 1759 (see no.63).

In this picture, his acknowledged master-piece, Ramsay may be said to have attained perfect expression of his ideal of the 'natural portrait'. His wife is not posing for her likeness,

but has been captured in the everyday domestic act of arranging a vase of flowers, and she turns her serene face towards the observer, the painter himself, as he enters the room. The exquisite colour – mostly soft pastel shades – is matched by the harmonious balance of the design, which holds what action there is in a momentary stasis, as though for our contemplation, and which reflects the intellectuality that underlies the tender sentiment expressed.

The picture provides us with particularly clear evidence of Ramsay's technical procedures in this period. The head was executed at the first sitting – according to his normal practice from 1738 – in a vermilion underpainting, over which the final colours were thinly applied. The remainder of the composition was first laid in with a warm umber, which has been left virtually untouched in the window-shutters on the left, and which also underlies the pink, yellow and white flowers in the vase. The final colours were then added with much use of glazing. Margaret Ramsay's dress, covered by the lace fichu, would at one stage have been entirely in monochrome, the final plum-colour being swept on in a transparent glaze (under which the mono-chrome underpainting is still visible) and then picked out, while the paint was still wet, to reveal the white lace of the fichu. To adopt the phrase used by Horace Walpole to describe the character of Ramsay's art, the very method is 'all delicacy'.

It has been frequently, but mistakenly, assumed that the picture was painted during Ramsay's second visit to Italy from 1754 to 1757, and that it is to be identified with a portrait of Margaret Ramsay mentioned by Robert Adam in a letter of 2 January 1756 to one of his sisters. The work mentioned by Adam was in fact a very different composition, showing the artist's wife with a parasol held above her head (see Alastair Smart, 'A Newly Discovered Portrait of Allan Ramsay's Second Wife', *Apollo*, xiii, May 1981, pp.288 ff., fig.7). The latter picture was painted shortly after the birth in Rome, in March 1755, of the painter's daughter Amelia (no.105), as though in celebration of the event; and it is very possible that the Edinburgh picture commem-orates the birth of his second daughter Charlotte in September 1758. More pertinently, the style indicates a date not far from the year 1760. Likewise, the evidence from the costume and the styling of the hair is particularly suggestive. The emphatic plait, conforming to the tendency from the late 1750s for ladies to wear their hair piled on top of the head, and the toupet at the front, with its rather severe line, similar to that in the *Lady Susan Fox-Strangways* of 1761

(no.71), would be surprising much before 1759. Similarly, the size of the sleeve ruffles again points to a dating not earlier than 1757. (The above comments on costume and hair-styling are based on information kindly communicated to the compiler by Dr. Aileen Ribeiro.) An indication that the picture is to be dated before 1760 is provided by the apparent repetition of primary features of the composition in a portrait by Ramsay of *Maria, Countess of Coventry* (present whereabouts unknown). The young countess was to die in September 1760 from cancer of the skin, which had so destroyed her once acclaimed beauty that she could not bear to be seen in daylight, and it is therefore unlikely that she sat for her portrait as late as that year. Further evidence is supplied by another portrait by Ramsay seemingly derivative in its design from the Edinburgh *Margaret Ramsay* – a half-length of the *Countess of Sutherland* (Dunrobin Castle), which was almost certainly painted about the time of Lady Sutherland's marriage in April 1761.

Ramsay's preoccupation with this type of composition over a period of several years – culminating in a very much later half-length of *Jean Morison of Haddo* (Private Collection) – suggests that he was pleased by the naturalness of the attitude, which avoids the sense that the sitter is posing for her portrait. It may have had a similar appeal to prospective patrons or sitters who might have seen the Edinburgh picture in Ramsay's house. (See also under no.104.)

67

STUDY FOR THE PORTRAIT OF MARGARET LINDSAY, THE ARTIST'S SECOND WIFE

NGS, D.2094. *Red chalk, heightened with white, on buff paper, 7⅝ × 7¾in (19.4 × 19.7cm). Study of the sitter's left hand, holding a white rose, for no.66. c.1758–60.*

National Gallery of Scotland, Edinburgh

This well-known study, slight though it may appear, exemplifies the delicacy of the drawing-style developed by Ramsay during his second visit to Italy. The precision of the drawing has, unfortunately, been lost in the painting (no.66) due to some minor rubbing in the area of the hand. This damage also occurs in the version, possibly by David Martin, in the collection of the Marquess of Lansdowne.

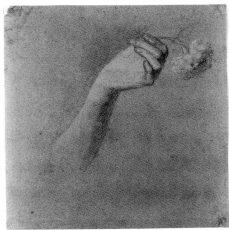

67

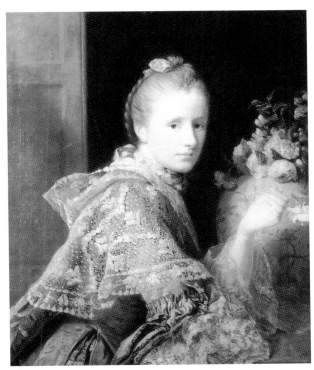

66

68

ANNE CHAMBERS,
COUNTESS TEMPLE

Canvas, 50½ × 40½in (128.3 × 102.9cm). Three-quarter-length: in a brilliant blue ruched dress with wide lace sleeves and ribbon tippet, and blue and white frilled cap, seated in profile to the left beside a gilt wood table, on which she rests her left arm, and holding a spool and thread in her right hand and a piece of embroidery in her left; in the background to the left, a window partly screened by a light red curtain; a mantelpiece to the right, on which is placed a china vase delicately coloured in pinks and grey-greens. Signed and dated, lower left (below the window): A. Ramsay/1760.

The Trustees of the Chevening Estate

Anne Chambers (1709–1777), daughter of Thomas Chambers of Hanworth; married, in 1737, Richard Grenville, 2nd Earl Temple (no.77).

 A payment to Ramsay, evidently for this picture, is recorded in the ledgers of the 2nd Earl Temple's banking account with Coutts & Coutts (later Coutts'):

 3 January 1761 … to Mr Ramsay … £42.
 (Coutts' Bank, London: Ledger 37, fo. 363, Account of Earl Temple.)

The vivid blue of the sitter's dress establishes the dominant note in what is one of Ramsay's most original exercises in colour-orchestration; and, besides being contrasted with the light red of the curtain, it is set off by the cooler notes of silvery grey in the mantelpiece and grey-green in the passage of landscape glimpsed through the window. The feeling is particularly French. Similarly, the informality of the presentation, whereby the sitter is represented as being occupied with her embroidery in her parlour or drawing-room, is paralleled in many French portraits of the period.

 A study by Ramsay for the hands and spool of thread has been preserved: NGS, D.2105. Red chalk, heightened with white, on buff paper, 7⅜ x 7⅜in (18.7 × 18.7cm).

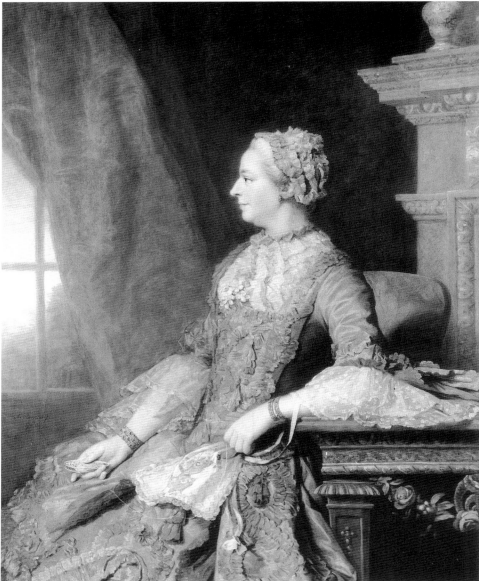

68

*Canvas, 50 × 40in (127 × 101.8cm). Three-
quarter-length: in a purple dress with yellow
flowers at her breast, seated with her left arm resting
on a table and holding a closed fan at her lap, her
right hand gloved, her left hand concealed by a muff.
Signed and dated, lower left:* A. Ramsay/1761.

Birmingham Museums and Art Gallery

Mary Atkins, sister of Rear-Admiral Samuel
Atkins; married, in 1726, Captain (afterwards
Admiral) William Martin of Hemingstone in
Suffolk (1696?–1756). Her husband, appointed
Rear-Admiral in 1744 and promoted Admiral of
the Blue in 1747, played a leading part in the
neutralization of the Kingdom of Naples in 1742,
and subsequently in protecting Tuscany from
Spanish invasion. He spent his last years in
retirement at Twickenham. He was a lover of
the classics and a fluent linguist in French,
Italian, Spanish and German.

Ramsay's chalk study of the pose is included
in the exhibition (no.70).

The picture is one of a considerable number
of female portraits by Ramsay from the middle
1750s onwards, and especially in the 1760s, that
show close affinities with the work of Jean-Marc
Nattier, official painter to the daughters of Louis
XV. Kitson observes of it: 'Ramsay's smoothness
and directness, quite unlike the robustness of
Reynolds or the bravura of Gainsborough,
reflect the Italian background of his art. But
there is something French in his brushwork and
colour, here reflected in silvery tonality that
recalls Nattier, as does the rather nonchalant,
almost homely, flavour of the portrait, which in
Britain is hardly paralleled until Raeburn,
another Scot' (Michael Kitson, *The Age of
Baroque*, London, 1966, p.61).

Ramsay adapted the design of the *Mary
Martin* to his posthumous portrait of Queen
Charlotte's mother, Princess Elisabeth
Albertina (no.99).

69

70

COSTUME-STUDY FOR THE PORTRAIT OF MARY MARTIN

NGS, D.2038. *Black chalk, heightened with white,
on light blue paper, 16⅛ × 12in (41 × 30.5cm).
Inscribed at the top in white chalk, in Ramsay's
hand:* bouquet left breast / Single drop [?] *(the
last word unclear). Study of pose and costume for
no.69, drawn in 1760 or 1761. The design was
slightly modified in the painting by the introduction
of a bouquet of flowers at the sitter's breast and by
the consequent need to drop the position of the left*

*hand: the inscription on the drawing clearly relates
to the first of these modifications and perhaps also to
the second.*

National Gallery of Scotland, Edinburgh

Ramsay presumably consulted this drawing
when, some eight or nine years later, he adapted
the design of the *Mary Martin* (no.69) to his
posthumous portrait of Queen Charlotte's
mother, Princess Elisabeth Albertina of
Mecklenburg-Strelitz (no.99). One
consequence of his procedure is that the
princess, who died in 1761, is portrayed as being
dressed in the fashion of her day.

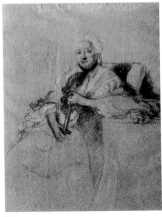

70

LADY SUSAN FOX-STRANGWAYS

Canvas, 35½ × 27¾in (90.2 × 70.5cm). Half-length: in a white dress with blue trimmings, a tippet passing around her neck and down to her bodice, a blue pompon on her head; seated on a chair by a table, on which she leans her left elbow; in the background, to the left, a fluted pilaster, and, to the right, a curtain. Signed and dated, bottom right: A. Ramsay/1761.

Private Collection

Lady Susan Fox-Strangways (1743–1827), baptized Susannah Sara Louisa, eldest daughter of Stephen Fox Strangways, 1st Earl of Ilchester, by his wife Elizabeth Strangways Horner (whose maiden name of Horner he adopted); bridesmaid, in 1761, to Queen Charlotte. In 1759 she went to live at Holland House, where she formed a close attachment to Lady Sarah Lennox (afterwards Bunbury), one of the sisters of Ramsay's patroness Lady Holland (no.90), the two girls attracting the attention of society by their beauty and intelligence, and performing together in the family plays which had become a tradition at Holland House. In April 1764, to the distress of her parents and to the disapproval of society in general, she eloped with the Irish actor William O'Brien (died 1815), a distant relation of the O'Briens, Viscounts Clare, who, since 1758, had been engaged by Garrick for Drury Lane. She then accompanied her husband to North America, where he was given an appointment under Sir Henry Moore, governor of the province of New York, before moving to Quebec. In May 1768 O'Brien was gazetted secretary and provost-master-general of Bermuda. In 1771 they returned to England and settled at Stinsford House, near Dorchester, O'Brien being appointed, through Lord Ilchester's interest, receiver-general of Dorset. There are monuments to O'Brien and Lady Susan in Stinsford Church.

Two chalk studies by Ramsay for the picture are known: see no.72.

Horace Walpole noted the picture during a visit to Melbury House in July 1762 soon after it was painted:

> Lady Susan Fox-Strangways, by Ramsay, half length, very good, 1761: … in white & green ribbands.
> (Horace Walpole, 'Journals of Visits to Country Seats &c.', *Walpole Society*, XVI (1927–8), 1928, p.47.)

The picture is also mentioned in a letter to the sitter from Lady Sarah Bunbury, written from London on 15 September 1765 after she had been staying at Melbury (i.e. after Lady Susan's elopement):

I could not bear Redlinch where I staid for one night only, and even at Melbury you were not free from my thoughts for one moment. I do assure you, I spent much of my time in looking at your picture by Ramsay that hung in the closet to the Chintz Room where I was.
(*The Life and Letters of Lady Sarah Lennox 1745–1826* (ed. The Countess of Ilchester and Lord Stavordale), London, 1901, vol.I, p. 175.)

This sensitive portrait is one of the most perfect of Ramsay's realizations of his ideal, as expressed in his essay *On Ridicule* (1753), of the 'graceful in Nature', and typifies the delicacy and reticence of his personal interpretation of the rococo style. The motif of the folded hands – contrasting in their relaxed naturalness with the often stilted gestures common in English portraiture of the first half of the century – recalls the work of such contemporary French painters as Jean-Marc Nattier and Jacques André Aved; but it is also to be noted that the same manner of representing a sitter's hands already occurs in Van Dyck's portrayal of the Countess of Pembroke in his group of the *Herbert Family* at Wilton, a composition of enormous influence which would have been particularly well known in the eighteenth century through Bernard Baron's fine engraving of 1740. There are various hints of Ramsay's study of Van Dyck at the time of his early commissions for the Court (from the year 1761). Similar poses are to be seen in some female portraits by Reynolds of about this date (e.g. the *Kitty Fisher* at Petworth: National Trust, Egremont Collection; painted in 1759).

STUDY OF THE HANDS FOR THE PORTRAIT OF LADY SUSAN FOX-STRANGWAYS

NGS, D.2083. *Red chalk, heightened with white, on buff paper, 7⅜ × 7⅜in (18.7 × 18.7cm). Preparatory study for no.71 (painted in 1761).*

National Gallery of Scotland, Edinburgh

A complete study of the pose is in the Ashmolean Museum, Oxford (1507): black chalk, heightened with white, on blue paper, 19⅗ × 12⅓in (49.8 × 31cm), irregular. (See David Blayney Brown, *Ashmolean Museum, Oxford: Catalogue of the Drawings, IV, The Earlier British Drawings, British Artists and Foreigners working in Britain from before c.1775*, Oxford, 1982, no.1507.)

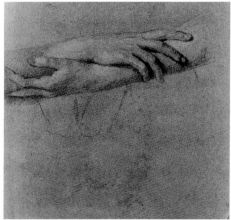

72

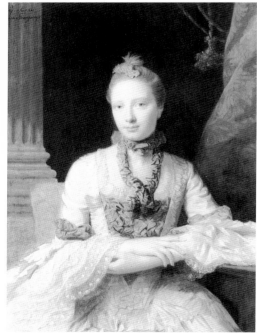

71

73

(SIR) WILLIAM GUISE

Canvas, 49¼ × 39¼in (125.1 × 99.7cm). Three-quarter-length: standing, sworded, with his right arm resting on two books lying on a table, a fluted pilaster behind. Signed and dated, bottom left: A. Ramsay./1761 [?]. The last digit, which is not very clear, has also been read as a 4: see below. Inscribed, bottom right: Sir William Guise v Bᵗ. ᴍ.ᴘ./ obᵗ. unmarried 1783.

Sir John Guise, Bt., and the Trustees of the Elmore Court Estate

William Guise (1737–1783), English politician; only son of Sir John Guise, 4th Bt., of Elmore Court in Gloucestershire, whom he succeeded as 5th baronet in 1769; took his ᴍ.ᴀ. at Oxford in 1751, and in 1754 entered Lincoln's Inn; in October 1762 went to Lausanne, ostensibly to learn French but also, apparently, to recover from a disappointment in love; while in Lausanne, formed a close friendship with Edmund Gibbon, the future historian, with the consequence that they agreed to make the Grand Tour together, arriving in Rome on 2 October 1764; in 1769 signed the Gloucestershire petition in favour of Wilkes; elected Member of Parliament for Gloucestershire in 1770, becoming a supporter of the Opposition.

During his journey to Italy in 1764 Gibbon wrote to his father: 'Mr Guise and I travel in great harmony and good humour. He is indeed a very worthy sensible man … He is very far from being ignorant and will be more so every day, as he has a very proper spirit of curiosity and enquiry' (*Letters of Edmund Gibbon* (ed. J. E. Norton), London, 1956, vol.ɪ, p.179). On 3

December 1764 the two friends were admiring Anton Raphael Mengs's famous ceiling painting of *Parnassus* in the Villa Albani, completed three years earlier (see *Gibbon's Journey from Geneva to Rome: His Journal from 20 April to 2 October 1764* (ed. Georges A. Bonnard), London, Edinburgh etc., 1961).

A costume study by Ramsay for this portrait is at the Yale Center for British Art, New Haven, Connecticut (ʙ1977.14.6069 (75/ 6/12/ 47)). Black chalk, heightened with white, on light blue paper, 19¾ × 12⅛in (50.2 × 30.8cm). Inscribed in Ramsay's hand, to the right: *7 button / from bottom.*

The alternative reading *1764* for the date on the canvas would seem to be excluded by the fact that, so far as is known, the sitter was abroad during the whole of that year – unless, of course, the sittings took place towards the end of 1763 and the picture was completed in the year following, in Guise's absence. The developed style, with its depth and richness of tone and its poetic lighting, would certainly be compatible with the later dating. There are some *pentimenti* around the head.

This is one of the most beautiful of all Ramsay's portraits of male sitters. The rococo elegance of the pose may well have made a particular impression on Francis Cotes, whose three-quarter-length of *Richard Myddelton* (*c*.1767–70) at Chirk Castle (exhibited Nottingham University Art Gallery, *Introducing Francis Cotes, R.A. (1726–1770)*, 1971, no.33) is very similar in mood, while apparently reflecting, like Ramsay's portrait, strong French influence.

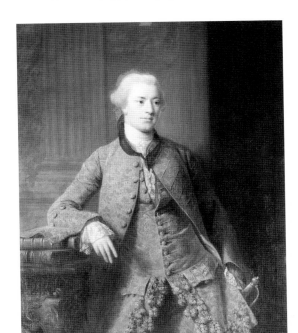

73

74 *plate 33*

KING GEORGE III IN CORONATION ROBES (REPLICA)

Canvas, 98¼ × 64⅛in (249.7 × 163cm). Full-length: in coronation robes of blue and ermine worn over a gold coat and gold breeches, standing on a carpeted dais and resting his left hand on a table, on which there is placed a crown; in the background, to the left, a large fluted column, with a curtain. Replica of the original coronation portrait in the possession of Her Majesty The Queen.

Scottish National Portrait Gallery, Edinburgh

George III ascended the throne in October 1760. By his sittings thereafter to Ramsay he indicated, in effect, his choice of the artist whom he desired to become his Principal Painter in Ordinary in succession to John Shackleton (died 1767), Principal Painter in the previous reign. It seems that in consequence Ramsay considered it unnecessary to make formal application for the post to the Lord Chamberlain, William Cavendish, 4th Duke of Devonshire, who, without consulting the King, renewed Shackleton's appointment. An inevitable difficulty and embarrassment arose, for, whereas the official State portraits of the King and Queen and the many copies that were required of them were normally the responsibility of the Principal Painter in Ordinary, the King had sat to Ramsay rather than to the much inferior Shackleton, and afterwards intimated his desire that all the replicas ordered through the Lord Chamberlain's department should likewise be entrusted to Ramsay. It was necessary therefore for Ramsay's position at Court to be given some official status: this was done in December 1761 by his appointment as 'one of His Majesty's Principal Painters in Ordinary'. (It was, however, stipulated that, although he would continue to enjoy the King's patronage, the salary that went with the office of Principal Painter would continue to be reserved for Shackleton.) On Shackleton's death in 1767 Ramsay succeeded him in the full office of Principal Painter in Ordinary, which, before the foundation of the Royal Academy in December 1768, with Reynolds as its first President, was the highest honour to which a British artist could aspire.

The circumstances relating to the appointment of December 1761 are explained in a letter of 10 January 1766 from Ramsay to William Henry Cavendish Bentinck, 3rd Duke of Portland (1738–1809), at that time Lord Chamberlain (as well as being, as it happened, the son-in-law of the 4th Duke of Devonshire), in which an account is given of the commissions for the original coronation portraits and the profile portrait of the King for the coinage:

Upon my return from my second journey to

Italy, in September 1757, I had the honour of being employed to paint his Majesty, then Prince of Wales, at whole length; and my work, when finished, was so fortunate as to recieve [sic] his approbation. When his Majesty came to the Crown he was still pleased to honour me with his employment, and I painted, from the life, a whole length picture of him for Hanover, a profil for the coinage, and another whole length, which, after the Coronation, I, by his Majesties orders, dressed in Coronation robes. Soon after her Majesty's arrival, she likewise did me the honour to sit to me; and these two pictures in Coronation robes are the originals from which all the copies ordered by the Lord Chamberlain are painted.
(The Hallward Library, University of Nottingham, Portland MS. PwF 8031; quoted by R. W. Goulding and C. K. Adams, *Catalogue of the Pictures belonging to His Grace the Duke of Portland*, London, 1936, pp.470 ff.)

In a letter of 19 December 1761 to Lord Bute Ramsay refers both to the picture of the King 'intended for St. James's' and to the full-length for Hanover which he was 'new-painting'.

After his appointment in December 1761 as 'one of His Majesty's Principal Painters in Ordinary', Ramsay was responsible for producing, with the help of his studio assistants, the vast number of copies of the coronation portraits of George III and Queen Charlotte (no.75) which Ambassadors and Governors of Provinces were entitled to receive as presents from the King, and which others could purchase by application to the Lord Chamberlain's department. The production of such copies of official State portraits was one of the normal duties of a Court painter; and Ramsay's appointment of December 1761 enabled him, rather than Shackleton, to fulfil the King's wish that all the copies of the coronation portraits should be his own responsibility. The fact that so many of them were produced has been widely misunderstood, and it has frequently been stated, quite erroneously, that soon after receiving his Court appointment Ramsay painted little or nothing apart from these copies. Nevertheless, for several years Ramsay insisted on painting the heads himself, as we are informed by his first biographer Allan Cunningham, who had most of his information from Ramsay Richard Reinagle, the son of Ramsay's chief assistant Philip Reinagle. In a letter of 28 October 1762 to Lord Bute, which refers to copies of the coronation portrait of the King, Ramsay says: '... I have resolved to give the last painting of all of them with my own

hand' (Yale University Library, Tinker Collection, 1707).

Joseph Moser, who knew and admired Ramsay both as a painter and as a writer, gave the following account of the veritable picture-factory which Ramsay's studio in Soho Square had become in consequence of the unabating demand for replicas of the coronation portraits:

I have seen his show-room crowded with portraits of His Majesty in every stage of their operation. The ardour with which these beloved objects were sought for by distant corporations and transmarine colonies was astonishing; the painter with all the assistance he could procure could by no means satisfy the diurnal demands that were made in Soho Square upon his talents and industry, which was probably the reason why some of these pictures were not so highly finished as they ought to have been.

On his removal, by 1767, to 67 Harley Street, Ramsay converted the coachmen's rooms and the haylofts into a painting-room, rebuilt to form one long gallery, and it was there that the majority of the replicas were painted.

Initially, his principal assistant was David Martin, who had entered his studio as an apprentice as early as 1752 (and had also joined him in Italy in 1755). By the financial year 1766–7 Martin was receiving fees from Ramsay in excess of £300. From about 1769 Ramsay's principal assistant in the production of the copies of the coronation portraits was Philip Reinagle, who remained in his service until the artist's death in 1784, and who is said to have painted as many as ninety pairs of the State portraits of the King and Queen. The production of these copies was a lucrative business, and helped to make Ramsay a very rich man. The income received by him for royal commissions in the period October 1775 to October 1776, when he was away in Italy and Reinagle was painting the pictures, may be taken as an indication of the financial benefit brought to him by his office. This is recorded as follows: 'Allan Ramsay, Principal Painter in Ordinary, for several whole Length Pictures of Their Majesties and other Work done for His Majesty within the time of this account – £1,127. 17. 0.' (Public Record Office, Declared Accounts). For each such replica Ramsay received £84, his standard price for a full-length by the later 1760s, out of which he initially paid Reinagle £10, until, in 1781, Reinagle's fee was increased to £42 (i.e. half the total payment). (By then, Ramsay had been in enforced retirement from painting for over eight years, owing to the accident to his right arm.)

The original coronation portrait of George III and the pendant of *Queen Charlotte* (no.75) are known to have been completed by March 1762, when they were seen by Horace Walpole, who made the following comments on them:

Ramsay has done another whole length of the king, better than he did for Lord Bute ..., when the king was Prince of Wales. This has more air, and is painted exactly from the very robes which the king wore at his coronation. The gold stuff and ermine are highly finished; rather too much, for the head does not come out so much as it ought.
(Horace Walpole, *Anecdotes of Painting in England* (ed. F. W. Hilles and P .B. Daghlian), Yale University Press, 1937, vol.v, p.56.)

This replica of the coronation portrait is a fairly early example, and its high quality suggests that it is one of the versions in the execution of which David Martin played a leading part, but which Ramsy completed with his own hand.

For a detailed account of the original in the collection of Her Majesty The Queen see Oliver Millar, *The Later Georgian Pictures in the Collection of Her Majesty The Queen*, London, 1969, vol. 1, pp.93 ff. (no.996). Sir Oliver has hailed the picture as the most distinguished State portrait of a British monarch to have been painted since the time of Van Dyck.

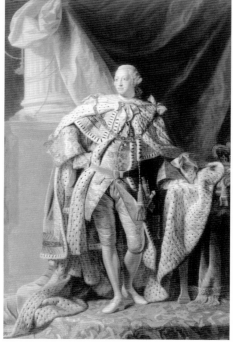

74

QUEEN CHARLOTTE IN CORONATION ROBES

Canvas, 98⅞ × 64½in (251.1 × 164cm). Reduced in size to suit the room in which it hangs. Strips have been cut from the canvas along the top and along the right side, and the canvas has been folded back behind the stretcher along the left side. Full-length: in robes of state, standing in front of a carved chair decorated with crown, sceptres, cipher and royal supporters; her left hand extended towards her crown, which rests on a cushion placed beside two sceptres on a table; a column to the right, a curtain to the left; in the background a curved alcove faced by pilasters. Probably painted in 1761–2. Reasons are given below for believing this to be the original coronation portrait, which was completed before March 1762.

Schloss Wilhelmshöhe, Kassel

Charlotte, Duchess of Mecklenburg-Strelitz and Queen of Great Britain (19 May 1744–1818); daughter of Karl I of Mecklenburg-Strelitz (1708–1752) by his wife Elisabeth Albertina (1713–1761), third daughter of Ernst Frederick I, Duke of Saxe-Hildburghausen, by his wife Countess Albertine of Erbach; married, at St. James's Palace, on 8 September 1761, King George III (no.74), with whom she was crowned on 22 September 1761 by Thomas Secker, Archbishop of Canterbury.

This picture, along with a companion-portrait of the King in coronation robes, was presented by George III to William I, Elector of Hesse-Kassel. Its provenance, accordingly, is compatible with the hypothesis proposed here that the Kassel picture is the original coronation portrait of Queen Charlotte commissioned from Ramsay by the King as a pendant to his own portrait. Hitherto it has been assumed that the original coronation portrait of Queen Charlotte is to be identified with a full-length in Buckingham Palace (see Oliver Millar, *The Later Georgian Pictures in the Collection of Her Majesty The Queen*, London, 1969, vol.I, p.95).

The original portrait is known to have been painted as a pendant to a full-length of George III which was apparently commissioned not long after the King's accession in October 1760, and which, after the coronation ceremony on 22 September 1761, was revised to incorporate the coronation robes. Writing to the 3rd Duke of Portland (then Lord Chamberlain) on 10 January 1766 about these and other royal portraits, Ramsay explained: 'Soon after her Majesty's arrival, she likewise did one the honour to sit to me; and these two pictures in coronation robes are the originals from which all the copies ordered by the Lord Chamberlain are painted' (The Hallward Library, University of Nottingham, Portland MS. PwF 8031; quoted in

R. W. Goulding and C. K. Adams, *Catalogue of the Pictures belonging to His Grace the Duke of Portland*, London, 1936, pp. 470 ff.). The portrait of the Queen was completed by March 1762, when Horace Walpole remarked upon it: 'It is much flattered, and the hair vastly too light' (Horace Walpole, *Anecdotes of Painting in England* (ed. F. W. Hilles and P. B. Daghlian), Yale University Press, 1937, vol. v, p.56).

As in the case of the coronation portrait of the King (see under no.74), numerous copies of the full-length of Queen Charlotte were supplied by Ramsay and his studio assistants, during a period of over two decades. The original portrait, therefore, must resemble in every detail these studio replicas and especially those that can be given an early date, and must be in Ramsay's style of the early 1760s. All the known copies agree in having the same composition, and differ in this fundamental respect from the Buckingham Palace portrait, which represents the Queen at a later age and places her in a different architectural setting; and it is in the 'poetical' style developed by Ramsay in his final years in practice. Moreover, the latter picture portrays the Queen as conforming to the fashion for high-piled, powdered hair prevalent from the late 1760s, and consequently cannot have been the work criticized by Horace Walpole for making her hair 'vastly too light'.

Indeed, as an inscription on the back of the canvas suggests, the picture in Buckingham Palace would appear to have been painted for Princess Augusta (no.97), Queen Charlotte's mother-in-law.

By contrast, the Kassel picture reflects all the characteristics of Ramsay's manner in the early 1760s, and may be compared stylistically, for instance, with the *Lady Susan Fox-Strangways* of 1761 (no.71), whether in respect of its combination of delicate precision of draughtsmanship and refined modelling, or with regard to the absence of the freer handling which Ramsay adopted towards the end of the decade.

The fluid brushstrokes in the light grey area around the head are also typical of an autograph Ramsay of *c*.1760. The delicate colouring (e.g. the powder-blue of the Queen's dress) and the soft tonalities in the draperies as a whole may also be noted. The hypothesis that this is the original coronation full-length of Queen Charlotte – or conceivably a very early version from Ramsay's own hand – would account, in short, for its extreme refinement of style, in which it is matched by none of the known replicas executed in Ramsay's studio.

Here certainly is the type, echoed only in the very best of the replicas, of that 'much flattered'

image of the young Queen upon which Horace Walpole remarked. It is to be found again, with varying degrees of fidelity, in such early studio replicas as the examples in the London Guild-hall, the Scottish National Portrait Gallery in Edinburgh and Williamsburg, and in the collections of the Earl of Ancaster, the Marquess of Bristol and a few others. Indeed the Kassel picture, which has been hidden away for so long from the attention of historians of British art, is now revealed as a particularly lovely example of that 'delicacy' of feminine portraiture which Horace Walpole had already recognized as being one of Ramsay's distinctive virtues as a painter.

According to Allan Cunningham, the crown jewels and regalia were sent to Ramsay's house in Soho Square at the time that he was working on the original full-length of the Queen. At the request of the artist, who was alarmed by his responsibility, sentinels were posted day and night before and behind the house. In accordance with the etiquette of the time, Queen Charlotte would have sat to Ramsay in one of the royal palaces rather than in the artist's painting-room; but the finishing of the picture, including the painting of the draperies, jewellery and regalia, would have been undertaken in his studio at 31 Soho Square, almost certainly with the aid of a lay-figure.

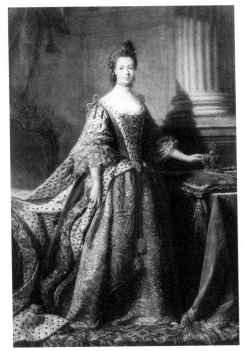

75

76

STUDY OF KING GEORGE III'S
CROWN

NGS, D.255. *Black chalk, heightened with white, on light blue paper, 9¾ × 12⅛in (24.8 × 30.8cm). Study of the crown for the full-length of* George III in Coronation Robes *(Her Majesty The Queen), of which no.74 in the present exhibition is a good version.*

National Gallery of Scotland, Edinburgh

76

77 *plate 35*

RICHARD GRENVILLE,
2ND EARL TEMPLE

Canvas, 88 × 57½in (223.5 × 146.1cm). Full-length: in Garter robes, wearing a snood and the chain and badge of the Garter, and with a plumed hat in his right hand, walking in a park; to the right, the base of a column, and in the distance, to the left, a river and a town. Signed and dated to the right: A. Ramsay/1762.

The National Gallery of Victoria, Melbourne

Richard Grenville (afterwards Grenville-Temple), 2nd Earl Temple (1717–1779), English statesman; known as 'Squire Gawkey'; eldest son of Richard Grenville of Wotton (died 1727) by his wife Hester Temple, afterwards Viscountess Cobham and Countess Temple; Member of Parliament for Buckingham from 1734 to 1741 and from 1747 to 1752, and for Buckinghamshire from 1741 to 1747; appointed First Lord of the Admiralty in 1756; Lord Privy Seal from 1757 to 1761; married, in 1737, Anne Chambers (no.68). His sister Hester married William Pitt the Elder, 1st Earl of Chatham, the celebrated statesman and Prime Minister.

This is one of the grandest of Ramsay's full-lengths: the treatment of the draperies is particularly dashing, and the handling of colour brilliant, but these aspects of the painting are not permitted to distract attention from the commanding portraiture. The picture is unusual for Ramsay in this period in containing so much movement.

The imposing design of the *Earl Temple* evidently influenced Reynolds's conception of his full-length of the *1st Marquess of Cholmondeley* at Houghton (fig.14), which was exhibited at the Royal Academy in 1780. In view of the interval between the two pictures of nearly two decades, it may be noted that in the previous year, 1779, Reynolds had painted Lady Mary Grenville, who became Countess Temple on the death of the 2nd Earl Temple in the same year.

Ramsay's portrait was presumably commissioned by the sitter, and it hung originally at Stowe, his family seat. It is said to have been given by him to his brother-in-law William Pitt, 1st Earl of Chatham (1708–1778), but it was still listed in the Stowe catalogue in 1780.

78 *plate 36*

MARTHA, COUNTESS OF ELGIN

Canvas, 30 × 25in (76.2 × 63.5cm). Half-length: in a pink dress and black shawl, a rose at her breast, flowers in her hair, seated in a greyish-green sofa with her hands concealed in a muff. Dated on label: 1762. *Perhaps painted c.1763–4.*

The Earl of Elgin and Kincardine, K.T.

Martha Whyte (died 1810), daughter of Thomas Whyte (a London banker), and an heiress of £30,000; married, on 1 June 1759, Charles Bruce, 5th Earl of Elgin and 9th Earl of Kincardine; became governess to Princess Charlotte of

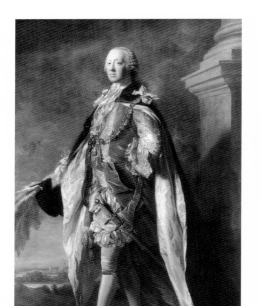

77

Wales, daughter of the future George IV.

Her husband made notable improvements at the family seat of Broomhall, near Dunfermline, where he employed John Adam as his architect, developing coal and limestone workings on the estate, building a harbour and a model village on the north shore of the Forth, and establishing a school and library for his tenants. In 1757 he made the Grand Tour, meeting Robert Adam in Italy.

In the year before the sitter's marriage, the seventeen-year-old James Boswell confided his passion for her in a letter to a friend (see *Boswell in Holland 1763–1764* (ed. Frederick A. Pottle), New York, 1952, p.30n).

Ramsay's portrait of the Countess of Elgin – one of the loveliest of all his portrayals of women – must be accounted among his supreme achievements in the orchestration of subtly blended colour. It is also a prime example of his success in adapting the French rococo style to his own sensibility. In fact the composition closely resembles that of a half-length portrait by François-Hubert Drouais of *Elizabeth Gunning, Duchess of Hamilton and Argyll* (Inveraray Castle: fig.15), which is inscribed as having been painted in 1763. The resemblance is of special interest in view of Ramsay's long connection with the Argylls. Elizabeth Gunning's second husband, whom she married in 1759, was a second cousin of Ramsay's patron the 3rd Duke of Argyll (no.29), and Ramsay may well have known Drouais's portrait. If, therefore, the *Countess of Elgin* reflects that knowledge, a date for its execution in or soon after 1763 seems to be required. Such a dating would be entirely compatible with the developed style, with its free handling and depth of chiaroscuro in the modelling of the features.

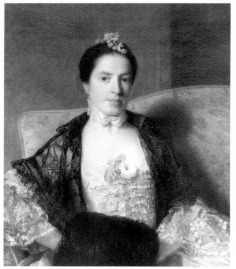

78

PHILIP, VISCOUNT MAHON AS A BOY

CHARLES, VISCOUNT MAHON, AFTERWARDS 3RD EARL STANHOPE, AS A BOY

Canvas, 30 × 24in (76.2 × 61cm). Full-length: in a light red coat, seated sideways to the left at a table, his head turned towards the spectator, with a porte-crayon in his right hand and a sheet of paper in his left. Painted in 1762. Companion to no.80.

The Trustees of the Chevening Estate

For the sitter see no.30. A study by Ramsay of the hands, *porte-crayon* and paper is known: NGS, D.2112. Red chalk, heightened with white, on buff paper, 6½ × 7¼in (16.5 × 18.4cm).

In 1764, after Lord Mahon's death at the age of seventeen, a mezzotint engraving was published by James Watson with a Latin epitaph. This is lettered: *A. Ramsay pinx¹. 1762. J. Watson fecit 1764.* It is inscribed, below: *Philippus Stanhope Vicecomes de Mahon, / Philippi Comitis Stanhope & Griselda Hamilton Uxoris Filius Primogenitus, qui Mortuus est Mensis Julii Die Sexto, Anno 1763, Annos natus 17, et diem unum. / Heu Pietas! heu prisca Fides! heu Funus acerbum!*

The design and mood of Ramsay's portrait suggest comparisons with the work of Jean-Baptiste Chardin and especially with Chardin's variations on the theme of 'The Card-Castle' (of the 1730s), three of which were engraved, and with his *Jeune dessinateur taillant son crayon*, which was engraved by Faber in 1740. (On these compositions see David Carritt, 'Mr Fauquier's Chardins', *Burlington Magazine*, CXVI, September 1974, pp.502 ff.)

A small copy of the picture is in the collection of the Earl of Haddington at Mellerstain; a further, inferior copy was at Tyninghame.

Canvas, 30 × 24in (76.2 × 61cm). Half-length: in a blue coat, leaning on his left arm with a bilboquet cup in his left hand and with his right hand on his hip. Signed and dated, bottom left: A. Ramsay/ *1763. Companion to no.79.*

The Trustees of the Chevening Estate

Charles, Viscount Mahon (1753–1816), politician and scientist; younger son of Philip, 2nd Earl Stanhope by his wife Grisel Hamilton, daughter of Charles, Lord Binning; educated first at Eton and subsequently at Geneva; married (1), in 1774, his cousin Lady Hester Pitt (died 1780), eldest daughter of the 1st Earl of Chatham, and (2), in 1781, Louisa Grenville (died 1829), daughter of the Hon. Henry Grenville (brother of Richard, 2nd Earl Temple, of George Grenville (the politician) and of Lady Chatham); Member of Parliament for Chipping Wycombe from 1780 to 1786, when he succeeded his father as 3rd Earl Stanhope; a strong opponent of the war with America and of British policy towards France after the French Revolution; at the age of eighteen wrote a paper on the pendulum which won a prize at the Stockholm Academy; in 1772, at the age of nineteen, elected a Fellow of the Royal Society; pioneered the steamship and modern printing techniques; the author of various other inventions, including two calculating machines designed to solve complex mathematical problems; published *The Principles of Electricity* (1779) and other works; younger brother of Philip, Viscount Mahon (nos. 30 and 79).

On meeting Lord Mahon again in Geneva in 1773, Ramsay was impressed by his precocious intellect but critical of a quality of eccentricity and gaucherie which was to persist in later life. On 22 November 1773, on his return to London,

Ramsay wrote to Lord Mahon's uncle the Hon. George Baillie, at Mellerstain, giving his impressions of Mahon's character:

> He is an excellent young man, has a friendly, generous and public spirit, a good understanding very well cultivated, with regard to many branches of business; and [is] master of all the exercises which belong to a Gentleman and an Officer; but he is still somewhat deficient in matters of dress, and modes of behaviour requisite in mixed companies, and which, however trifling they may seem to scholars, are very essential in life, especially to a man who, by his birth, is necessarily thrown amongst people of that Class who seldom think of accomplishing themselves in any thing else.
> (Mellerstain MSS.: Allan Ramsay to the Hon. George Baillie, London, 22 November 1773.)

Ramsay and his wife are documented (Mellerstain MSS.) as being at Chevening on 28 August 1763, the year in which the portrait of Lord Mahon was painted.

Ramsay was already on close terms with the 2nd Earl Stanhope, who had proposed him in 1757 for election to the Society of Arts (Royal Society of Arts, *Subscription Book (1754–63)*, under 14 December 1757), and he developed a like relationship with Lord Mahon.

The wooden object in the sitter's hand is a bilboquet cup, which was made of polished light wood (such as sandalwood). Bilboquet, a drawing-room game popular with the French and Italian nobility, enjoyed a certain vogue in England in the eighteenth and early nineteenth century. One competitor threw a light ball, which the other player endeavoured to catch in the cup.

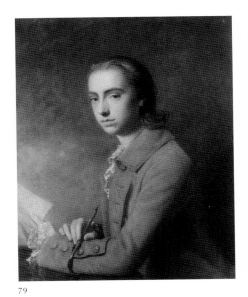

79

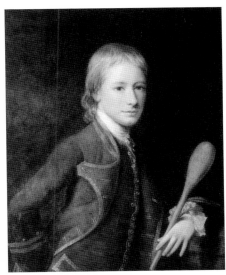

80

QUEEN CHARLOTTE WITH A FAN

Canvas, 30 × 25in (76.2 × 63.5cm). Half-length, in profile facing to the right. c.*1763.*

Private Collection

Two sheets of studies for the portrait are known (nos. 82 and 83), comprising four separate drawings of the Queen's right hand and forearm, and testifying to Ramsay's desire to achieve a union of the natural and the graceful – the aesthetic value which he had extolled in his essay *On Ridicule* of 1753 as the representation of the 'graceful in nature'. Queen Charlotte was known for her plainness of feature, and although Ramsay here portrayed her very sympathetically, the addition of the motif of the hand holding a fan creates a secondary point of emphasis of great beauty in itself. This indeed was one of the aspects of the picture that particularly struck James Northcote, Reynolds's pupil and biographer, as he explained in one of his conversations with William Hazlitt:

> I have seen a picture of his of the Queen, soon after she was married – a profile, and a fan in her hand: Lord! how she held that fan! It was weak in execution and ordinary in features – all I can say of it is, that it was the farthest possible removed from anything like vulgarity. A professor might despise it; but in the mental part, I have never seen any thing of Vandyke's equal to it. I could have looked at it forever … I don't know where it is now; but I saw in it enough to convince me that Sir Joshua was right in what he said of Ramsay's great superiority. His own picture of the King, which is at the Academy, is a finer composition and shows great boldness and mastery of hand; but I should find it difficult to produce any thing of Sir Joshua's that conveys an idea of more grace and delicacy than the one I have mentioned….
> (William Hazlitt, *Works* (ed. E. P.Howe), XI (*Conversations of James Northcote, Esq., RA*), London, 1932, p.274.)

The painting forms the pendant to a profile portrait by Ramsay of George III (in the same collection), the original of which was painted for the coinage.

The book on which Queen Charlotte rests her right arm is the second volume of Hume's *History of England*. Its inclusion in the portrait was appropriate to the likeness of a foreign princess who before her arrival in England at the age of seventeen had no real knowledge of the country of which she was now Queen.

This is the most intimate of Ramsay's portraits of the Queen, and recalls the tradition that he was on unusually close terms with his royal patrons, and that one reason for his being a favourite at Court was his ability to converse with the Queen in her native German. (Ramsay's relationship with George III and Queen Charlotte is considered in some detail in the compiler's new biography of the painter.)

Inferior versions of the picture are known. These are lacking in the refinement of draughtsmanship that characterizes the original, as well as displaying nothing of its fluent brushwork, seen most strikingly in the rendering of the Queen's features and in the freely brushed grey background.

NGS, D.2086. *Red chalk, heightened with white, on buff paper, 9 × 7⅜in (22.9 × 18.7cm). Two studies of the Queen's right hand and forearms, and her closed fan, in no.81.*

NGS, D.2102. *Red chalk, heightened with white, on buff paper, 9⅛ × 7¼in (23.2 × 18.4cm). Two studies of the Queen's right hand and forearm, and her closed fan, in no.81. The upper drawing on this sheet comes closest to Ramsay's final conception; but he still preferred to show in the painting more of the second finger than appears in any of the studies.*

National Gallery of Scotland, Edinburgh

These four studies reflect the seriousness and intensity of Ramsay's endeavour to arrive at the most perfect expression of the 'graceful in nature'. The drawing-style, with its emphasis upon purity of line, exemplifies the value to Ramsay of the studies he had made after such masters as Domenichino and Raphael (nos. 58 and 59) during his second visit to Italy (1754–7).

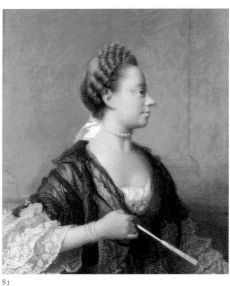

81

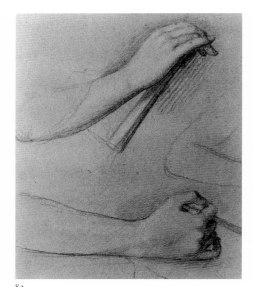

82

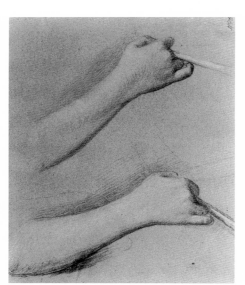

83

Canvas, 24 × 21in (61 × 53.3cm). Half-length: wearing the light blue ribbon of the Order of St. Esprit. Probably painted in 1763: see below.

**The National Trust,
Ickworth, the Bristol Collection**

Louis-Jules-Barbon Mancini-Mazarini, Duc de Nivernais (or Nivernois) (1716–1798), French diplomat and Minister of State; author of some essays and poems; became Ambassador to the Court of St. James in 1761, and helped to negotiate the terms of the Peace of Paris of 1763, which ended the Seven Years' War, but his efforts were not much appreciated by his fellow countrymen; retired eventually to his fine château of Saint-Mur. He had been Ambassador in Rome in 1748 and in Berlin in 1756. He was imprisoned during the French Revolution. Lord Chesterfield tried to get his son Philip Stanhope, when he was on his Grand Tour, to model himself on Nivernais, as an example of good breeding.

The concentration of the lighting upon the sitter's head, while the lower part of his frame is cast into shadow, relates the portrait of Nivernais to such works of the mid-1760s as the *Rousseau* (no.92) and the *Hume* (no.93). The portrait can probably be dated to 1763, and prior to the autumn of that year, when Nivernais returned to France. On grounds of style, however, a slightly later date would make sense, and it is not entirely impossible that Nivernais sat to Ramsay in 1765, when the painter spent some weeks in Paris.

Canvas, 37¾ × 29½in (95.9 × 74.9cm). Half-length: in a blue coat, seated to the left on a red-backed chair, a paper in his right hand, to which he points with his left hand, his face turned towards the spectator. Probably painted c.1764.

Hunterian Art Gallery, University of Glasgow

William Hunter, M.D., F.R.S., F.S.A. (1718–1783), eminent Scottish surgeon, anatomist, obstetrician and collector; brother of the anatomist John Hunter (1728–1793), and son of John Hunter of Long Calderwood, East Kilbride, Lanarkshire, by his wife Agnes; entered the University of Glasgow at the age of fourteen, and subsequently studied under William Cullen (1710–1790) at Hamilton and under Alexander Monro, *primus* (1697–1767), in Edinburgh; in 1741 went to London, becoming the assistant of James Douglas (1675–1742), the physician and anatomist; in 1748 visited Leiden and Paris; appointed in the same year surgeon-accoucheur to the Middlesex Hospital; shortly afterwards, set up as a physician in Jermyn Street; later moved to a house in Great Windmill Street, where he established a lecture-theatre, a dissecting room and a museum; appointed in 1764 Physician Extraordinary to Queen Charlotte; in 1768 became the first Professor of Anatomy in the Royal Academy of Arts.

Besides his eminence within his profession, Hunter showed great discernment and breadth of taste as a collector, and his bequest now forms the nucleus of the Hunterian collection at the University of Glasgow, of which he was an alumnus and which conferred upon him the degree of M.D. (see Andrew McLaren Young and others, *Glasgow University's Pictures: A Selection of Paintings, Drawings, Prints, and other Works from the Hunterian Museum, University of Glasgow*, exhibition catalogue, P. & D. Colnaghi & Co. Ltd., London, and Glasgow University Press, 1973). His collection of pictures was particularly notable for the inclusion of three works by Chardin, the influence of whose art is detectable in some of Ramsay's portraits of the 1760s, such as the *Hunter* itself and the *Philip, Viscount Mahon* of 1762 (no.79); and it may well have been Ramsay who drew Chardin's merits to Hunter's attention. In addition to similarities in design and in the crisp handling of colour, many of Ramsay's portraits of this period compare closely with paintings by Chardin in their use of an undefined, silvery-grey background, freely brushed in over a light umber ground, as indeed we see in the *Hunter*.

In its general disposition of compositional elements the portrait of Hunter possesses a

certain resemblance to the half-length by Jean-Baptiste Perronneau of *The Sculptor Adam the Elder* (Louvre, Paris).

Ramsay's preliminary study in chalks of the pose (NGS, D.2017), shows the sitter at three-quarter length, the intended picture area being afterwards defined by a rectangle drawn in white chalk.

The portrait was evidently commissioned by Hunter himself (and was bequeathed by him to Glasgow University). It has usually been dated c.1760 or earlier, but for no persuasive reason. In the writer's opinion a considerably later date is indicated by the developed style, and not least by the free brushwork, fluid handling and subtle treatment of light. If this judgment is correct, the portrait may well commemorate Hunter's appointment in 1764 as physician to the Queen, and there would have been particular appropriateness in its having been commissioned from the painter to the Court.

This type of design, in which a sheet of paper held in the sitter's hand is balanced, so to speak, against his head, as a secondary point of focus in the composition, is especially characteristic of Ramsay's 'second style', and can be seen in the *Robert Wood* of 1755 (no.49) and the *Philip, Viscount Mahon* of 1762 (no.79). The same principle of composition was adapted by Ramsay's pupil David Martin to his masterly portrait of Benjamin Franklin, in the White House, Washington, D.C., which was painted, interestingly enough, before Martin had left Ramsay's studio to set up practice on his own, so that the conception may owe much to Ramsay's active influence.

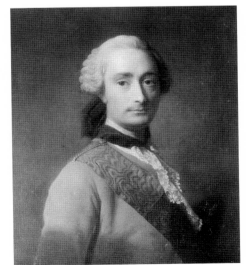

84

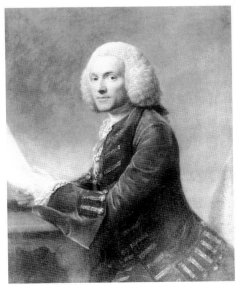

85

QUEEN CHARLOTTE AND HER
TWO ELDEST CHILDREN

Canvas, 98 × 63¾in (248.9 × 161.9cm); the two
children and the Queen's head painted on three
separate and contiguous pieces of canvas, sewn into
the main support. Full-length group. Presumably
begun in 1764, but perhaps not completed within the
same year.

Her Majesty The Queen

The Queen, in a pink ruched dress, holds on her
lap Prince Frederick, afterwards Duke of York
and Prince and Bishop of Osnabrück (born 16
August 1763, died 1827); Prince George
Augustus Frederick of Wales, afterwards
George IV (born 12 August 1762, died 1830),
stands on the left wearing light blue 'coats' and
holding a bow in his left hand and arrows in his
right; behind him, a toy drum; to the right, a
harpsichord, on which are placed a workbasket
and a copy of Locke's *Some Thoughts concerning*
Education (1693); leaning against the
harpsichord, a large portfolio.

Ramsay made numerous preparatory
drawings for the painting. These included a
detailed compositional study (no.87), studies of
the Queen's hands and forearms and studies of
the Prince of Wales (no.88).

The execution of the picture, or at least its
commencement, can be dated *c.*1764 from the
apparent ages of the two princes. A payment to
Ramsay from the Privy Purse is recorded on 3
February 1769: 'Paid Mr Ramsay Painter for a
picture of the Queen with the Prince of Wales
& Prince Frederick' (Royal Archives, Windsor,
Geo. 17216). But if this refers to the original
painting, rather than to one of the known
versions, there was an extraordinarily long delay
in payment for it. There is a tradition that
Ramsay was slow in finishing the picture, but it
is scarcely a reliable one, and its central asser-
tion, that the Prince of Wales is represented
twice, is manifestly absurd. This tradition is
given in its fullest form by Croly: Ramsay, we
are told, was asked to paint the Queen and the
Prince of Wales, then an infant in arms, within a
given time, but took so long to finish his portrait
of the Prince of Wales that when he at last
completed the picture two years later, the Prince
had grown into 'a sturdy child'; Ramsay then
proceeded to add a second portrait of him,
placing him at his mother's knee (The Revd. G.
Croly, *The Personal History of ... George IV* (2nd
ed., London, 1891), pp.252 f.). And as we are
solemnly informed by Pyne, George IV himself
narrated the story of how, in consequence of
Ramsay's slowness in working, it was resolved
'to introduce his royal highness in another
position in the same composition' (W.H. Pyne,
The History of the Royal Residences, London, 1819,

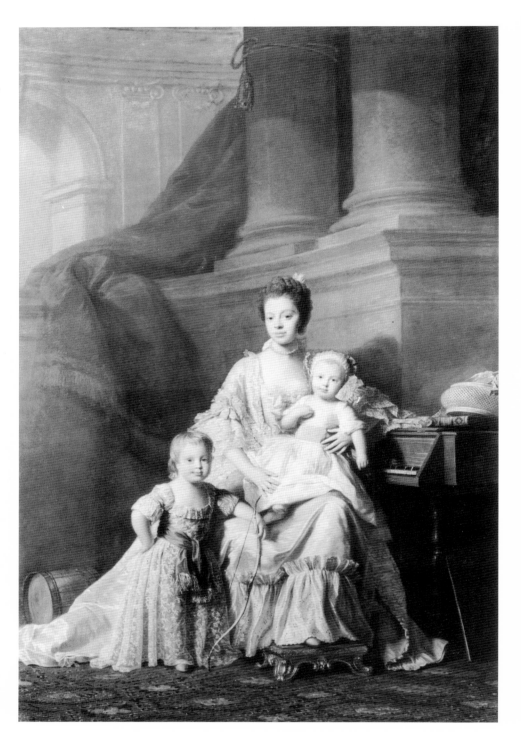

1, p.100). It is, however, possible that the story
originated in some delay in the completion of
the picture.

Ramsay's procedure in painting the Queen's
head and the portrayals of the two princes on
separate pieces of canvas was a convenient one in
the case of royal portraiture, the etiquette of
which required the sittings to take place in one
of the palaces rather than in the artist's studio –
where the picture would have been completed

from drawings and perhaps with the use of lay-
figures. (Occasionally, however, Ramsay
employed the same method in portraits of other
than royal sitters, e.g. nos.60 and 65.)

The imposing architectural forms in the
background recall the typical conventions found
in the state portraiture of Carle Vanloo, *peintre*
du roi, and his nephew Louis-Michel, e.g. the
latter's full-length of *Louis XV* of 1760 at
Versailles (a good version is in the Wallace

Collection, London); and it is of interest that the two French painters visited London in 1764, meeting both Ramsay and Reynolds. But the closest affinities with contemporary French painting are to be seen in the exquisite colouring, with its pastel shades of pink, blue and green. Notwithstanding the grandiose palace interior, Ramsay's portrayal of Queen Charlotte expresses an intimacy of feeling appropriate to the essentially domestic character of the picture, which is emphasized by the inclusion of such details as the workbasket, the copy of Locke's essay on education and the portfolio propped against the harpsichord; and indeed the Queen herself is portrayed less in her regal than in her maternal aspect, and holds her infant son close to her breast. The toy drum and the bow and arrows bring to mind a contemporary account of family life at Buckingham House, where the King and Queen are said to have delighted in having their children playing around them (see Oliver Millar, *The Later Georgian Pictures in the Collection of Her Majesty The Queen*, London, 1969, vol. I, p. xiv).

Full-scale versions of the composition, of high quality, are in the collections of the Duke of Beaufort and the Marquess of Lansdowne.

87

COMPOSITIONAL STUDY FOR THE PORTRAIT OF QUEEN CHARLOTTE AND HER TWO ELDEST CHILDREN

NGS, D.2149. *Black chalk, heightened with white, on light blue paper, 16¾ × 11⅛in (42.6 × 28.3cm). Detailed compositional study, but with certain differences from the final design, for no.86: the Prince of Wales's toys of drum and bow are here placed in the foreground; the portfolio lies under the harpsichord; part of the Queen's chair is shown – a detail omitted from the original in Buckingham Palace but retained (still more prominently) in a fine version of the painting at Badminton. Probably 1764.*

National Gallery of Scotland, Edinburgh

This drawing was first recognized as a study for the Buckingham Palace picture by the late Queen Mary.

88

STUDY OF THE PRINCE OF WALES FOR THE PORTRAIT OF QUEEN CHARLOTTE AND HER TWO ELDEST CHILDREN

NGS, D.1997. *Black chalk, heightened with white, on light grey paper, 16¼ × 10⅝in (41.3 × 27cm). Head and shoulders. Study of George, Prince of Wales (afterwards King George IV), for no.86.*

National Gallery of Scotland, Edinburgh

87

88

89 *plate 40*

ANN HOWARD

Canvas, 30 × 25in (76.2 × 63.5cm). Half-length: in a white dress with a white lace rufflet and a pink shawl, with a white feather in her hair and pink roses and pearls at her bosom; seated in a woody landscape. c.1766–9.

Private Collection

Ann Witham (1733/4–1794), eldest daughter of Henry Witham, of Cliff Hall, Piercebridge, Yorkshire, by his wife Catherine; married, in November 1754, Philip Howard of Corby Castle (1730–1810), only surviving son of Thomas Howard of Corby Castle, by his second wife Barbara Musgrave. The sitter was the mother of the antiquary Henry Howard (1757–1842), whose portrait by William Millar is at Corby Castle. Ann Howard travelled extensively with her husband in France. She was an admirer of Jean-Jacques Rousseau (no.92) and befriended his disciple Louis-Alexandre de Lannay, comte d'Antraigues (1753–1812), the secret agent and political intriguer. In his unfinished novel *Henri et Cécile*, d'Antraigues seems to have taken Ann Howard as a model for his heroine, Cécile, who is represented as living at 'Corbi'. (See Colin Duckworth, 'D'Antraigues and the quest for happiness: nostalgia and commitment', *Studies on Voltaire and the Eighteenth Century*, The Voltaire Foundation at the Taylor Institution, Oxford, CLI–CLV, 1976, pp.62 ff.)

The poetic treatment of light in the *Ann Howard*, together with the muted tones of the landscape background, is a feature of Ramsay's very late style, and there are close similarities to the *Princess Augusta* of 1769 (no.97). Also characteristic of this period in Ramsay's development is the allusive treatment of landscape details, which are suggested with free strokes of the brush.

90 *plate 41*

LADY CAROLINE FOX, BARONESS HOLLAND

Canvas, 40 × 48in (101.6 × 121.9cm). Half-length: in a pinkish-red, fur-trimmed dress and lace cap (tied under the chin), seated in a green-backed armchair beside a table, on which there are two books and a workbasket, and holding at her lap a greenish-grey cloth-bound book, with her left hand crossed over her right wrist. Inscribed, bottom right: Caroline Lady Holland, / died 1774, / Ramsay Pinxt. *Commissioned in 1763 for the gallery at Holland House, Kensington; completed in 1766.*

Private Collection

Lady Georgina Caroline Lennox (1723–1774), daughter of Charles, 2nd Duke of Richmond (1701–1750) by his wife Sarah, elder daughter of William, Earl Cadogan; married, in 1744, the statesman Henry Fox (1705–1774), who in 1763 was created (1st) Baron Holland; created (in her own right), on 5 May 1762, Baroness Holland of Holland; mother of the statesman Charles James Fox (1749–1806). She was the sister of Lady Louisa Conolly (no.65).

Lady Holland and her husband became important patrons of Ramsay in the 1760s, on their conversion of the Library, or Long Gallery, of Holland House in Kensington into a picture gallery designed for portraits of members of the Fox and Lennox families, which were chiefly commissioned from Ramsay and Reynolds. These included Ramsay's portraits of *Lady Holland, Lady Kildare* and *Lady Louisa Conolly*.

The commission for the portrait of Lady Holland is first mentioned in a letter from the sitter to her sister Emily (Lady Kildare), which is dated 11 September 1763: 'Ramsay is doing mine, to go between the doors, over against the window' (*Correspondence of Emily, Duchess of Leinster (1731–1814)* (ed. Brian FitzGerald), Dublin, 1949, vol.I, p.388).

Ramsay made two known drawings in chalks for the picture: (i) NGS, D.225. Black chalk, heightened with white, on blue paper, 16 × 10⅝in (40.6 × 27cm). Study of the head (in the painting the light source is reversed). (ii) NGS, D.2084, see no.91 below.

The *Lady Holland* may be said to represent the ultimate realisation of Ramsay's ideal of the 'natural portrait'; it is also one of his richest exercises in vibrant colour. The head has lost some pigment; but the sitter's pallor may perhaps be partly explained by the fatal cancer which developed several years before her death.

A copy of the portrait is recorded in the *Common Place Book* (p.153) of the poet Samuel Rogers as being at St. Anne's Hill House, Chertsey, the home of Lady Holland's son Charles James Fox (MS. in a Private Collection).

91

STUDY FOR THE PORTRAIT OF LADY HOLLAND

NGS, D.2084. *Red chalk, heightened with white, on buff paper, 7⅜ × 9¼in (18.7 × 23.5cm). Study of the hands and book for no.90, together with a further faint sketch of the left hand. Mid-1760s (the painting being completed in 1766).*

National Gallery of Scotland, Edinburgh

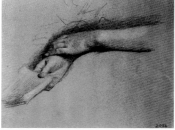

91

89

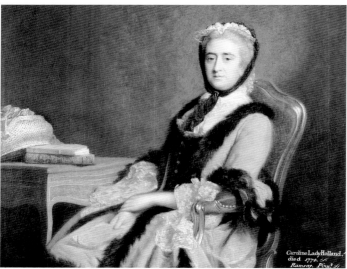

90

Canvas, 29½ × 25½in (74.9 × 64.8cm). Half-length: in a black fur cap and a purple gown trimmed with fur, his right hand raised to his breast. Painted in London for David Hume, early in 1766. Companion to no.93.

National Gallery of Scotland, Edinburgh

Jean-Jacques Rousseau (1712–1778), the French-Swiss social philosopher and moralist, had come to England in January 1766 in order to escape the persecution to which he was being subjected in France and Geneva on account of the revolutionary views on society, education and religion expressed in his *Du Contrat Social* and *Emile* (both of 1762) and in his *Lettres écrites de la montagne* (1764). On learning that the French authorities had issued an order for his arrest, he had sought the protection of Marshal Keith (no.19) at Motiers-Travers, which was then within the territories ruled by Frederick II of Prussia; but not finding a safe refuge there from his enemies, and fearing that his life was in danger, he was advised by Keith to remove himself to England, which he did with the assistance of David Hume (no.93). Hume solicited a pension for him from the King; and an admirer with advanced views, Richard Davenport, made available to him his Staffordshire house, Wootton Hall.

Hume had by then settled in London, and Rousseau was his guest before leaving for Wootton. Ramsay's portrait was completed by 18 March 1766, as appears from a letter of 22 March of that year from Hume to John Home of Ninewells, in which he says:

> Rousseau left me four days ago … Surely Rousseau is one of the most singular of all human Beings, and one of the most unhappy. His extreme sensibility of Temper is his Torment; as he is much more susceptible of Pain than Pleasure. His Aversion to Society is not affectation as is commonly believed. When in it, he is commonly very amiable, but often very unhappy. And tho' he be also unhappy in Solitude, he prefers that Species of suffering to the other. He is surely a very fine Genius: And of all the Writers that are or ever were in Europe, he is the man who has acquired the most enthusiastic and most passionate Admirers. I have seen many extraordinary scenes of this Nature. He sat for his Picture at my Desire. It was to Allan Ramsay, who has succeeded to Admiration, and has made me a most valuable Portrait. (*The Letters of David Hume* (ed. J. Y. T. Greig), Oxford, 1932, vol.ii, pp.26–7.)

It would appear at first sight from this letter that it was Hume who commissioned the portrait; but later in the same year Hume gave a different account, which makes it clear that Ramsay painted the picture as a present to him:

> The fact was this. My friend, Mr Ramsay, a painter of eminence and a man of merit, proposed to draw Mr Rousseau's picture and when he had begun it, told me he intended to make me a present of it. Thus the design of having Mr Rousseau's picture drawn did not come from me, nor did it cost me anything. (David Hume, *A Concise and Genuine Account of the Dispute between Mr Hume and Mr Rousseau*, London, 1766.)

Rousseau posed in the famous Armenian costume which aroused the curiosity of London society. In the same year, 1766, Hume himself sat to Ramsay for the half-length now in Edinburgh (no.93), wearing a costume only marginally less striking than Rousseau's, and the two pictures adorned Hume's parlour until his death, hanging in his London house until his return to Edinburgh in 1769. No doubt they constantly reminded him of the part they had played in Rousseau's notorious quarrel with him, the circumstances of which can be briefly stated.

Not long after his arrival in England, Rousseau, who was a prey to delusions of persecution – understandable in part on account of the real persecutions he had suffered – began to level at Hume some strange accusations. At first, he said, Hume had shown him various marks of friendship; but 'that of causing my portrait to be painted … was not of the number', for it carried with it 'too much the affectation of popularity' and savoured of 'ostentation'. These and other complaints were conveyed in a long letter to Hume which the Scottish philosopher later found it necessary, after some reluctance, to publish in self-defence, together with his own patient reply, since Rousseau, who did not leave England until May 1767, was making no secret of his antagonism and its imagined causes.

Ramsay himself was fully acquainted with these developments, and a hitherto unpublished letter from his wife to Countess Stanhope at Geneva, dated 5 August 1766 and written before Hume finally decided to go into print, gives an idea of the painter's own attitude to Rousseau's conduct:

> D: Hume has at last had a letter from Rousseau or rather a pamphlet it is 18 sheets of folio paper wrote very close and very small giving all his reasons for believing him to be in a conspiracy against him which are so very ridiculous and foolish that it is hardly possible to give any account of it without having the letter it self to make extracts from. Were it ever published [it] would turn out very much to the disgrace of Rousseau and be greatly to Hume's honour, but he does not now think it worth his while for in having this letter in his possession he is under no apprehension of any thing that Rousseau might have publish'd against him and of which he had no guess, so that unless Rousseau takes it into his head to bring this nonsense himself into print which is not at all impossible on some of them at Paris who are very desirous of its being published and have wrote to Hume about it. The progress of the pension stopt upon his first impertinent letter to D: Hume and we do not understand that it is to go any further, tho in this last 18 sheet letter he disowns that he ever refused it and has bestowed a great deal of lick spit praise upon the King and Mr Conway [Francis Seymour Conway, afterwards Marquis of Hertford, Lord Chamberlain in 1766] in order no doubt to get it. (Chevening MSS.: Margaret Ramsay to Grisel, Countess Stanhope. Addressed: *A Madame la Contesse Stanhope à Genève par Paris*. London, 5 August 1766.)

Rousseau's sudden resentment at having been asked to sit for his portrait was far from being the most serious of the charges that he levelled at Hume; but it must have come as a surprise, for the portrait had been accounted a great success; the King had asked to see it; Hume had praised it in his letter to John Home of Ninewells, and had also described it, in a letter to the Comtesse de Boufflers, of 16 May 1766, as an 'admirable portrait'; and Rousseau himself had originally been pleased with it, for he had written from England to a friend: 'un bon peintre d'ici m'a

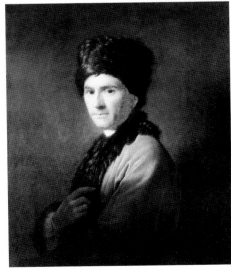

92

aussi peint à l'huile pour M Hume. Le roy a voulu voir son ouvrage et il a si bien réussi qu'on croit qu'il sera gravé' (*Correspondance Générale de Jean-Jacques Rousseau* (ed. T. Dufour), xv, Paris, 1931, p.125). Four years later, however, in his pathological *Rousseau juge de Jean-Jacques* (or *2ᵉ Dialogue*), he was protesting that Ramsay had given him the features of a 'Cyclops' – a description that could only perhaps have been suggested by one of the various replicas or even by David Martin's engraving – whereas (he objected) he had made Hume out to be a handsome man: but (he protested) it was he, Rousseau, who was handsome, and Hume who was a veritable 'Cyclops'. Hume, he wrote, 'desired this portrait as ardently as a deeply smitten lover desires his mistress's. Through importunities he extorted the consent of Jean-Jacques.' He complained further that he 'was made to wear a deep black cap and a deep brown garment; he was posed in a dark spot; and, in order to paint him seated, he was made to stand up, stooped over, supported by one hand on a low table, in an attitude where highly strained muscles altered the very contours of his face.' Rousseau's conclusion was that the portrait had been designed, at Hume's instigation, to demonstrate to the whole of Europe that he was ugly. Writing to a correspondent who had acquired an engraving of the portrait, he pleaded: 'Look more closely, and take it out of your room – this wild face which is certainly not mine.'

Notwithstanding Rousseau's conduct, Ramsay appears to have kept up some kind of contact with him. Early in 1767, knowing Rousseau's passion for engravings of high quality, he sent him some twenty examples by British engravers, declining Rousseau's request to him to name a price. One of these was a portrait of the King – presumably Ryland's line engraving (no.62) after Ramsay's portrait of George III as Prince of Wales, or his engraving of the coronation portrait (published and exhibited in 1767). A letter from Ramsay to Diderot makes it clear that the painter was not impressed by Rousseau's view of the 'Noble Savage', for Ramsay describes Rousseau's concept of the natural state as 'la nature à quatre pattes' ('Nature on all fours') (*Oeuvres Complètes de Diderot*, IV, Paris, 1875, p.52).

In 1767 Richard Davenport commissioned from Ramsay a copy of the portrait for Wootton Hall, in reference to which Ramsay wrote to him on 16 June of that year, enclosing a bill for £21, with £2 8s. extra for the frame and case:

I hope by this time you have given shelter under your roof to my Jean-Jacques Rousseau, who, if he should prove less witty, will be at the same time less ungrateful, less mischievous and less chargeable than his predecessor. I am afraid, however, that both of them are attended with more expense than their company is worth, as you will see by the note which, in obedience to your commands, I have enclosed.
(*The Mirror*, 1826; quoted by Robert Brydall, *Art in Scotland, its Origin and Progress*, London, 1889, p.119.)

On 8 July Ramsay wrote again to Davenport, acknowledging the receipt of his fee and giving further news of Rousseau, who had left England for France the previous May:

I have received the money of your draught for Rousseau's picture and frame, for which I give you a great many thanks. As to the *original*, in every sense of the word, the last advice we had of him were by Lady Holland, who arrived at Calais the day after he left it, and where he had entertained the simple inhabitants with the *hairbreadth 'scapes* his liberty and life had made in England. Where he has disposed of himself we have not yet learnt; but so much importance will not continue long anywhere without being discovered.
(ibid., loc.cit.; National Library of Scotland, MS.3420, fos. 233–4.)

Joseph Burke (*English Art 1714–1900*, London, 1975, p.175) has suggested that the portrait derives ultimately from Raphael's *Baldassare Castiglione*, and this may indeed be the case, but the lighting presents the clearest example in Ramsay's whole *oeuvre* of an aspect of his late style that has for the most part been previously overlooked. The strong light that falls on Rousseau's face, and which contributes to the intensity of the concentration upon his mobile features and fervid expression, while the lower part of his figure and his hand are thrown into shadow, can be matched, although less dramatically, in other portraits by Ramsay of the middle and late 1760s, such as the *Duc de Nivernais* (no.84) and the *David Hume* of 1766 (no.93). The most obvious source of this development in Ramsay's final period is Rembrandt, whose influence on eighteenth-century English portraiture is apparent from time to time in the work of such artists as Hudson, Reynolds, Hone and Frye. Already in the late 1740s Hudson had based his bust-length portrait of *Charles Erskine* (National Gallery of Scotland, Edinburgh: engraved by James McArdell) on an etching by Thomas Worlidge of a reputed self-portrait by Rembrandt, which was then in the possession of the 3rd Duke of Argyll. From that point onwards the instances of Rembrandtesque echoes in British portraiture become too numerous to mention. In Ramsay's case they are typically unassertive, and never involve the strong oppositions of light and dark such as are found in Reynolds; but the interest in effects of lighting apparent in the *Rousseau* and *Hume* of 1766 is developed significantly in portraits painted shortly afterwards, in which – as, for example, in the *Princess Augusta* of 1769 (no.97) – the play of light can distil a tender lyricism. Whatever may be thought of Rousseau's assertion that in sitting to Ramsay he was forced to adopt an attitude of great discomfort, it is interesting that, according to his own account, he was 'posed in a dark spot' – which suggests that before commencing the portrait Ramsay was very much concerned to provide particular conditions of lighting. The accuracy of this part of Rousseau's recollections is borne out by the dark grey background (a feature also of the *Hume*), replacing the lighter greys which Ramsay had usually preferred hitherto, the effect being to concentrate attention upon the sitter's face, which seems to swim in a surrounding pool of darkness.

Nathaniel Hone's *Self-portrait* at the Royal Academy (30 × 25in (76.2 × 63.5cm)), reproduced in Desmond Shawe-Taylor, *Genial Company: The theme of genius in Eighteenth-Century British Portraiture*, exhibition catalogue, Nottingham University Art Gallery, 1987, pp.50, no.43) shows the clear influence of the *Rousseau* (which remained in London for some three years), both in the lighting and in other features: the artist even wears a purple costume, like Rousseau, although now with a lace collar, in the style of the seventeenth century. The picture has been dated *c*.1765: accordingly a more precise date for it would be 1766 or shortly after.

A considerable number of copies of the *Rousseau* are known. A portrait of Rousseau by Ramsay's pupil and assistant David Martin (28 × 22in (71.1 × 55.9cm)), probably a reduced copy of no.92 made by him in connection with his engraving of 1766, was in the sale of his books, pictures and other effects held on 14 January 1799 (see *A Catalogue of the Valuable and Choice Books, Prints, Sketches, Original Drawings, Portraits, Paintings by the First Masters … The property of the late David Martin, Esquire*, no.399 – under *Paintings and Sketches by Mr Martin*).

DAVID HUME

Canvas, 30 × 25in (76.2 × 63.5cm). Half-length: in a scarlet coat and scarlet waistcoat, both trimmed with gold, with a white jabot, seated with his arm resting on two leather-bound books placed on a table, of which the spine of the lower volume bears the title in gold lettering: TACITI / OPERA. *Painted in London in 1766 as a companion-piece to the portrait of* Jean-Jacques Rousseau *(no.92).*

Scottish National Portrait Gallery, Edinburgh

David Hume (1711–1776), eminent Scottish philosopher and historian, one of the greatest figures of the Enlightenment; son of Joseph Home of Ninewells by his wife Catherine Falconer, daughter of Sir David Falconer (1640–1688), Lord President of the Court of Session; changed the spelling of his name to Hume because, as he put it, 'thae glaekit English buddies' made him rhyme with *comb*; studied at the University of Edinburgh; in 1748 appointed to General St. Clair's embassy to Vienna and Turin, returning to Scotland in the following year; Keeper of the Advocates' Library in Edinburgh from 1752 to 1757, resigning in the latter year in the train of clerical interference in his liberal choice of books for the library; in Paris from 1763 to January 1766, as Secretary to the British Ambassador to the French Court, Francis, 1st Earl of Hertford (1718–1794); returned to London in the company of Rousseau, to whom he offered protection in England from his persecutors abroad; appointed Under-Secretary in 1767, remaining in London until the late summer of 1769, when he finally, and thankfully, returned to Edinburgh; died unmarried; author of *A Treatise of Human Nature* (1739–40), *The History of England* (1754–7), *Dialogues concerning Natural Religion* (1779) etc.; founder of an empirical system of philosophy and a fearless opponent of religious bigotry and superstition (e.g., in his *Essay on Miracles*). Hume was revered in his lifetime for his exemplary character and sweetness of nature, and was known in France as *le bon David*. He has claims to be regarded as the greatest British or European thinker of the Enlightenment, as well as the supreme master of English prose of the eighteenth century.

In 1754, together with Adam Smith, Hume helped Ramsay to found the celebrated debating club known as the Select Society of Edinburgh, becoming its treasurer. A close friend of Ramsay, he sought his advice on the first volume of his *History*, and showed him some of his philosophical writings prior to their publication. Hume's influence upon Ramsay's thinking was profound, as is particularly evident in the painter's most important literary work, the *Dialogue on Taste* of 1755.

Hume's features would doubtless have presented a certain problem to any portrait painter, to judge at any rate from Lord Charlemont's description:

> Nature, I believe, never formed any Man more unlike his real Character than David Hume …. The Powers of Physiognomy were baffled by his Countenance, neither cou'd the most skilful in that Science pretend to discover the smallest Trace of the Faculties of his mind in the unmeaning Features of his Visage. His Face was broad and fat, his mouth wide and without any other Expression than that of Imbecility. His eyes vacant and spiritless, and the Corpulence of his whole Person was far better fitted to communicate the Idea of a Turtle-eating Alderman than of a refined Philosopher.

In Ramsay's portrait Hume is shown in the scarlet, semi-military 'uniform' which he had been asked to wear on being appointed in 1748 secretary to General St. Clair's Military Legation at Vienna and Turin. As the picture was destined to hang in Hume's house beside the *Jean-Jacques Rousseau* (no.92), this splendid 'uniform' may well have been intended by Ramsay to match the exotic Armenian attire in which Rousseau had sat for his own portrait. On being shown the portrait of Hume, which he had specially asked to see, George III remarked to Ramsay that, while he considered it a good likeness, he thought the dress 'rather too fine'; to which Ramsay wittily replied, 'I wished posterity should see that one philosopher during your Majesty's reign had a good coat upon his back.'

The inclusion in the picture of a volume of Tacitus pays tribute to Hume's eminence as a historian; the other volume, which we should expect to bear the name of an ancient philosopher, but which is unidentified by author or title, must have been intended to allude to Hume's own philosophical distinction; and that Ramsay set out to portray his friend principally as the philosopher is suggested by the character of the picture as a whole, as well as being supported by the anecdote concerning George III just cited. Whatever Lord Charlemont may have felt about Hume's physical appearance, Ramsay created out of it an exceptionally powerful image of philosophical detachment and intellectual power. As in the *Rousseau*, the deep shadows bathing the lower part of the figure and the modulations of dark tone that model the features reflect Ramsay's study of Rembrandt. The consequent focus of the lighting upon the face seems expressive of the light of intellect illuminating the surrounding darkness.

The portrait was engraved in mezzotint in 1767 by Ramsay's principal assistant David Martin.

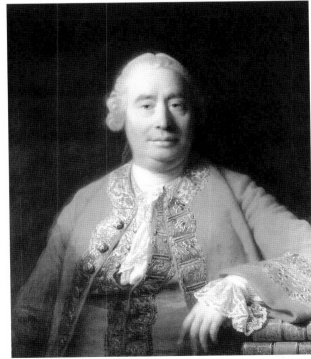

93

Canvas, feigned oval, 29⅛ × 24⅜in (74 × 61.9cm). Bust-length. Formerly signed to the right: A. Ramsay. Probably painted c.1766–8, perhaps in Edinburgh.

National Gallery of Scotland, Edinburgh

Anna Bruce (died 1810), daughter of General Sir John Hope-Bruce, 7th Bt. of Craighall (died 1766), by his second wife Marianne Denune; as the heiress of Arnot, married, in 1774, Thomas Williamson, an Edinburgh surgeon who adopted the name Bruce. The sitter was a half-cousin of Ramsay's first wife Anne Bayne (no. 15).

The earlier literature generally accepted a date of *c.*1760 for the portrait; but the style is characteristic of Ramsay's work of the later 1760s. In 1963 a more plausible date, *c.*1765, was proposed by Robin Hutchison and Colin Thompson in their catalogue of the exhibition *Allan Ramsay (1713–1784), his masters and rivals* (Edinburgh, 1963, under no.110). More recently Macmillan has suggested 1767 (Duncan Macmillan, *Scottish Art 1460–1990*, Edinburgh, 1990, pp.108 f.), although without supporting evidence. In 1989 Dr. Lindsay Errington noticed that the dress worn by the sitter is almost exactly repeated in a bust-length portrait at Newhailes of *Anne Broun, Lady Dalrymple*, which is now known from records of payments to Ramsay to have been begun in 1766 and completed in 1767; and it seems likely that Anna Bruce sat for her own portrait at about the same time, or, in view of its more developed style, a little later.

Affinities have long been detected between the *Anna Bruce of Arnot* and the work of Gainsborough in his Bath period, and Sir James Caw, for instance, assumed that Ramsay was taking note of the poetical manner which

Gainsborough was developing in the 1760s (see J.L. Caw, 'Allan Ramsay, Portrait Painter,' *Walpole Society*, XXXII (1937), p.60). Macmillan, on the other hand, has suggested that the influence was in the opposite direction, and that Gainsborough derived his late style directly from Ramsay – a thesis of great interest but one that still awaits detailed examination. What the *Anna Bruce* certainly reflects is a development in Ramsay's style during the later 1760s in which poetical allusiveness of statement takes the place of precise definition of form – a lyricism broadly analogous to what we find in late Gainsborough, and yet distinct from it.

A lace fichu, said to be that worn by Anna Bruce in Ramsay's portrait, has been preserved in the Dalyell family: the Bruce and Dalyell families are connected by marriage.

95 *plate 46*

PRINCE WILLIAM, AFTERWARDS DUKE OF CLARENCE (LATER KING WILLIAM IV), AS A CHILD

Canvas, 50½ × 38½in (128.3 × 97.8cm), including an early addition on the right of about 1½in (3.8cm). Full-length: in 'coats', standing in a carpeted room and beating a toy drum which bears the royal cipher. Evidently painted in 1767 or 1768.

Her Majesty The Queen

Prince William Henry, afterwards Duke of Clarence; third son of King George III and Queen Charlotte; ascended the throne in 1830 as King William IV; born 21 August 1765; died 1837 (being succeeded by his niece, Queen Victoria).

The portrait is datable to the year 1767 or 1768, since the Prince seems to be about two years old.

It was at one time ascribed to Zoffany and by 1872 was mistakenly identified as a portrait of the prince's younger brother Edward, afterwards Duke of Kent (1767–1820), father of Queen Victoria. The correct attribution and identification are due to Sir Oliver Millar (Oliver Millar, *The Later Georgian Pictures in the Collection of Her Majesty The Queen*, London, 1969, vol.I, p.96, no.999; vol.II, pl. 6).

A payment to Ramsay in 1769 of £152 5s 'for other portraits' (i.e. portraits other than the coronation full-lengths of *George III* and *Queen Charlotte*) is recorded in the Royal Archives at Windsor (Geo. 17216), and may have included payment for this picture, as Millar suggests (op.cit., vol.I, p.96).

An interesting feature of the picture is the inclusion, beside the Prince, of a table bearing a large gilt vase, two teacups and a cream jug. Domestic details of this kind are often found in portraits by such eighteenth-century French painters as La Tour, Nattier and Aved. The china ornaments on the mantelpiece represented in Ramsay's *Countess Temple* (no.68) suggest the same source of inspiration.

96 *plate 44*

THE HONOURABLE ANNE GRAY

Canvas, 30 × 25in (76.2 × 63.5cm). Nearly half-length, in a landscape. c.1769–70 (?).

Private Collection

The Hon. Anne Gray (1747–1802), third daughter of John, 11th Lord Gray (1716–1782) by his wife Margaret Blair (died 1790), heiress of Kinfauns, Perthshire; married, in 1766, George Paterson, Esq., of Castle Huntly.

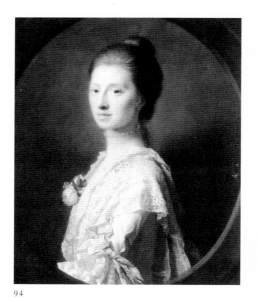

94

95

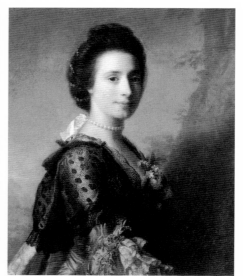

96

AUGUSTA OF SAXE-GOTHA, PRINCESS DOWAGER OF WALES

AN ANTIQUE URN

Canvas, 55½ × 45in (141 × 114.3cm). Three-quarter-length: in a light blue dress, walking in a garden and fingering with one hand a rope of pearls wound around the other wrist. Signed and dated, lower right: A. Ramsay 1769.

S. K. H. der Prinz von Hannover

Auguste, or Augusta, Princess of Saxe-Gotha (1719–1772), youngest daughter of Frederick II, Duke of Saxe-Gotha-Altenburg, and mother of King George III; married, in 1736, Frederick, Prince of Wales (1707–1751), eldest son of George II. Presiding over the 'Leicester House circle' in her widowhood, she helped to bring to political prominence John Stuart, 3rd Earl of Bute (no.60), whose close relationship with her became the subject of much gossip, providing ammunition for Bute's enemies and for political scribblers and caricaturists. His devotion to her is reflected in the column which he dedicated to her memory at his seat of Luton Park in Bedfordshire, and which was subsequently transferred to the gardens at Mount Stuart, on the Isle of Bute. The monument bears an inscription taken from Virgil's *Aeneid*, Book IV, line 335: *Dum memor ipse mei dum spiritus nos regit artus.*

(The whole passage in the *Aeneid* can be rendered: 'Nor shall it ever be bitter to me to remember Elissa while I have remembrance of myself and while my breath governs my limbs.')

Princess Augusta had previously sat to Ramsay for a full-length commissioned about 1764 by Lord Bute. The portrait of 1769, on the other hand, was commissioned by Princess Augusta herself for the Brunswick Court. Ramsay was paid 50 guineas for the picture, as is shown by his receipt, dated 31 May 1769:

> Received from her Royal Highness the Princess Dowager of Wales fifty guineas being in full for a half length picture of her Royal Highness sent to Brunswick, by me
>
> Allan Ramsay
>
> £52–10–0

(Royal Archives, Windsor, Geo. 55588.)

(The term 'half length' was used in the eighteenth century for what is now called a three-quarter-length.)

This is one of the finest of all Ramsay's royal portraits. It belongs to the series of commissions which Ramsay received from the royal family after his appointment in 1767 to the office of Principal Painter in Ordinary to their Majesties; and it is primarily in these works that Ramsay developed the lyrical style which crowns his achievements as a painter, and which gives such distinction to his sympathetic portrayal of Princess Augusta.

There is a study by Ramsay, in red chalk, heightened with white, of the Princess's right hand (NGS, D.2076a verso).

NGS, D.1856. Red chalk, heightened with white, on buff paper, 17 × 10½in (43.2 × 26.7cm). One of two chalk studies of one of a pair of antique urns which stand on the sunken East Terrace at Windsor Castle (provenance unknown). Ramsay introduced a representation of the urn into a full-length of Princess Augusta (Private Collection) painted c.1764, and into two other portraits.

National Gallery of Scotland, Edinburgh

This drawing may usefully prompt some consideration of the relevance to Ramsay's art of his classical learning and antiquarian interests, which have generally been seen as belonging to an entirely separate compartment of his mind and even as a distraction from his avocation as a painter. It may be said that the refined sensibility manifested by this beautiful drawing is reflected not only in the portraits for which it served as a study but also in Ramsay's 'second style' as a whole.

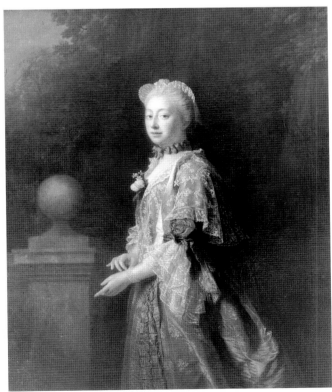

97

98

PRINCESS ELISABETH ALBERTINA
OF MECKLENBURG-STRELITZ

PRINCE FREDERICK, DUKE OF
YORK, AS A CHILD

Canvas, 50⅛ × 40in (127.3 × 101.6cm). Three-quarter-length: in a blue dress and crimson-lined ermine cloak, seated on a gilt, green-backed chair by a table, with a closed fan in her hands. Probably begun in 1769.

Her Majesty The Queen

Elisabeth Albertine, or Albertina, Princess of Mecklenburg-Strelitz (1713–1761), mother of Queen Charlotte (nos. 75, 81 and 86) and daughter of Ernst Friedrich I, Duke of Saxe-Hildburghausen, by his wife Countess Albertine of Erbach; married, in 1735, Prince Karl I, Duke of Mecklenburg-Strelitz; died shortly before her daughter Charlotte's departure for England to marry King George III.

This is a posthumous portrait, the likeness being based on a bust-length portrait by Daniel Woge (Her Majesty The Queen). In all other respects the composition is entirely of Ramsay's invention, and it would appear that he made use of his chalk study (no.70) for the three-quarter-length of *Mary Martin* (no.69), as has been pointed out by Sir Oliver Millar (Oliver Millar, *The Later Georgian Pictures in the Collection of Her Majesty The Queen*, London, 1969, vol.I, pp. 96f., no.1001; vol.II, pl. 4). This procedure ensured that the Princess, who had died many years earlier in 1761, was represented in the style of dress fashionable in her own lifetime.

Ramsay made chalk studies of the hands and fan, for which he must have employed the services of a model. These are on the back of a similar study for the Brunswick *Princess Augusta* (no.97), which is signed and dated 1769, and Millar argues plausibly from this that the two pictures were painted in the same year. It is certainly probable that the portrait of Princess Elisabeth Albertina was at least begun in 1769.

The picture was evidently painted for Queen Charlotte as one of a series of portraits of her relations which she commissioned from Ramsay and Zoffany.

The fan held upright in the sitter's hand constitutes a motif not uncommon in eighteenth-century French portraiture, where its *locus classicus* may be said to be Quentin de La Tour's portrait of *Queen Marie Leczinska*. Ramsay had introduced the motif as early as 1740 in a portrait of *Elizabeth Symonds* (Walker Art Gallery, Liverpool), and also in a drawing of his wife made in Florence in October 1754 (The Yale Center for British Art, Paul Mellon Collection, New Haven, Connecticut, B1977.14.6048: reproduced in Alastair Smart, *The Life and Art of Allan Ramsay*, London, 1952, pl. XXIV(a)). In a more general sense the portrait of Queen Charlotte's mother shows that in his final years as a painter Ramsay was as attracted as never before to the work of his French contemporaries, in this instance perhaps consciously emulating the brilliance of colour often to be seen in the work of such painters as Nattier, Perronneau and Aved.

Canvas, 64¼ × 43⅜in (163.2 × 111.5cm). Full-length: in a blue, gold-embroidered coat and waistcoat, with pink sash, standing with his legs crossed and leaning with his right arm on a table covered with a red tablecloth, on which there are a globe and three books; in the background, a column to the left, and a curtain and a red-backed chair to the right; a green carpet with red patterning. Painted c.1770–2.

S. K. H. der Prinz von Hannover

Frederick Augustus (16 August 1763–1827), Duke of York and Albany, Prince and Bishop of Osnabrück (1764–1803), Field-Marshal; second son of George III and Queen Charlotte; married in 1791, Princess Charlotte Ulrica Catherine (died 1820), daughter of Frederick William II, King of Prussia.

The uppermost of the two large volumes on the table is lettered on the spine: HISTORY/OF ENGLAND/VOL I. The volume underneath is similarly lettered: GESCHICHTE/VON/OSNABRUCK [*History of Osnabrück*]. Lying on top of these two volumes is a light blue-grey, cloth-bound book or notebook similar to that seen in the portrait of *Lady Holland* of 1766 (no. 90).

As in the case of the group-portrait of *Queen Charlotte and her children* (no.86), the introduction of a history of England – which was presumably intended for one of the volumes of the famous work by Hume – has an obvious pedagogic significance, relating to the young Prince's education in statecraft, while the history of Osnabrück is no less patently pertinent to his responsibilities as titular head of the city-state.

In preparation for the picture, Ramsay made two sketches of the proposed composition in oil on paper (nos. 102 and 103), presumably as trial pieces submitted for approval before the execution of the portrait. These are unique in his known *oeuvre*. One or both may have been sent to Hanover. The study of the accepted design (no.102) is considerably rubbed and damaged, possibly in consequence of its passage by sea. The beauty of Ramsay's management of tonal harmonies is particularly apparent in the other sketch (no.103), which is undamaged. There then followed a typical study of the pose in chalks (no.101), representing the Prince in the cross-legged pose indicated in one of the oil sketches.

This hitherto neglected work, painted virtually on the eve of Ramsay's enforced retirement from painting, was the last of the dozen known portraits commissioned from him by the royal family. Its realism of detail may

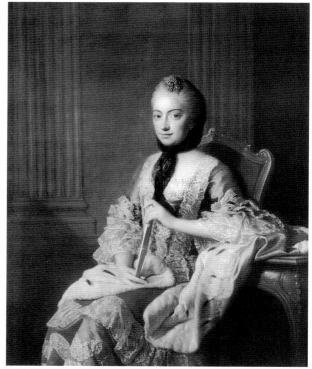

99

possibly reflect the artist's response to his rivalry at Court around 1770 with Johann Zoffany, who now shared with him the favour of the King and especially of Queen Charlotte. However that may be, in what was to be the last of his distinguished series of royal portraits, Ramsay exerted all his powers, in a manner that in other respects suggests conscious emulation of Van Dyck. In his group-portrait at Windsor, *The Three Eldest Children of Charles I* (fig.17), Van Dyck had given Prince Charles a cross-legged pose which may have influenced that of the Duke of York in Ramsay's picture. More significantly, Ramsay here created an image of his royal sitter comparable with the court portraiture of Van Dyck in its combination of unaffected naturalness and appropriate dignity of presentation. Finally, the superlative qualities of the portrait demonstrate that in his last years in practice there was no falling off in Ramsay's powers as an artist.

101

COSTUME-STUDY FOR THE PORTRAIT OF PRINCE FREDERICK, DUKE OF YORK

NGS, D.252. *Black chalk, heightened with white, on grey paper, 15⅛ × 10⅜in (38.4 × 26.4cm). Full-length study for no.100.*

National Gallery of Scotland, Edinburgh

102, 103

COMPOSITIONAL STUDIES FOR THE PORTRAIT OF PRINCE FREDERICK, DUKE OF YORK

NGS, D.512(1). *Oil on paper prepared with a brown wash, 11⅝ × 8⅜in (29.5 × 21.3cm). Complete compositional study in colour for no.100. The Prince's attitude is identical to that seen in the chalk study (no.101) for the portrait. The colours were slightly changed in the final painting.*

NGS, D.512(2). *Oil on paper prepared with a brown wash, 12⅛ × 8¾in (30.8 × 22.2cm). Complete compositional study in colour for no.100, but with a different pose from that eventually chosen.*

National Gallery of Scotland, Edinburgh

These oil studies are unique in Ramsay's known *oeuvre*. They are presumably trial pieces, submitted for approval prior to the execution of the portrait, and one or both may have been sent to Hanover. Once the design of the picture had been finally decided upon, Ramsay would have proceeded to make a chalk drawing of the Prince from life – i.e. no.101.

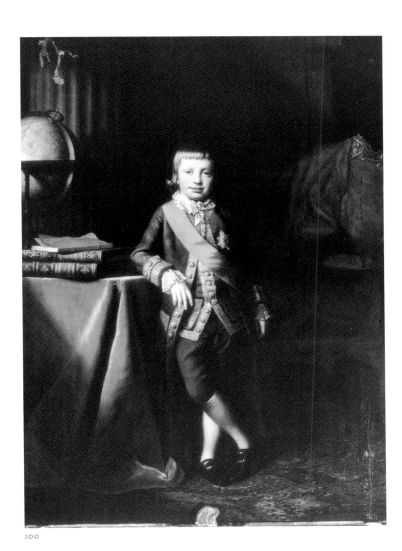

100

101

102

103

LADY CHARLOTTE BURGOYNE

Canvas, 39 × 29in (99.1 × 73.7cm). Three-quarter-length: in a blue dress, seated with a book, bound in red, in her hands. Painted c.1772 (?).

Private Collection

Lady Charlotte Stanley (died 1776), daughter of Sir Edward Stanley, 11th Earl of Derby; eloped with John Burgoyne (1722/3–1792) (no.54), the future general, dramatist and politician, who described her as 'the tenderest, the faithfullest, the most amiable companion and friend that ever man was blessed with'.

Two preparatory studies for the picture are known: (i) NGS, D.2040. Black chalk, heightened with white, on buff paper, 15½ × 11⅞in (39.4 × 30.2cm). Study of the pose, but with differences in the dress. (ii) NGS, D.2077. Red chalk, heightened with white, on buff paper, 8⅝ × 7½in (21.9 × 19.1cm). Study of the hands and book, together with a further study of the left hand.

A very late dating for the portrait is indicated by the character of the sitter's costume and especially by the styling of her hair, high-piled and powdered according to the fashion of the late 1760s and the early 1770s. In its general treatment, not least in the use of brilliant colour in the rendering of the dress, the picture has close affinities with the three-quarter-length of *Princess Elisabeth Albertina* of c.1769–70 (no. 99).

It is of interest that in 1772 Ramsay and Burgoyne – then Member of Parliament for Preston – were making common cause in the affairs of the East India Company, of which Ramsay, as a substantial shareholder, was one of the proprietors. A question of national importance had lately arisen over the issue of the Company's undetermined right to acquire territory in India and to declare war without the consent of the British Government. While the Ministry was naturally insistent upon curbing the powers that the East India Company had assumed, the Company's directors were strongly opposed to any such restriction. The dispute had come to a head in 1769, when the Directors appealed to the proprietors for their support. Ramsay had thereupon addressed a letter to the Directors defending the Government's position. This appeared in print in 1772, and Ramsay followed it in the same year with a further pamphlet in two parts – the first taking the form of a letter he had written to the Prime Minister, Lord North, and the second comprising the text of a speech which, as one of the proprietors, he had delivered at East India House on 12 November 1772, at a meeting of the General Court of the Company (*An Enquiry into the Rights of the East-India Company of making War*

and Peace …, London, 1772; *A Plan for the Government of Bengal* …: *In a letter to the Right Honourable Lord North* … *To which is added, The Speech of an East India Proprietor* …, London, 1772). The entire issue had meanwhile come up for debate in the House of Commons, and on 13 April 1772 Burgoyne had made the decisive speech which resulted in the setting up of a government committee of inquiry. Burgoyne's proposals, advocating adequate ministerial control over the East India Company, were to form the basis of subsequent legislation. The speech followed only some three weeks after Ramsay's letter to Lord North, dated 20 March 1772 and outlining similar views. Ramsay had known Burgoyne in Rome, where he had

painted his portrait (no.54), and their mutual association, many years later, with a national issue on which they shared a common viewpoint may well have given rise to Burgoyne's commission for a portrait of his wife.

The vase of flowers represented in the portrait is repeated from the half-length of *Margaret Ramsay* in Edinburgh (no.66) probably painted c.1758–60, and we may speculate on the possibility that the Burgoynes had admired the picture on a visit to Ramsay's house, and had requested the repetition of the motif of the vase of flowers in the portrait of Lady Charlotte.

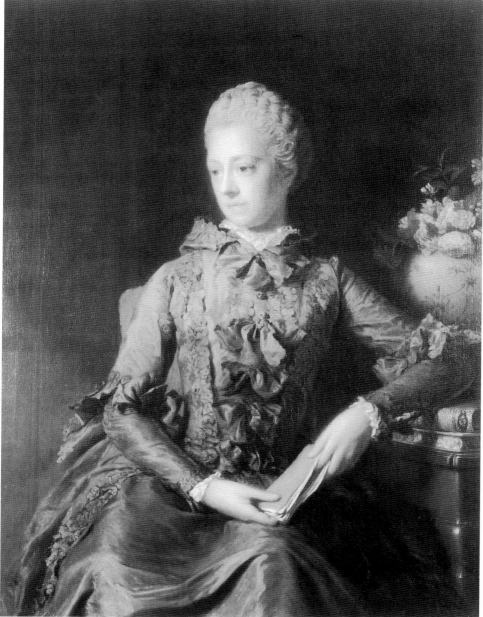

104

NGS, D.2008. *Red chalk, heightened with white, on grey paper, 11¼ × 8½in (28.6 × 21.6cm). Head and shoulders only: in a mob-cap with a bow at the top, her head turned three-quarters to the right.*
Inscribed on the back, in Ramsay's hand: Ischia, July 8, 1776.
The sitter is identifiable from a similar drawing, inscribed on the verso as being a portrait of Amelia Ramsay, in the Huntington Library and Art Gallery, San Marino, California (63.52.200). The latter drawing was also made on the Island of Ischia in 1776.

National Gallery of Scotland, Edinburgh

Amelia Ramsay (1755–1813), elder daughter of Allan Ramsay by his second wife Margaret Lindsay; born in Rome; accompanied her parents to Italy in 1775; married, in June 1779, Lieut.-Colonel Archibald Campbell of Inverneil (1739–1791), son of James Campbell, Writer at Inveraray, shortly after Archibald Campbell's return from his command of the successful expedition against Georgia in the previous year; in the summer of 1780, accompanied by her sister Charlotte, and narrowly escaping capture by the combined French and Spanish fleets, joined her husband in Jamaica, where he had been appointed Lieutenant-Governor with the rank of Brigadier-General, becoming Governor from 1782 to 1784; returned from Jamaica in August 1784, when her father hurried home from Italy to greet his daughters, but died on reaching Dover; in October 1785 accompanied her husband, who had been knighted on 30 September of that year, to Madras, on his appointment as Governor; on his resignation owing to ill-health, returned to England with her husband in 1789. In Madras Lady Campbell was noted for her work to improve education and medical care, and in 1787 she founded the Military Female Orphan Asylum.

Writing from London in May or June 1779 to his brother Duncan, Archibald Campbell announced his forthcoming marriage to Amelia Ramsay in the following terms:

Since my arrival in this Metropolis, I have become a convert to the rigid principles of a Batchellor; by the amiable qualifications of Miss Amelia Ramsay, a lady, who exclusive of every Personal charm, possesses the most valuable accomplishments and happy disposition that I could ask or wish for. – The daughter of Allan Ramsay Esq. of whom you have heard so much, as a Painter to the King, would perhaps be of little consequence to me in Point of Connexion, had not she been also the Neice [*sic*] of Sir John Lindsay Knight of the Bath; Sir David Lindsay Lieut. Gen. in the Army; and Grandneice to Lord Mansfield; with the whole of which families she has been on habits of easy friendship, admired, careful, and beloved. Exclusive of the importance of such a connexion in England, it affords me serious weight and consequence in Scotland, and in the end may prove so to all our family on either side of the world. Miss Ramsay has no pride in her own consequence and is too sensible not to accommodate herself to my ambitious inclinations should I wish to pursue them. I think you will like her; and learn from such an outline she is a treasure in herself. – Her father gives me Four thousand pounds with this Lady; and I would have married her without a shilling were it necessary she should have none. There is but one Boy and Girl more in the family and the old Cadger is Rich and very Highly respected; a most Sensible, Pleasing Clever Old man …

Old Ramsay (as usual) was sent for to the Queen's Palace to wait on their Majestys'; and he acquanted [*sic*] them, that the Conqueror of Georgia had made a conquest also of his Daughter which gave him as much pleasure as the former: Their Majestys' smiled, and were graciously pleased to say handsome things upon the occasion. – Thus we stand at Court …
(Campbell of Inverneil MSS., in the possession of J. L. Campbell of Canna.)

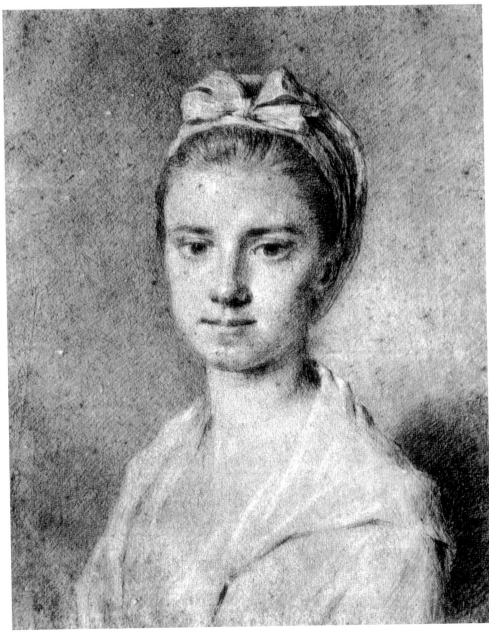

105

A YOUNG LADY IN A PINK DRESS
(?AMELIA RAMSAY)

In a letter endorsed 24 June 1779, Campbell wrote in similar vein to his brother James:

> You must not be surprized to hear that I am likely to form a valuable connexion for our family. A lady of Harley Street the Daughter of the famous Allan Ramsay, connected and in high regard with Lord and Lady Mansfield and Neice to Lord Stormont, Sir John and Sir David Lindsay Gent^n. of high repute and distinguished Interest at present. They have all received me warmly and in the Course of a fourthnight I am in hopes to be in possession of one of the Most Amiable well disposed Ladies of this Metropolis, easy and free from Pride and in short all I could desire or wish …
> (Campbell of Inverneil MSS.)

Further light is cast on the impression made by Amelia Ramsay upon those acquainted with her by a letter written on 28 May 1780 by Sir Archibald's man of business in London and namesake, Archibald Campbell, to Robert Stewart in Calcutta, in which he refers to Amelia's marriage to Campbell in the previous year, remarking of her that she is 'a lady of infinite beauty and merit' who 'possesses all the numberless qualifications and accomplishments which you and I would think our friend had a right to expect in his bride,' and adding that 'there is not a happier couple in the King's Dominions than they are.' (Campbell of Inverneil MSS.)

Amelia Ramsay brought her husband a dowry of £4,000, of which there is a careful note, showing the interest on it, in Archibald Campbell's Account Book, under the date 6 July 1782:

> Allan Ramsay Esq 1782 July 6 received from Allan Ramsay my Father in Law Esq^r. in full of Mrs Campbell's portion £4000 …
> Interest on £2000 from
> 18 July 1779 to this day
> 3 yrs. less 2 days at 4 p^rc £239:9:2
> Interest on the rem^g. } £4248:9
> £2000 f^m. 26 May to
> this date £8:19:8 }
> (Campbell of Inverneil MSS.)

Canvas, 30 × 25³/₁₆in (76.2 × 63.9cm). Half-length: in a pink dress, leaning her arms on a table or ledge, with her hands folded together. Unfinished. (Nineteenth-century additions to the hands, arms and lace sleeves were recently removed.)

**Yale Center for British Art,
Paul Mellon Collection**

This beautiful painting, which for some reason was left unfinished, has usually been dated *c.*1760, which may well be correct. However, the young sitter's resemblance to Ramsay's elder daughter Amelia, whose appearance as a girl of twenty-one is known from two chalk studies by Ramsay made on the island of Ischia in 1776 – the Edinburgh drawing NGS, D.2008 (no.105) and more particularly a drawing in red chalk in the Huntington Library and Art Gallery, San Marino, California (63.52.200) – raises the possibility that the picture is very much later, and indeed that it represents Amelia (born in 1755) at about the age of sixteen or seventeen. A dating in the early 1770s would be compatible, for instance, with the dark brown background, such as is found in portraits by Ramsay painted after 1765 (an example being the *Hume* of 1766: no.93). There is, however, insufficient evidence to allow a definite identification of the sitter with Amelia, which remains accordingly in the realm of speculation.

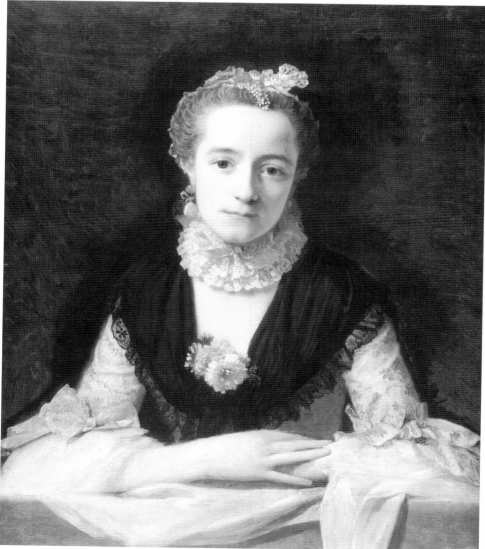

106

107

MARGARET RAMSAY,
THE ARTIST'S SECOND WIFE

NGS,D. 2009. *Red chalk, heightened with white, on grey paper, 14½ × 11in (36.8 × 27.9cm). Head and shoulders, looking down to the sitter's left. Evidently drawn in 1776.*

National Gallery of Scotland, Edinburgh

This lovely drawing of the artist's wife has previously been dated *c.*1755 and associated with Ramsay's second visit to Italy of 1754–7. The style, however, is identical to that of dated drawings of 1776, made during his third Italian visit (1775–7).

108 *plate 48*

SELF-PORTRAIT AT THE AGE
OF SIXTY-TWO

Red chalk, heightened with white, on buff paper, 11⅜ × 8½in (28.9 × 21.6cm). Head and shoulders. Inscribed in ink on the verso, in Ramsay's hand: A. Ramsay, drawn by himself in the Island of Ischia / August 1776.

National Portrait Gallery, London

This is one of a small group of portrait-drawings made by Ramsay in the summer of 1776, when during his third visit to Italy (1775–7) he spent a few weeks with his family on the Island of Ischia. He had gone to Italy – accompanied by his wife and his daughter Amelia – in the hope of a cure for the physical debilitation he had suffered by his calamitous accident in 1773. The baths of Ischia were especially famous for their curative powers.

The other drawings in this group include portraits of his wife (no.107) and his daughter Amelia (no.105). It would appear that his injury primarily affected his upper arm and shoulder, and it is therefore possible that he was enabled to produce such accomplished drawings by resting his elbow on a table.

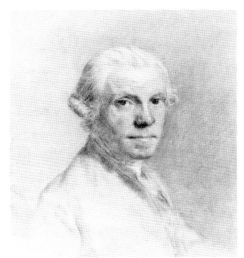

108

107

MARBLE BUST OF ALLAN RAMSAY, BY MICHAEL FOYE

Marble, h. 24in (59.9cm). Inscribed: J.M.E.FOYE sculpt. ROME 177- *(the last figure defaced). Executed in Rome during Ramsay's third visit to Italy of 1775–7.*

Scottish National Portrait Gallery, Edinburgh

The Irish sculptor Michael Foye, or Foy (recorded from 1767), worked in Rome from the year 1773. Kerslake suggests that the Edinburgh bust was the 'Busto of an Artist' exhibited by 'Foy' at the Society of Artists in 1777 (201): see John Kerslake, *National Portrait Gallery: Early*

Georgian Portraits, London, 1977, vol.I, p.277.

Although it can be said that Foye was conforming to a long-established tradition in European portrait-sculpture for the portrayal of eminent men, the toga in which Ramsay is here dressed seems entirely appropriate to the painter's secondary avocation – especially in his later years – as a classical scholar and antiquary, and more particularly in respect of his work at this time on his *Enquiry into the Situation and Circumstances of Horace's Sabine Villa* (the publication of which was prevented by his death).

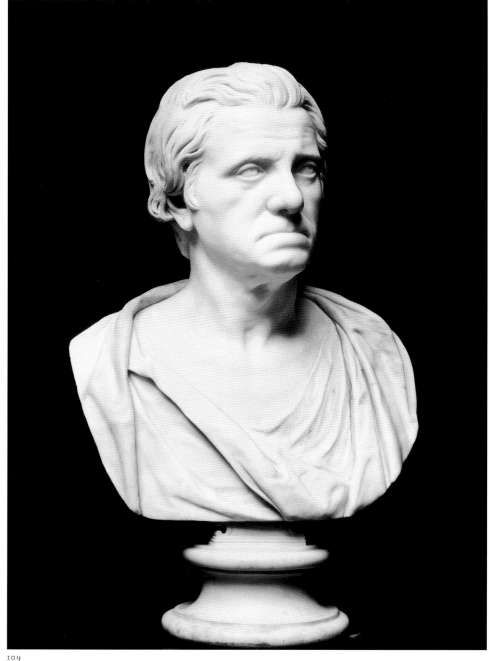

109